Perception and Imaging

Perception and Imaging
Second Edition

Richard Zakia

Julieanne Kost

Focal Press

An Imprint of Elsevier

Boston Oxford Auckland Johannesburg Melbourne New Delhi

Focal Press is an imprint of Elsevier

∞ Recognizing the importance of preserving what has been written, Elsevier prints its books on acid-free paper whenever possible.

Library of Congress Cataloging-in-Publication Data
Zakia, Richard D.
Perception and imaging / Richard Zakia.—2nd ed.
p. cm.
Includes bibliographical references and index.
ISBN-13: 978-0-240-80466-8 ISBN-10: 0-240-80466-X
1. Composition (Photography). 2. Visual perception. 3. Gestalt psychology. I. Title.

TR179 .Z34 2001
770'.1'1—dc21
ISBN-13: 978-0-240-80466-8
ISBN-10: 0-240-80466-X 2001040786
British Library Cataloguing-in-Publication Data
A catalogue record for this book is available from the British Library.

Cover Photo Pete Turner

The publisher offers special discounts on bulk orders of this book.
For information, please contact:
Manager of Special Sales
Butterworth–Heinemann
225 Wildwood Avenue
Woburn, MA 01801-2041
Tel: 781-904-2500
Fax: 781-904-2620

For information on all Focal Press publications available, contact our World Wide Web home page at: http://www.focalpress.com

10 9 8 7 6 5 4

Printed in the United States of America

To Professor Rudolf Arnheim
A dear friend, colleague, and mentor who
kept the spirit of Gestalt perception alive
in the 20th century

Photo of Pete Turner and the author.

The cover photograph titled *Hawk in Tree, Ngorongora Crater, Tanzania,* was taken by Pete Turner while on assignment in Africa.

1956 Yearbook photographs. (Pete Turner [left] and the author have been friends and colleagues ever since their school days at the Rochester Institute of Technology. They began their studies as freshmen in 1952 and graduated in 1956.)

Contents

Appendix A Additional Concepts 327

Preface

The first edition of this book, published in 1997, began with a handwritten quote by Henri Cartier Bresson:

Photography has not changed since its origin esccept in its technical aspects which for me are not a major concern. — Henri Cartier-Bresson

This 1978 statement by Henri Cartier-Bresson[1] is worth considering, particularly with the increasingly sophisticated imaging technology currently available. Regardless of the medium used, how high tech it might be, and with what speed images can be manipulated, it is the human factor that is important. Pictures, regardless of how they are created and recreated, are intended to be looked at. This brings to the forefront not the technology of imaging, which of course is important, but rather what we might call the "eyenology" (knowledge of the visual process — of seeing).

What is known about vision and the visual process is overwhelming; what is directly applicable to pictures is not, and this is what this book presents as an introduction. We take the eye and how we see for granted. But scientists studying the visual process and working in cognitive science recognize its complexity. Dr. Calvin Mead, a professor of computer science at the California Institute of Technology, puts it this way: "The visual system of a single human being does more image processing than do the entire world's supercomputers."[2] Our visual process is unique and how it functions is still somewhat of a mystery.

This new edition maintains the integrity of the earlier edition and extends it to include the other visual principles important to photographers and other imagers, regardless of the medium (including cinema, video computer animation, graphic design, web design, and multimedia) used to capture, manipulate, reproduce, or display visual information.

The concepts in each chapter have been selected on the basis of their relevance to the perception of visual images and information. This book

is an attempt to share with you, regardless of the technology you use, what I have over many years gleaned from a historical and contemporary parade of others having a like concern. The technology will continue to change, but the process of visual perception will remain essentially the same.

In this second edition, considerable attention has been given to color including the different ways in which color can be measured and specified (Munsell, Ostwald, Pantone, CIE), color perception, defective color vision, synesthesia, and metamerism. Synesthesia is the ability of one sensory input to trigger another. Some people can actually see colors, for example, when listening to music. Two women, who are mentioned in the text, actually see different colors when looking at black-and-white type. Synesthesia is highly relevant to visual imagery. That sound can and does enhance the color and quality of motion pictures has long been known and exploited. Not as well known, perhaps, are the anecdotal remarks by photographers such as Edward Weston who wrote in his daybooks, "Whenever I can feel a Bach fugue in my work, I know I have arrived."[3]

Other photographers who may have had synesthetic experiences include Stieglitz, David Hockney, Minor White, Paul Caponigro, and Carl Chiarenza. The composer and photographer Ernest Bloch captioned some of his tree photographs with the titles of musical compositions by Beethoven and Bach. Stieglitz was a close friend of Bloch. Might his *equivalents* be considered a form of synesthesia?

A section on color connotations, how colors affect our feelings, includes some of the practical and useful writings of designer Massimo Vignelli. The chapter on critique now has a procedure for using group dynamics in a critique format to help students become more at ease during critique sessions and participate more.

Common contour, the edges in an image, plays a very important role in perception. The careful juxtapositioning of near and far contours in a photograph can destroy depth. Pete Turner brilliantly reveals this in his color photograph "Push." One finds that his photograph, in all of its somewhat subtle simplicity, is highly complex.

New findings on the mysterious smile of the painting *Mona Lisa* by Leonardo da Vinci (the "now you see it, now you don't" smile), suggests the significant role that peripheral vision plays in perception.

The importance of rhetoric in both the written and spoken word has long been recognized and used to give impact to a statement and to persuade. A new chapter on how rhetoric applies to the visual image begins with a rhetorical matrix, which provides a structure for designing or critiquing images. Rhetoric is essential to language, and language can be thought of as anything and everything that conveys meaning. Twenty examples of how rhetoric is used (intuitively or intentionally) in photography, graphic design, painting, advertising, and movies are included and discussed. Examples of how rhetoric has been used in other areas such as poetry, song titles, lyrics of songs, cartoons, business signs, and the Bible

are presented in the exercise section to emphasize the importance and pervasiveness of rhetoric.

Throughout the preparation of this book, considerable attention has been directed toward having the words and pictures support each other—word text and picture text as one text. As far as possible and practical, the layout of the book addresses this concern.

The quotations included along the side of each page are intended to serve as visual "sound bites" to support the information in the text. Unless otherwise noted, the quotations are from three of my earlier books that are now out of print (*Perceptual Quotes for Photographers, Quotes by Artists for Artists,* and *Quotations for Teachers*).[4,5,6]

Please note that whenever the word photographer is used in the text, it is used in a collective sense to include the multiplicity of ways image practitioners capture, create, and manipulate visual images.

Notes

1. *Henri Cartier-Bresson.* A catalogue of 390 of his photographs selected by him for the Scottish Arts Council Exhibition arranged in association with the Victoria Albert Museum in 1978. The introduction is a handwritten statement by Cartier-Bresson titled, "L'Imaginaire d'aprés Nature."
2. Judith Axler Turner, "Figuring Out the Rules for How the Brain Works," *The Chronicle of Higher Education,* October 26, 1988, p. A3.
3. Nancy Newhall, *The Daybooks of Edward Weston,* Millerton, NY: Aperture, 1973, p. 234.
4. Richard D. Zakia, *Perceptual Quotes for Photographers,* Rochester NY: Light Impressions, 1980 (out of print).
5. Richard D. Zakia, *Quotes by Artists for Artists,* Rochester, NY: Zimzum Press, 1994 (out of print).
6. Richard D. Zakia, *Quotations for Teachers,* Rochester, NY: Zimzum Press, 1995 (out of print).

Photographs mentioned in this book that are not shown can be seen on the World Wide Web (WWW) using search engines such as Google and Yahoo. (Type in the photographer's name and click on "Images".)

Acknowledgments

My thanks to the many people who have assisted me along the way. Dr. Leslie Stroebel, my friend, colleague, and former teacher, carefully read the entire text and made many useful suggestions helping to clarify my thinking and writing. Lois Arlidge-Zakia, my wife of many years, also read the entire text for grammatical correctness, and my daughter, Dr. Reneé Zakia, made suggestions on rhetoric. Thanks also to Pete Turner for his two photographs, one of which appears on the cover, to Dr. Carl Chiarenza and Paul Caponigro for their suggestions on synesthesia, and to Karin Franz, Jarrod Gahr, and Peter Sucy for their assistance. My appreciation also goes to the students who helped me in the preparation of some of the graphics: Sunah Ahn, Suzanne Blum, Joe DiGioia, Ya-Li Hsu, Jeff Mariotti, and Gary La Croix. I am also grateful to the many photographers, past and present, whose photographs serve to illuminate the text.

Special thanks to Diane Wurzel, assistant editor at Focal Press; Maura Kelly, Production Manager; Lorretta Palagi, Copyeditor; and Marie Lee, Executive Marketing Manager for their gracious help and guidance along the way. Many thanks go out to the many unnamed men and women whose work has made this book a physical reality.

A very special thanks to all the many artists and writers whom I have quoted throughout the text. Their words add "color" to many of the perceptual ideas presented and emphasize their importance. In the words of Benjamin Disraeli,

The wisdom of the wise and the experience of the ages are perpetuated in quotations.

*THE SOUL NEVER THINKS
WITHOUT AN IMAGE*

Aristotle

I

Selection

Many an object is not seen, though it falls within our range of visual ray, because it does not come within the range of our intellectual ray, i.e., we are not looking for it. So, in the largest sense, we find only the world we look for.

Henry Thoreau

French print by Pierre Crussaire, 1774 (The Metropolitan Museum of Art). How many profile faces do you find? How long did it take? What visual search strategy did you find yourself using?

1

GANZFELD

Imagine for a moment a visual world in which there are no visual elements. You are able to see but your visual field is completely homogeneous. The situation described rarely exists in our normal visual world, but you can imagine, for example, being in a very dense fog, looking into a large integrating sphere, or flying an airplane through a dense cloud or at a very high altitude where the sky is completely uniform in brightness. Such imaginary situations approximate a homogeneous visual field, or *Ganzfeld*.

The artist tries to wrest truth from the void.

Barnett Newman

What kind of visual experience does a Ganzfeld provide? You can discover for yourself by covering each eye with a diffusing shell such as a white plastic spoon or half of a table-tennis ball, or, easier but less effective, by just closing your eyelids in a brightly lighted area.

Experiments in which subjects were exposed to a homogeneous visual field for a prolonged length of time revealed some interesting results. The subjects typically attempted to locate something in the visual field to fixate on to provide a reference point. Failing to do so commonly resulted in a feeling of disorientation, and some subjects imagined they saw variations of tone where none existed or even experienced hallucinations or a temporary loss of vision.

Only feeling is real. It was no "empty square" that I had exhibited but rather the feeling of non-objectivity.

Kasimir Malevich

Although airplane pilots, car and truck drivers, and skiers have reported disorientation when exposed to an unstructured visual field, it is an uncommon experience, but the phenomenon does emphasize the importance of having something in the visual field to fixate on for the visual system to function properly. Even when the visual field is not completely homogeneous, perception of the observed scene may not be accurate unless appropriate visual cues are also present. An illuminated spherical ball in an otherwise darkened room, for example, can be perceived as being different in size and distance by different observers, and decreasing the size of the ball by releasing air may be perceived by some observers as a ball of constant size moving away from them.

FIGURE–GROUND

The black triangle in the white square in Figure 1.1 represents a simple heterogeneous visual field. The image, like most scenes that we encounter in our daily lives, possesses a pair of distinguishable attributes identified as *figure* and *ground*. Several important observations can be made regarding figure–ground relationships:

1. Even though the figure and ground are in the same physical plane, the figure often appears nearer to the observer.
2. Figure and ground cannot be seen simultaneously, but can be seen sequentially. (With a little effort you can see a white square with a triangular hole.)

3. Figure usually occupies an area smaller than does ground.
4. Figure is seen as having contour; ground is not.

 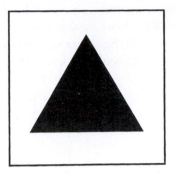

Figure 1.1 Homogeneous and heterogeneous fields.

Look at any land-scape photograph. You see the shape of things, the mountains and trees and build-ings, but not the sky.

Kurt Koffka

Figure is seen as having form; ground is not (except of course when ground is seen as figure, as in the case of a white square with a triangular hole).

In the heterogeneous world in which we live, people are free to select what attracts their attention as figure. In a given situation different things will be seen as figure, depending on a variety of circumstances. For example, different people walking down a main street will, at any instant and depending on their interests, see:

1. A clock telling the time of day if they are hurrying to a meeting;
2. A theater if they are looking for entertainment; or
3. A bus or taxi if they are looking for transportation (Figure 1.2).

In a film, video, or multimedia, a good musical accompani-ment will not call attention to itself.

Reneé Evan

Figure 1.2 Figure–ground is a selective process.

Figure–ground relationships are used in many diagnostic tests. Most of us have taken tests for defective color vision in which we try to group certain color spots to see a number or design. The inability to discriminate among colors and to group some color spots as a figure identifies the presence of defective color vision. Whenever we look at a heterogeneous

Though clay may be molded into a vase, the utility of the vase lies in what is not there.

Lao Tze

visual field, that which we see as an object is called *figure,* and the figure is always seen against some background. The first step in perception is distinguishing figure from ground. Sometimes it is easy to see figure against ground; sometimes it is not. What factors contribute to our perception of figure? Why do we see things as we do? A powerful and convincing demonstration of the figure–ground relationship was presented by K. Koffka in 1922 with an equivocal fence design (Figure 1.3).

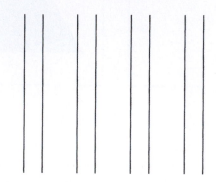

Figure 1.3 Equivocal fence phenomenon. What do you see?

Examine the image in Figure 1.3 and describe what you see. Your first impression might well be that of black lines against a white background area. If so, the black lines are figure. A simple concept, isn't it? But let's continue. Look at it a little longer and you might see four narrow white stripes, bars, or fence slats. If you do, they are figure and the remainder of the picture is ground. But why do you see the four narrow stripes as figures? A simple answer is that it is easier to see the narrow stripes, but it explains nothing. A better answer is that the two lines that make up the narrow slat are closer together and, therefore, there is a greater tendency for the viewer to group them into some figure. Three important points can be made here:

Give me mud and I will make the skin of Venus out of it. If you will allow me to surround it as I please.

Eugene Delacroix

1. One can predict that the closer together two elements are, the greater the probability that they will be grouped together and seen as figure. (This is called the *law of proximity* and is discussed in more detail later.)
2. It is impossible to have figure without ground. Put differently, what we call background in a picture is very important.
3. It is nearly impossible to see the four narrow slats and the three wide slats simultaneously. You cannot have figure without ground.

The figure–ground relationship in Figure 1.3 can be enhanced by taking a pencil and darkening the narrow stripes.

Figure–Ground Boundary

Figure 1.4 shows a single contour line that serves as a boundary for the facial profile of an old man and the head and torso profile of a woman. It is possible to see either the woman or the man. When the old man is seen it is because the opposite side of the contour line has become ground.

The border line between two adjacent shapes having double functions, the act of tracing such a line is a complicated business. On either side of it, simultaneously a recognizability takes shape.

Maurits Escher

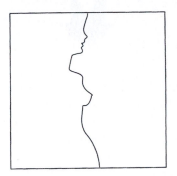

Figure 1.4 Figure–ground boundary. Profile of an old man or head and torso profile of a woman?

The converse, of course, occurs when you see the woman. The contour line is common to both images and is called a *common contour* or a *shared contour*. Competition for the contour is called *contour rivalry*. The sharing of the common border creates a visual tension, a pull in one direction and then the other, that can only be resolved when the decision is made to see it belonging to one side of the contour or the other. This can readily alternate, giving a dynamic dimension to the image and even some ambiguity. (The importance of closure in resolving contour rivalry and facilitating perception will be seen in Chapter 2, "Gestalt Grouping.")

Graphic Symbols

The concept of figure–ground is used extensively by artists in the design of graphic symbols. Figure 1.5 is an example of an effective use of figure–ground. Initially one might see the black arrowheads pointing like a compass in four directions and later notice the large letter M in the white area.

One reason for this is that the black areas are closed and easier to see as figure than the open white area. Once the letter M is seen as figure it can alternate with the black arrows and be seen as figure or as ground. Both, however, cannot be seen as figure simultaneously. Figure needs a ground area from which to emerge.

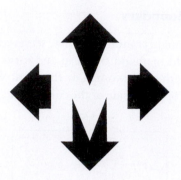

Figure 1.5 *Figure–ground. If you decide that the dark areas are figure, you see arrows. If you decide that the light areas contained within the dark area are figure, you see a letter. (Courtesy Mapco Inc., Tulsa, Oklahoma.)*

What's in a Name?

The term *figure–ground* may be new to some readers but the concept is well established. Different disciplines seem to have different vocabularies for describing the same concept.

Dynamic interaction in the field decides what becomes a unit, what is excluded from it, what is figure, and what falls back as mere ground.

Wolfgang Kohler

Artists and photographers often refer to it as *positive–negative space*. Such exclusiveness in terminology is further demonstrated in the field of communications engineering where the term *signal-to-noise ratio* is used to quantitatively describe figure–ground relationships. Recognizing that we may be using different words to describe the same concept can improve communications among the various disciplines.

Discipline	Label
Psychology	Figure–ground
Art and photography	Positive–negative space
Engineering	Signal-to-noise ratio

Figures 1.6 through 1.10 show examples of figure–ground, positive–negative space, and signal-to-noise ratio from the point of view of a psychologist, a designer, a photographer, a photographic engineer, and a television engineer.

The vase gives form to the void, and music gives form to silence.

Georges Braque

Increasing the differences between figure and ground (negative and positive space, or signal and noise) increases the vividness of the corresponding perception. In Figure 1.3, for example, we could make it easier for a person to see the narrow stripes as figure by darkening them, thereby increasing the tonal contrast between figure and ground. (Does darkening the wider stripes change your perception of figure–ground? Try it. Make a few copies of Figure 1.3, darken them differently, and test them out with your friends.)

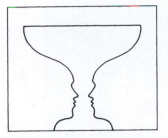

Figure 1.6 *Figure–ground (psychologist). Goblet or profiles? Such a figure–ground reversal was first shown by the Danish psychologist Edgar Rubin in 1915.*

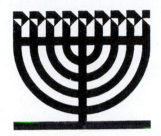

Figure 1.7 *Figure–ground: Positive–negative space (designer). (Design by Steve Chapman and Tom Morin.)*

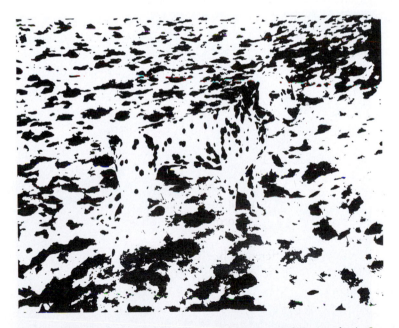

Figure 1.8 *Figure–ground: Positive–negative space (photographer). Some spots are selected from the complete field of spots and, because of their relationship, are grouped to form the shape of a dog. (High-contrast photograph by Roger Remington.)*

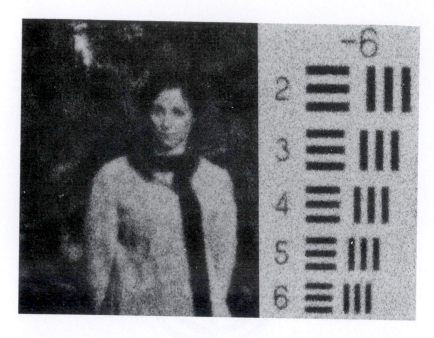

Figure 1.9 Figure–ground: Signal-to-noise ratio (photographic engineer). (Photograph [grainy] by Carl Franz.)

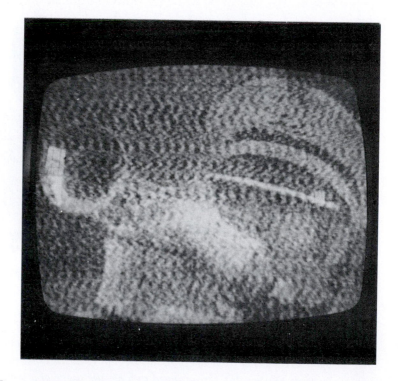

Figure 1.10 Figure–ground: Signal-to-noise ratio (television engineer).

Graininess and Noise

The unhomogeneity of uniformly exposed areas in photographs resulting from the microstructure and clumping of the silver or dye particles that make up the image is identified as *graininess* when viewed or judged subjectively and *granularity* when measured objectively and assigned a number.

The graininess/granularity can also be referred to as noise because it reduces the amount of information (signal) that the image conveys to the viewer. The grainy picture therefore has a reduced signal-to-noise ratio. Photographers can increase the signal-to-noise ratio by reducing the graininess level, for example, by selecting a fine-grain film, a fine-grain developer, or a larger-format film that does not require as much magnification as a smaller-format film.

Note, however, that photographers sometimes purposely introduce graininess (or other overall texture pattern) into a photograph for any of various reasons, including to suppress fine-detail information in order to place more emphasis on areas having larger tonal masses, and to produce a desired artistic effect.

Consciousness is more interested in one part of its object than in another, and welcomes and rejects, or chooses, all the while it thinks.

William James

Resolution

Resolving power targets are often used in photography to determine how well a photographic system can reproduce repetitive lines that decrease in width and space (spatial frequency). If the number of black bars that can be distinguished as signal are considered, we can see how graininess adds to the noise level and makes the visual signal less distinguishable (Figure 1.11).

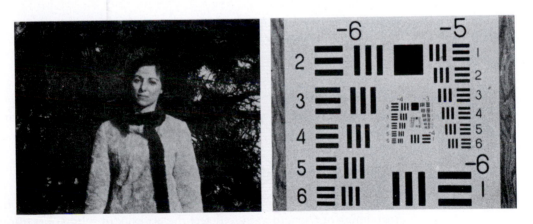

(A) Good figure–ground (high signal-to-noise ratio).

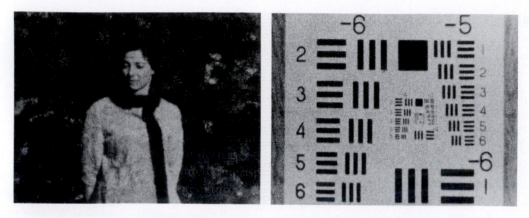

(B) *Fair figure–ground (moderate signal-to-noise ratio).*

(C) *Poor figure–ground (low signal-to-noise ratio).*

Figure 1.11 Resolving power targets as figure–ground. Increasing amounts of graininess lower the signal-to-noise ratio, causing a poor figure–ground relationship. (By Carl Franz.)

A similar situation exists with video monitors and when slides are projected onto a textured screen where the texture is visible from the normal viewing distance.

Figure–Ground Enhancement

We can only recognize what we know.

E. H. Gombrich

An interesting example of figure–ground enhancement concerns the photographing of a sonar screen to detect the presence of submarines during World War II. The image of a submarine on the screen is dependent on sound waves being reflected from the submarine. Because other things in the water also reflect sound waves, the visual noise pattern that is displayed on the screen obscures the image of the submarine, making the signal-to-noise ratio too low to detect it. The following simple and ingenious

technique was used to solve the problem. A series of pictures was made over a given time period. These pictures were then superimposed and viewed. Because the noise pattern on the sonar screen was random, the effect of superposition of the pictures was to average out the noise. The image of the submarine was not random and was, therefore, enhanced. The total effect was an increase in the signal-to-noise ratio and an image in which the distinction between figure and ground was significantly increased.

Photographers and other image makers must continuously be aware of the concept of figure–ground when making pictures. Controls at the disposal of photographers to enhance the figure include:

- Camera viewpoint, to select an angle that reveals the desired information about the main subject and also minimizes competition for attention between the background and the subject;
- Lighting, to provide detail, form, and texture in the main subject and also to provide tonal separation between the subject and the background;
- Focus and depth of field, to obtain a sharp image in the areas of interest and to allow other areas to be rendered less sharp;
- Choice of film, including color, normal contrast black-and-white, high-contrast, infrared, and fine-grain film, to provide the desired information about the main subject;
- Choice of camera filter, to produce the desired tonal rendering of the subject and tonal separation between the subject and the background; and
- Printing controls, including overall contrast control and selective dodging and burning to emphasize areas of interest and subdue other areas.

Vision changes while it observes.

James Ensor

One of the most common mistakes made by beginning photographers, cinematographers, and videographers is to ignore the background while concentrating on the main subject, and then discover in the two-dimensional image that the depth in the original scene has collapsed and a background object such as a pole or tree appears to be growing from the head of a person in the foreground (see Figure 2.5 in the next chapter).

Nonvisual Figure–Ground

The concept of figure–ground is not limited to visual perception but can be applied to all sensory experiences. You can demonstrate the concept of figure–ground with sound by talking to a friend in a normal voice when there are other sounds in the background; for example, at a cocktail party, in a noisy restaurant, or when a radio is blaring in the same room. Usually it is possible to carry on a conversation. Your voices are figure (signal) and the other sounds are background (noise). In sound recording and sound mixing, minimizing background noise enhances signal quality

If you do not expect it, you will not find the unexpected, for it is hard to find and difficult.

Heraclitus

(acoustical figure), although some background noise is often desired to provide an appropriate atmosphere.

Run your fingers over the surface of some textured object. What you feel is figure, the information that tells you the texture of the surface. The reading of Braille depends on feeling the raised dots and determining their configuration. Carefully sip from a glass of quality wine and attend to the variety of tastes and smells (one at a time) that you can distinguish, such as sweet, mild, flowery, and so on. Professional wine tasters have their own vocabulary—delicate, noble, soft, foxy, mousy, mellow, elegant, robust, simple, and complex. In a room with many different odors you will undoubtedly smell that which is strongest or, depending on your own individual inclination, that which is least or most familiar. In so doing you are distinguishing figure from ground.

Look for what you don't see.

Rashid Elisha

Because all of our senses are tied into the same central nervous system (information processing center), it is not surprising that a concept such as figure–ground should be valid for all senses. The figure–ground relationship plays an important part in our daily lives. For example, when you purchase any item, be it a car, camera, computer, or CD player, your choice is pretty much determined by the features that you value most. If you are looking for style when you buy a camera, that becomes figure and you choose the camera on that basis (Figure 1.12).

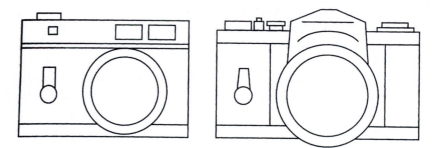

Figure 1.12 Viewing system as figure. When choosing a camera in a particular price range, look for one in which the viewing system makes it easy for you to see the picture, otherwise you will miss much of the fun in making photographs. Look for a viewing system that is big and bright and makes focusing easy. Two basic types of viewing systems are shown above, a viewfinder camera (left) and a single-reflex camera (right).

The more one looks, the more one sees. And the more one sees, the better one knows where to look.

Tielhard de Chardin

A husband and wife, looking over a furnished model home, will often disagree on the home. A possible reason is that one may be looking at the quality of construction (figure) and the other at overall design as enhanced by the attractive furnishings. Florists arranging flowers realize that the space between flowers is as important to the overall effect as the flowers themselves. Portrait photographers and cosmetologists use figure–ground techniques to accentuate the positive features in a face and eliminate the negative.

Many other examples are possible. A special field of psychology looks on certain mental disorders as the inability of a person to distinguish figure from ground in everyday experiences. Part of the therapy is directed toward helping the patient make these distinctions. The concept of figure–ground enters into most aspects of our daily living.

NOTAN

In his book on composition published in 1919, the artist-teacher Arthur Wesley Dow wrote, "As there is no word in English to express the idea contained in the phrase 'light-dark,' I have adopted the Japanese word 'Notan' (dark, light). . . . Chiaroscuro has a similar but more limited meaning. . . . Darks and lights in harmonic relations—that is Notan."[1] Dow was very influential in introducing artists to the Oriental style of painting, painting that rarely represents shadows. The painter-photographer Barbara Morgan, who was strongly influenced by Dow's work and teaching, incorporated it in her own work and introduced it into her art courses at the University of California in the early 1900s.

Related masses of dark and light can convey an impression of beauty entirely independent of meaning.

Arthur W. Dow

The importance of negative space (ground) is essential in Notan. As in music, it provides the *interval* between and among the visual elements we call figure. Criteria for one type of Notan involving simply black and white are:

1. The negative space or ground is sufficiently enclosed so that it has a potential shape.
2. Neither figure nor ground is dominant (Figure 1.13). They have a visual balance that allows the viewer to experience a reversibility where figure can become ground and ground, figure.

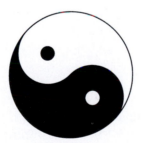

Figure 1.13 The graphic symbol for Taoism, representing Yin/Yang, is perfectly symmetrical, either half being seen as figure or ground. The Yin represents the passive or feminine, and the Yang, the active or masculine. The sigmoid line that bisects the circle is a contour common to both the Yin and Yang. It separates and unites, it represents the interplay of the two forces around an unchanging center. Depending on the context, it represents other dualities such as light/dark, good/evil, earth/heaven, birth/death, pain/pleasure.

The works of Dutch graphic artist Maurits C. Escher are stunning examples of Notan (Figure 1.14). Escher was influenced by the Moorish mosaics in the Alhambra and in the mosque La Mezquita at Cordola during his 1936 trip to Spain, where he made detailed sketches. He noticed that the contour lines were common to both figure and ground and served a double function. "On either side of it, a figure takes shape simultaneously. But, as the human mind can't be busy with two things at the same moment, there must be a quick and continuous jumping from one side to the other. The desire to overcome this fascinating difficulty is perhaps the very reason for my continuing activity in this field."[2]

Figure 1.14 Sample of the type of patterns traced by M.C. Escher. Alhambra (Majolica), 1936.

A properly executed silhouette can serve as Notan if attention is paid to the white background area, the interval or negative space. In 1922, Man Ray made a profile silhouette of his favorite model, Kiki, and titled it "Kiki Silhouette." In 1989 the photograph sold for $66,000 at Christie's.

VISUAL SEARCH

The term *visual search* implies that the viewer is purposefully looking for something specific (Figure 1.15). This is distinct from somewhat similar related activities such as *selection,* scanning, and attention, where the effort is generally less conscious and the objective less definite. The most satisfactory procedure for studying a person's behavior during the searching process is to tell the person exactly what is to be located. This is the procedure used by Ulric Neisser who did extensive research in this area.

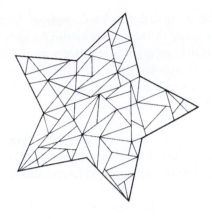

It often happens that
what stares us in the
face is the most diffi-
cult to perceive.

Tielhard de Chardin

*Figure 1.15 Search the star illustration and find the small star imbedded
within the larger star. Try to separate it from the interlacing
lines that make up the ground, and see the small star as fig-
ure. Shared contours and continuity of line reduce the visual
signal-to-noise ratio, and make the task difficult. (See
Appendix B, "Answers to Selected Exercises," for the answer.)*

Neisser presented his subjects with columns of about 50 different let-
ter groups.[3] The subjects were instructed to look at the columns and as
quickly as possible locate the specified target, which had been placed in
a randomly selected position. In one experiment the visual search tasks
were varied in this way:

Column A Find K in one of the letter groups.
Column B Find a letter group that does not have a Q.
Columns C and D Find Z in one of the letter groups.

A partial listing of the letter groups used by Ulric Neisser in his visual
search studies follows:

Column A	Column B	Column C	Column D
PODC	QLHBMZ	URDGQO	XVWMEI
ZVBP	QMXBJD	GRUQDO	WXVEMI
PEVZ	RVZHSQ	DUZGRO	XMEWIV
SLRA	STFMQZ	UCGROD	MXIVEW
JCEN	RVXSQM	QUCRDO	VEWMIX
ZLRD	MQBJFT	DUCOQG	EMVXWI
XBOD	MVZXLQ	CGRDQU	IVWMEX
PHMU	RTBXQH	UDRCOQ	IEVMWX
ZHFK	BLQSZX	GQCORU	WVZMXE
PNJW	QSVFDJ	GOQUOC	XEMIWV
CQXT	FLDVZT	GDQUOC	WXIMEV
GHNR	BQHMDX	URDCGO	EMWIVX

*Actual vision consti-
tutes a sampling, as
though only certain
points of the per-
ceived figure were fix-
ated while others
were neglected.*

Jean Piaget

Neisser found that the Column A task required less time than the Column B task—it is easier to locate and identify a specified item than to note its absence, which apparently requires a more careful examination of all of the letters. Somewhat different conditions were established for the visual search task of finding the Z in Columns C and D. You may want to scan the two columns to note whether more time is required to locate the Z in one column than in the other.

Neisser discovered that subjects required less time for Column C, in which all of the background letters have somewhat round shapes, than Column D, where both the background letters and the target letter have angular shapes.

A relevant observation for photographers is that a viewer separates figure from ground more easily when their features are distinctively different. It was also found that a person can do multiple search tasks in about the same length of time required for a single task. In less than a month of practice, subjects were able to attend to five different target letters in the same time required for one. This suggests that there are perceptual strategies that can be used, analogous to combining separate small units of information into larger chunks, to make the visual search process more efficient.

Before tripping the shutter to capture a picture, photographers are commonly expected to perform certain visual search tasks. Such tasks can be divided into two basic categories: (1) to locate the presence of desirable features and (2) to confirm the absence of undesirable features. Thus, in trying to capture a fleeting expression of a person's face during a portrait sitting, a photographer will first perform a visual search to be sure the lighting and the pose are correct and that there are no distracting features such as loose hairs, wrinkled clothing, and light traps. Then, having determined the expression desired, the photographer will continuously monitor the facial features waiting for the decisive moment that stimulates the response to trip the camera shutter. Neisser's research suggests that these are perceptual skills that can be learned when the person knows the specific objective of the search.

CAMOUFLAGE

The word *camouflage* comes from the French word *camoufler,* which means "disguise." It is not restricted to the visual sense as evidenced by the use of various products such as perfumes, spices, and "white noise" to disguise smells, tastes, and sounds. Tactile camouflage was reported in the Bible when Jacob stole his brother's inheritance by deceiving his blind father who depended on touch for identification of his first-born son, Esau, who had hairy arms. Periods in art such as anamorphosis and cubism, which dealt with the reorganization of objects in ways that contradicted everyday experiences, were involved with visual camouflage.

When inspiration does not come to me, I go halfway to meet it.

Sigmund Freud

The limits of my language means the limits of my world.

Ludwig Wittgenstein

Anamorphic techniques, which reached their golden age in the 17th and 18th centuries, severely distorted central perspective and the observer was easily deceived by a barely recognizable image. Picasso recognized the relationship between his work and camouflage techniques when, seeing the colors of paint and geometric design used to hide artillery in World War I, he exclaimed, "We are the ones who made this—it's cubism."

Three basic methods are used to conceal information. The first is to blend the object with its surrounding—that is, to merge figure with ground. This can be done by lowering the contrast between figure and ground, and making shapes, outlines, forms, surfaces, colors, and the like common to both. In Janet Kaplan's book, *Unexpected Journeys,* she wrote of how the surrealist Mexican painter Remidios Varo embedded a sketch of herself and her lover in one of her paintings, "Embroidering Earth's Mantle."[4] Many artists, past and present, have used camouflage to add intrigue and interest, and a sense of discovery to their work. One of the most interesting is Salvador Dali. One has only to look critically at some advertisements to see how well things can be hidden in a picture to entertain and to persuade. The Sierra Club ad in the exercise section of this chapter is a playful and meaningful example.

A second method of camouflage is to hide the object so that it is no longer visible. In the early days of photography the "detective camera," which consisted of a camera hidden in an object such as a flask, cane, or umbrella, allowed the photographer to sneak pictures unobtrusively. Camera miniaturization now provides more subtle ways of concealment.

The third way to conceal information is through deceit—for example, by rearranging the figure so that it looks like something else, by dislodging old connections and introducing new configurations, by manipulating correspondences and by changing angles into crossings (Figure 1.16).

I photograph what I do not wish to paint, and I paint what I do not wish to photograph.

Man Ray

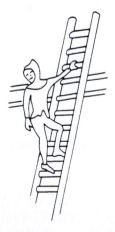

The hardest thing to see is what is in front of your eyes.

Johann W. Goethe

(A) *Blending is the manipulation of visual elements so that figure and ground merge. Two of the rings on the ladder merge with the railings against which they rest and are seen as part of, and a continuation of, the railings. Detail from "Belvedere" by Escher*

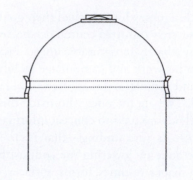

(B) Hiding is the covering up of an object with another. In a discussion
 of Expressionism, Rudolph Arnheim points out that a parabolic curve
 is more gentle than a circular one.[5] He shows how Michelangelo in
 the design of St. Peter's transforms two circular contours into a
 parabola by using a lantern to hide the intersecting points of the cir-
 cles at the apex.

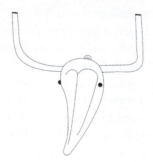

(C) Deceiving is the rearranging of visual elements so that they form a
 different gestalt. Sketch of a Bull's Head by Picasso. The original is a
 bronze cast of parts of a bicycle in the Galerie Louise Leiris, Paris.
 Paul Rand wrote about this piece, ". . . to do much with little—to
 find a bull's head in a bicycle seat and handlebars—is another aspect
 of Piccaso's wizardry, his humor, his childlike spontaneity, his skill as
 a punster, amid his ability to improvise and invent with limited,
 often surprising means."[6]

Figure 1.16 Blending, hiding, and deceiving.

Before taking a portrait of a person, cosmetics are often used to hide
blemishes on the skin, to dull its shiny surfaces, and to add color to the
face. Lipstick and eye makeup are used to deceive—the shape and size of
the lips and eyes are altered to enhance the beauty of the face. Makeup
artists in photographic studios, television studios, and stage studios are

masters in the art of camouflage. Lighting can be used to change the shape, form, surface, and color of objects.

Soft lighting reduces contrast so that small irregularities on the face blend into the face. Other examples of camouflage are the use of color filters and soft-focus lenses when taking a photograph, and the use of texture screens and textured papers when printing. In copy work, particularly in the restoration of old photographs, filters perform wonders in optically eliminating unwanted spots, streaks, and stains and hand or electronic retouching is used to eliminate remaining imperfection.

When figures are not sufficiently different from their backgrounds, they blend in with their surroundings and no "thing" is perceived.[7]

Roy R. Behrens

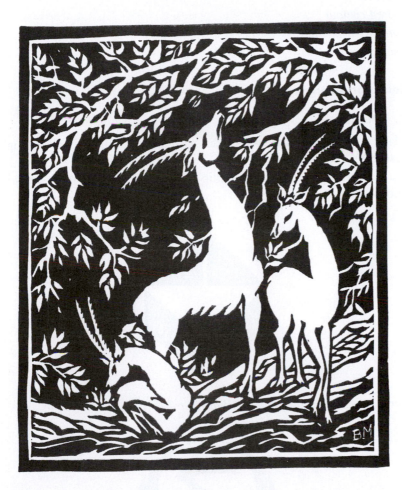

Darks and lights in harmonic relations —that is Notan.

Arthur W. Dow

"Dark and Light," 1926 © Barbara Morgan. (Courtesy Willard and Barbara Morgan archives.)

KEY WORDS

camouflage
common contour
contour rivalry
figure–ground
Ganzfeld
interval
Notan
positive–negative space
selection
shared contour
signal-to-noise ratio
visual search

An intention is turning of one's attention toward something. In this sense, perception is directed by intentionality. This can be illustrated by the fact that consciousness consists of a figure–ground constellation.

Rollo May

Selection Exercises

1. Notan

Many corporation logos are excellent examples of Notan. Look through magazines and start a collection of those that appeal to your visual sense. Study them and note the relationship and balance between figure–ground and positive–negative space.

Pacer Products Logo (Courtesy of Fiberboard Pacer Products)

JAL Logo (Courtesy of Japan Airlines)

Create your own personal Notan using a white and dark neutral color (black or gray), or a nonneutral color (red, green, blue, and so on).

2. The Interval

Emphasize the negative space when taking a picture. Learn to see the interval between visual elements as figure. Position your camera in such a way as to make the interval between the positive elements the integral part of your picture. (Remember a camera can move in *x, y, z* directions, and can also yaw and pitch.)

The anthropologist Edmund Carpenter has written, "In the West, man perceives the objects but not the spaces between. In Japan, the spaces are perceived, named and revered as the *MA,* or intervening interval." Use your camera or computer to give visual reverence to the MA, the interval.

The artist, Piet Mondrian, in his very interesting abstraction, "Flowering Apple Tree" (1912), reveals the hidden beauty in the spaces between the branches of a common tree. The photographer, Aaron Siskind, created a striking Notan by surgically cropping a large billboard sign so that the interval becomes an integral component of the image and creates a complementary duality similar, in a way, to the classic Yin/Yang.[8] (A 90-degree clockwise rotation of the image reveals the letter Siskind might have selectively photographed.)

Sketch of Aaron Siskind's "Chicago 30" (1949).

3. Typography

Most of us, when we read the printed word, are seldom aware of the particular style of the type and its careful design. The white space (interval) within a letter form is critical to both the clarity of the letter and its aesthetic quality. No letter stands alone but must coordinate and harmonize with any of the other 25 letters in our alphabet, and the space between letters must work in unison with each other. If you have a computer, select "Font" and look at the variety of styles available.

A note of music gains significance from the silence on either side.

Ann Morrow
Lindberg

The artist notoriously selects his items, rejecting all tones, colors, shapes which do not harmonize with each other and with the main purpose of his work.

William James

Try designing the letters of the initials of your first and last names so that the black letter form harmonizes with the white areas. (Typographic artists work in a large size and then reduce the letter.)

4. Symmetry

You can have some fun with the Heublein ad on page 23 by considering a couple of questions:

a) How many bottles are there in the ad?
b) How many drinking glasses are there?

Note the importance of the symmetry in the position of the similar glasses and bottles and the vertical layout of the type in creating a MA, a negative space or ground that can be seen as figure—as having shape. Try creating a similar ad.

5. Camouflage

Play a game of imaging hide-and-seek. Create or capture an image in which something is camouflaged (hidden, blended, rearranged) and have a friend try to find it.

Man cannot discover new oceans unless he has courage to lose sight of the shore.

Andre Gide

6. More Camouflage

Create an image in which the foreground and the background merge. Matisse and others did this by painting objects in the foreground the same color and pattern as those on the wall in the background. In the book *Veruschka* by Vera Lehndorff and Holger Trulzsch, a nude model is painted like the background, placed against it, and photographed.[9] The images are stunning with mythological and philosophical impact: Animate and inanimate object become one. "The salt doll walks into the water."[10]

7. Visual Search: Ecology

The text in the Sierra Club ad on page 24 invites one to search out the animals in the woods. Some are small and some are big, one is running and one is pecking, another with alert ears seems to be watching. Notice how easy it is to find the figures that have a clear background compared

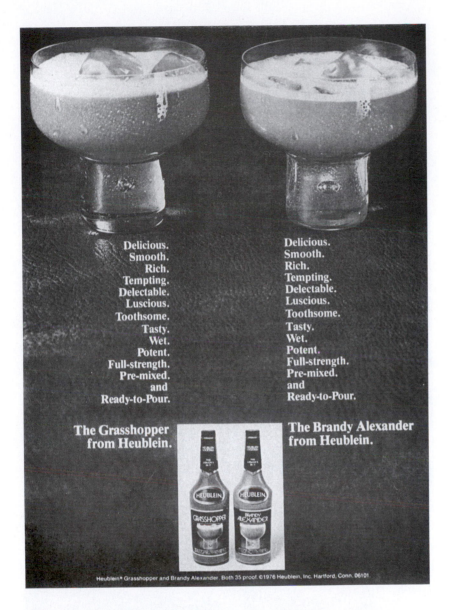

Heublein ad.

to figures that blend with the wooded background. How many "animals" can you locate? You should be able to find at least six, but there are a few more that are more difficult to find since they blend in so well with the wooded ground. How difficult was the task? (A similar task, based on geometric forms, has been used to determine "visual field dependency," which will be discussed in Chapter 8, "Personality.") Make copies of the Sierra Club ad and have friends try separating the figures from the wooded ground.

Sierra Club ad. (Courtesy of the Sierra Club.)

8. Verbal Visual Search

When you first look at the 9 ×10 letter matrix below, you see an array of letters. When you are told, however, that these letters make up words and that the words run in various directions (horizontal, vertical, and diagonal), you begin to separate figure from ground. Try it.

Look for these words and draw a circle around them when you find them. (Please note: Some letters are common to more than one word.)

ASA
APERTURE
CAMERA
COLOR
DEVELOP
EXPOSURE
FILM
FILTER

FOCUS
GESTALT
HYPO
LENS
PHOTO
SHUTTER
TRIPOD

Notes

1. Arthur Wesley Dow, *Composition,* Garden City, NY: Doubleday, Page and Co., 1919, p. 53.
2. M. C. Escher, *Escher on Escher,* New York: Abrams, 1989, p. 32.
3. Ulric Neisser, "Visual Search," *Scientific American,* June 1964, p. 210.
4. Janet Kaplan, *Unexpected Journeys,* New York: Abbeville Press, 1988, p. 21.
5. Rudolf Arnheim, *Art and Visual Perception,* Berkeley: University of California Press, 1974, p. 451.
6. Paul Rand, *Design, Form and Chaos,* New York: Yale University Press, 1993, p. 198.
7. Roy R. Behrens, *Design in the Visual Arts,* Upper Saddle River, NJ: Prentice-Hall, 1984, p. 53.
8. Carl Chiarenza, *Aaron Siskind,* New York: Little, Brown, 1982, p. 128.
9. Vera Lehndorff and Holger Trulzsch, *Veruschka: Transformations,* Boston: Little, Brown, 1985.
10. Joseph Campbell, *The Inner Reaches of Outer Space,* New York: Harper & Row, 1988, p. 73.

2

Gestalt Grouping

Abstract formal elements are put together like numbers and letters to make concrete beings or abstract things; in the end a formal cosmos is achieved so much like the creation that a mere breath suffices to transform religion into art.

Paul Klee

Designed by Harvey Carapella.

GESTALT

The *Gestalt* school of psychology, which was originated in Germany about 1912 by Dr. Max Wertheimer, provides us with some simple and convincing evidence about how man organizes and groups visual elements so that they are perceived as wholes. In other words, what you experience when you look at a picture is quite different from what you would experience were you to look at each item in the picture separately.

Field Theory and Gestalt

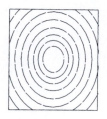

Max Wertheimer, in carrying on his visual research, was influenced by theories being formulated in physics in the late 1800s and early 1900s. Scientists like Faraday, Helmholtz, and Hertz were studying the physical phenomena of electricity, magnetism, and gravity. They hypothesized that a type of electrical, magnetic, and gravitational "field" existed, and that elements within that field are held together by some type of sympathetic force. The field elements influence one another; they either attract or repel. Their strength is a function of such things as size, position, and nearness.

Wertheimer might have argued that physical fields have their counterpart in psychological fields—in visual fields. The main principle of Gestalt psychology supports this; the way in which an object is perceived is determined by the total context or field in which it exists. Put differently, visual elements within a person's visual field are either attracted to each other (grouped) or repelled (not grouped). The Gestalt laws of *proximity* (nearness), *similarity, continuity*, and *closure* describe how grouping occurs within a context or field.

The same Gestalt laws and theory, interestingly enough, were used to study human group dynamics by Kurt Lewin and by Fritz Perls to establish Gestalt therapy.

We all work, study, play, and worship within a restricted environment or field; relationships can attract or repel. We tend to associate with people who have similar interests and values and are influenced by those closest (with most proximity) to us. We are more at ease if we can continue a task and see it to completion (closure) before undertaking another task.

Unfinished tasks (nonclosure) can cause tension and frustration. We try to keep a healthy outlook by knowing when to "bend with the wind" or "go with the flow" (*Pragnanz* in Gestalt terminology). The key element on which the Gestalt laws are based, *simplicity*, can be the key to a good life.

Photographers out to capture a picture can succeed or fail based not only on their technical or artistic competence but also on their knowledge of and sensitivity to the field in which they are working.

The whole is different from the sum of its parts.

Synergy—the behavior of whole systems is not predictable from its parts.

Every person experiencing as he does his own solitariness and aloneness longs for union with another. He yearns to participate in a relationship greater than himself.

Rollo May

Things should be made simple, not simpler.

Albert Einstein

In Gestalt theory, the whole is different from the sum of its parts. In Figure 2.1 a person can choose to see each visual element (the individual letters) separately or as a group that forms an image of a camera. Seeing the camera is seeing the totality of the visual elements. This single figure formed by grouping the visual elements is a gestalt.

Figure 2.1 An example of Gestalt—the camera as a whole is different from the sum of the visual elements.

Figure 2.2 is an early example of how an artist grouped a variety of powerful symbols to create a gestalt that serves as a visual metaphor for the suffering caused by the exploits of Napoleon.

GESTALT LAWS

The Gestalt psychologists were especially interested in figure–ground relationships and in the things that help a person to see objects as patterns or "good figure." They suggested a number of principles, but we shall concern ourselves with only four:

1. Proximity,
2. Similarity,
3. Continuity, and
4. Closure.

These four Gestalt principles or laws are important to conceptualize, because if a photographer knows how a person most probably organizes or groups visual elements when looking at a picture, the elements can be arranged to favor or disfavor certain groupings.

In a gestalt, components interact to such an extent that changes in the whole influence the nature of the parts and vice versa.

Rudolf Arnheim

It is curious that I always want to group things: a series of sonnets, a series of photographs: whatever rationalizations appear they originate in urges that are rarely satisfied with single images.

Minor White

Gestalt is a field whose forces are organized in a self-contained, balanced whole.

Rudolf Arnheim

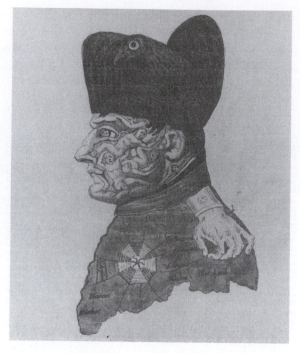

Figure 2.2 *"Triump des Jahres 1813," by Johann M. Voltz (John Hay Library, Brown University). The hat represents the Prussian eagle digging its claws into Napoleon. The visual elements that make up the face are some of the countless dead caused by Napoleon's lust for fame and power.*

Proximity

The closer two or more visual elements are, the greater the probability that they will be seen as a group or pattern. Look at the black dots in Figure 2.3.

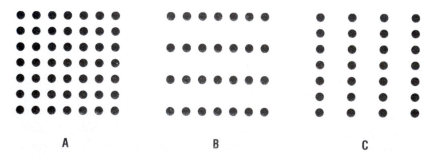

A **B** **C**

Figure 2.3 *Organization of visual elements according to proximity.*

Each configuration of dots A, B, and C can be seen as forming a square. Within the square in B, the dots are closer together horizontally than vertically and, therefore, are seen as groups of horizontal rows or as a horizontal movement. It is difficult to see them otherwise. The effect can be enhanced by moving the horizontal dots closer together. Move the dots to a position where they are physically or psychologically (visual resolution) touching and you would see a line.

The dots in C are seen as vertical columns or movements since they are closer together in the vertical direction. Because the dots in A are at equal distances, they are not easily seen as vertical or horizontal.

The dots in A, B, and C in Figure 2.3 demonstrate that by using the same visual elements and simply changing their proximity, a viewer will group them in different ways. As an exercise, you might try rearranging the space between the dots so that a person sees groupings of dots in a slant direction. Try some other arrangements. To test your success, have your friends look at the arrangements.

Moving the dots in Figure 2.3 closer to each other horizontally facilitated a horizontal grouping of dots; closer vertical proximity facilitated a vertical grouping. If the dots were in a three-dimensional array one could move into greater proximity in the third dimension and facilitate grouping in terms of depth. This is exactly what happens, for example, when photographs are taken of people with no consideration for the background. Because a photograph is a two-dimensional representation, objects in three-dimensional space are brought into closer proximity and tend to be seen as one group. The problem increases as the focal length of the lens and the camera distance increase.

Proximity of objects in space, then, influences the way in which we group visual elements. Because space is three dimensional, think three dimensionally when preparing to take a picture. Look at Figures 2.4 and 2.5, which illustrate the ways in which objects arrange themselves side by side or front to back.

Spacing between letters or numbers plays an important role in what is seen. Read the words shown here:

FAT HER
HAT RED
PEN TAX

Did you read the letters as six separate words or as three?

Some time ago while browsing in a bookstore I noticed a book with the title *Super-vision*. I was delighted and excited to have found a new book dealing with extraordinary visual phenomena. A scanning of the text was disappointing, however, for it proved to be a business book on supervision (supervising people). I wondered whether the publisher realized how this particular division of the title on the cover might be perceived by viewers.

The coherent way of investigating any field is to examine its possible relatedness to other things.

Frederick Sommer

Proximity is the simplest condition of organization. We hear words in verbal coherency, primarily because of the temporal proximity of their sound elements.

Gyorgy Kepes

SUPER-VISION

Figure 2.4　　Proximity facilitates grouping side by side.

*True Friends are a
sure refuge.*

Aristotle

Figure 2.5　　Proximity facilitates grouping front to back.

Consider the critical nature of horizontal space between the visual elements "1" and "3" shown in Figure 2.6.

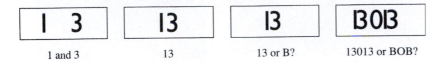

| 1 and 3 | 13 | 13 or B? | 13013 or BOB? |

Figure 2.6 Although the visual elements are the same (1 and 3), their changing proximity can cause different perceptions and perhaps even uncertainty and ambiguity.

Proximity and Learning

Information presented side by side or in the same time frame facilitates learning. Not only do we tend to group events that occur close together; we also tend to associate them and make comparisons. This has always been used effectively in advertising and, occasionally, in teaching. Figure 2.7 shows examples of proximity in learning and in advertising.

It is important to note that the eye can make the most critical judgments of whether two visual stimuli are the same or different when the stimuli occur side by side in space. Visual instruments such as densitometers and colorimiters operate on this principle. When you are trying to make a better photographic print you usually compare it side by side with your previous print or some reference print.

One of the most difficult tasks for a photofinisher is to print your color negative so that the print matches a print you have received earlier. When you get the new print and compare it with the previous one you will invariably find differences. One of the first things students learn in color printing is that it is easier for someone to accept a color print when it is not compared with another print of the same photo.

Many students are not clear about the relationships that exist among some familiar terms used in photography: stops, factors, neutral density (ND) filter, and exponents—photographers usually talk about changing camera exposure by stops, realizing that a one-stop change means an increase or decrease by a factor of two.

How is this related to exponents to the base 2 and to ND filters in 0.30-density increments? Making a table in which exponents, factors, stops, and ND filters are in proximity helps one to see and remember the relationships.

The proximity of optical units is the simplest condition for a crystallization of unified visual wholes.

Gyorgy Kepes

In imaging, the more bits, the more tones that can be displayed in a digitized image. A 7-bit image (2^7) can display 128 tones.

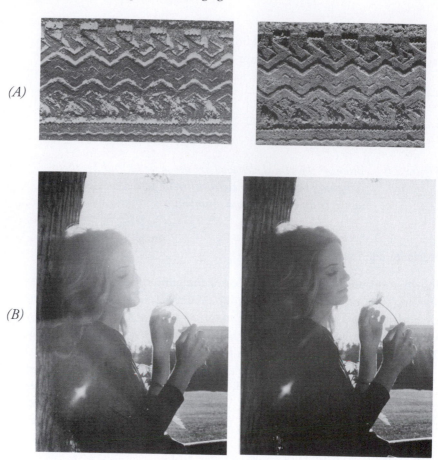

Figure 2.7 (A) Proximity facilitates learning by comparison. Note how the
 white shadows in the negative and the black shadows in the
 positive affect the design imprint. In one case the imprint looks
 raised and in the other depressed. Rotate the book 180 degrees
 and observe what happens. Make comparisons at different
 angles. At what angle does the imprint reverse itself? (B) Prox-
 imity facilitates comparisons in advertising. Photography by
 James Katzel. (Courtesy Honeywell Photographic Products.)

Relationships

Factors	Exponents (Base 2)	Stops	Natural Density Filter
1	2^0	0	0.00
2	2^1	1	0.30
4	2^2	2	0.60
8	2^3	3	0.90
16	2^4	4	1.20

Note that stops are exponents to the base 2. Factors are the numbers
that result from raising base 2 to a power (exponent). The factor doubles
each time the exponent increases by 1. The relationships among expo-
nents (base 2), factors, and stops seem logical, but the increments for ND
filters do not. The reason is that density values are based on exponents
to base 10. It can be somewhat confusing, but all you need to remember
is that a density change of 0.30 is 1 stop (0.15 is a 1/2 stop change). Math-
ematically, $2^1 = 2$. Density values for all filters are log 10 values, and log-
arithms are exponents $10^{0.30} = 2$.

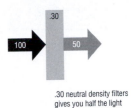

.30 neutral density filters
gives you half the light

Whatever favors organization and comparison will also favor learn-
ing, retention, and recall. Thus the law of proximity is equivalent to what
educators call "association by contiguity." In terms of information pro-
cessing, pictures presented side by side and in proximity require less mem-
ory storage and retrieval. Pictures presented in a time sequence rely more
on memory, and the longer the time delay, the more probable the loss of
information or distortion of information in memory.

Proximity and Area

*The smaller an area or space, the greater the probability that it will be seen
as figure, rather than ground.* This statement is similar to the one made
about proximity. Every area is bounded by an edge or line. The greater
the proximity of these edges or lines, the greater the probability that the
area within the lines will be seen as figure. This was demonstrated in Chap-
ter 1 in the equivocal fence diagram (Figure 1.3).

Figure 2.8 shows how proximity of lines determines the size of the
enclosed area and how proximity facilitates the selective segregation of the
smaller visual segments from the larger so that the smaller segments are
seen as figure.

*An average outdoor
scene has a brightness
ratio of 128:1 (seven
stops, seven zones, 2^7).*

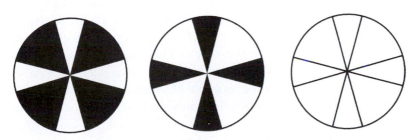

Figure 2.8 *The closer the radial lines, the smaller the enclosed area and
therefore the greater the probability it will be seen as figure. It
is easier to see the smaller segments as figure against the larger
segments as ground, even when the image is rotated so that
the larger areas are vertical and horizontal.*

Notice also that it is much easier to see the smaller segments as figure in the middle illustration than in the other two. This demonstrates the importance of contrast and how it can be used along with area to increase or decrease the ease with which certain visual patterns are seen as figure. An example of the effective use of area and contrast in the design of graphics is shown in Figure 2.9.

Figure 2.9 Area and contrast play an important role in the design of graphics.

Temporal Proximity

Proximity is not limited to the spatial arrangement of things. It also applies to the temporal arrangement of events. Things that occur close together in time will tend to be grouped together. Tell someone that you are going to spell a word aloud and that you want them to identify the word. The person will think it an easy task and indeed it is unless you pause between certain letters. If the word CHO PHO USE is spelled aloud in groups of three letters, it will be difficult to identify the word unless the listener repeats the letters so that the pauses between all letters are equal. This experiment has been tried with a number of people and few were able to identify the word without repeating the letters or writing them down without the pauses.

Music provides yet another example of the importance of proximity to perception. The sound of middle C on a piano represents a frequency of 262 cycles per second. If the frequency is increased, the sound vibrations occur closer together in time and the acoustical experience is an increase in pitch.

Motion picture and television editing require careful placement of frames so that their projection in time will favor grouping. One of the major reasons for editing is to facilitate the perceptual grouping of elements that occur in time and space. Events that occur close together in time and space tend to be grouped together.

Apply the Gestalt law of proximity to the arrangements of things you photograph and design and you can encourage people to see the rela-

In Hopi, there is no word which is equivalent to "time" in English. Because both time and space are inextricably bound up in each other, elimination of the time dimension alters the spatial one as well.

Edward Hall

tionships you want them to see. For the most part they will be unaware
of how you arrange the visual elements since spatial and temporal prox-
imity are natural ways for us to group things. When things are experi-
enced as grouped, we see the whole and not the individual elements that
make up the whole.

Black on white provides a good level of visual contrast. The result is
a high signal-to-noise ratio—a strong figure–ground relationship. What
is seen as figure, however, depends not only on contrast but also on area.
In Figure 2.10A, the areas of the black bars and white bars are the same
and it is equally probable that either will be seen as figure. In Figure 2.10B,
reading from top to bottom, figure evolves from a black line to a white
line as area changes. Note, however, that at one point both the black and
white bars are of equal area and there is a perceptual situation similar to
Figure 2.10A.

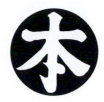

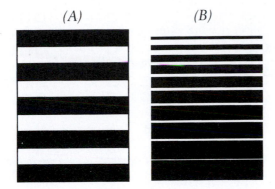

(A) (B)

*Figure 2.10 What is seen as figure is determined by area and influenced
by contrast.*

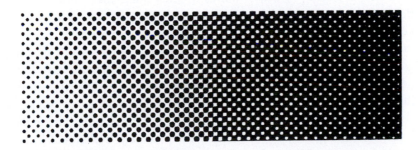

*Figure 2.11 A halftone screen in which small dot areas, whether black or
white, are seen as figure.*

Another example of the visual relationship between area and contrast
is the halftone graphic arts screen shown in Figure 2.11. Reading from
left to right, the figure changes from a black dot to a white dot.

Many other factors, of course, will influence what a person sees as figure—things such as shape, texture, color, closed areas versus open areas, pattern, expectancy, and so on. Figures 2.10 and 2.11 emphasize two important variables in design and perception—area and contrast. Add other variables to these illustrations such as color, and what is seen as figure can change.

Similarity

Visual elements that are similar (in shape, size, color, movement, and so on) tend to be seen as related. When we see things that are related we naturally group them and therefore see them as patterns. This is readily observable in Figure 2.12.

A B C

Figure 2.12 Organization of visual elements according to the law of similarity (shape).

The overall configuration for A, B, and C remains square, but B is now seen as having horizontal rows of alternating circles and squares and C is seen as having vertical columns of alternating circles and squares. Because all the visual elements in Figure 2.12A are similar and have the same proximity, no patterns are seen within the array. Note that the proximity of the visual elements in B and C remains constant but that the grouping of these elements in alternating vertical and horizontal directions is based on the similarity of circles or squares. This demonstrates the influence of similar elements in the way we see and group things. It also suggests that similarity can be a stronger force than proximity in perceptual grouping. Additional examples are presented in Figure 2.13.

Refer to Figure 2.8 and note how natural it is to group the four small (or large) pie-shaped segments together and how extremely difficult it is to group dissimilar segments such as a small segment and two large segments. Many different patterns could be created from Figure 2.8 by various groupings of small and large pie-shaped segments. It is relatively easy to do this by using pencil and paper but extremely difficult to do just by looking. Try it!

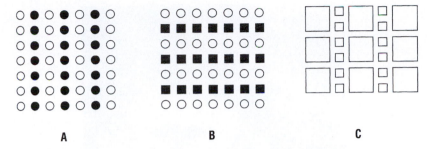

A B C

*Figure 2.13 Additional examples of the ease with which similar visual
 elements are grouped.*

Similarity of Shape

Visual elements that have similar shapes such as those shown in the skeleton of a leaf tend to be grouped together. Because of the similarity and proximity of the curved lines, they are easily seen together to form a pattern. Such repetition of similar lines can be thought of as a visual "beat" —a visual counterpart of the rhythm that is associated with motion and sound.

Figure 2.14A shows how a particular camera angle and lens serve to record a picture in which three objects group to make an interesting composition. All three objects are similar in form but different in size, which gives perspective and depth to the image. The interval between the first and second objects (proximity) helps to keep the composition from losing its interest. One can find many images in which three persons standing side by side are grouped in a similar manner—Figure 2.14B is one example.

In Figure 2.14B, three young German farmers, dressed alike in their dark suits and white shirts, stand posed, looking directly at the camera. They are positioned in a way similar to that in Figure 2.14A. The proximity between the man on the left and the two on the right is critical and adds interest to the arrangement. It is integral to the composition—to the visual syntax. The play and counterpoint between the similarity and dissimilarity provide additional interest. All three men have similar suits, hats, canes, and look directly at the viewer.

The farmer on the left, however, strikes a dissimilar pose. His hat and cane are tilted, a cigarette dangles from his mouth, and he seems to have a different expression on his face, but his body posture is similar to that of the other two men. Note also the left hand of the man in the middle. It is a powerful working man's hand and it stands out prominently as a figure–ground element giving the composition further interest. Was August Sander aware of all this? I doubt it, but I do believe he may have been unconsciously "aware" of it. He has captured a decisive and historical moment in time that we now share.

(A)

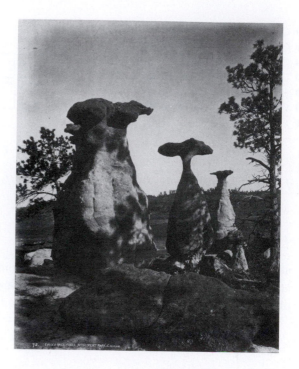

(B)

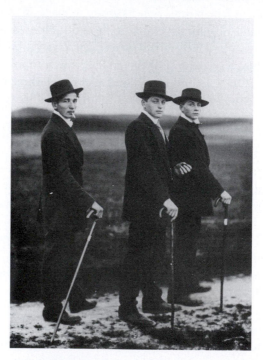

Figure 2.14 *(A) "Eroded Sandstones, Monument Park, Colorado," by*
 William H. Jackson (George Eastman House). (B) "Jung-
 bauern Westerwald" ("Young Farmers"), 1914, August
 Sander (George Eastman House).

Henri Cartier-Bresson's 1945 photograph of two prominent scientists who are husband and wife titled "Irene and Frederick Joliot-Curie" is a tender visual display of how a loving married couple grow more alike as their marriage matures.[1] Bresson reveals this by capturing their similar facial expressions and hand and body gestures and also their similarity of dress.

Similarity and Repetition

The familiar painting "American Gothic" by Grant Wood provides some interesting observations on similarity (Figure 2.15). Perhaps the most obvious is the shape of the three-pronged pitchfork and the "three-pronged" design in the man's overalls just to the right of the pitchfork.

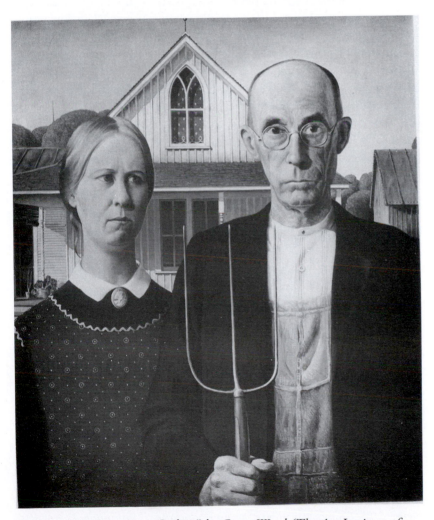

How many times do you think a person should see a movie to catch everything in it?. . . Three times, at least, to pick out all the details and the intentions behind them.

Alfred Hitchcock

Figure 2.15 "American Gothic," by Grant Wood (The Art Institute of Chicago).

One can also find the shape elements of the pitchfork rhythmically repeated in several places—the upper part of the woman's apron and the white collars and chin lines of the wife and husband. Other "tridents" can also be found in the painting:

1. The three vertical stripes in the man's shirt group with the three-pronged design in the overalls;
2. Both faces are shaded in such a way that it is easy to group the nose and the area below it into the center prong of a trident (the outer prongs being the outer facial contour);
3. The three parallel roof lines on the extreme left and right; and
4. The three parallel fingers on the man's hand.

If one assumes that the pitchfork could be symbolic of Satan, then the expressions on the faces of the people in the picture take on new meanings and one can understand why this classic portrait of rural Americans precipitated an uproar among Midwesterners when it was first exhibited at the Art Institute of Chicago in 1930.

In Figure 2.16 the positions of the hands, fingers, and pens are similar, as are the size and shape of the pens and the angles at which they are held. The photographer has been careful to show the same side of all three pens. Even the shadows from the pen points are similar. In addition, the pens are close together. Similarity of visual elements and proximity facilitate grouping.

Merely copying the object is not art. What counts is to express the emotion called forth in you, the feeling awakened. . . .

Henri Matisse

Figure 2.16 Similarity of size, position, and shape, and dissimilarity of hands. (Courtesy Parker Pen Company.)

Similarity and Proximity

Photographers sometimes use symbolic associations to provide similarity and grouping. Figure 2.17 shows how an advertiser used a photograph of a cat sleeping curled up alongside an air conditioner that has a unit similar in shape to that of the cat. The similarity of shapes facilitates grouping, which in turn enhances association between the familiar quietness of the sleeping cat and the implied quietness of the air conditioner.

Figure 2.17 Similarity of shape and projected similarity of meaning. (Courtesy York Division Borg-Warner Corporation.)

In his book *East 100th Street,* Bruce Davidson* has a photograph of a child partially naked with straggly hair and head tilted standing limp on a fire escape against a steel bar railing that takes the form of a cross (Figure 2.17A).[2] It serves as a reminder (for many) of the paintings of the crucifixion of Jesus, hanging partially naked and limp on a cross. By using similar design elements the photographer facilitates our grouping of these two separate events (the photograph and what is in memory). When this occurs the photograph takes on a much deeper meaning and feeling. If

Metaphor joins dissimilar experiences by finding the image or the symbol that united them at some deeper emotional level of meaning.

Jerome Bruner

*In a conversation with Bruce Davidson on September 5, 1996, he provided this additional information regarding his photograph: The photograph should be seen in the context of the others in the book. It is a statement about the space in which the people of East 100th Street lived, their rooms, vacant lots, alley ways, as well as the relation of shadows and shapes. Symbolically, yes, the photograph can be seen as a Christ figure. Beyond that it is a child playing on a fire escape. The face is in deep shadow with little to no detail, the half light, half dark of her environment. The time context is also a factor. The photographs were made in the 1960s, a time in which man was exploring outer space. The photograph is about inner space.

one sees the child as representing innocence, then the question might be asked, "Who is responsible for the child's 'crucifixion'?" A nonreligious interpretation might be that the child, representing innocence and humanity; is being imprisoned by the "bars" of the fire escape. Who is responsible for this imprisonment? Powerful images such as this are layered, have archetypal reference, and, therefore, live on and on.

Some elements are seen together because they are close to each other; others are bound together because they are similar in size, direction, shape.

Gyorgy Kepes

Figure 2.17A *"Untitled," by Bruce Davidson. One of a series of photographs for his book,* East 100th Street, *taken by Bruce Davidson in the Harlem area in New York City in 1966.*

Symmetry and Asymmetry

Split an apple down the center and you have two very similar halves. This is an example of bilateral symmetry. It occurs frequently in nature—man being a prime example with symmetrical features such as the face, arms, hands, legs, and the not-so-familiar bilateral brain. There are various types of *symmetry*, which can be described in terms of design elements such as letters and symbols. Place a mirror on one side of and at a right angle to the letter A and the reflection is unchanged, while the reflection of the letter D remains unchanged only if the mirror is placed above or below the letter.

In both cases, reflection is used to describe this type of symmetry. Letters such as N, H, and X can be rotated 180 degrees (upside down) and appear the same. This is called *twofold symmetry*, while a symbol such as a plus sign (+) possesses *fourfold symmetry*, appearing identical in four different rotations.

A circle remains the same regardless of rotation or reflection and therefore represents complete symmetry.

Symmetry can be considered a special case of similarity. Visual elements that are symmetrical provide for visual balance—for a "good gestalt." The more symmetrical an area is, the greater the tendency is to group it and see it as figure. Figure 2.18 shows how one readily groups symmetrical shapes to see the vertical areas 1, 3, and 5 as figure.

Simplicity of shape, especially symmetry, predisposes an area to function as figure.

Rudolf Arnheim

Figure 2.18 Symmetry facilitates grouping.

It is extremely difficult to see vertical areas 2 and 4 as figure because their vertical boundaries are not symmetrical. The more symmetrical an area is, the more readily it is seen as figure. Figure 2.18 represents a simple situation to illustrate the importance of *symmetry* to grouping and *asymmetry* to nongrouping. Much of what we encounter in life is in some way symmetrical, including our bodies. In the visual world, symmetry of line or shape is also accompanied by other attributes such as color, tone, texture, and form.

Photograph by Charlotte Marine

A vertical axis produces more compelling visual symmetry than a horizontal axis.

Rudolf Arnheim

Symmetry also has an effect on our perception of depth. Generally speaking, the more symmetrical a design, the more it is seen as two dimensional.

In printing a photograph or showing slides, a problem can occur if the emulsion side of the image is positioned away from the enlarger or projector lens rather than toward it. Surprisingly enough, this is a problem only with pictures that include man-made objects, because in nature it is difficult to identify left and right sides.

When making montages of nature scenes, however, care must be taken that the sun angles and shadows are alike in the component images if the combination picture is to appear balanced and realistic.

Complete or perfect symmetry in photography is often undesirable because it tends to portray a static or monotonous situation. Some asymmetry is necessary to establish interest and tension. In portrait photography; lighting is normally adjusted to break up the symmetrical form of the face, and the subject is rarely photographed straight on.

Similarity and Symmetry

In art there are perceptions, opinions, speculations, and interpretations, but no proof. This is both its mystery and its magic.

Paul Rand

Visual elements do not need to be symmetrical to be similar in shape, form, color, and so on. However, when they are both similar and somewhat symmetrical they can provide a visual rhythm—a balanced, repetitive grouping. In terms of communications theory there is a desirable redundancy. In the terms in which Henri Cartier-Bresson[3] talks about photographs, one might say that there is a relationship of form and geometric pattern.

Symmetry and Graphic Symbols

Symmetry plays an important part in the graphic identifications used by many corporations. Note in Figure 2.19 the visual balance provided by the symmetry of the visual elements. Note also the proximity of the visual elements and how proximity and symmetry work together to facilitate the grouping of the visual elements into a whole visual unit—into a gestalt. You have probably also observed the strong figure–ground relationships present in these logos as well as a fine example of Notan.

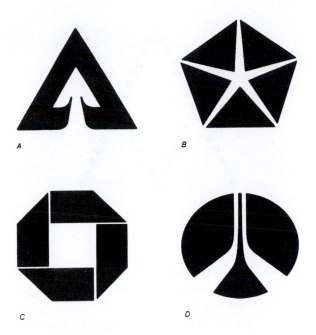

Figure 2.19 *Examples of symmetry in the design of graphics: (A) Weyer-
hauser Company. (B) Chrysler Corporation. (C) Chase
Manhattan. (D) Rockwell International.*

Continuity

*Visual elements that require the fewest number of interruptions will be grouped
to form continuous straight or curved lines.* If you refer back to the array of
small circles in Figure 2.12A and consider all the possible lines or shapes
that could be generated from such a 7×7 array of circles, it becomes appar-
ent that man's visual process seeks simple lines and shapes—those that
require the least change or interruption in the visual experience.

 If the circles in Figure 2.12A were electric lights and if each light were
wired to go on and off independently, we would have a system for gen-
erating just about any line, shape, or picture we might desire. There are
such signs located in Times Square, Picadilly Circus, and the Ginza. (When
all the lights are on or off we have, however, a situation similar to Figure
2.12A.) A television screen is, in a way, similar to such signs, for it has
thousands of little phosphor lights (pixels).

 Analogies could be made to other display systems such as the halftone
dot matrix in graphic arts (refer to Figure 2.11). Such an array is the basis
for a video screen and inkjet printers.

 Now look at Figure 2.20 and notice the first thing that you see.

When there is a
choice between several
possible continuations
of a line, the sponta-
neous preference is for
the one that carries
on the intrinsic struc-
ture most consistently.

Rudolf Arnheim

*Figure 2.20 Organization of visual elements according to the law of
continuity.*

Was it a pair of Xs? Seeing a pair of Xs would require the fewest inter-
ruptions or changes. Seeing a diamond is also relatively simple. Both the
Xs and the diamond are familiar and require few visual changes. The dia-
mond, in addition, is a closed figure and this facilitates its perception. We
will be discussing this later when we talk about closure. If you look hard
enough you can see other familiar figures, perhaps a W, an M, or a V.
The letters W, M, and V are harder to see because they require more visual
changes. Put differently, it is easier to see the slanting lines as continuous
than discontinuous. To see them as discontinuous one has to visually tear
the gestalt apart. This requires great effort and concentration.

The Union Flag or Jack shown in Figure 2.21 provides an interest-
ing example of continuity. It is easy to see a cross and an X.

*In working with
multimedia, it is
imperative that
sound and sight be
experienced holisti-
cally. Continuity in
design is essential,
including any inter-
active development.*

Figure 2.21 The Union Flag of the United Kingdom.

David Page

The cross is continuous and it would be extremely difficult to see it otherwise. The X, however, is discontinuous, but because of the arrangement of visual line elements it is relatively easy to see as continuous. It is interesting to note that this Union Flag is a combination of national emblems of England, Scotland, and Northern Ireland.

Figure 2.22A is a detail of a pencil drawing by William Blake. It shows an old man seated with a book between his knees arguing with two men in monkish habits. Note the careful placement of the monk's extended finger, which groups easily with the curved cowl of the monk. Note also that the tips of the extended fingers continue on to group with the cowl of the other monk.

A photograph that serves as an excellent example of the importance of continuity is Edward Weston's "Nude, 1936" (Figure 2.22B). The model for the photography was Weston's wife Charis. The photograph is also titled "Charis, Santa Monica." Charis described her modeling experience thus:

> *. . . I sat in the bedroom doorway [to the sunroof] with the room in shadow behind me. Even then the light was almost overpoweringly bright. When I ducked my head to avoid looking into it, Edward said, "Just keep it that way." He was never happy with the shadow on the right arm, and I was never happy with the crooked hair part and the bobby pins. But when I see the picture unexpectedly, I remember most vividly Edward examining the print with a magnifying glass to decide if the few visible pubic hairs would prevent him from shipping it through the mails.[4]*

A nude figure sits with one leg tucked under her body and the other upright with the model's tilted head resting on it. Both arms embrace the legs in an oval shape with hands joined together at one knee. The model's face is not visible, just the top of her tilted head, with the hair clearly parted. If one were to put a piece of tracing paper over the photograph and then trace the contours of the body, they would discover a magnificent continuation of line. Of all the photographs Weston made, this, according to his son Cole, was his favorite. On photographic nudes, Weston wrote ". . . without any instructions to the models (I never use professionals, just friends) as to what they should do, I would say 'move around, all you wish to, the more the better.' Then something happened. I would say 'Hold it.' And things did happen all the time."[5]

I never hear Bach without deep enrichment—I almost feel he has been my "influence."

Edward Weston

(A)

(B)

Figure 2.22 (A) Detail of unidentified historical scene by William Blake.
(Lessing J. Rosenwald Collection, National Gallery of Art,
Washington, D.C.); (B) "Nude, 1936," Edward Weston.
©1981 Center for Creative Photography, Arizona Board of
Regents.

Continuity and Typography

Type comes in many different styles (Figure 2.23). One style that has dominated printing for many years is the serif type style. The upper word WINE (Figure 2.23A) is an example of serif type style, while the lower word WINE shows the same word in a sans serif style.

One possible reason for the dominance of serif letters in text type styling might be that they provide a "good" gestalt. Serif letters group together more naturally than sans serif letters, as you can see by looking again at Figure 2.23A. The terminal strokes (serifs) on serif letters provide better visual continuity. Figure 2.23B shows a novel example of the use of continuity in typography. One could think of it as a visual onomatopoeia—the word looks like what it says.

An example of a novel and contemporary type design is shown in Figure 2.23C. Notice the number of changes the shape of each letter takes on. Change demands attention. A number of perceptual studies have shown that the eye is attracted by change: change in contrast, color, texture, shape, line, position—change in direction.

A **WINE**

WINE

B **WAVES**

C **WAVES**

Figure 2.23 Different type styles give different effects. (A) The letters in the popular serif style in the upper word WINE group easier than they do in the lower sans serif style. (B) Continuation can be used to provide some interesting effects with printed words. (C) The Caustic Biomorph type design by Barry Beck.

Continuity and Sequences

Moving images (whether the medium is film, disk, videotape, or computer generated) can be thought of as a sequence of visual images that vary in their spatial as well as temporal arrangement. The same can be said for still pictures that are sequenced in a spatial array, for a person viewing each picture in sequence does so in a time frame (Figure 2.24).

Figure 2.24 Sequence still photography, "Women Jumping over Chairs —20 Lateral Views," Eadweard Muybridge (George Eastman House).

One difference between motion pictures and still pictures that have been arranged in sequence is that with the latter far fewer pictures per event are represented.

Jumping abruptly from one scene to the next, or from one train of thought to another, reduces the strength of the relationship between adjacent pictures. What precedes or follows a frame or a picture influences the perception of it. There are situations, of course, when creating just such an experience—a disruption, a dissonance—is desired. But for the most part, the attempt is to provide a smooth and continuous (both in space and time) transition. Dissolves, fades in or out of focus, wipes, and similar techniques are designed to enhance this transition.

When we try to represent visual and auditory experiences through the use of sight-and-sound media and multimedia it is imperative that a good continuity of events be established. This is the main purpose of script writing, storyboarding, and editing film, videotape, audio tape, and written texts. One of the major problems in television programming is how to introduce commercials without interrupting the integrity and continuity of the program.

In putting images together I become active, and excitement is of another order—synthesis overshadows analysis.

Minor White

Closure

Nearly complete familiar lines and shapes are more readily seen as complete (closed) than incomplete lines and shapes. In Figure 2.25 the viewer groups the visual elements to see a triangle, not three unrelated lines—a circle, not a series of dots.

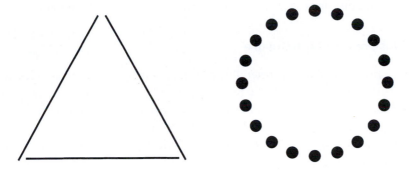

Figure 2.25 *Organization of visual elements according to the law of closure.*

The proximity and similarity of the visual elements are important in order to facilitate this perception of a triangle and a circle as one seeks to establish a visual equilibrium—a balance, a closure. The design of the five-star flag for a general of the U.S. Army provides an effective example of closure (Figure 2.26).

Forces of organization driving toward spatial order toward stability, tend to shape optical units into closed compact wholes.

Gyorgy Kepes

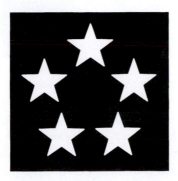

Figure 2.26 *Flag for a general of the army. A pentagon shape can be seen when closure within the star is made.*

A careful look at the area within the five stars causes one to see a pentagon shape. The physical shape formed by the edges of the stars is not continuous, but is perceived as continuous because the Gestalt law of

closure is operating. Other Gestalt laws are also operating to facilitate this perception:

1. Proximity — the closeness of the stars;
2. Similarity — all the stars are of the same size, shape, and color (white); and
3. Continuity — the orientation of the stars is such that straight continuous lines are formed from each of the five pentagon apexes.

Closure and Nonclosure

U.S. presidential flags further illustrate the interdependence of the Gestalt laws (Figure 2.27). Both the presidential and vice-presidential flag symbols have visual elements (stars) that can be grouped to form a circle. With the presidential flag symbols, however, the stars are more easily seen as forming a continuous line describing a circle. Closure to form a circle of stars provides a good gestalt.

An object in possession seldom contains the same charm that it had in pursuit.

Pliny the Younger

(A) (B)

Figure 2.27 *(A) Symbol of the flag of the vice president of the United States. Although the 13 stars are the same, they are not in proper proximity to allow easy closure of the visual elements. It is difficult to see a circle even though the stars are laid out in the form of a circle. (B) Symbol of the flag of the president of the United States. The proximity of the stars and the similarity of their orientations and shapes provide for continuation and closure.*

Several years ago a friend from Queensland, Australia, sent a cartoon showing a person standing in front of a psychotherapist's office, about to enter but pausing with a puzzled look. The name plate on the door read PSYCHO THE RAPIST. Humor here highlights the importance of the *interval* to perception.

This is true regardless of the sensory modality but especially true for sight and sound. Change the interval between tones in music and you change the music. In Michelangelo's painting of "The Creation of Adam" (Figure 2.28), changing the distance between the finger of the Creator and the finger of man changes the event, closure is denied.

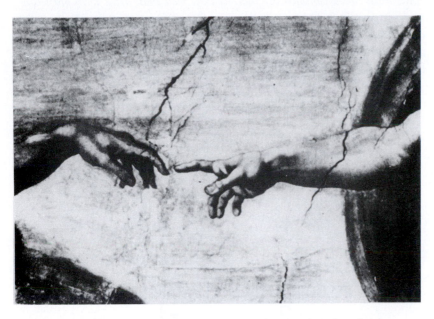

Figure 2.28 *The critical space between the fingers of God and Adam provides a decisive distance that invites closure. From "The Creation of Adam" by Michelangelo.*

If we listen to a continuous note on the fringe of audibility, the sound seems to stop at regular intervals and then start again. Such oscillations are due to a periodic decrease and increase in one's attention, not to any [physical] change in the note.

Carl Jung

The interval allows the viewer to complete the action; it is a critical distance, it is an invitation to participate in the event—in contemporary jargon, it is interactive. The same can be said for the painting "La Danse" by Henri Matisse in which five nude women are dancing in a circle and in a clockwise movement, their hands all joined together except for the two women in front. Between their outstretched hands is a gap, a narrow separation, an interval that invites the viewer to complete the action, to join in.

Henri Cartier-Bresson's famous photograph "Place de l'Europe, 1932" shows a man leaping over a large pool of water in a flooded street and his reflection in the water.[6] One of the things that makes this photograph memorable is that the man appears to be suspended in air. As he leaps, his forward motion is captured on film just before the heel of his outstretched right foot touches its reflection in the water. The decisive moment becomes the decisive distance—the critical interval that invites the viewer to participate in the photograph by completing the jump.

Whoever listens to the
drum hears silence.

Georges Braque

REM EMB ERTH ISIFYO UPU TTH EINT ERV ALINTH EWRO NGPLA CEITC ANCA USEP ROB LE MS. *

Closed Areas

Areas with closed contours are more readily seen than areas with open contours. In Figure 2.29A the closed areas 2 and 5 are easier to see than the open areas 1, 3, 4, and 6, even though the jagged lines are all similar and are in the same proximity to each other. In Figure 2.29B, the closed black bars are also easily identified as figure.

(A)

(B)

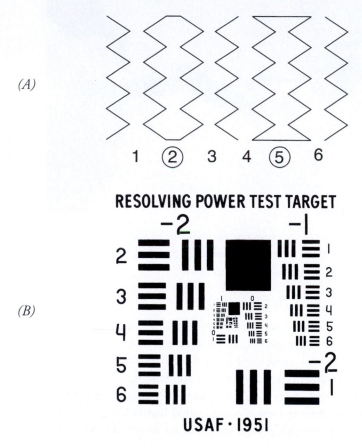

Figure 2.29 (A) Closed areas are more easily seen as figures. (B) The closed black bars on a resolving-power target are easily seen as figure.

One of the reasons the letter M shown in Chapter 1 (Figure 1.5) is so difficult to see is because the area is open rather than closed. The arrows, being closed, are readily seen as figure.

*Remember this if you put the interval in the wrong place it can cause problems.

The widths of the black bars in a resolving power target are exactly the same as the widths of the white spaces between them (Figure 2.29B). The lengths of the black bars are definite because they are closed areas, whereas the white spaces are not even seen as bars because they are open areas. To see the white spaces as white bars, one has to provide for closure. You can do this by simply drawing a line around the three black bars to form a square.

Also in Chapter 1 (Figure 1.4), a single contour line was used to show a figure–ground boundary. This line, with some effort, could be seen as belonging to the face of an old man or to part of the face and body of a woman. The perception of one over the other can be controlled by enclosing the single contour line (Figure 2.30). In this way one can manipulate visual elements so that perception of what is to be communicated is more certain.

Figure 2.30 Profile of an elderly man or head and torso of a woman? Closed areas are more readily seen as figures. Contrasting the enclosed areas by darkening them would make them even easier to see as figures.

A closed area appears more formed, more stable, than one which is open and without boundaries.

Gyorgy Kepes

The Zeigarnik Effect

In 1927 a Russian psychologist, Bluma Zeigarnik, conducted a series of experiments in which she showed that tasks that are interrupted before completion are more likely to be remembered than similar tasks completed without interruption.[7] Subjects were asked to perform simple tasks such as recalling favorite quotations from memory, solving a riddle, or doing mental arithmetic problems. Some of the subjects were given sufficient time to solve the problems and others were not. Upon questioning a few hours later, it was discovered that the subjects who were not allowed sufficient time for completion had better recall. This superiority of memory recall for uncompleted tasks, however, is short, and seems to disappear within 24 hours.

The experience is not an uncommon one, as evidenced by the fact that after a test or similar event one tends to give more attention to the questions that could not be answered. A similar situation exists when one

The incomplete image and the unexpected image set the mind a puzzle.

E. H. Gombrich

is puzzled about something they have read or seen that did not make sense so they decided to sleep on it. During the night the unsolved puzzle keeps the mind active and sometimes makes sleep difficult. Until the puzzle is solved, or frustration takes over and it is dismissed, it remains active in the mind.

Unresolved, complex personal problems and worry are even more persistent in refusing to be dismissed from the mind. Television soap operas and the old movie serials such as "The Perils of Pauline" are examples of the Zeigarnik effect.

The Zeigarnik effect is a variant of the Gestalt principle of closure. Research suggests that personality plays an important role. People who are highly anxious recall completed tasks better, while those who are achievement oriented recall uncompleted tasks better. A task that is not completed can cause tension. People have different tolerances and strategies for coping with tension—for some, tension can provide motivation; for others it can encourage withdrawal.

A certain amount of visual tension in a picture—an ambiguity, an illusion, a confusion, a novelty, an unexpected situation—can result in a pictorial Zeigarnik effect. The picture becomes a visual riddle that may remain unsolved during viewing. This unanswered riddle remains in memory and is recalled and thought about until it is solved and a closure is formed. Many pictures have such riddle characteristics. The most common, perhaps, are those used in advertising. Often, picture and copy go together to produce a puzzle that is not solvable in the short time typically devoted to viewing the advertisement. Rebuses (riddles composed of word syllables depicted by pictures or symbols) can be found in some advertisements.

GESTALT CRITIQUE

A photograph that shows excellent geometric form and nicely demonstrates various Gestalt laws is Henry Jackson's photograph of three American Indian women and a child (Figure 2.31). The positions of the faces of the three women are such that they are easily grouped to form a symmetrical triangle. A similar but inverted triangle could also be formed by grouping the faces of the two seated women and the young child. Other groupings are also possible, such as the diamond shape at the foot position of the child is grouped with the faces of the three women. The light area around the child is also triangular in shape.

I propose that many authors are influenced more by writers they only partly understand than by those they fully comprehend, for the former leave unfinished business in one's mind.

Rollo May

"Golfer's Dream"

by David Spindel

Figure 2.31 *Three North American Indian women photographed by
Henry Jackson (Smithsonian Institution National
Anthropological Archives, Bureau of American Ethnology
Collection).*

The grouping of the various visual elements into triangular shapes
might be analyzed in this way:

- *Proximity.* The faces of the three women are in position to form
 a symmetrical triangle. The two who are seated are at eye level
 with each other. They form a base line for the standing woman's
 head as one apex, or the baby's face or toes as another.

The recognition, in real life, of a rhythm of surfaces, lines, and values is for me the essence of photography; composition should be a constant of preoccupation, being a simultaneous coalition, an organic coordination of visual elements.

Henri
Cartier-Bresson

- *Similarity.* Grouping into a series of triangular shapes is facilitated by the similarity of the shapes of the faces, the facial features, hairstyle, and expression.
- *Continuity.* The outer shape of the women provides visual line elements that are close enough and in proper position to be grouped as continuous. Another example of continuity can be seen in the striped blanket of the standing woman. Jackson must have arranged the blanket carefully so that there would be continuity of stripes and so that they would form inverted triangular shapes.
- *Closure.* One example of closure, of course, is the grouping of faces to form stable shapes such as triangles. Other examples are the ease with which one sees closed areas such as the black-and-white stripes that do not blend in with the background.
- *Figure–ground.* You may have noticed that Jackson was careful to position one of the hanging light-colored dress pieces behind the head of the standing woman so as to provide a good figure–ground relationship in a critical picture area.

Man as Participant

Forming is more important than form.

Paul Klee

Man derives satisfaction from being able to form a closure that allows him to become an active participant in the visual experience. The concept of closure is not restricted to vision. It is basic to our humanity—to the way we experience things. A variety of examples can be cited to illustrate this. The art of teaching, in part, consists of providing learners with enough information organized in such a way that they can put it together, add the missing elements, and discover for themselves (closure) what the teacher wants them to experience. If someone recited "Mary had a little lamb whose fleece was white as _____" it could be predicted that most people would finish the nursery rhyme (closure) with the word "snow."

Years ago when cake mixes were first marketed they were a dismal economic failure even though the product was of good quality and convenient to use. Research studies determined that the failure was due, ironically, to the fact that manufacturers had done everything but bake the cake. They had, in fact, made the product too convenient to use. By changing the cake mix ingredients and making it necessary for the user to increase active participation by cracking, adding, and mixing in an egg, cake mixes became an almost instant success.

Interactive media, well designed, invite a person to participate in an event for entertainment, information, or instruction.

Keith Tripi

Every artist who successfully paints or photographs nudes knows that, in part, what is excluded is as important as what is included. The viewer is allowed the freedom to participate to form closure. The lesson is simple. In any planned experience, never deprive the participant of the opportunity to participate—to become involved. Raising questions throughout this book and providing exercises are ways of attempting to apply this rule.

Gestalt Laws as a Means

Knowledge of language, by itself, does not make one a great writer or poet. Knowledge of the Gestalt laws, in and of themselves, does not ensure a good picture any more than does knowledge of imaging processes or of sophisticated equipment and materials. Some of the excellent photographs made in the early days of photography attest to this. It is not sufficient merely to know about something. One must be able to apply that knowledge skillfully. A good picture is a result of knowledge and ability—of knowing and doing. Both can be achieved with rigorous discipline and practice.

The Gestalt laws, therefore, are not an end in themselves, but merely a means to an end—a means of improving the effectiveness of pictures. The laws, which might better be thought of as guiding principles, attempt to describe in a simple way how man segregates and groups visual information. These principles, then, can guide a photographer in creating pictures that facilitate visual communications.

A person learns significantly only those things which he perceives as being involved in.

Carl Rogers

A Word of Caution

The Gestalt laws of perceptual organization have been separated in this book for convenience—convenience in presentation and convenience in learning. You must not, however, think of them as separate, for they are related and work together to facilitate seeing. Visual elements that are close together, that are similar, that form a smooth contour, and that allow for closure can produce an effective composition.

Keep in mind, however, that many excellent pictures have been taken that do not conform to the Gestalt laws of perceptual organization. Examples of such pictures are those with strong emotional appeal and those that delve into the unconscious.

There is also a flip side to the Gestalt laws. If you know how to arrange visual elements so that they are easy to group visually, you also know how to arrange them so that they are difficult to group. You may choose to do the latter in order to create a feeling of tension or dissonance in your photograph, to camouflage, or merely to force the viewer to look harder.

As far as I am concerned, taking photographs is a means of understanding that which cannot be separated from other means of visual expression.

Henri Cartier-Bresson

PRAGNANZ

The Gestalt laws of organization are one attempt to formulate a set of principles that seem to describe the way we segregate and group visual elements into patterns or units. The overall rationale for why people organize and group information the way they do is explained in part by the law of *Pragnanz,* which was introduced by the founder of the Gestalt movement, Dr. Max Wertheimer. In the words of Koffka, the law of Pragnanz can be formulated like this:

The classic concept of the [Freudian] primary process (which forms unconscious phantasy) denies it any structure.

Anton Ehrenzweig

Psychological organization will always be as "good" as the prevailing conditions allow.

Although the term *good* is not defined, it is associated with such properties as regularity, symmetry, simplicity, uniformity, and closure—in short, properties that minimize stress and maximize stability. Prevailing conditions refer to the stimulus pattern (see Figure 2.32). More broadly, it refers to the perceptual environment.

Ideally I want every piece analyzed, technically, structurally, formally. And I want it to come out shatteringly integrated, like a crystal, totally whole, defying analysis.

Michael Tilson

Figure 2.32 *Prevailing conditions influence psychological organization: (A) Stable as a three-dimensional pattern. (B) Stable as a two-dimensional pattern. (C) Unstable.*

Seeing

Seeing involves more than just the stimulus pattern (picture) and environment. Much of what we see depends on our past experiences (memory), our own personalities, and what we are looking for. This is why the same picture often gets a variety of responses from viewers. What people experience depends on external and internal factors—what they are looking at and what they are looking for. Figure 2.33 provides some insight into the complexity of what appears to be the simple process of seeing.

Man, actively though unconsciously, structures his visual world. Few people realize that vision is not passive but active . . . in fact, a transaction between man and his environment in which both participate.

Edward Hall

What a person sees and experiences is called a percept (the product of perception, which is a process). What a person reports seeing is a verbal attempt to describe a nonverbal experience. It is an attempt to verbalize a percept and often falls short. *Saying is not seeing.*

Psychologists and others still have no way of positively knowing a given person's percept and probably never will. The percept is a result of interactions between the physical stimulus pattern and the unique psychological makeup of a person. No two people are completely alike, not even identical twins. To further complicate things, a person's psychological makeup varies from time to time and from place to place. The same cup of coffee will taste different in the morning than later in the day. Hot dogs taste different at a football game than they do at home.

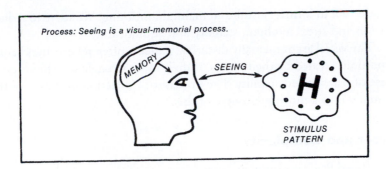

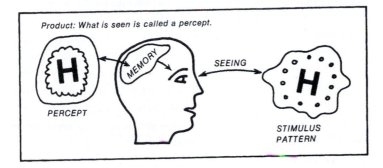

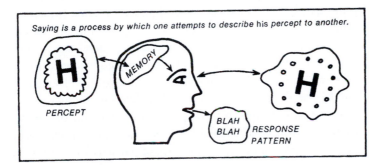

Figure 2.33 Seeing and saying are not the same. Saying is a verbal attempt to describe a visual percept.

Many factors, therefore, influence what we experience, and people will respond differently to what they are looking at. In spite of the differences among us, some basic similarities do exist and these influence how we organize things.

This, it is thought, is the meaning of the law of Pragnanz. We tend to organize our world so that we can cope with it. We search for stability, meaning, balance, security, and so on. We feel more comfortable when what we are looking at can be comprehended or experienced. If too much information is presented at one time, we either filter out some of it or simplify it by grouping or "chunking" it. If there is insufficient information,

The artist does not draw what he sees, but what he must make others see.

Edgar Degas

*The sole difference
between myself and a
madman is the fact
that I am not mad.*

Salvador Dali

we add to it to form a closure and maintain meaning. We strive to reduce tension and stress to obtain stability and equilibrium.

The visual art of mentally disturbed patients often reflects the chaotic conditions created by their illness or their inner struggle to achieve some sense of balance and stability. The Prinzhorn Collection of the art of the mentally ill is a moving example of this.[8]

Order and Complexity

We defined Pragnanz law as an overriding principle under which the Gestalt laws of perceptual organization operate. According to this principle, psychological organization or grouping of information is facilitated by such things as regularity, symmetry, and simplicity. The organization of information by a person is dependent on the amount of information presented, which, in turn depends on the redundancy and predictability of the various individual elements present within an array of information. In other words, if visual elements are well ordered, there is a high degree of redundancy and, therefore, predictability. Psychological organization of the visual elements will be facilitated, but what is experienced (percept) could be quite boring.

The point is this: The Gestalt laws, if mechanically applied in the practice of photography, filmmaking, art, design, multimedia presentations, or any other means of communications, might be technically correct but the product could be monotonous and mundane. There may be no challenge for the person viewing what has been designed, no sense of excitement or of curiosity, no motivation to become involved. Too much has been done by the designer and there is little left for the viewer to add. Psychological organization is an active process from which a person derives pleasure and satisfaction. Too much order in a picture or presentation or design deprives a person of the creative act of participation. Some variation is needed to engage a person—to add a little spice.

Rudolf Arnheim, who was a student of Max Wertheimer in the 1920s, eloquently describes the importance of variation in the design of things. He talks about order and complexity, defining order as "the degree and kind of lawfulness governing the relations among the parts of an entity" and complexity as "the multiplicity of the relationships among the parts of an entity." He then goes on to say:

> *Order and complexity are antagonistic, in that order tends to reduce complexity while complexity tends to reduce order. To create order requires not only rearrangement but in most cases also the elimination of what does not fit the principles determining the order. On the other hand, when one increases the complexity of an object, order will be harder to achieve.*
>
> *Order and complexity, however, cannot exist without each other. Complexity without order produces confusion—order without complexity produces boredom. Although order is needed to cope with both the inner*

The marginal quotations alongside the main text read:

It took years to become spontaneous and simple. Nijinsky took thousands of leaps before the memorable one.

Martha Graham

To define is to destroy, to suggest is to create.

Stephane Mallarme

You have to know how to preserve that freshness and innocence a child has when it approaches things.

Henri Matisse

In order to be able to understand the great complexity of life and to understand what the universe is doing, the first word to learn is synergy.

Buckminster Fuller

and outer world, man cannot reduce his experience to a network of neatly predictable connections without losing the stimulating riches and surprises of life. Being complexly designed, man must function complexly if he is to be fully himself—and to this end the setting in which he operates must be complex also. It has long been recognized that the great works of man combine high order with high complexity.[9]

INFORMATION THEORY

There are alternate ways to describe a given visual experience. The Gestalt laws were formulated in the early 1900s to provide some principles of how man tends to group visual elements. In the mid-1900s visual elements were identified as informational elements, and the ways in which such elements were grouped could be described in terms of *information theory* or communication theory. The principal concepts are uncertainty and redundancy.

The amount of information conveyed by what we see (percept), for example, depends on the number of different ways in which visual elements can be grouped (uncertainty or alternatives). The more redundant the visual elements, the fewer the alternatives and the easier the grouping. One of the reasons why things that are symmetrical are so easy to see is that there is great redundancy of information. Information on any one side of the symmetrical figure is readily predictable from information on the opposite side. Symmetry is one of the things that provides for a "good" gestalt or Pragnanz. The graphic symbols used by many corporations and businesses are often symmetrical and redundant (Figure 2.34).

Many of the Gestalt principles pertain to the distribution of information in the pictures. For example, "good" figure is a figure with a high degree of internal redundancy.

Ralph Norman
Haber

PURE WOOL

Figure 2.34 The Pure Wool mark provides a good gestalt. There is good figure–ground relationship, regularity, symmetry, proximity, continuity, simplicity, balance, closure, and stability. It has a high redundancy of visual elements, many of which can be eliminated without loss of recognition but with severe loss of the aesthetic experience.

The eye appears to act according to the principle of least effort and do no more than is imposed on it.

Floyd Ratliff

Such redundancy means that there is little uncertainty in the probability that the symbols will be identified, even when some of the redundant information is missing. The experience itself however, would be different.

The Gestalt laws operate to reduce uncertainty by facilitating the grouping of visual elements—by redundancy of information. Information that is easily grouped is said to have properties for Pragnanz (Gestalt theory) or redundancy (information theory). Roughly speaking then, the Gestalt laws of perceptual organization describe various types of redundancy. The Gestalt laws are easy to comprehend but are not easily quantifiable. Information theory, although quantifiable, is more difficult to grasp and leads to error when one tries to use it to quantify human perception.

All things are connected. Whatever befalls the earth befalls the children of the earth.

Chief Seattle

This thou must always bear in mind, what is the nature of time whole, and what is thy nature, and how this is related to that, and what kind of a part it is of what kind of a whole; and that there is no one who hinders thee from always doing and saying the things which are according to the nature of which thou art a part. —Marcus Aurelius

Figure 2.35 gives a visual summary of the Gestalt principles covered in this chapter, and Figure 2.36 shows graphic examples.

The designs of many of the international graphic symbols presently in use and being proposed provide excellent examples of the Gestalt laws. The few shown in Figure 2.36 were selected from the several thousand categorized by H. Dreyfuss.[10] Two symbols, the Star of David and that for Yin/Yang, remind us that graphic symbols go far back into history and that their design is ageless.

For me expression . . . is located in the entirety of my painting: the position the figures are in, the empty spaces around them, time proportions—all of it contributes. Anything that is not necessary to the painting damages it. A work must establish an overall harmony.

All four Gestalt laws are readily identified in the Olympic graphics (Figure 2.36H). The dark wavy lines are similar in contour, but vary in thickness. The closed dark wavy lines are narrower than the white lines and are, therefore, more readily seen as figure. In certain areas the dark wavy lines become thicker (greater proximity) and facilitate a grouping of visual elements in that area.

Similarity, proximity, and continuation work together to facilitate the closure of a person in action. This closure provides meaning and psychological balance (Pragnanz).

Henri Matisse

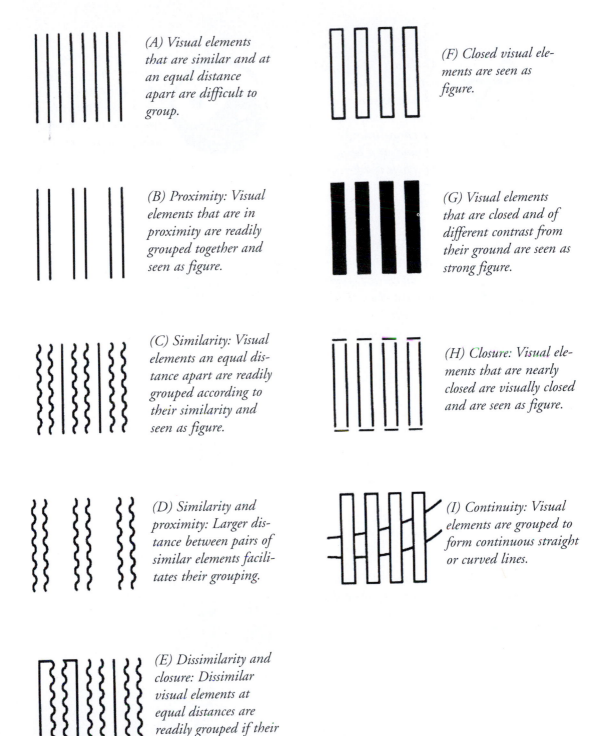

(A) Visual elements that are similar and at an equal distance apart are difficult to group.

(B) Proximity: Visual elements that are in proximity are readily grouped together and seen as figure.

(C) Similarity: Visual elements an equal distance apart are readily grouped according to their similarity and seen as figure.

(D) Similarity and proximity: Larger distance between pairs of similar elements facilitates their grouping.

(E) Dissimilarity and closure: Dissimilar visual elements at equal distances are readily grouped if their areas are closed.

(F) Closed visual elements are seen as figure.

(G) Visual elements that are closed and of different contrast from their ground are seen as strong figure.

(H) Closure: Visual elements that are nearly closed are visually closed and are seen as figure.

(I) Continuity: Visual elements are grouped to form continuous straight or curved lines.

Figure 2.35 Gestalt summary.

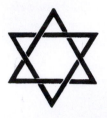 (A) Gestalt: The graphic symbol for Judaism is seen as a total configuration of a star, not as six separate triangles surrounding a hexagon. The whole is different from the sum of its parts.

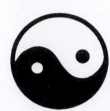 (B) Figure–ground: The graphic symbol for Taoism, representing Yin/Yang, is perfectly symmetrical, either half being seen as figure or ground.

 (C) Proximity: The closeness of the small bars allows easy grouping into a clockwise movement.

 (D) Similarity: (1) Bright or hazy sun; sand; snow. (2) Cloudy bright, no shadows.

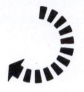 (E) Symmetry: (1) Water sports area. (2) Shooting. The wavy lines are similar and therefore are grouped together.

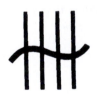 (F) Continuation: The wavy line is easier seen as one continuous line than not.

 (G) Closure: Radioactive sign. The three dark segments are easily seen since they represent closed segments. The similar unenclosed (white) segments are difficult to see.

 (H) Similarity, proximity, continuation, and closure: (1) Ice hockey. (2) Cross-country skiing.

Figure 2.36 Graphic examples of Gestalt principles.

KEY WORDS

asymmetry

closure

continuity

field theory

Gestalt

information theory

interval

Pragnanz

proximity

similarity

simplicity

symmetry

Zeigarnik effect

"Minor White" by David Spindel

Gestalt Grouping Exercises

1. Tandem Gestalts

Expose a roll of film in such a way that pairs of frames serve as one through some kind of connection or association. The Gestalt principles of similarity, continuation, closure, proximity, symmetry, and common fate can serve as connectors. (Cut the roll of film into appropriate strips and make a contact print of each strip.)

2. Cut-and-Paste Gestalt

Take some of your old photographs or those printed in magazines and cut them into smaller pieces. Lay the pieces on a table as you would a jigsaw puzzle. Now select pieces and arrange them in a way so that they create an interesting gestalt. As a variation try grouping visual elements that do not normally belong together, elements that when combined provide humor or puzzlement (Zeigarnik effect).

3. TV Screen

Consider your TV screen as a source of moving and changing pictures in which each frame is on for 1/30th of a second. In 1 second you have an opportunity to photograph 30 different pictures—in 1 minute up to 1,800 different pictures.

Place your camera so that you can focus on the entire TV screen and set the shutter speed at 1/30th of a second (1/15th with a focal-plane shutter). If you are using film with an ISO speed of 160/23°, set the aperture at about f/2.8.

Sit close to your camera with your finger on the shutter release. Think of the Gestalt laws and watch the changing TV pictures until you see an image that has a Gestalt design. Quickly take a photograph of it.

Photograph by Jose Henrique Lorca

Art is not an object but an experience.

Josef Albers

Expose a few rolls of film in this way and then study the results. It is an excellent way to develop your perception and timing so that you can capture pictures that exist for only a fleeting second.

4. Chance Video Gestalts

The surrealist artists used techniques of free association and automatic writing to tap their unconscious from which creative ideas spring. Had they been living during our electronic age they might have used electronic writing.

Robert Heinecken used the unpredictable spontaneity of video imagery combined with a photographic transparency taped to the screen to create new images. The creative mind of man blends photography and videography into new gestalts. Try the Heinecken approach.

5. Chance Camera Gestalts

Images can be superimposed in a camera with double exposures. Double-expose a roll of film one frame at a time, half of the roll by careful choice and the other half by chance. Compare the images. If your camera does not allow double exposures to be made, expose an entire roll of film, rewind it, and then expose it again. (Take precautions to prevent the film leader from being completely rewound into the cassette.) Make prints and study them.

There is no "must" in art, because art is free.

Wassily Kandinsky

There is an old standard saying about the arts, "You need to learn all the rules and then forget them."

Joseph Campbell

Photograph of Dr. Rudolf Arnheim (right) and author. Happy accident (chance).

6. Chance Enlarger Gestalts

Images can be superimposed by choice or chance in the darkroom to create other images. Superimpose any two negatives in a negative carrier and print them. Do it two different ways:

a) By choice
b) By chance

Try these variations:

a) Rotate one of the negatives 180 degrees and print the sandwich. Compare.
b) Instead of superimposing the negatives in the carrier, project and expose each separately on the same sheet of photographic paper.
c) Project and print one negative with the paper in a flat position and then project and print the second negative with the paper tilted.
d) Project and print one negative in focus and then the other slightly out of focus.

7. Similarity: Dissimilarity

Photograph two people in such a way as to accentuate their similarities. Think in terms of facial features and expressions, hands, gestures, gender, and so on.

There is nothing new in art except talent.

Anton Chekhov

To think is to differ.

Clarence Darrow

Photo by Scott Calder. (Courtesy Ilford, Inc.)

8. Cropping and Closure

The Gestalt laws can help you while you are framing a picture in a camera viewfinder or cropping a picture that is being printed. Notice in the photograph below how careful the photographer was in framing the scene. She wanted to show the similarity of shapes between natural terrain and animals. Her tight framing of the upper section of the white and black horses does this dramatically. She was also mindful of the white area on which her photograph was to be mounted so that the lower black area is closed by the white mountboard, and the white area is closed by the dark area of the photograph itself.

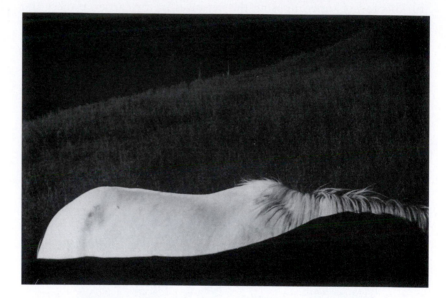

Photo by Lisa Jones.

Lisa Jones wrote of her photograph, "I like the look of fields that have hills and slopes in them. . . . I like the body shapes to animals and their textures. There are some field hill contours that feature animal shapes. . . . And when there is harmony between the field forms and the animal shapes, then it really resounds nicely."

9. Treasure Hunt

Take another look at some of your contact prints and see if cropping can improve the photograph. You might also look around and see if some photographs or parts of photographs might work well together in pairs. The same can be done with film or video footage not used. Play around, you may discover treasures.

10. Typography

Search out different styles of typefaces used in advertisements, posters, film or video titles and identify the Gestalt laws that are operating. Try styling your own type. Check your library for books on typography.

11. Gestalt Scrap Book

Start a scrap book of various examples of the Gestalt laws that you can identify in magazines. Cut out pictures and illustrations and paste them in your scrapbook with proper identification. You may want to lay out your book in this sequence:

a) Figure–ground
b) Proximity
c) Similarity
d) Continuity
e) Closure
f) Pragnanz

Start looking for stamps that have incorporated in their design some of the Gestalt laws of perceptual organization. You will be surprised at how many you can find once you begin looking for them. Do not limit yourself to any one country. Stop at a stamp collector's store and look around. Start a collection.

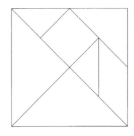

12. Tangrams

A tangram is a seven-piece Chinese puzzle similar to our jigsaw puzzle in that the object of the game is to fit pieces together. It is quite different from a jigsaw puzzle, however, since it contains only seven geometric pieces that can be fitted together in different ways to form a variety of greater shapes. It is a good example of Gestalt because the figures that result from the various possible combinations of the same seven pieces are different from the sum of the pieces or parts.

The seven pieces that make up a tangram can be traced and cut from the square shown: The object of the game is to group these seven pieces to form figures other than squares, such as a cat. The task is difficult because there are many different ways in which the seven pieces can be positioned and you must group them to make a whole figure. Note that even when the seven parts are clearly shown, the initial tendency is not to see seven individual parts but to see the totality of these parts grouped into the form of a cat.

Paul Rand in his book *Paul Rand — A Designer's Art,* writes about the importance of tangram exercises:

> *Many design problems can be posed with these games in mind; the main principle to be learned is that of economy of means—making the most of the least. Further, the game helps to sharpen the powers of observation through the discovery of resemblances between geometric and natural*

forms. It helps the student to abstract—to see a triangle, for example, as a face, a tree, an eye, or a nose, depending on the context in which the pieces are arranged. Such observation is essential in the study of visual symbols.[11]

Here are some forms for you to try. (The answers are given in Appendix B, "Answers to Selected Exercises.")

WHALE PORTRAIT

HORSEMAN BOAT

It takes formidable energy and discipline to evoke the subjective from the literal, to convert the specific into the universal.

Barbara Morgan

If you are interested in more information on tangrams, books on the subject are available in some museum bookstores and from Dover Publications, 31 East 2nd Street, Mineola, NY 11501.

13. Don't Be a Square

Try solving this visual-tactile problem if you have not seen it before. If you have seen it, try it on friends and observe how they attempt to solve it.

Given the array of 9 dots shown below, connect them all with only four straight lines. You are not allowed to lift the pencil from the paper. Try solving the 16-dot problem using the same technique. (The answers are given in Appendix B.)

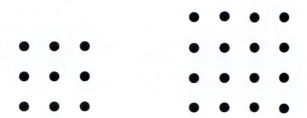

9 Dots: Connect the dots with only four straight lines. 16 Dots: Connect the dots with only six straight lines.

Notes

1. *Henri Cartier-Bresson,* New York: Aperture, 1976, p. 43.
2. Bruce Davidson, *East 100th Street,* Cambridge, MA: Harvard University Press, 1970.
3. Henri Cartier-Bresson, *The World of Henri Cartier-Bresson,* New York: Viking Press, 1968.
4. Amy Conger, *Edward Weston Photographs,* Tucson, AZ: Center for Creative Photography, University of Arizona, 1992, Figure 968.
5. Nancy Newhall (ed.), *Edward Weston,* New York: Aperture, 1971, p. 84.
6. Henri Cartier-Bresson, op. cit., p. 39.
7. Leslie Stroebel, Hollis Todd, and Richard Zakia, *Visual Concepts for Photographers,* New York: Focal Press, 1980, pp. 166, 167.
8. Hans Prinzhorn, *Artistry of the Mentally Ill,* Berlin: Springer-Verlag, 1922, 1923, 1968; English edition, 1992.
9. Rudolf Arnheim, *Psychology of Art,* Berkeley: University of California Press, 1972, p. 124.
10. H. Dreyfuss, *Symbol Sourcebook,* New York: McGraw-Hill, 1972.
11. Paul Rand, *Paul Rand — A Designers Art,* New Haven, CT: Yale University Press, 1985, p. 192.

3
Memory and Association

The more facts a fact is associated with in the mind, the better possession of it our memory retains.

William James

"Cherill Horse, Wiltshire, England." © Marilyn Bridges, 1985. This decorative chalk marking of a horse embedded in a hillside was created in 1780 and was photographed from a very low-flying airplane. Its length is 123 feet—over a third the length of a football field.

When photography first came into existence with the daguerreotype in 1839, it was referred to as "a mirror with a memory." A person could hold a photograph and recall past events. Photo albums, school yearbooks, and the like serve as visual diaries of past experiences, memories of times past.

Memory is a diary we carry about with us.

Oscar Wilde

Memory is an integral part of perception. It is much easier to see what we know, what is stored in memory, than to see what we do not know, what is not in memory. In fact, one of the familiar problems in teaching students how to draw is to convince them to draw what they see and not what they know. The same can be said for photography—photograph what you see and not what you know and project onto the object. "Let the object come to you, don't go to the object," Henry Thoreau reminds us. This is a difficult task since memory and perception are so closely tied together. Minor White in photographing landscapes recognized this connective problem and prayed for "pristine vision," vision that can avoid memory, vision with the innocence of a child.

Vision without association—pristine vision?

Minor White

SHORT-TERM MEMORY/LONG-TERM MEMORY

All of our senses are connected in memory. We have memories not only of visual experiences but also of experiences involving sound, smell, taste, touch, movement, and balance. The memories we remember for a long time are called *long-term memories* (LTMs) and are contrasted with *short-term memories* (STMs) that we remember just long enough to use and then forget. One example of STM is a telephone number that we look up, dial, and then forget. A number in LTM that we don't forget, for example, may be our social security number.

Cramming for an exam is mostly STM, remembering just long enough to pass an exam. It is short-term learning.

There is a limit to the amount of unrelated information a person can hold in STM, from five to nine items, averaging seven. One researcher[1] referred to this limitation as "The magic number seven, plus or minus two." To experience this limitation, have someone read to you a set of unrelated numbers such as 7932586 or letters such as RFGLMPQ. Then try to recall them in proper sequence by saying them or writing them. Sound easy? Try it with five to nine unrelated numbers, letters, or words.

I have a grand memory for forgetting.

Robert Louis Stevenson

Because we are limited in the amount of information we can retain correctly in STM, one should be cautious with the amount of information included in the design of a photograph, poster, advertisement, or multimedia program if it is going to have some memorable impact.

From STM to LTM

The human brain is a 3-pound universe having 100,000,000,000 cells.

A number of strategies are available for transferring information from STM to LTM such as rehearsal, association, attention, and mnemonics—common procedures we use to learn things and remember them. Some 50 years ago, as a navy radio operator I learned Morse code so well that I can still easily recall it. Practice, practice, practice shifts things from STM to LTM.

One does not become a great athlete, dancer, musician, or photographer without practice. Students of Minor White recall his taking hundreds of pictures without film in his camera, just for practice.

Body as Memory

Our entire body is a memory system. I am, for example, writing this manuscript by hand, even though I have a computer to which I will transfer the text later. Why do I do this? Somehow, perhaps like an artist-painter, my hand movements help coordinate my thinking and tickle my memory. Athletes and dancers use their entire body as a memory system and practice with it. (A typical inch of skin has about 19,000 sensory cells.)

I see again in memory my dear.

Francis Picabia

Deaf people who use finger spelling and sign language use their fingers to recall how to spell a word and their hands to recall other things.

Mnemonics

Another technique for fixing things in memory so they can be recalled later is to use a *mnemonic.* The familiar mnemonic used to remember whether to set a clock 1 hour ahead in the spring of the year and 1 hour behind in the fall is "Spring forward, fall back." Mnemonics I have used to help students avoid common misspellings of words such as *visible* (visable) and *aperture* (aperature) is that the word visible has two "eyes" ("i"s) to see with, and that there is no "rat" in aperture. I also remind them that the correct spelling for the word gray in America is with an "a" and that in England it is with an "e," grey.

There are more cells in the human brain than there are stars in the universe.

Michael Gazzaniga

Zone system photographers use Roman numerals from 0 to X as a mnemonic for visualizing the different colors in a scene in terms of their tonalities or lightnesses. A maximum black is zone 0, pure white zone X, and a middle gray zone V.

VISUAL MEMORY/COLOR MEMORY

Visual memory is as important in all phases of photography as is taste memory for a chef or wine taster, smell memory for a fragrance designer, kinesthetic memory for a dancer.

My way is to seize an image that moment it is formed in my mind, to trap it as a bird and to pin it at once to canvas.

Joan Miro

Photographers, in printing a negative, try to recall the experience they had when exposing the film and what their intentions were; how they visualized the scene initially. In making a color print it is necessary to realize that colors in the scene photographed are not remembered as they are seen; light colors are remembered as being lighter, dark colors as darker, and hues as being more saturated. Film manufacturers are aware of this and design their products so that the color reproduction coincides with remembered colors.

It is a poor sort of memory that only worked backwards, the Queen remarked.

Alice in Wonderland

Color memory is vital in postproduction work such as editing color film or video, in film-to-videotape transfers, and in multimedia work. In editing film or video, for example, an outdoor scene shot in daylight in which a woman is wearing a red dress has to look similar to one that might have been shot with the same red dress at another time, say, indoors at a cocktail party.

In a film-to-videotape transfer, a person sits in front of a video screen as film passes, frame by frame. Some of the film may have been shot in different cameras, under different lighting conditions, and sometimes with different color films. The person has to make color corrections so that there is a continuity of colors as well as tonalities and levels of brightness. This is a difficult task requiring excellent visual memory as well as color memory. It is a highly sought-after talent.

Sequencing

To engage a sequence we keep in mind the photographs on either side of the one in our eye.

Minor White

Visual memory is essential in any work requiring sequencing—for instance, when preparing large exhibits of photographs or editing pictures for a book, film, video, slide presentation, multimedia, computer animation, or storyboard.

The task becomes increasingly difficult when one moves from working strictly in a visual mode such as with photographs to a film/video mode, and to a multimedia mode. Computer imaging, manipulation, and integration using CD-ROM opens a range of opportunities and challenges to image makers.

ASSOCIATION

The graphic solution of the problems of perspective and space by their [Japanese] art incited me to find something analogous in music.

Igor Stravinsky

We remember things through *association.* When I was first introduced to a gentleman named Lothar, I could not remember his name on later occasions, since it was strange to me. He advised me to remember it as "*Low tar,* more taste," a slogan for a cigarette at that time. I have never since forgotten it. Whenever I *hear* opera, I am transported to Verona, Italy, where I once sat in the coliseum listening to the grandeur of live Italian opera. When I am in my car behind a stopped bus, the *smell* of diesel reminds me of my Navy days aboard the diesel-burning destroyer, the *USS Duncan.*

When I *look* at the photograph by Bruce Davidson of a child standing on a fire escape (see Chapter 2), I see the Christian image of a crucified Christ and experience the emotions associated with that image.

When Minor White was teaching at the Rochester Institute of Technology (RIT), he would, during his critique sessions, make remarks such as "Yes, this is a photograph of a tree (or rock), but what else is it?" The "what else is it?" part of the question is significant. It is what the image is *about.* Seeing the tree or rock as only a tree or a rock is a literal inter-

pretation. What the tree or rock may signify, the associative meaning, the connotation, is what makes a photograph a good or great photograph, a memorable one. Edward Weston's photograph of a rock cluster, "Eroded Rock No. 51, 1930"[2] (Figure 3.1) is more than a literal eroded rock, and the association one can make is one of the things that makes it a great photograph—it is a visual *metaphor,* a poetic statement.

Figure 3.1 "Eroded Rock No. 51, 1930," Edward Weston (Center for Creative Photography Arizona Board of Regents).

Weston titled this photograph quite literally. What makes this rock more significant than the many others he must have photographed? Literally it is a rock formation resting on small pebbles of stone, but what else is it? In Weston's own words, it is more than just a rock. The aim is ". . . to photograph a rock, have it look like a rock, but be *more* than a rock."[3] Visually and poetically it is more than a rock or rock cluster. The shape, form, and lying position of the rock suggest that of a reclining nude model or a sculpture of one.

In a similar way the photograph in Figure 3.2 can be seen as a visual metaphor; as such, it becomes a more interesting picture. Men are in various positions of dress in a primary grade school room. Four are seen putting on their white robes, one has a black robe. Who are they, and what is their purpose? One might easily mistake them for Klansmen but they are not; they are Trappist monks away from their monastery dressing for a special ceremony in which one of the monks (not shown) will be consecrated as their abbot. This is a literal description of the photograph. At another level

Every concept in our conscious mind, in short, has its own psychic associations.

Carl Jung

it is interesting to contrast the monks in white against the monk in black. White signifies innocence and purity, black darkness and death. The monk in black appears ghost-like, in profile, walking out of the picture.

Figure 3.2 "Trappist Monks," Richard Zakia.

The contrast of white against black also suggests *Notan,* a Japanese word meaning dark/light, the interaction between two opposing forces (see Chapter 1). In the ancient Chinese symbol of Yin/Yang these opposing forces are seen in perfect harmony. (Niels Bohr, a Danish theoretical physicist who died in 1962, would remind us that opposites are complementary.)

Advertisements

The copy in a romantic ad for Perrier reads:
Kiss
Love
Joy
Desire
Man
Woman
Perrier

Advertisements are based on associations (see Figure 2.17), and the associations made are your very own. Advertising operates on the basis of visual suggestion. Popular figures in sports are shown in ads for related products to suggest success, winning; the archetypal hero image.

In like manner, the cowboy in cigarette ads can project the same rugged hero archetype. Women's products suggesting beauty, slimness, playfulness, and so on, are always in the context of appropriate signifiers such as an admiring handsome male figure, a beautiful female celebrity, flowers, diamonds, and the like. Many ads are based on familiar works of art, directly or indirectly by style (Figure 3.3).

Figure 3.3 Art in ads. (Courtesy of Scoresby Scotch.)

Associating a product with a work of art gives it significance and value. The association, according to John Berger in his book, *Ways of Seeing,* is that "Art is a sign of affluence; it belongs to the good life; it is part of the furnishing which the world gives to the rich and beautiful . . . art also suggests a cultural authority, a form of dignity, even wisdom, which is superior to any vulgar material interests. . . ."[4]

Works of art have intrinsic formal qualities and are easily recognized by a large public; they become a sort of Gestalt. "Art expresses some of the most intense testimony to who the members of a society are, what they do, what they think and feel. Once acknowledged as art and valued as such, works created by artists acquire a special status . . . they become symbolic expressions . . . successive interpretations of the same work accumulate in a shared way of seeing and understanding. . . ."[5]

For art at its roots is association . . . the power to make one thing stand for and symbolize another.

Robert Hughes

Props (Signifiers)

The props used in creating a photograph are intended to have associative value. They can be thought of as *signifiers.* A snake or serpent, for example, can signify temptation, danger, sexiness, or rebirth as it sheds its skin, depending on the context in which it is used. A serpent can also take the

form of an *ouroborus,* coiled in a circle and biting its own tail. It represents a primitive idea of a self-sufficient Nature, a Nature that always returns in a cyclic pattern to its own beginnings. In its broadest sense it is symbolic of time and of the continuity of life. The circular form of the ouroborus symbol can often be seen in advertisements for women's bracelets.

In selecting a particular prop, think of what you want it to signify or suggest in the context in which it will be used. What association do you want the viewer/reader to have? An apple with a bite in it made by a sensual-looking woman signifies one thing; an apple in a bowl of fruit as part of a photo still life signifies something else.

In designing a photograph, poster, advertisement, or any visual message, decide first on what you would like the message to convey, how you would like it to be read, and then select the props, including models, and arrange them to create a good gestalt.

Props as signifiers can take many forms and what they signify or connote is context dependent. Props serve to foster associations and, for convenience, here is a list of props by categories:

Animals: Bat, bear, bull, cat, cow, coyote, crocodile, deer, dog, dolphin, elephant, fish, fox, frog, goat, horse, lamb, lion, monkey, mouse, pig, serpent, turtle, whale, wolf.

Birds: Dove, eagle, falcon, goose, magpie, owl, peacock, pelican, phoenix, raven, robin, stork, swallow, swan, wren.

Flowers: Bluebell, columbine, dandelion, hyacinth, iris, lily, lily of the valley, lotus, orchid, pansy, poinsettia, poppy, rose, sunflower.

Fruit: Apple, apricot, banana, cherry, fig, grape, kiwi, mango, orange, peach, pomegranate, quince.

Insects: Ant, bee, butterfly, fly, grasshopper, mantis, scorpion, spider.

Nature: Cave, cloud, lightning, moon, mountain, night, ocean, rain, rainbow, rivers, sea, sun, water, wind, trees.

(Information on these signifiers and others including categories such as motifs, sacred objects, rituals, deities, supernaturals, zodiac, body parts, plants, and minerals, can be found in *The Woman's Dictionary of Symbols and Sacred Objects* by Barbara G. Walker, Harper & Row, 1988.)

Colors

Colors also serve as signifiers and are culture as well as context dependent. The following is a list of some colors and the various meanings they can take on, realizing that for each named color there are hundreds of variations in hue, chroma, and lightness:

Let us forget things and consider only relations.

Georges Braque

When a painting is said to represent nothing but significant form—to carry no meaning, associative connections— the speaker does not know what he is talking about.

Arthur Koestler

Black: Glossy black suggests formal wear and class, whereas dull black suggests mourning and death.
Blue: Propriety, truth, masculinity, business-like, timeless, inner peace.
Brown: Earth, security, comfort.
Gold: Wealth, generosity, expensive, upper class.
Green: Environment, health, self-esteem, fertility.
Yellow: Happiness, success, intellect, sunlight, warmth.
Orange: Assertiveness, endurance, pride.
Purple: Sorrow, penitence, spiritual mastery.
Red: Passion, vitality, creativity, warmth.
Silver: Intuition, dreams.
White: Purity, honesty, cleanliness.

Analogy is the only language understood by the unconscious.

Carl Jung

Color is symbolic, and in its millions of hues, chromas, and lightnesses it feeds our emotions with various connotations that are culturally agreed on. The listing given here is for Western culture. In other cultures the color associations are different. For example, in some Asian countries, white symbolizes mourning; in Mexico blue does.

Feeling blue; green with envy; seeing red.

Equivalents

Another way to think of association is in terms of what Alfred Stieglitz and his followers called *equivalents.* In simple terms it is the ability of one thing to bring to mind something else. A photograph can serve as an equivalent that triggers memory and elicits certain feelings and experiences. Stieglitz in the early 1920s photographed clouds that, for him, evoked feelings similar to those derived from listening intently to classical music; visual and auditory became equivalent. Edward Weston in his diaries refers to some of his photographs of peppers, rocks, and sea shells in terms of visual metaphors or equivalents of the human torso. Minor White wrote about different levels of equivalence. At a graphic level one can establish equivalents of shape, form, color, texture, direction, and movement.

At a higher level, symbols, personal imagery, and inner experiences come into play. "Any photograph, regardless of its source, might function as an Equivalent to someone, sometime, someplace. If the individual viewer realizes that for him what he sees in a picture corresponds to something within himself—that is, the photograph mirrors something in himself—then his experience is some degree of Equivalence."[6]

An equivalent can be represented as a triad as shown in Figure 3.4.

Things have always found their expression through a system of reciprocal analogy.

Charles Baudelaire

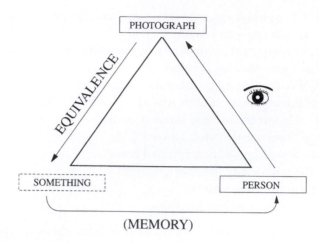

Figure 3.4 Equivalence. A photograph serves to trigger an experience held
in long-term memory. Memory and photograph resonate.
What is in memory and what is seen in the photograph
become equivalent.

The scientist Wolfgang Pauli wrote, ". . . the conscious realization of
new knowledge . . . seems . . . to be based on a correspondence, a 'match-
ing' of inner images pre-existent in the human psyche with external objects
and their behavior."[7]

People look at photographs and are reminded of something held in
memory. The photograph therefore serves as an equivalent for something
latent in memory. The process can also work in reverse: Something brought
forth from memory and pondered can recall a photograph. On the day
Edward Weston died, Minor White photographed a waterfall near
Rochester, New York, at a fast shutter speed so as to stop the action—
the flow of water over the falls. For Minor the photograph served as an
equivalent for the death of his friend and mentor, and the memory of his
death calls forth the photograph he made.

Synesthesia

Associations can also be brought forth by what is called *synesthesia,* the
ability of one sensory input to trigger another. As an example, a person
can be so moved by music that he or she actually experiences colors. A
powerful photograph for a food advertisement is one that will make a per-
son looking at it begin to salivate; here the visual triggers the taste sense.
Objects in photographs having visual texture can be experienced as tac-
tile. In some way all of our senses are interconnected and interactive. Sight
can and does set off other senses: sound, smell, taste, touch, movement,
and balance. A photograph with a tilted horizon line or a tilted person
or object can elicit a sense of imbalance.

I want a red to be
sonorous, to sound
like a bell.

Pierre Renoir

A painting by Mondrian titled "Broadway Boogie-Woogie" is a visual invitation to experience the bouncing movements of an earlier dance craze. It consists of a "bouncing" pattern of hundreds of bright little red, yellow, and blue squares against a light gray background.[8] (See Chapter 4, "Space, Time, and Color," for more on Synesthesia.)

Our eyes . . . work in constant cooperation with the other senses.

Rudolf Arnheim

Onomatopoeia

Another way to think of association is in terms of *onomatopoeia,* the formation of a word that sounds like what it represents: bang, crash, buzz, cuckoo, tick-tock, choo-choo. Traditionally, onomatopoeia refers to words that sound like their referent, but we can extend the definition to include more than just the sound of words but also their meaning, as in the use of *simile*:

(Seeing) It looks like . . .
(Hearing) It sounds like . . .
(Touching) It feels like . . .
(Tasting) It tastes like . . .
(Smelling) It smells like . . .

Everything is connected to everything else.

Lenin

I recall seeing a photograph that was poorly printed and messy, and being puzzled by it until I realized that the photographer was making a statement about the slums in a major city pictured in the photograph. One could think of this as a visual onomatopoeia—the messy, poorly printed photograph itself looks like the city slums shown in the photograph. Presentation and content work together to underscore the visual statement.

In his book, *Mirrors, Messages and Manifestations,* Minor White, who extends equivalence to a metaphysical level, makes this statement:[9]

Not equal to	equivalent to
Not metaphor	equivalence
Not standing for	but being also
Not sign	but direct connection to invisible Resonance.

Everything is shared by everything else; there are no discontinuities.

Frederick Sommer

KEY WORDS

association
color memory
equivalents
long-term memory (LTM)
metaphor
mnemonic
Notan
onomatopoeia
ouroboros
short-term memory (STM)
signifiers (props)
simile
synesthesia
visual memory

"Rag,"© Ruth Bernhard.

It was a cleaning rag hanging on the line to dry. But when I saw it, I didn't see a rag. I saw a crucifixion. And I loved the way the light was touching it.

Ruth Bernhard

Memory and Association Exercises

1. The Magic Number 7, Plus or Minus 2

Discover how many numbers or letters you and your friends can recall correctly after looking at or hearing each of the following sequences once.

(3 items) 852 RLZ
(4 items) 9352 WKNS
(5 items) 58401 RSYWQ
(6 items) 693195 KGDPRM
(7 items) 8251743 HXSWRNW
(8 items) 03756419 ZWUNVRVC
(9 items) 480651975 YTRWSXMKJ
(10 items) 9128374653 RVSXWJHNMK

Variations: Try recalling the letters or numbers after 5 or 10 minutes with no interruptions and with interruptions (interference). Try the same with these numbers and letters: 246813579 and AEIOUABCDEFG. Although there are 9 number and 12 letters, if one sees the relationships in the numbers and letters, they are no longer independent and can be grouped so that there are only two unrelated number sets and letter sets. Grouping reduces the amount of information that has to be remembered.

Winning at cards requires luck and good short-term memory.

2. Visual Memory

Select a photograph or advertisement from a magazine and study it for a few minutes with the intention of remembering all the details. Now close the magazine, and after a time try to draw a sketch of it and write in the colors as you remember them. Compare your sketch and colors with those of the picture in the magazine.

3. Tonal Memory/Color Memory

Make a good print of one of your black-and-white negatives photographically or electronically. Study the print and remember it. At a later date, without referring to the print, make another print so that it will match tones in the first print. Now compare the two prints. Try the same exercise by making a color print from a color negative or transparency.

4. Visualization

The heart of the zone system is the ability to visualize a color scene as not having hue or chroma (chrominance) but only lightness. Black-and-white photography records only lightness or brightness. This is a difficult task that takes much practice and a good visual memory. Expose a roll of film to different objects that you see and believe will reproduce as a middle 18 percent gray (zone V) in the print.

Process the film as you normally do and print each frame for the same time. Study your results and try again. Ansel Adams has remarked, "Without visualization, the Zone System is just a five-finger exercise." Visualization requires practice, practice, practice!

5. Coupling

Expose a roll of film so that the two images in each pair of adjacent frames (1 and 2, 3 and 4, 5 and 6, and so on) will couple to form a single image. To be successful you have to remember the content and position of the first image that is to be coupled to the second image.

No man has a good enough memory to make a successful liar.

Abraham Lincoln

. . . [S]implicity requires a correspondence in structure between meaning and tangible pattern.

Rudolf Arnheim

6. Doodle Memory

A good way to gain practice in visual memory is to draw a doodle, cover it, and then try to duplicate it immediately afterward and a short and a long time afterward.

7. Picture Association

Words can trigger images stored in LTM of which we may not be aware. What picture first comes to mind when you think of:

a) a sports hero e) an advertisement
b) the moon landing f) Olympics
c) a male or female vocalist g) MTV
d) a humorous event h) terrorism

(In deciding whether or not to caption a photograph, ask yourself whether you want to direct, and perhaps limit, the interpretation, or leave it open to "free association.")

8. Potential Signifiers/Props

What association do you make for the following signifiers:

a) moon
b) dog
c) lotus
d) dove
e) peach
f) butterfly
g) rainbow
h) orchid

9. Clouds as Equivalents

The photographer/cinematographer Ralph Steiner exhibited some of his cloud pictures at Dartmouth College some years ago and invited the attendees to title his photographs. The associations they made were interesting and playful and can be found in his book, *In Pursuit of Clouds* (Albuquerque, NM: University of New Mexico Press, 1985). Here are some examples: "The Devil's Spear," "Riding the Surf," "Night Comes Creeping," "Inflated Ego," "Primeval Swamp," "Skeleton in a Ballet Class," "The Wind Bird," "Hysterical Pinwheel," "Divine Grace," "Shroud of Darkness," "Goya's 'Chronos Devouring His Children,'" "Dazzling Chaos," "Eggdrop Soup," and "Marshmallow Lava."

Take some photographs of clouds that you see as equivalents and have friends independently title them, and then compare their titles with titles you may have given the photographs.

Why limit yourself to what your eyes see when you have an opportunity to extend your vision?

Edward Weston

10. Visual Metaphors

Look over some of your photographs and write a sentence or two describing them metaphorically. Example: A photograph of a scenic view of hills and valleys with a highway rambling through it might be described in this way: "The highway is a serpent sliding over and around the landscape" or, simply, "The highway carpets the land." As a variation, find a poetic sentence or a metaphor that speaks to you and try to find its photographic equivalent.

Notes

1. George Miller, "Information and Memory," *Scientific American,* August 1965, p. 195.
2. Nancy Newhall (ed.), *Edward Weston,* New York: Aperture, 1971, pp. 40, 41.
3. Ibid., p. 41.
4. John Berger, *Ways of Seeing,* New York: Penguin Books, 1988, p. 135.
5. Mihai Nadin and Richard Zakia, *Creating Effective Advertising Using Semiotics,* New York: Consultant Press, Ltd., 1994, p. 119.
6. Minor White, "Equivalence: The Perennial Trend," *PSA Journal,* Vol. 29, No. 7, pp. 17–21.
7. Harry Robin, *The Scientific Image,* San Francisco: W. H. Freeman, 1993, p. 146.
8. Robert Hughes, *The Shock of the New,* New York: Alfred A. Knopf, 1981, pp. 206, 207.
9. Minor White, *Mirrors, Messages and Manifestations,* New York: Aperture, 1969.

When I was young, I could remember everything, whether it happened or not.

Mark Twain

4

Space, Time, and Color

It is through the magic of photography that light becomes the subject matter with colors, forms, space, and time relationships that express my deepest feelings and beliefs.

Wynn Bullock

"College Basketball," © *Andrew Davidhazy.*

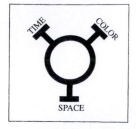

The wonderful variety of visual experiences available within our visual field can be grouped into three areas; space, time, and color as shown in Table 4.1.

Table 4.1 Three Visual Attributes (Adapted from R. W. Burnham et al., *Color: A Guide to Basic Facts*)[1]

Visual Experiences

Space	*Time*	*Color*
depth	movement	hue
transparency	flicker	saturation (chroma)
size	sparkle	brightness (value)
shape/form	fluctuation	
texture	glitter	

SPACE

Capturing pictures with a camera involves the transformation of objects located in a three-dimensional field to that of a photographic two-dimensional field.

In a 3-D field the ability to see depth—to judge distance—involves a number of visual cues, two of which directly involve the eyes: disparity and convergence. In looking at objects at varying distances in space, the eyes converge; the closer the object, the more the convergence (Figure 4.1).

Perspective: From medieval Latin perspectiva, optics; from late Latin, perspectivus, of a view; from Latin perspicere to see through or into.

American Heritage Dictionary

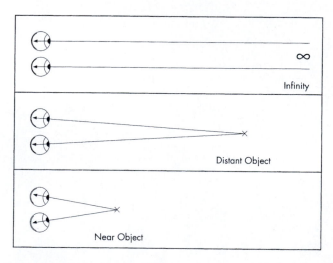

Figure 4.1 Convergence is a 3-D depth cue. At infinity the eyes point straight ahead. For various distances the eyes converge; the nearer the object the more the convergence.

Whereas convergence involves the movement of the eyes, disparity, the basis for stereoscopic depth perception, involves the position of the images formed on the retina from each eye. The two images locate in slightly different positions, and in order for the person to make sense out of this disparity, or incomplete fusion of the two images, the disparity is perceived as representing depth.

When looking at a picture in a 2-D field, the image has a number of depth cues that provide the perception of depth, and we respond to them automatically. Figure 4.2 provides examples of several types of two-dimensional depth clues:

It is striking to note how few straight lines, parallel or not, appear in a landscape not yet touched by human hands.

Maurits Escher

- *Relative size:* The same object at a far distance appears smaller than at a close distance.
- *Linear perspective:* Railroad tracks (parallel lines) appear to come closer together as distance increases.
- *Texture gradient:* Imagine a plowed field photographed from a perpendicular position; as distance increases the rows appear closer and closer in the photograph.

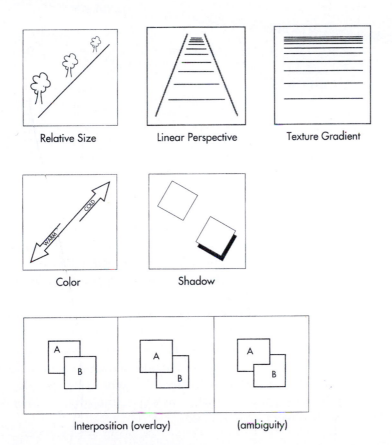

Figure 4.2 Two-dimensional depth clues. When looking at a 2-D picture there is no physical depth.

- *Color:* There is a tendency for warm colors such as reds to be seen as advancing and cold colors such as blues, receding.
- *Shadow:* An object casting a shadow appears to have more depth (separation) than one that does not.
- *Interposition (overlap):* A person standing in front of a car overlaps or blocks out part of the car.

Figure 4.2A illustrates another type of depth perception, aerial perspective. Objects at far distances are less clearly seen than near objects due to aerial haze.

Figure 4.2A Aerial perspective, Kerry S. Coppin, photographer.

For a moving image, two additional depth cues come into play; *motion perspective* and *motion parallax.* With motion perspective we experience depth because the image of an approaching object increases in size. With images moving across our visual field, near objects appear to move faster than far objects (Figure 4.2B).

With motion parallax a lateral change in camera position reveals objects in the background that were blocked from view by objects in the foreground. To experience this, imagine a window as a viewfinder on a camera; moving your head (camera) from side to side causes parts of the objects previously covered by the window frame to be seen. Color also plays a role as a depth cue; warm colors such as reds appear to advance, whereas cool colors such as blues seem to recede.

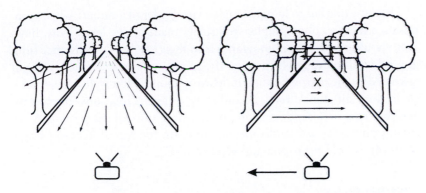

Figure 4.2B Motion perspective. Left: Near objects appear to move faster when looked at or photographed than far objects. Right: If a person fixates at the × position and moves from right to left, objects beyond × move in the same direction while those forward of × move in the opposite direction. Movement appears least near the fixation × point. The same condition exists when a photographer, moving from right to left, fixates his video camera or movie camera on the × position.

Camera as a Space Vehicle

A camera in space can be moved in three different directions: up or down, left or right, forward or backward, plus three rotational movements, as with a plane or space vehicle: pitch, yaw, and roll, as shown in Figure 4.3.

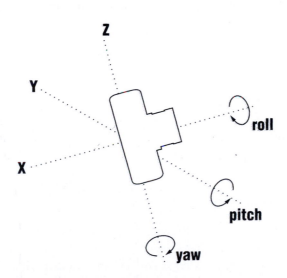

Figure 4.3 The camera as a space ship. Maneuver your camera up, down, and around, and take some unusual pictures. Play around, experiment!

A circle is isotropic, a square is anisotropic.

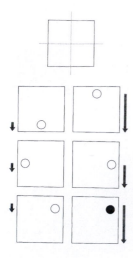

Because one has to look through a viewfinder of a camera when composing a picture, photographs are usually made at eye level. This, however, should not restrict photographers to their height—the distance from ground level to eye level. Imagine the camera as a space vehicle and not restricted by the person holding it. Move it about as if it were a space vehicle in three different directions and three different rotations (pitch, yaw, and roll) to arrive at the best composition and unusual perspective. Ansel Adams photographed landscapes standing on the top of his van using a platform to hold his tripod and view camera.

Anisotropicity

When something is identical in all directions it is called *isotropic*. Adapting this word to a visual field suggests that the visual weight of an object would be the same regardless of its position within the field. This, of course, is not the case, and the word anisotropic defines the fact that the same object will have a different visual weight depending on its position within the picture. Imagine the visual field bisected horizontally and vertically as shown in the margin. An object positioned in the upper half of a picture, or the right half, will have more weight than the same object at the bottom half or left half of the picture.

Objects within a picture frame, depending on their size, position, tonality, and color have different visual weights.

The color of the object also carries weight. Dark colors will appear heavier than light ones. In composing a picture to establish visual balance, one must take into account size, color, and position of the objects within the field, their relationship to each other, and the negative space that surrounds the objects. Creating balance and harmony within a picture is strictly a subjective visual task.

The importance of the anisotropic nature of our visual field can readily be seen in typographic design—the design of letters. Not only must each letter form be balanced top to bottom and left to right but it must also balance when the various 26 letters are combined to make the millions of words at our disposal. The letter S, for example, looks visually balanced top to bottom because the top half, which carries more weight, is made smaller than the bottom half. Turning the letter form upside down emphasizes the difference.

Convexity/Concavity

As shown in the margin on the next page, a curved surface can be seen as having two sides, an inner side and an outer side. If the outer side is seen as figure, the shape is seen as convex, and it is experienced as pushing out. When the inner side is seen as figure, the shape then appears to be concave and it is experienced as collecting, as being receptive.

The sail on a sailboat demonstrates this nicely; the concave side of the sail is receptive; as it collects the wind, the convex side pushes out and pulls the boat along with it. A similar situation exists with a hot air

balloon; as the inner concave part of the balloon collects hot air, the outer convex side pushes up. An open hand raised in prayer is receptive, while a closed fist is convex and aggressive. Generally speaking, concavity is seen as receptive, nurturing, and feminine, while convexity is seen as masculine and aggressive. Concave seating arrangements in theaters, classrooms, and houses of worship tend to give the gathering a sense of participation and togetherness.

Transparency

A material that is completely transparent, such as glass, is nearly invisible, and any object behind it can be seen clearly. A partially transparent (translucent) material allows an object to be seen in a veiled or muted way, which is often more interesting. Translucency in a picture is associated with a loss of contrast of an object, as represented in Figure 4.4.

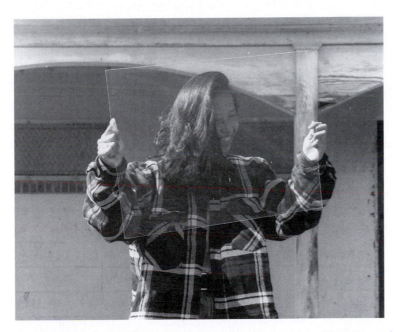

Figure 4.4 "Nok Kettavong," photo by Samantha Powell. A partially transparent material will reduce the contrast of what is behind it.

Software, such as Photoshop, provide many opportunities for image manipulation.

Translucency in a photograph can be simulated during printing by dodging and burning-in techniques and by using various filters that alter contrast. With electronic imaging, the manipulation to alter contrast is more direct and simpler.

Photographs of moving objects taken during a long exposure time of seconds to minutes result in the moving objects appearing somewhat transparent. The reason for this is that, as the objects move, they receive less

exposure, and the edges of the objects are not sharp. The result is a loss of contrast that gives the moving object an appearance of transparency. The technique was used in the early days of photography in what was called "ghost photography." The ghost-like images were used to deceive the gullible into thinking the photographs were the ghosts of their deceased loved ones.

TIME (MOVEMENT)

EADWEARD MUYBRIDGE (1830-1904) Photography

Photography, the ability to stop time and capture an image using light, had its beginnings in the 1820s with the heliographic work of Joseph Nicéphore Niépce, and in the 1830s with the photogenic drawings of Fox Talbot and the daguerreotypes of Louis Jacque Mandé Daguerre. Motion pictures, the ability to recreate time and movement using a series of projected photographs, had their beginnings in the late 1800s. "Beginning in 1872, the analysis of motion by the camera was carried on for some 20 years by Eadweard Muybridge and Thomas Eakins in the United States, by Etienne Jules Marey in France, and by Ottomar Anschütz in Germany."[2]

Each successive frame of a movie is projected on exactly the same space—the screen—while each frame of comics must occupy a different space. Space does for comics what time does for film.

Scott McCloud,
Understanding Comics, 1994

Photographers and cinematographers have this in common: Both use cameras and film, and both take still pictures. The primary difference is that with a movie camera the cinematographer can take still pictures in a continuous mode at a rate of 24 pictures a second, while the photographer, with a shoot-and-advance camera, takes pictures one at a time.

And when the still pictures are projected, the photographer's images are shown one at a time, while the cinematographer's images are shown in continuous time. The photographer wishing to create the impression of motion in a picture must do it with a single photograph or with two or more adjacent photographs.

Implied Motion

In simulating the feeling of movement in a still photograph, photographers use techniques such as a slow shutter speed or focus to slightly blur the image, or panning a moving object to cause the background to blur. Multiple exposures have also been used to suggest movement in a still photograph. The American painter Thomas Eakins, in his photographic studies for his paintings, photographed on a single plate successive stages of a man jumping, which he titled, "History of a Jump." The famous "Nude Descending a Staircase" by the French artist Marcel Duchamp (1912) transforms a "posed female nude—into a supremely energetic statement. . . ."[3]

The development of electronic stroboscopic flash by Dr. Harold Edgerton of MIT in the 1940s made the task of recording multiple images on a single sheet of film, to suggest motion, a routine matter.

Motion can also be implied in a single still photograph by capturing the action at the precise moment the gesture and position of the entire

articulated body lie between stillness and mobility. Figure 4.5 shows a photograph from Barbara Morgan's book, *Summer's Children*. Her ability to suggest motion in her still photographs of dancers in the early 1940s was referred to as "stillness and mobility" by Professor Rudolf Arnheim.

A basic problem in art is how to project action upon an immobile, flat surface.

Rudolf Arnheim

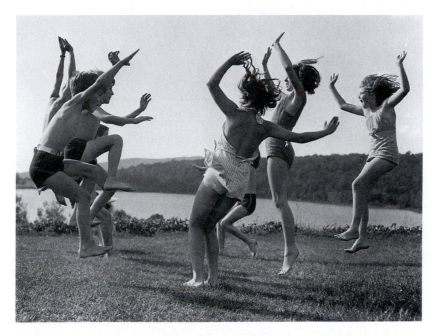

Figure 4.5 *"Children Dancing by the Lake," 1940. © Barbara Morgan (Williard and Barbara Morgan Archives, Dobbs Ferry, New York). Implied motion is suggested in this joyful photograph of spirited children.*

In photographing dance, I think of the bodies in their space as a series of convex and concave forms in rhythmic movement.

Barbara Morgan

Disappearance

In the early days of photography, slow film speeds required long exposure times, which resulted in moving vehicles and people being underexposed and a bit blurry. The longer the exposure time, the more the blur and the fainter the image of a moving object. And, if the exposure was sufficiently long, the moving object would be underexposed so badly that no detectable image would be formed. By controlling exposure time, therefore, one can make moving objects " disappear." Such control is most useful when, for example, one is trying to photograph a store front on a busy street. Using a small aperture and *neutral density filters* in front of the lens allows for long exposure times. A scene requiring an exposure of 1/125th of a second at f/8 would receive the same exposure at 1/30th of a second at f/22. Adding a 3.0 neutral density filter in front of the lens increases the required exposure time by 10 stops to 32 seconds at f/22. Each additional 0.30 of neutral density (ND) corresponds to one full stop (a 0.10 ND filter is 1/3rd of a stop) as shown in Table 4.2.

Always to see the general in the particular is the very foundation of genius.

Arthur Schopenhauer

Table 4.2 Using Neutral Density Filters to Increase Exposure Times		
0.30	1 stop	2×
0.60	2 stops	4×
0.90	3 stops	8×
1.00	3 1/3 stops	10×
2.00	6 2/3 stops	100×
3.00	10 stops	1000×
4.00	13 1/3 stops	10,000×

An alternative method for the disappearance of moving objects is to repeat a series of very short intermittent exposures, exposures too short to record moving objects. For example, if a scene requires an exposure of 1/50th of a second at f/22, a summation of 20 intermittent exposures of 1/1000 of a second at f/22 would be equivalent (20/1000 = 1/50). (This assumes no intermittency effect.)

COLOR

Just as space is three dimensional, so is color in the sense that it has three dimensions or attributes: *hue, saturation* (*chroma*), and *lightness* or brightness (value). Color is a visual experience dependent on light—if there is no light, then there is no color. The often-read and repeated statement that black is the absence of color is incorrect: Black is a color. More correctly, black is a color that has no hue. Blacks, grays, and whites are all colors having different lightnesses. They are *neutral colors*—achromatic colors—colors without hue. Black-and-white photography records only the lightness dimension of color—the tones or values.

The zone system is based on the ability to visualize and photographically control the brightness (lightness, value) dimension of color in tones of blacks, grays, and whites.

Color Notation

Measurements and standards are part of our daily routine to which we do not give much thought. Physical measurements such as distance, temperature, time, and so on, are relatively easy to make. They do not require a human observer. When it comes to color measurements, however, it is quite a different matter. Color, by definition, is a visual experience dependent on a human observer, as is the perception of sound, smell, taste, and touch. Remember this tricky little question?: "If a tree falls in a forest and there is no one around, does it make a sound?" Without a human observer, there is no sound, no noise to be heard. There are, of course, physical vibrations that can be recorded.

Color can be measured in a number of different ways; the most sophisticated being psychophysical measurements such as those used in the CIE and related systems. Such measurements include a human observer. An analogy may be useful here. The temperature on a winter day may be a cold 32°F (0°C). That is strictly a physical measurement using a thermometer. The wind chill, however, may be (feel like) a colder 20°F or so. That is a psychophysical measure.

Munsell System

A number of different methods are available to specify color. One of the earliest is the *Munsell system,* which is an international standard. In 1905 Albert Munsell, an artist/painter and art teacher, published his first edition of *A Color Notation.* He was concerned about the difficulty of specifying colors precisely. Disagreement on how to identify colors caused a multitude of communication problems. He set forth to establish a purely visual system of identifying colors, since color is strictly a visual experience. To do this, he prepared hundreds of color chips having different *hues,* which he described as the "name of the color"; different *values* or lightnesses from black to white; and different *chromas,* how strong or intense a particular hue is. The chips were first arranged in terms of their hues (reds, yellows, greens, blues, and the in-between hues). Then each grouping of hues was arranged in terms of its values. For example, green hues were arranged from the darkest green to the lightest. The next arrangement was the most difficult, grouping all the chips having the same hue and value according to their chroma or saturation. At one end green chips having the same value or lightness were arranged so that they went from a near-neutral green to a strong vibrant green—one that was highly saturated.

Munsell used the metaphor of a tree to illustrate the relationship between hue, value, and chroma as seen on page 141. He even included a painter (himself?) off to the right of the illustration with a dog looking at the canvas. At the top of the shortened tree trunk is the sun beaming its light on the tree. Without light there is no color, just *colorants.* The trunk of the tree represents values/lightnesses from 1 as black to 9 as white. On the extended branches around the tree hang signs indicating the various hues: yellow, red, yellow-red, and so on. Note that the signs are in various positions on the branches, some are close to the trunk and some at the extreme of the branches. The reason for this is to show that some hues can be more saturated, have a higher chroma, than others. Munsell indicates this by assigning numbers to the leaves on the branches. Some of the numbers go higher than others. The numbers on the leaves farthest from the trunk indicate the maximum chroma possible for a particular hue. Red, for example, can be highly saturated with a chroma of 10, while green can only reach a chroma of 7. To specify a particular color using the Munsell tree, one would first indicate the hue, then the value,

Munsell notations can be converted to CIE and vice versa.

then chroma. For example, a color having a green hue, a value of 4 and a chroma of 5 can be written as "Green 4/5" (hue value/chroma, HV/C). A darker green would be "Green 3/5," and a lighter one, "Green 5/5." The hue and chroma would be the same but the lightness would differ.

The Munsell tree presents a useful visual mnemonic for remembering that color occupies a three-dimensional space. The various hues are on branches that circle the trunk of the tree, values rise vertically from black to white on the tree trunk, and chroma increases as the branches extend away from the trunk. A useful exercise would be to color the tree illustration on page 141 with the colors indicated by the listed color names (hue) and the numbered values and chromas. This could be done using colored pencils or by scanning in the illustration and using a computer. Color Plate I, an abstract equivalent of the Munsell tree, may be of some help. It features 309 glossy color chips for 10 constant hues. Circling the center post, representing neutral values from black to white, are the various hues that increase in chroma as they extend away from the center post. The transparent plastic supports on which the color chips are attached represent a symmetrical color space. The distribution of the different color chips within that reference space is asymmetrical, favoring the saturation (chroma) of some colors more than others.

The trunk of the tree is now a center post. Notice that the various colors adjacent to the posts have very little hue and chroma, and look nearly neutral. At the bottom of the post the neutrals are very dark, and at the top, nearly white. At any level of value, the colors become more saturated as they move away from the neutral center post—chroma progressively increases. Some colors extend farther than others do, which indicates that not all colors can reach the same high chroma. Color Plate II shows hues in a circle, around a neutral axis rising from black to white with chroma increasing as it moves away from the neutral center post. For a middle gray value, the warmer colors reach a greater chroma than the blue-green colors.

The Munsell system is unique because it is based on *equal color differences.* Munsell selected and arranged each color chip so that the intervals between chips would be visually equal in adjacent hue, value, and chroma. It is a visual system for color specification and, again, it is an international standard. For additional information, visit the Web site www.munsell.com. Other systems are based on mixing colors of light or colorants such as inks. For example, Pantone color samples are based on the mixture of color inks.

Color Ordering Systems

In the field of art and design, color ordering systems are very useful in providing a generous and orderly arrangement of color samples from which to choose. Each sample has its own notation and is easily and readily identified and communicated. With the Munsell system, for example, a par-

Newton named seven colors, which corresponded to the seven tones on a diatonic musical scale.

Yellow always carries with it the nature of brightness, and has a serene gay, softly exciting character.

Goethe

ticular blue hue identified as 2.5PB and having a value of 5 and a chroma of 6 is identified as 2.5PB 5/6. If one wanted a red hue of the same value, they could choose a moderate red hue of 2.5R 5/8. The red chroma (8) is higher but the value (5) is the same. If, on the other hand, one wanted three different hues having the same chroma, they could select:

Moderate red	2.5R	5/8
Purple	5P	3.5/8
Yellow green	5Y	6.5/8

Other color ordering systems include the *Ostwald system,* which is based on *additive mixtures* of color; the Lovibond Tintometer color space, which is based on *subtractive mixtures* of colorants; and the Swedish Natural Color System (NCS) based on color appearance.

Ostwald System

The German chemist Wilhelm Ostwald developed his system of color specification at about the same time Munsell developed his. It is based on the amounts of white or black added to an illuminated spinning disk having a color of maximum chroma. The colors are arranged around the circumference of a circle so that *complementary colors* are opposite each other. In the Ostwald color system, the vertical axis series of 8 relative brightnesses (values) are at constant chromas rather than constant hues.

Red colors tend to increase tension. White, blues, and greens tend to release tension.

The Ostwald system provides the artist/painter with information on how much white or black paint to mix with a hue to get a particular color and is, therefore, sometimes preferred by artists. Adding white "tints" to a color makes it lighter, whereas adding black "shades" to a color makes it darker. "The Ostwald System has proved to be a practical value when it is necessary to mix a chromatic pigment with either black or white. In printing, the white paper and black ink can be thought of as adding to the chromatic colors. . . ."[4]

Pantone®

The *Pantone® Color Formula Guide* is not a color-ordering system but is a useful color-specification system for printing inks. It is a practical color-naming system, as are the color swatches found in paint stores to specify and name paint colors. The *Pantone Guide* is a book of color swatches containing more than 1,000 Pantone spot-color ink mixtures, each having a number for identification and communication (see Color Plate III). The ink mixtures are available on coated or uncoated paper, and on a mat surface. The number of a particular color swatch is used to communicate to a printer the mixture of inks necessary to produce the sample color. The result is usually a good approximation to the color on the reference Pantone numbered swatch. Keep in mind, however, that perceived colors are dependent on their surround, and the surround for the isolated

Pantone swatch will be somewhat different from that of the printed image/text. Pantone also has available *Pantone Matching System Colors for the Web.* This is authoring software for both Macintosh and Windows computers. More information is available at the Pantone Web site, www.pantone.com.

Other naming systems include *Trumatch Colorfinde,* consisting of 2,000 process-color swatches arranged in a way that is slightly more perceptually based than the Pantone system, and Agfa's *PostScript Process Color Guide I,* which contains 16,000 examples of process colors. This represents a full sampling of C,M,Y colors from 0 to 100 percent dot coverage. Additional samples incorporate four different levels of black ink (referred to by the letter K). "Given the variability in printing inks, papers, and processes, all of these systems can be considered only as approximation guides. They are known to be not very stable, and replacements of swatch books every six months or so is recommended. Regardless, using them is far better than working with no guides and uncalibrated/uncharacterized imaging systems."[5]

CIE System

In 1931 the *CIE system* of color specification became an international standard for colorimetry—the measurement of color. The letters CIE stand for Commission Internationale l'Eclairge (The International Commission on Illumination).

Color specification with the CIE system differs from that of the Munsell system in that a mixture of red, green, and blue light is used, in varying amounts to match a given sample. It is a matching system of color specification. A standard colorimetric observer is used to adjust the amounts of red, green, and blue light that will match a known sample of color. The observer views the colors through a small aperture. The colors viewed are not surface colors but rather aperture or film colors. They have no surface characteristics. The numerical data derived from a large number of matched samples are put through some mathematical manipulations and transformed into a graphic representation, as seen in Figure 4.6.

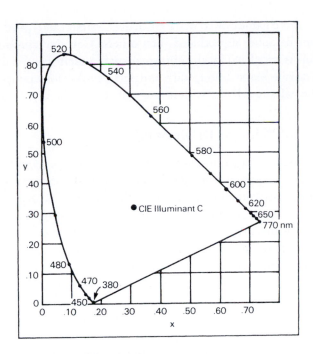

Figure 4.6 CIE chromaticity diagram. A two-dimensional representation of chrominance (hue and chroma) for a particular color at a certain level of luminance (value, brightness), and a specific CIE standard light source. All possible colors are contained within the horseshoe shape.

CIE Chromaticity Diagram

Chromaticity refers to two of the three attributes of color—hue and chroma. The first thing to notice in Figure 4.6 is the traditional x and y (horizontal and vertical) axes for plotting two variables. The periphery of the horseshoe shape represents the maximum saturation for any given color and is indicated numerically by the wavelength of the color. For example, 480 nanometers (nm) lies in the blue area, 520 nm is in the green area, and 590 nm in the red area. No colors exist outside the horseshoe corral. The x and y axes are used to plot the chrominance of any color. The plot will fall somewhere within the horseshoe. The closer the colors fall to the periphery of the horseshoe shape, the higher the chroma and therefore saturation.

 By plotting a large number of different colors that an imaging system (such as photography, a video monitor, or inkjet printer) can reproduce, a range of colors (gamut) can be mapped within the horseshoe corral. In this way it is possible to compare the gamut of colors that can be reproduced by various imaging systems. This is an important tool in research and development of imaging systems. For example, different colorants C,Y,M,K (dyes, inks, toners) or R,G,B phosphors can be tested to see if

Gamut—The complete range of something (such as colors).

they extend the gamut of colors a particular system can reproduce. Will some color be better reproduced than others? Can the reproduction of some colors be sacrificed for the improvement of others? For the user, comparisons can be made among different sets of inks, for example, to see which one will provide the widest range of colors (the largest gamut).

Luminance (Value or Brightness)

Green is the color of growth, hope, happiness, spring life over death.

Kathleen M. O'Neil

The CIE diagram shown in Figure 4.6 is for just one level of luminance (value or brightness). For every other level of luminance, another two-dimensional map would be needed. In looking at the CIE diagram, imagine a vertical axis (perpendicular to the diagram) analogous to the tree trunk in the Munsell tree. One can imagine a pile of such horseshoe-shaped diagrams representing the chromaticities at various luminances from black to white. This would generate a three-dimensional space. What would such a color space look like? It certainly would not be symmetrical. The shape would change as the pile moves from the lowest luminance to the highest.

How the shape might change can be seen in the asymmetry of the three-dimensional color space for Munsell colorants as illustrated by the Munsell color solid shown in Color Plate IV. For a given level of luminance (value), there is a limit to the saturation (chroma) a particular hue can display. At high levels of luminance, yellows have the highest chroma and blues the lowest. At the lower levels of luminances, blues do much better. This can be shown in Table 4.3 in terms of Munsell notation:

Table 4.3 Munsell Notation for Two Colors

Color	Hue	Value/Chroma
Yellow	5Y	8/11
Blue	7.5PB	2.9/12.8

Naming Colors within the CIE Map

Figure 4.7 illustrates how groupings of colors would be located on the CIE chromaticity map. Notice that the largest segment of color is in the green location; green being the color to which the eye is most sensitive. The light source used was a CIE illuminant C, daylight. Had a different light source been used the arrangement of colors would be somewhat different. The various CIE standard light sources and their *correlated color temperatures* (CCTs) are listed in Table 4.4.

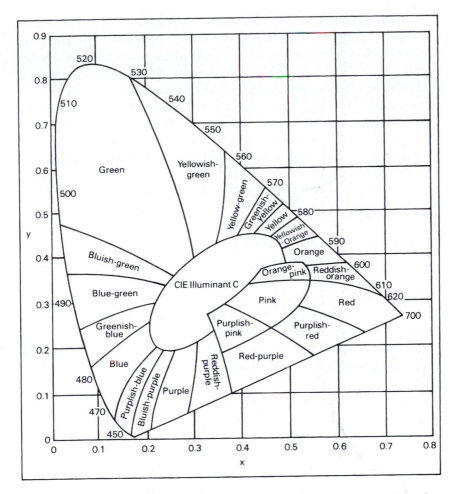

Figure 4.7 *The CIE chromaticity diagram with approximate locations of various colors when viewed under CIE standard illuminant C. "The color names . . . have been suggested by Kenneth L. Kelly of the National Bureau of Standards."[6] The area labeled CIE Illuminant C represents a somewhat neutral area. Moving away from this neutral area, the colors become progressively more saturated.*

Table 4.4 Standard CIE Illuminants

CIE illuminant A	2,856 K (Kelvin)
CIE illuminant C	6,774 K daylight (CCT)
CIE illuminant D65	6,504 K daylight (CCT)
CIE illuminant D50	5,003 K daylight (CCT)
CIE illuminant F2	4,230 K cool-white fluorescent (CCT)
CIE illuminant F8	5,000 K fluorescent (CCT)
CIE illuminant F11	4,000 K triband fluorescent (CCT)

CIE illuminant A, having a color temperature of 2,856 K, approximates the color temperature of a 100-watt tungsten lamp. (All other CIE illuminant standards are listed as correlated color temperature, because they are not blackbody radiation sources on which color temperature is designated.) Photographic daylight (sunlight plus skylight) is 5,500 K. D50 with a CCT of 5,003 K represents average daylight and is often used in the graphic arts. D65 having a CCT of 6,504 K also represents average daylight and is used in colorimetric measurements. The F series of fluorescent standards is broken down into 12 types, 3 of which are shown in Table 4.4.

Color Gamuts

The gamut of green colors is the largest discernible by humans.

It is important to realize that the gamut for any and every medium used for producing and reproducing colors will fall somewhere within the horseshoe space, as shown in Figure 4.8. Notice that the gamut of colors that can be reproduced at a particular level of luminance is less than the colors the human eye can see, which is represented by the boundaries of the horseshoe shape. The shaded area represents colors that can be seen but are not reproducible. Every color reproduction medium has this limitation.

Figure 4.8 The gamut of reproducible colors possible for a photographic transparency film at one level of luminance. The gamut will be different at different levels of luminance and for different films.

In terms of saturation, the blue and green areas, which depend on the cyan dye (blue-green), are not reproduced as well as the red-yellow areas. The culprit is the cyan dye, which should (ideally) only absorb red light. It has an enormous appetite, however, and absorbs some of the green and blue light as well. The magenta and yellow dyes are more efficient in their absorption, absorbing little red and blue light and red and green light, respectively.

An ideal cyan dye or ink would absorb only red light.

The CIE system is very useful, as an international standard, for assessing and comparing how well a particular color reproduction system can reproduce colors: photography (prints and transparencies, using different C,M,Y dyes), video monitors (using different R,G,B phosphors), and printing systems using different C,M,Y,K inks, dyes, toners, and papers. Figures 4.9A and B illustrate the color gamut for a particular set of R,G,B phosphors and a particular set of C,M,Y,K inks.

(A) *(B)*

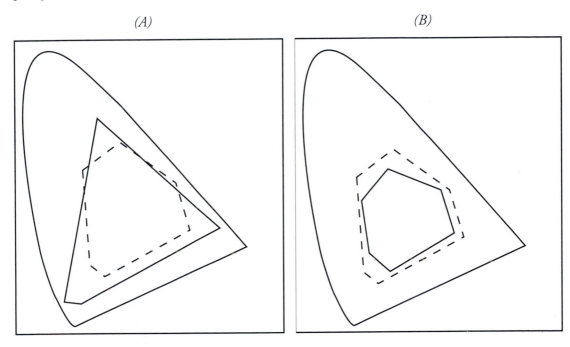

Figure 4.9 *(A) Gamuts of reproducible colors for a particular monitor (solid lines) and inkjet printer (dashed lines). The gamut of colors is for one level of luminance and will be different at other levels as well as for different monitors and printers. (B) Gamuts of reproducible colors for a particular inkjet printer (dashed lines) and a press printer (solid lines) at one level of luminance.*

After reviewing the color gamuts in Figures 4.8 and 4.9A and B, we can see that the ranges of colors that can be reproduced by films, monitors, and printers vary and are limited. As represented, transparency film

Although inkjet printers use C,M,Y,K inks, the colors produced depend on the particular set of inks used—as does the cost and the archival properties.

can reproduce the most colors and a press printer, the least. The differences should not be surprising when one considers that color reproduction systems are either additive or subtractive, that the colorants used vary, and that the color modalities (object, volume, aperture, illumination, illuminant) differ. The colors on a monitor are *illuminant colors,* red, green, and blue emitting phosphors. The prints from an inkjet printer or press printer are *object* or *surface colors* reflected and not absorbed by the cyan, magenta, yellow, and black colorants.

The limited range of colors that a press printer can reproduce compared to a monitor or film is quite acceptable in practice, as long as side-by-side comparisons are not made. Reproduced images in magazines, for example, are well received. Even color reproductions in newspapers, which use a lesser quality of paper, are acceptable when seen without comparison.

Language Problem

The color gamuts on CIE diagrams are device dependent. A gamut for one inkjet printer, for example, will not be exactly the same as that for another. The gamut is also dependent on the ink and the paper. Gamuts for monitors also vary depending on the phosphors used. Gamuts describe the range of colors that a monitor or printer is capable of producing under a certain set of conditions. Change the conditions and the gamut changes. In short, the gamuts shown on CIE diagrams are unique and represent only the particular device being used to reproduce colors—monitors, digital printers, press printers, scanners, and digital cameras used to capture the original image. If a film camera is used, the color gamut will be unique to that film—color negative or color transparency.

With so many different devices (components) used to reproduce color it would be nice if they all spoke the same "language." This is not the case. Monitors speak R,G,B and printers C,M,Y,K. Each has its own "dialect" and gamut. To get all the components to understand each other and work together is essential. What is needed is something that can do the translating among the various devices. This is where CIE L*a*b* enters the scene. It is a device-independent color space that serves as a language intermediary between different devices. CIE L*a*b* is a three-dimensional channel space where L* represents luminance (value), a* is the redness or greenness (hue/chroma), and b* is the yellowness or blueness (hue/chroma).

L*a*b* is based on a mathematical model instead of any set of colorants or devices, such as a monitor, printer, or scanner. As a mathematical abstraction it can, and does, contain all the colors the eye can see. It has no gamut as such, so no colors exist outside its three-dimensional space.

Color Appearance

How color is measured and specified is very important. In order for measurements to be repeatable, restrictions on the viewing conditions and the

presentation are essential. For the measurements to be valid, they must predict how well they will do in the situation in which they will be used. The 1931 CIE system does not predict color appearance. It has been very useful for specifying colors but only under a standard method of measurement, which compares two color samples of light, isolated in a narrow viewing field (2 to 10 degrees) using an aperture mode for presenting the colors to be matched. It does not specify how the colors will look in a larger more complex viewing field. *Color appearance* models build on the solid foundation of the CIE system to provide color appearance data under practical viewing conditions.

In 1976 CIE established two uniform color spaces, CIELAB and CIELUV, that can be looked upon as color appearance models. These two systems take into account the phenomenon of chromatic adaptation (*color constancy*). A detailed description and explanation of these two systems and other color appearance system is beyond the scope of this book. For those who would like to pursue the topic further, Dr. Mark Fairchild's book, *Color Appearance Models*, is an excellent reference.

The Visual Field

One should not overlook the broader aspects of how the visual field can influence color. For example, assume a person is looking at a color image on a computer monitor. If the field of view is restricted to just what is on the screen and nothing more, the image will have a certain look. If the visual field is now extended to include the frame of the monitor, the perceived image will look a bit different, depending on the width and color of the frame. If the view is extended further to include the area around the computer, the perceived image will again be somewhat different, depending on the surround. For highly critical color matching, as in the editing work in postproduction houses, the area surrounding the computer monitor is kept clear of objects and the wall surrounding the monitor is an 18 percent neutral gray. Another factor to be considered is the level of the ambient light in the room and its color temperature. Is the lighting tungsten, fluorescent, daylight, or combinations? These same variables exist for viewing images in a gallery or at home. Color is a slippery chameleon and changes as the viewing conditions change.

The eye is the only valid instrument for measuring color.

Flare Desaturates Colors

The light reaching the eyes from an image on a computer screen consists of the light being emitted by the phosphors on the screen mixed with any ambient light reflected from the glass surface over the screen. This ambient light, called *flare,* tends to desaturate the colors of the screen image. The stronger the amount of light falling on the screen and entering the eyes, the greater the flare and therefore the greater the desaturation of the image.

Reduce flare by cleaning the glass on your monitor.

For critical color work, a black hood can be rigged around the computer monitor and used to shield the screen from flare light just as a lens hood on a camera shields unwanted stray light. Digital cameras with LCD screen displays, when used outdoors, suffer most from stray light. Screen hoods for digital cameras, video cameras, computer monitors, laptops, and the like are available from a variety of sources including www.hood-manusa.com.

Flare is also a problem when looking at prints in a gallery or elsewhere. Next time you visit a gallery try this: Cup your hands over your eyes to block some of the overhead light illuminating the print from entering your eyes. Your cupped hands will act as a shield, a hood, and protect the eyes from flare light from above and from the sides. (Some stray light, however, will still enter the eyes from reflections off of the print, especially if it is glass covered.) You will be somewhat surprised and delighted with the improvement in the colors you will experience. You may also be surprised by others in the gallery looking at you in a puzzled manner.

Color Test Chart

Please remember that no two monitors have exactly the same palette or contrast. . . .

Arnold Gassan

Basic color names: white, gray, black, red, green, blue, yellow, orange, pink, and brown.

To test how well a particular imaging system can faithfully reproduce colors, or to compare one system against another, some type of reliable color test chart is needed.

Ideally the chart should have a representative range of colors and a scale of neutrals from black to white. One such color test chart that has these features is the *GretagMacbeth ColorChecker*. It consists of 24 color samples in a 6 × 4 array as seen in Color Plate V. The color samples are close visual matches to real objects such as foliage, skin tones, and blue sky and have the added feature that the colors are specified in Munsell notations as well as CIE notation and National Bureau of Standards (NBS) color names (see Table 4.5). Notice how dark colors such as purple have a low Munsell value 3 and a low CIE luminance value Y of only 7 percent. Yellows, on the other hand, have a high luminance and Munsell value. A yellow with a Munsell value of 8, for example, has a luminance of 59 percent. Note also that all the neutral colors have the same x,y numbers but different luminances, from 3 percent for black to 90 percent for white.

Table 4.5 GretagMacbeth ColorChecker*

Color No.	Name	Munsell Notation		CIE (1931)		
			Value/			
		Hue	*Chroma*	*x*	*y*	*Y (%)*
1	Dark skin	3.1YR	3.7/3.2	0.40	0.35	10
2	Light skin	2.2YR	6.5/4.1	0.38	0.34	36
3	Blue sky	4.3PB	4.9/5.6	0.25	0.25	19
4	Foliage	6.7GY	4.2/4.1	0.34	0.42	13
5	Blue flower	9.7PB	5.5/6.7	0.27	0.24	24
6	Bluish green	2.5BG	7/6	0.26	0.34	43
7	Orange	5YR	6/11	0.51	0.41	30
8	Purplish blue	7.5PB	4/10.7	0.21	0.18	12
9	Moderate red	2.5R	5/10	0.45	0.31	20
10	Purple	5P	3/7	0.28	0.20	7
11	Yellow green	5GY	7.1/9.1	0.38	0.49	44
12	Orange yellow	10YR	7/10.5	0.47	0.44	43
13	Blue	7.5PB	2.9/12.8	0.19	0.13	6
14	Green	1.0G	5.4/9.7	0.30	0.48	23
15	Red	5R	4/12	0.54	0.31	12
16	Yellow	5Y	8/11	0.45	0.47	59
17	Magenta	2.5RP	5/12	0.36	0.23	20
18	Cyan	5B	5/8	0.20	0.25	20
19	White	N	9.5/	0.31	0.32	90
20	Neutral 8	N	8/	0.31	0.32	59
21	Neutral 6.5	N	6.5/	0.31	0.32	36
22	Neutral 5	N	5/	0.31	0.32	20
23	Neutral 3.5	N	3.5/	0.31	0.32	9
24	Black	N	2/	0.31	0.32	3

*Includes color sample names, Munsell notations, hue, value/chroma, and CIE values *x*, *y*, and Y (luminance). Inter-Society Color Council–National Bureau of Standards (ISCC-NBS) names for the 24 color samples are not included here but are included with the ColorChecker, some of which can be seen in Table 4.7. (The CIE numbers are rounded off for convenience and clarity, and can actually be plotted on a CIE diagram.)

The results of a test can be subjectively judged by simply comparing the test print to the ColorChecker colors and observing which colors reproduced best, including how well the neutral colors reproduce. Care should be taken that the surface of the test print is similar to that of the ColorChecker. One would not test a glossy color print against a matte print, unless of course, they were interested in how the surface of a paper affect

*Color, as the most
relative medium in
art, has innumerable
faces or appearances.*

Joseph Albers

colors. Because the color samples in the ColorChecker are quantifiable, in terms of CIE and Munsell notations, quantitative measures of the test print can be made and compared if one has the necessary instrumentation.

Tests using the ColorChecker can be helpful in simple comparisons such as deciding whether to purchase a new color printer, a different set of inks, higher quality paper, and the like. First determine how well your present system will reproduce the colors in the ColorChecker, and use your findings as a reference. Then change one component of your imaging system, for example, the inks, and judge the results. The comparison may reveal that the new set of inks are better for some colors and not others. Decide which colors are most important for your work. A portrait photographer would certainly require the best dark and light skin colors possible, a landscape photographer would be more interested in how well blue sky and green foliage, for example, reproduce with the new inks.

After the testing is done with the ColorChecker, it would be advisable to actually capture images outdoors or indoors to judge how well the test results stand up in practice. Such a test, of course, is purely subjective and memory dependent because one cannot compare the captured images with the original scene. Nevertheless, it is a worthwhile procedure, because not only are there a greater range of color surfaces and textures but also shadows. Further, the ColorChecker colors are all object or surface colors. In nature, other color modalities are represented, *volume color* (water), *aperture color* (sky), and sometimes *illumination* and *illuminant colors.*

If a ColorChecker or equivalent is not available, you could instead collage a grouping of color samples and tailor make your own test chart using things such as paint chips from a local paint store, samples of cloth, pieces of tree bark, and the like.

*An 8-bit color system
has a palette of 256
colors (2 to the 8th
power).*

The GretagMacbeth ColorChecker contains only 24 color samples of a much larger color space. This is somewhat of a limitation but necessarily a practical one because of size constraints. For digital color testing, GretagMacbeth now has available ColorChecker DC, which consists of 180 color samples including some high-gloss colors (see Color Plate VI). The new ColorChecker is based on color standards developed by the International Color Consortium (ICC) and CIE. It can be used for testing color on a digital scanner, camera, or printer.

Color Reproduction

*Color depends on
light. No light, no
color.*

Light fills our atmosphere, but we are unaware of it because it is invisible until it is reflected from some surface. The light illuminating a surface is usually white—white light. Outdoors it is sunlight and skylight; indoors it is tungsten, fluorescent, or halogen. All of the colors we see around us are a result of the selective filtering of the variety of colors that already exist in the white light. Every color that we see already exists in the white light. When white light reflects from a surface such as grass, for

example, the grass acts as a green filter, absorbing all the colors in the white light except the green, which it reflects. This is why grass is green. Bananas are yellow because they act as a yellow filter; tomatoes, as a red filter; and so on.

That white light contains all the colors was demonstrated by Sir Isaac Newton in 1666, and even earlier by Leonardo da Vinci. Newton, as you recall, directed sunlight into an optical prism, which separated the white light into its various components; red, orange, yellow, green, blue, and violet. A rainbow is produced in the same manner. Sunlight, incident on small water droplets suspended in air, becomes separated and displays a spectrum of colors from red to purple.

If white light can be separated into its various colors, then the reverse should be true, and is. However, it is not necessary to mix all of the colors in white light to create white light. What is needed are only three colors of light: red, green, and blue. If this were not the case, color reproduction in any one of the mediums that reproduce color—photography, printing, film, video, etc.—would be much more complicated.

Painters, however, can use as many color pigments (colorants) as they please. A painter selects his or her own palette of pigments to apply to a canvas. Some colors are applied directly; some are mixed before being applied. The painter is not limited by the number of colorants that can be used. The photographer with only three colorants for his palette can reproduce most colors using combinations of cyan, magenta, and yellow transparent dyes. To reproduce color on a video screen, only three colorants are needed but this time they are red, green, and blue phosphors. The two systems are different. One requires transparent dyes; the other requires tiny lights called phosphors.

Subtractive Systems

Color reproduction systems that use cyan, magenta, and yellow colorants are called *subtractive systems*. They include photography, graphic arts printing, sublimation printing, inkjet printing, and electrostatic printing. The colorants can be dyes, inks, toners, or pigments. All of the colors we see in prints and transparencies, in magazines, newspapers, and posters are produced using a subtractive system of color reproduction. Often a fourth colorant, black, is added to darken the blacks in an image and give it added contrast.

Additive Systems

The colors seen on a computer monitor or a television set are a result of a mixture of only three colors of light: red, green, and blue phosphors (see Color Plate VII). These mixtures, in various amounts, produce all of the colors seen on the screen. Each phosphor lights up when it is excited and goes off when it is not. When all three phosphors are excited, the

color white is seen. When none of them are excited, black is seen (see Table 4.6). The size of the phosphors is too small to be seen by the naked eye; they can be seen by holding an 8× eye loop to the screen or a camera lens. You will notice that the phosphors are arranged in a repetitive pattern, and the different phosphors go on and off as the image on the screen changes.

Color dots too small to be resolved by the eye fuse to give an additive mixture of colors.

Table 4.6 Additive and Subtractive Mixtures of Colorants Used to Reproduce Colors Seen on a TV Screen or in Photographs

Additive Mixtures of Red, Green, and Blue Light/Phosphors	Subtractive Mixtures of Cyan, Magenta, and Yellow Colorants (dyes, inks, toners)
Green + Blue = Cyan	Magenta + Yellow = Red
Red + Blue = Magenta	Cyan + Yellow = Green
Red + Green = Yellow	Cyan + Magenta = Blue
Red + Green + Blue = Neutrals	Cyan + Magenta + Yellow = Neutrals
Red + Green + Blue = White	**No** Cyan, Magenta, or Yellow = White
No Red, Green, and Blue Light = Black	Cyan + Magenta + Yellow = Black

Both additive and subtractive color systems are based on controlling red, green, and blue light.

Gordon Brown

An early additive photographic system for reproducing colors was *Dufaycolor*. It consisted of a mosaic of red, green, and blue filters of about the same size as the phosphors in a video screen. The mosaic was placed over, and in contact with, a panchromatic emulsion that recorded the red, green, and blue colors passing through the little filters.

Color Management

Color management must enable one to specify, control, and predict color from start to finish.

Peter Sucy

Color reproduction is an extremely complicated affair. Capturing a digital image, and having the image on the computer monitor and the image on the final hardcopy output both look like the original image, is complicated by a number of factors. Original scene lighting, camera characteristics, monitor-color gamut, calibration, printer-color gamut, printer calibration, viewing conditions, reflective versus transmissive viewing differences, and RGB to CMYK color space conversion are just some of the variables to be taken into account.

Color management attempts to limit the number of variables and provide some predictability to the color reproduction process. A known, defined color space is used to provide a reference to other color spaces. By profiling (taking measurements of the specific color target and translating them into known color space) the color characteristics of the input device, monitor, and the output device, the conversion of an image from one color space to another can be better predicted.[7]

Color Is a Chameleon

Color is not only dependent on light and, of course, an observer, but also on its context or surround. Change the surround of a color and the color, which is strictly a visual experience, changes. A red apple against a green background will look more saturated (reddish) than against a maroon background or a neutral background.

Every time the background of a color changes the color itself changes; it is an interdependent and interactive figure–ground relationship. Artist and former Yale professor Josef Albers in his classic book, *Interaction of Color,* wrote that ". . . with color—'we do not see what we see.' Because color, as the most relative medium in art, has innumerable faces or appearances."8

Constancy

Size

Constancy implies consistency in the perception of the various qualities of objects, such as size, shape, lightness, and color. The viewing conditions may change, but how we actually see an object remains quite consistent. For example, the perceived size of an object such as a tree or car remains the same even as we move farther away from it or closer to it. This is a common everyday experience. We know that the optical image on the retina gets smaller as we move away from an object or larger as we move closer but this does not change our perception. Evidentially, the change in image size is automatically interpreted as a change in viewing distance rather than a change in the size of the object. Even when we look at a series of different size prints or small thumbnail images on a video screen monitor, the size of the objects or person is seen as normal. We can zoom in on a thumbnail image and make it larger, but the objects or person will still be seen as normal in size—an amazing perceptual feat in which memory plays a critical role

Shape

The shape of an object will also remain constant even though the viewing angle may change. The circular-shaped watch on my left wrist retains its circular shape regardless of how I may rotate my wrist and change the viewing angle. The optical image on my retina will approach the shape of an ellipse but what is seen is not an elliptical shaped watch but rather the same circular-shaped watch. Constancy is an amazing visual phenomenon to think about. No matter how we look at an object and under what conditions of lighting, what we see remains constant and true to the object. Even when the shape of an object is somewhat distorted, producing an anamorphic image, our visual system can compensate for the distortion.

A color cannot exist without an environment.

Edwin Land

The range of adaptation of the human eye to color is surprisingly great.

Ralph Evans

Lightness

The lightness of an object remains pretty much the same even though the illumination level may change. The "white" of the page you are now reading will look white indoors or outdoors, under a dim tungsten light or under bright sunlight.

Color

Color is what you see, not what you should see.

Ralph Evans

The perceived color (hue, chroma) of an object will also remain the same even as the color quality of the light (color temperature) illuminating it changes. A bouquet of red roses will appear red under studio lights, as it will under sunlight or even on an overcast day. Color constancy is strictly a visual phenomenon, as are the other constancies of size, shape, and lightness. The situation is vastly different, however, when filming. Photographic experience reminds us that red roses, for example, photographed under different lighting conditions require either daylight or tungsten film or appropriate filters to record the red roses correctly. Under the mixed lighting of daylight, tungsten, and fluorescent, for example, proper filtration would be a real problem and, at best, a compromise. Perceptually, however, seeing the red roses as red poses little problem under such mixed lighting conditions.

Semir Zeki, in his book *Inner Vision,* seems to be alluding to the phenomenon of constancy when he writes ". . . the function of the brain is to represent objects as they really are, that is to say differently from the way we see them from moment to moment if we were to take into account solely the effect that they produce on the brain."[9] Artists who create caricature faces of prominent people seem to be able to capture something that is consistent, that is essential in the features of a particular face. Zeki suggests that what distinguishes a person, as an artist, is the ability to capture the essence of things, the essentials, to separate them from the larger array of visual information present. He offers a neurobiological definition of art: "that it is a search for constancies, during which the artist discards much and selects the essentials, and that art is therefore an extension of the function of the visual brain. . . ."[10] To make his point, he discusses in some detail the paintings of Jan Vermeer and Michelangelo.

Zeki suggests that there are constancies other than size, shape, and color, and that constancies have or should have wider applications. He speculates that constancy might apply to our recognition of faces, the relationship between objects, and even to more abstract concepts such as justice and patriotism.

Metamerism

Two color prints made with different sets of CMYK inks may look the same under one type of light source, such as tungsten or daylight, but

look different under fluorescent or halogen. This is called *metamerism* and is due to the fact that the spectral reflectance of the set of inks (how they reflect light at each wavelength) is somewhat different.

Metamerism can be a problem when working in black and white. "Most attempts to produce a high quality black-and-white inkjet print using CMYK inks are doomed to failure. Usually, the first effort is to mix CYMK primaries to approximate a neutral gray. But mixing primaries to make a 'neutral' gray evokes metamerism."[11]

There is also the problem of differential fading of the cyan, magenta, and yellow dyes to consider. Using only the black (K) ink usually results in a grainy-looking print devoid of some of the subtle tones in the original silver negative. Alternative inks and papers are available and a number of sources are listed in the Gassan article just quoted. Archival quality of the inks and papers, of course, is always a consideration.

An alternative black-and-white printing technology has been developed by Jon Cone and his associates. Piezography BWICC provides four neutral pigment inks; light gray, medium gray, dark gray and black. Replacing the color inks in printers such as the Epson and Canon can produce quality black-and-white prints said to have no metamerism.[12] For more information on Piezography see www.piezography.com. For current archival information on a number of different products see www.wilhelm-research.com/Services/services.html.

Metamerism is not limited to just the dyes and inks used to make an image. It can also occur if two observers have different color vision (observer metamerism) and when, for some color surfaces, the angle of illumination is changed (geometric metamerism). Such surfaces are highly directional in the way they reflect light. Plastics and metals are two examples.

Defective Color Vision

The retina of the eye consists of millions of light-sensitive rods and cones. The cones, which are located in the small fovea area of the retina, provide our perception of color (see Chapter 9, "Subliminals"). Normal color vision depends on the proper functioning of three types of cone pigments that selectively respond to red, green, and blue light. Color vision is said to be defective when these pigments do not function properly.

A number of different tests are available to evaluate defective color vision. Two of practical importance are the *Farnsworth-Munsell 100-Hue Test* and *pseudoisochromatic test plates.* The Farnsworth-Munsell 100-Hue Test consists of four sets of color samples that are to be arranged such that a gradual, orderly transition occurs from one hue to another. Pseudoisochromatic test plates contain an assortment of colored dots of random lightness. Within the arrangement of the dots, a person can identify a pattern or a number with normal color vision. Various plate arrangements are designed to detect persons with different kinds of color vision

deficiencies. Some people are unable to discriminate reddish and green-ish hues; others, yellowish and bluish hues. In addition, some people can see all the hues but have a reduced ability to discriminate particular hues.

Color vision deficiencies that are inherited affect males more than they do females; 8 percent of men, but only 0.4 percent of women have these deficiencies. The X chromosome carries the genes for photopigments. Women inherit two X chromosomes, one from the father and one from the mother. Men inherit one X chromosome from the mother and a Y from the father. If the X chromosome does not include the photopigment gene, the son will have a color vision deficiency.

Color vision deficiencies are no problem when making color images for oneself. But if the images are intended to be seen by others, there is a real problem. If a computer monitor is being used by more than one person, and one of the users has a color deficiency, such as a reduced sensitivity to a particular hue, this may cause a problem. It is particularly important that subjects selected for critical color judgment tests be tested for any color deficiencies. It is also important for judges of color photographic contests to have normal color vision. A color blindness test is available on the Internet at www.geocities.com/Heartland/8833.coloreye.html.

Simultaneous Contrast and Assimilation

A dark surround makes white areas (highlights) in a picture appear lighter.

Physical and psychophysical measurements made to specify color do not account for the effect that different backgrounds can have on the appearance of color. The importance of this can be seen in Figure 4.10A in which the lightness dimension of a gray color changes as a function of the changing background. To make a gray color appear darker, choose a lighter background and vice versa. The greater the difference between a color and its background—between figure and ground—the more the change. The lightness of a color can also be changed by simply adding lines across the gray color as shown in Figure 4.10B.

A light surround makes dark areas (shadows) in a picture appear darker.

Notice in Figure 4.10B, however, that adding dark lines across the gray color darkens the color and that light lines lighten the color. The level of lightness change can be controlled by increasing or decreasing the number and width of the lines. The closer the lines are together, the greater the change. This visual effect of *assimilation* is the opposite of *simultaneous contrast*.

The same effect in color can be seen in Color Plate VIII. In the illustration on the left the white surround darkens the blue bar, while the blue bar with the dark surround is lightened (simultaneous contrast). The opposite happens when black lines and white lines are superimposed on the blue areas in the illustration on the right. The blue is lightened by the assimilation of the white lines and darkened by the dark lines. The same blue ink was used throughout. The blue colorant did not change; the blue color did.

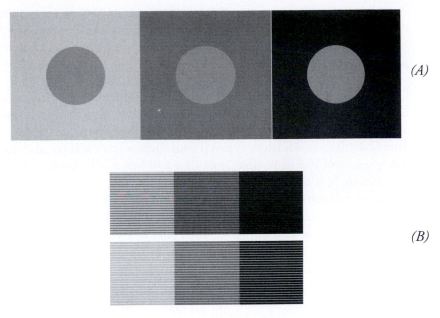

(A)

(B)

Figure 4.10 (A) Simultaneous contrast. A light surround darkens the small circular area. (B) Assimilation. A light surround lightens an area. (Assimilation is the opposite of simultaneous contrast.)

A practical example of how strongly assimilation can affect a color can be seen in Color Plate IX (from Ralph Evans, *An Introduction to Color*, New York: John Wiley & Sons, 1948, p. 192). A design pattern of black lines and white lines is imposed on a blue background. The black lines make the blue areas look darker, while the white lines make the blue areas look lighter. The color of the blue areas without the lines would be intermediate. Color is dependent on its surround. More white line patterns would make the blue look even lighter.

What happens if colored lines or design patterns are added to a neutral gray area? If the gray area, for example, is interlaced with blue lines, it appears bluish and darker; if it is interlaced with yellow lines, the gray area will appear yellowish and lighter. The neutral gray area takes on the tint of the blue and yellow colors.

Color Dependency

The colors in an image depend very much on one another. No color exists independent of its neighbor. "Depending on its neighbors, a color undergoes startling changes in appearance. In a painting by Matisse the deep purple of a robe may owe much of its saturated redness to a green wall or skirt bordering on it, whereas in another area of the painting the same robe loses much of its redness to a pink pillow or even looks quite bluish

Colors of contrasting pair of hues are complementary. They call for each other.

Rudolf Arnheim

in response to a bright yellow corner. Depending on what local associa-
tion one is looking at, one sees a different color."[13]

Phosphors and Pointillism

One could think of the soft-edged red, green, and blue phosphors on a
video screen as dependent, in part, on assimilation. When yellow areas
on a screen are seen, for example, it is because the red and green phos-
phors have been assimilated. When a white area is seen, it is because the
red, green, and blue have been assimilated. When a red, green, or blue
area is seen, it is because only those phosphors have been excited. The
thousands of colors seen on a computer monitor are a result of the assim-
ilation of various amounts of red, green, and blue phosphors.

*Paint not the thing
but rather the effect it
produces.*

Mallarmé

The art movement begun in the late 1800s by Georges Seurat, known
as *Pointillism,* consists of an array of color dots on canvas, which func-
tion in a similar manner. For example, red and blue dots from a distance
produce purple. Up close, one sees only a display of dots of different col-
ors. At normal viewing distance, the various dots blend, and a picture with
a variety of assimilated colors is seen.

Seurat was very interested in the science of color and color vision,
which became the basis for Pointillism. One of the scientific papers that
had a great influence on him was *The Law of Simultaneous Contrast* by
Eugene Chevreul, written in 1839—the same year that another French-
man, Louis Jacques Mandé Daguerre, announced his daguerreotype process:

> *Local color, Chevreul had shown, was mixed on the eye. A spot of pure
> color gave the retineal impression of a halo of its complementary around
> it: orange rimmed with blue, for instance, red with green, purple with
> yellow. The "interference" of these aureoles meant that each colour
> changes its neighbor. Colour perception is therefore a matter of interac-
> tion, a web of connected events, rather than the simple presentation of
> one hue after another to the eye. Seurat resolved to make this explicit by
> making his colour patches tiny, reducing them to dots: hence the name,
> "Pointillism." Stippled side by side, the dots grew by the millions like
> coral polyps. . . .[14]*

Seurat's process of producing color differed from that of contempo-
rary *Impressionist* painters such as Monet, Manet, Renoir, and Degas. They
chose their palette of colors, intuitively mixing the colors and applying
them to the canvas. Seurat did not mix his colors. His choice of pure col-
ors and their application to the canvas was based on scientific color prin-
ciples and what was then known about human color vision. He discovered
that his method of dot painting, using carefully selected pure colors, pro-
duced a radiance not possible by mixing colors. Seurat designed his can-
vas so that the eye did the mixing.

Seurat's Pointillism masterpiece, *A Sunday Afternoon on the Island of La Grande Jatte* (1884–1886) can be seen at the Art Institute of Chicago. It is a very large painting of billboard size—10 feet wide by nearly 7 feet high. Robert Hughes in an early book, *Shock of the New,* wrote that "... some critics who saw it in the 1886 Salon des Indépendants either teased Seurat for hiding reality under a swarm of coloured fleas (the dots) or made fun of his 'Assyrian' figures."[15]

Color Modality

"The contexts in which colors are experienced are called the modes of appearance of color; they are aspects of a total visual experience apart from color."[16] In practical terms, a fashion model will not look the same in a color reflection print, a transparency, or a video screen having the same measurable colorimetric characteristics. The reason is that the "modes of appearance of color" are different. Color is not only unique to its surround but also to its mode of presentation.

There are five different *modes of color appearance,* and it is important to distinguish these whenever color reproduction and comparisons are being made:

1. *Object color* is the color of the surface of an object such as a blue spruce tree, blue blouse, or sweater. Color reflection prints are surface colors.
2. *Volume color* is the color seen when looking into a transparent medium such as water, glass, or plastic. It is the color of a blue lake or swimming pool, a glass of red wine. Liquid filter colors are volume color.
3. *Aperture color* refers to color seen in space but not recognizable as belonging to an object, such as the bluish color of the sky. Color measurements made with densitometers and colorimeters using small apertures are aperture color measurements.
4. *Illumination color* is the color of light, other than white light, falling on an object, such as a bluish light reflected from a white dress or shirt for dramatic effect. The blue shadows on snow seen in photographs are a result of illumination from the blue sky on a sunny day. A color slide projected on a screen is illumination color (see Color Plate X).
5. *Illuminant color* is the color of the light source itself such as a red, yellow, and green traffic light, Christmas tree lights, computer screens, and fire.

The color seen on a video screen is illuminant color consisting of red, green, and blue phosphor lights. A color transparency viewed on an illuminator is a combination of illuminant color and surface color.

Viewing of a color in a particular situation is, at best, a peculiar mixture of attention, intention, and memory.

Ralph Evans

Primary colors—Subtractive primaries: cyan, magenta, and yellow (dyes, inks); additive primaries: red, green, and blue lights (phosphors); psychological primaries: red, green, blue, and yellow.

*Color is a means of
expressing light.*

Henri Matisse

Recognizing that the appearance of color is dependent not only on its surround but also on the different modalities of object, volume, aperture, illumination, and illuminant should caution one when making direct comparisons between different color modalities. Appearances of the same image in a print, in a transparency on an illuminator, or projected, or on a video screen, will not be the same.

Back in the 1960s Marshall McLuhan coined the phrase "The medium is the message." To paraphrase this slightly, one might say that the medium changes the message or, in terms of color appearance, the medium changes the color appearance.

Complementary Colors

When a neutral color is formed by the mixture of only two colors, those colors are said to be complementary. Imagine the beams of light from two slide projectors superimposed on a screen. Over one projector lens is placed a blue filter and over the other, a yellow filter. If adjustment of the intensities of the beams can produce the appearance of a neutral white, the two colors are complementary. By such an additive mixing of lights, a very large number of complementary colors can be found.

*Complementary
colors:
Red + Cyan
Green + Magenta
Blue + Yellow*

Subtractive complementary colors are of interest because they can make many near-neutrals and, thus, desaturated colors. In photography, a normal practice is to examine a test color print through a variety of CC filters, changing the filters until a "neutral" appears neutral. Such a procedure aids in distinguishing, say, a cyan color balance error requiring a red complementary filter from a blue error requiring a yellow filter.

The term *complementary* is also used with pigment mixtures. Two paints are complementary if, when they are mixed in correct proportions, a visual neutral gray or black results. Not all pairs of pigments that appear to be complementary are capable of producing a truly neutral mixture due to the complex light-absorbing characteristics of most pigments.

*Don't confuse the
spelling of the word
complement with
compliment. A
mnemonic for
remembering this is
that the latter word
has an "i" in it. "I"
pay someone a
compliment.*

In most color imaging systems three primary colors are used to produce color images since variable mixtures of three colors provide maximum control over hue, saturation, and lightness: red, green, blue (R, G, B) with the additive system and cyan, magenta, and yellow (C, M, Y) with the subtractive system.

Because of *afterimages,* complementary colors can also be seen using only one color. If one looks steadily at a vivid blue patch for a minute or so, and then looks at a white surface, a complementary yellow afterimage is seen.

Such perceptual complements are significant in color composition. When complements are made part of the design, each has the effect of making the other appear more saturated, and thus making the composition more dramatic than otherwise. On the other hand, an effect of delicacy and softness results from a design in which complements are avoided.

Color Temperature

A candle is said to give off light having a *color temperature* of 1800 degrees Kelvin (1800K); a 100-watt tungsten lamp has a color temperature of 2900K. Any source of light may be given a color temperature rating if it visually matches the light produced by a *blackbody* at the same temperature. The reddish color of light given off by a candle matches that of a blackbody at a temperature of 1800K. A blackbody is an ideal object capable of absorbing all light falling on it and then reflecting it. Color temperatures for some other sources of light are shown in Figure 4.11.

250-watt photographic lamp	3200K
250-watt studio flood lamp	3400K
Direct sunlight	5000K
Photographic daylight	5500K
Electronic flash	6000K
Overcast sky light	8000K
North sky light	15,000K

Figure 4.11 Color temperature for various light sources.

As color temperature increases, the color of the light source goes from reddish, to bluish, to white. Color film can be balanced for only one color temperature. The most accurate color is obtained when the film is exposed at that color temperature.

Daylight film is best when it is exposed at a color temperature of 5500K, a mixture of sunlight and daylight from about 10 a.m. to 3 p.m. Color temperature is also important in establishing standard viewing conditions for printing, judging, and displaying color images.

Mireds

Because the significance of a given change in color temperature values varies with the magnitude of the values themselves, a conversion of the numbers into *mireds* is useful. The number of mireds is found by dividing the color temperature value into 1,000,000 (for example, 2500K = 400 mireds).

A given change expressed in mireds has about the same significance at any level of color temperature. Color conversion filters are often identified with the change in mireds they produce with any blackbody source operated at any temperature level.

Correlated Color Temperature (CCT)

Light sources that do not approximate blackbody sources in their spectral emissions cannot be given true color temperature values. Fluorescent

Different video screens have correlated color temperatures that range from about 6500 to 10,000K.

Filter Conversions: An orange 85B converts daylight to tungsten. A bluish 80A filter converts tungsten to daylight.

Photographic daylight is 5500K or 182 mireds.

The correlated color temperatures of fluorescent lamps are typically 5000 to 7000K.

A trained colorist can distinguish among 1,000,000 colors, at least when tested under contrived conditions of pairwise comparison.

Edward R. Tufte

lights are such an example. They are, however, assigned a designation of correlated or equivalent color temperature.

Color Names

Considering that one can, under controlled conditions, distinguish between a million or so different colors (including variations in hue, chroma, and value) in side-by-side comparisons, it is inconceivable that any system of color names could be devised that would provide accurate identification of such a large number of different colors.

Color names, however, are the most commonly used means of identifying colors in nontechnical communication. When greater precision is not required, the basic hue names serve their purpose well—such as when referring to red, white, and blue flag colors. Other hue names can be added by identifying intermediate hues such as a reddish-blue. Also, value (lightness) variations can be identified as light or dark, and chroma (saturation) variations as strong or weak.

Although there are size limitations to any system that identifies colors by names, the Inter-Society Color Council (ISCC) and the National Bureau of Standards (NBS) produced the ISCC-NBS Method of Designating Colors and a *Dictionary of Color Names* in 1955 that included 267 different colors, identified by Munsell notations, and 7500 color names. Table 4.7 shows a sample of some color names and their Munsell values. These Munsell notations can also be converted to the scientific CIE (1931) system of color notations. For example, strong red with a Munsell value of 5R 4/12 has a CIE value of x = 0.54, y = 0.31, and Y = 12.

Table 4.7 Color Names, Munsell Notation, and ISCC-NBS Names

Color Names	Munsell Notation		ISCC-NBS Names
	Hue	*Value/Chroma*	
Red	5R	4/12	Strong red
Orange	5YR	6/11	Strong orange
Yellow	5Y	8/11	Vivid yellow
Foliage	6.7 GY	4.2/4.1	Moderate olive green
Blue sky	4.3 PB	5/5.5	Moderate blue
Dark skin	3 YR	3.7/3.2	Moderate brown
Light skin	2.2 YR	6.5/4.1	Light reddish brown
White	N	9.5/0	White
Gray	N	5/0	Medium gray
Black	N	2/0	Black

In the field of advertising, color names seem to be created primarily for emotional impact. It has been found, for example, that changing the name of the color of a product from a common name, such as pink, to a name that has a contemporary, exotic association, such as Oriental pink, without actually changing the color, can increase the sales of that product dramatically.

Cosmetic manufacturers marketing products such as lipstick commonly use sensually charged words such as

Strawberry Red	Dreamy Red
Lilac Champagne	Little Red-Red
Rose Crush	Darling Pink
Wild Wine	French Pink
Whispering Wine	Spicy Pink

The names *Spicy Pink* and *Whispering Wine*, for example, tend to stimulate the palate in addition to the eye or ear, a phenomenon known as synesthesia.

Color and Synesthesia

Synesthesia refers to the ability of a person receiving stimuli in one sensory mode to actually experience it in another. For example, when a certain musical pitch or combination of musical notes is heard, a person will actually see a particular color. In effect, and as strange as it may seem, they are "seeing" color through their ears. All of our senses, in some way, are connected. Some people actually smell odors when seeing certain colors. A person who has such synesthetic ability is called a *synesthete*. Most people, however, do not have this talent and are somewhat puzzled by those who do.

It is estimated by one researcher, Richard Cytowic, that 1 out of about 25,000 individuals is born into a world where one sense can trigger another and, sometimes, all five senses clash. He found that synesthetes are predominately women and that, in the United States, there are three female synesthetes for every male.

Dr. Cytowic takes the position that there is a decided difference between synesthetic experiences based on associations one might make and those that are not. He writes that his initial approach to studying synesthesia. ". . . was a sharp demarcation of synesthesia as a sensual perception as distinct from a mental object like cross-modal associations in non-synesthetes, metaphoric language, or even artistic aspirations to sensory fusion."[17]

In other words, and according to Cytowic's position, experiences due to some kind of mental association (Chapter 3, "Memory and Association") are not considered to be pure associative synesthetic experiences. For example, one person listening to a Beethoven symphony might visualize a beautiful bucolic landscape, whereas a synesthete might actually

Imagine a piano having 75,000 different sounds. This is the situation of painters.

Salvador Dali

Hooray for Hue!!

Advertisement, 1994

The artist, Edward Munch actually heard the colors screaming when he painted the Scream.

Pantone Web site

see ". . . blobs, lines, spirals, and lattice shapes; feel smooth or rough textures; tastes agreeable or disagreeable tastes such as salty, sweet or metallic."[18] In this sense, Stieglitz's concept of *equivalence* and Swedenborg's *correspondence* would be considered associative synesthetic experiences.

A colleague who teaches at one of the universities in Toronto, told me that he would ask students to make images in color that were possible equivalents to a song or symphony; sometimes he chose and sometimes they chose the piece. Similarly, a music teacher might instruct students to imagine the notes in music as colors. Both are good synesthetic-type exercises for students used by many teachers. One could consider such exercises and experiences as a type of synesthesia based on cross-modality associations, or rhetorical tropes (Chapter 11, "Rhetoric") such as metaphor, metonymy, simile, allusions, and the like.

Alfred Stieglitz may have been using cross-modality association when he titled his cloud pictures *equivalents,* and so might Ernst Block, the composer and amateur photographer, who titled some of his tree photographs using the names of earlier, famous composers.

Alfred Stieglitz, in 1922, titled a group of his cloud photographs "Music—A Sequence of Ten Cloud Photographs." A year later he wrote his intentions: ". . . I told Miss [Georgia] O'Keefe I wanted a series of photographs which when seen by Ernst Bloch (the great composer) he would exclaim: Music! Music! Man, why that is music! How did you ever do that? And he would point to violins, and flutes, and oboes, and brass, full of enthusiasm, and would say he'd have to write a symphony called 'Clouds.'"[19]

When he did complete his sequence of ten cloud photographs, he met with and showed them to Ernst Bloch. After studying them for a while, Block responded to them just as Stieglitz had wished for and expected. In a letter to Bloch, just after their meeting, he wrote enthusiastically on how much his remarks had meant to him, and how pleased he was that Bloch's experience with the photographs was the same as his.

Bloch, a well-known and respected composer, was also a photographer. Music and photography have much in common as Eric Johnson points out:

> Both photographer and musician work with similar fundamentals. The scale of continuous gray from black to white, within a photographic print, is similar to the unbroken scales of pitch and loudness in music. A brilliant reflecting roof can be heard as a high pitch or very loud note against a general fabric of sound or gray tone. This background fabric serves as a supporting structure for either melodic or visual shapes.[20]

Bloch was a very committed photographer for more than 50 years. Much of his work, such as the mountain scenes and portraits, was intuitive. He did a series of photographs of trees to which he felt connected. He captioned some of his tree photographs with names of composers he

Greatness lies in doing little things well.

Ernest Bloch

Perfumes, colors and sounds intertwine.

Baudelaire

felt were similar in structure and feeling. The photographs served as *equivalents* and evoked feelings much like each composer's music.

His photograph of a tree titled "Beethoven, Roverado, Switzerland, 1931" is of a massive and powerful tree. It had a twisted trunk that tilted at about a 40-degree angle clockwise. Had the tree continued its growth in that direction, it more than likely would have toppled and fallen. It appears that the tree struggled to right itself, and in so doing, developed two relatively narrow trunks angled about 40 degrees counterclockwise, in the opposite direction. This provided a counterbalance for the tilted lower part of the tree, allowing it to survive.

"Bach, Switzerland, 1931" is a grouping of narrow white birch trees brightly illuminated by the sun on one side, with one tree playing against another. The smaller trees in the grouping cluster around two larger and prominent birch trees in what appears to be a rhythmic arrangement. (Paul Caponigro, who informed me of the *Aperture* article quoted above, mentioned that Bloch also titled a young tree in blossom "Mozart.")

Whether Bloch and Stieglitz were having true synesthetic experiences, actually hearing music when photographing or looking at photographs, is not known. What is known, however, is that their visual experiences were closely related to their musical experiences at some level of synesthesia.

Two male photographer friends, both college professors, believe they have had synesthetic experiences. One reported that he does feel music when the picture begins to work. The other said he often experiences colors when some music is played. Whether they are associative synesthetic experiences or nonassociative is not certain. Another friend, a black-and-white photographer, experiences upper grays (zones VII and VIII) and white (zones IX and X) as high musical notes; lower grays (zones II and I) and black (zone 0) as low musical notes. Melodies, counterpoints, crescendos, and pianissimos elicit shapes and direction.

Some years back, I invited the California photographer Oliver Gagliani to visit and talk to our graduate students. He showed many of his black-and-white photographs and most of them were in the darker tones. When one student asked him why he preferred the darker tones, his reply was that, as a former musician, he had always favored the "darker" keys on the piano.

Two women synesthetes, Carol Steen and Karen Chenausky, one a visual artist and the other a language researcher, both actually see different colors when they look at black-and-white letters. On the MIT Web site, http://web.mit.edu/synesthesia, Karen presents the letters of her alphabet on the monitor screen in black and white and as one clicks on a letter, the color that is seen by Karen appears. Carol, for example, sees the letter A as pink, while Karen sees it as greenish. Some letters are seen in opaque, vivid color and others as metallics, opalescents, translucents. Carol has incorporated parts of her synesthetic experience into her paintings and sculptures.

For synesthetes, their mode of perceiving is real.

A black
E white
I red
U green
O blue

"Sonnet of
the Vowels"
by Arthur Rimbaud

In an e-mail correspondence with Carol, I asked if when she looks at a black-and-white photograph, she sees color or a color tint. She graciously replied, "When I see a black-and-white photograph, I see it as black and white. I do not see people, landscapes, objects, animals, sky, or sea, etc., as having any color tints. However, a black-and-white photograph of a sign, for example, having letters in English, Hebrew, Greek, Russian, will have these letters in color. My colors, of course. Some Chinese characters are in color for me as well. As I do not know their sounds, I am certain that the trigger for me for my synesthetic color perceptions, is in the character's shape. Same with the other languages."[21]

The most common form of synesthesia, that of color, is called *chromesthesia*. Musicians that are chromesthetic actually experience a particular color when hearing a musical note or series of notes. The color could well vary among musicians. One person hearing a C-sharp, for example, might experience it as the color red while someone else might see it as blue.

Many people are not aware of the profound effect of synesthesia on a person, and not understanding, have at times called them strange or crazy. "Most synesthetic individuals report extreme relief upon hearing that there are others who have the same kind of perceptions; although they knew their perceptions to be 'real' they frequently refrained from telling anyone about them for fear of being called mad."[22] (I recall an experience some years back. After giving a lecture on synesthesia, one of the students came into my office in tears, with her hands partially covering her eyes. After some consoling and discussion, I discovered that since her childhood she had experienced vivid colors when she listened to music. She never told anyone, not even her parents, thinking that she was not normal and fearing that she may have to be hospitalized or institutionalized. The class session for her was a form of therapy, releasing her from the years of unnecessary worry and dread.)

The phenomenon of synesthesia has a long and interesting history and many artists over the years have made some use of it. The Italian painter Archimboldo experimented with color music. Charles Darwin's grandfather tried to make a color-harpsichord in 1790. Composers such as Alexander Scriabin and Oliver Messiaen, Rimsky-Korsakov and Jan Sibelius were all thought to be synesthetic, seeing colors when they composed music or heard music. David Hockney is considered to be synesthetic, associating music, shape, color, and space. "Hockney's conception of space is related to his synesthesia (he feels that sound and color both relate to space) as are his photographic collages made of numerous tiny, shifting parts."[23]

Sounds clothe themselves in colors and colors contain music.

Baudelaire

Color and Sound

That sound can influence the perception of color in movies is relatively well known. Studies have shown that viewers rate movies with a musical sound track higher than one without. Even in the silent era of black-and-white movies, musical accompaniments made the film more enjoyable and

entertaining. Do you recall Walt Disney's early animation film, *Fantasia?* It was an attempt to combine music and color into a synesthetic experience.

In an article titled "Stretching Sound to Help the Mind See," Walter Murch writes: "Film sound is rarely appreciated for itself alone but functions largely as an enhancement of the visuals: by means of some mysterious alchemy, whatever virtues sound brings to film are largely perceived and appreciated by the audience in *visual* terms. The better the sound the better the image."[24] He also raised a rather interesting question regarding this marriage of image and sound on film: Why is it that sound usually improves the quality of the image and not the other way around? (Looking at it in another way, why is the image experienced as figure and the sound as ground?)

"Why this and not that" can be a puzzling question and, in a sense, a *koan.* (What is the sound of one hand clapping?) I have often wondered, and still do, why the apple in Magritte's painting *The Listening Room* (Figure 6.6) looks as large as it does. Why do we see a gigantic apple and not a miniature room? Some movies, such as *The Little Indians,* depend on such predictable illusions. Intellectually we are aware of the movie illusion and the Magritte illusion. We can identify Magritte's room as being miniature but we do not see it this way. If the big apple were replaced by a small size apple, would the room expand and appear larger? Illusions reveal much about how we see and this is why they have been exhaustively studied. Without the illusion of movement, we would not be able to experience movies or videos. What we would see would be a series of still pictures, 24 or 30 of them per second. Illusions are real, they are perceptual realities.

Much research and experimentation with color and sound as a synesthetic experience peaked in the late 1800s and early 1900s. Unlike color and sound in the movies, where the color presented is a color image containing a variety of colors, these experiments were done with a projected color and a specific note or notes of music. Composers and musicians were interested in the experience of presenting color and sound simultaneously, as were others. German composer Richard Wagner believed that visual, auditory, and other senses were part of one Gestalt experience. Aristotle first suggested the possibility of a *common sense*, a sense that connects all the other senses in some way. Gestalt psychologists in the 1920s developed the thesis of the unity of the senses, an elaboration on the Aristotelian idea of a common sense.

In 1915 Russian composer Alexander Scriabin (1871–1915) sought to express his own synesthesia by performing his composition *Prométhée* (Poem of Fire) in New York. He used a color organ called a *chromola* (an early RCA record player was called a Victrola). The chromola was used to project 12 colors on a rather small screen while music was being played. Unfortunately, the projection of colors onto the small screen was not very bright and did not provide the flood of colors needed. The performance, under these conditions, was less than successful. One can only speculate

Poetry is probably the most fruitful source of verbal synesthesia.

L. E. Marks

Background music can enhance slide presentations.

Like fire are the notes of trumpets.

Swinburne

Percyval Tudor Hart (1918) believed that in music, tone equaled hue and pitch equaled luminosity.

I am calling my new piece Rossini because I kept hearing Rossini as I worked on it.

Carl Chiarenza

Music-Pink and Blue No. 1
Music Blue and Green

Titles for two paintings by Georgia O'Keeffe

what the performance might have been like if Scriabin had had access to the present sound and visual technology that our rock band concerts have.

Dr. Cytowic, in his paper *Synesthesia: Phenomenology and Neuropsychology,* suggests that it would be useful to study the effects of commonly used drugs on synesthetic experiences since much is known about their psychopharmacology—drugs such as those used for depression and migraine headaches. In a 1989 study he singles out that the hippocampus in the brain necessary for experiencing synesthesia ". . . is also necessary for experiencing other altered states of consciousness that are qualitatively similar to synesthesia. For example, the perceptions during LSD-induced synesthesia, sensory deprivation, limbic epilepsy, release hallucinations, and the experiential responses during electrical stimulation of the brain all possess a generic elemental quality—just as they do in synesthesia."[25]

Recent artistic endeavors in research studies on synesthesia seem to be directed to digital devices and the preparation of algorithms that will translate music into color and into animated images.

Synesthesia and Photography

Synesthesia may help explain why some photographers are more successful than others, why some do very well in black and white but are less successful with color, and conversely. It is well known that two outstanding photographers, Ansel Adams and Edward Weston, tried their hand at color photography but did not produce any images as powerful as their black-and-white photographs, which have become classics in the art world. One rarely sees any color photographs by them hanging in galleries. Perhaps they were more tuned in to shapes, shadows, and tonalities.

Music played an important role in Weston's photography. He was strongly influenced by the music of Bach and would at times immerse himself in music for inspiration before going out to photograph. In his *Daybooks* he wrote, "I never hear Bach without deep enrichment—I almost feel he has been my greatest 'influence.' . . . Whenever I can feel a Bach fugue in my work, I know I have arrived."[26] Minor White, according to Paul Caponigro, once commented "When I hear Bartok's music in my prints, I know that I have arrived."[27]

At one time in his life Ansel Adams had to choose between becoming a concert pianist or a photographer. He chose photography, of course. It is interesting that in his development of the zone system of photography, he assigned a scale of 10 visual notes, using Roman numerals from 0 to IX as notations for scene lightnesses from black to white. He also used a much-quoted musical metaphor to refer to the photographic negative as *the score* and the photographic print as the *performance*. Certainly,

there must have been, for Adams, a synesthetic connection between the two arts, music and photography, as it was for Weston.

In correspondence with Paul Caponigro, a musician as well as an artist/photographer, I asked him if he ever experienced color while listening to music. He replied, "Years ago, while listening intently to a composition by Serge Rachmaninov I not only heard the sounds of his music but simultaneously watched a richly colored rug being woven and unfolding somewhere in my internal perception. . . . Synesthetics?"[28]

Photography, in a way, depends to some degree on synesthesia in both creating a photograph and experiencing it fully. For example, if a deliciously colorful photograph for a food advertisement only excited the eye and none of the other senses, it would not be much of a photograph. Synesthesia allows what is seen in a photograph to trigger other senses. A highly successful food photograph would cause a highly synesthetic person to probably drool. A person not so synesthetic would probably utter a verbal remark such as "The food certainly looks delicious." Without some level of synesthesia we would not experience taste, smell, texture, or emotions when looking at photographs or other visual images. We are all probably synesthetic to some degree, most of us through an associative mechanism. Dr. Rudolf Arnheim believes that synesthesia ". . . seems to be a curious blend of physiological interconnections and psychological associations of one kind or another."[29]

Brightness of a visual image relates directly to auditory brightness. . . .

L. E. Marks

A true synesthete's experience is nonassociative and they are few in number and mostly women. One might think of the synesthetic phenomenon as having a scale from 1 to 10. Few people are at level 10 or 1, level 10 being the synesthete. Most of us are probably somewhere in between.

(In the summer of 2001, Joyce Neimanis curated a large exhibition called, "Synesthesia: The Next Generation of Art." The exhibition, held in Chicago, displayed the work of 24 artists.)

Color Connotations

Graphic designers are well aware of the importance of a logo or logotype as a symbolic way of identifying corporations and products. Through extensive exposure, they become fixed in a person's mind so that the logo becomes a memorable representation. Symbols have a long history and have been used by cultures for a variety of purposes: religious, political, commercial, and so forth. Religious symbols, such as the cross representing Christianity, the Sign of David for Judaism, the Wheel of Doctrine for Buddhism, the Sanskrit OM for Hinduism, and so on, not only provide identification for a particular religion but also carry an emotional impact. Carl Jung reminds us that there are concepts beyond human understanding that cannot be defined, and it is one of the reasons all religions use symbols.

Flags in all their colors and insignias are also symbolic. During the 2000 Olympics in Sydney, athletes from different countries proudly and

joyfully carried the flag representing their country as they marched in the opening and closing ceremonies. Some of the medal winners even draped themselves in their country's flag and, overflowing with emotion, paraded in front of an audience of more than 100,000.

The year 2000 was also a presidential year in the United States with the Republican Party displaying their logo of an elephant and the Democratic Party their logo of a donkey. Both parties are represented by these logos in political cartoons, parades, banners, and the like.

Well-known commercial logos that are highly visible and have been around for a long time include Kodak, IBM, Apple, NBC's peacock, and CBS's stylized eye. The logos and what they stand for and represent are inseparable.

The highly successful international designer Massimo Vignellli extends the idea of logotype to include the importance of color, and to do so he introduces the term *chromotype.* The attention to color becomes an additional way to achieve an identity; one only has to think of IBM and think blue, or Kodak and think yellow, or Coca-Cola and think red. Color is symbolic and carries both meaning and emotion. And the colors used by companies such as IBM, Kodak, and Coca-Cola are very specific and carry stringent specifications for reproduction in packaging and advertising. Unfortunately, not all colors can be reproduced faithfully. Video monitors are limited by the red, green, and blue phosphors used; photography, inkjet and sublimation printers, newspapers, and magazines are limited by the cyan, magenta, yellow, and black dyes and inks used. In most cases, however, small color differences are hardly noticeable, unless a side-by-side comparison is being made.

Mr. Vignelli has kindly allowed me to make extensive use of one of his unpublished articles, *Chromotype and Connotations,* that he originally prepared for a summer workshop on semiotics given at the Rhode Island School of Design. It is one of the best discussions on the important role color plays in imaging and communications.

Color, in its tremendous variety of hues and shades, organizes our feelings according to precise connotations. These connotations are obviously related to whatever society generates them and reads them in a codified manner.

It is understood that the concept of chromotype as used here relates to our society, which is the intended final recipient of this code. Consequently the notion of chromotype becomes a specific tool in the hands of designers who could use it either to achieve an identity or to manipulate the reader's perception to reach a particular feeling as intended.

Practically all colors of the basic spectrum have assumed particular connotations to which we all respond in a codified way. However, the same color could have a very extensive range of connotations according to its different shades.

Colors in their strong shades tend to be interpreted as more expressive, vulgar, dynamic than their counterparts in the lighter shades, which

connote femininity, gentleness, elegance. Pink, for example, in its shock-
ing tones tends to represent a vibrant, violent, or perverse set of images,
while the softer pinks will conjure images of intimacy, femininity, and
sophistication. Reds span from the yellow range to the purple. The
brighter orange reds are full of life, vibrating energy, but miss the under-
statement which connotes elegance. The more sanguine reds stress man-
hood, definitely "macho" in their assumption. It is the red used in most
flags, uniforms, racing cars, cigarette packages. The terracotta reds are
meant to bring forward historical allusions. They refer to the Pompeian
frescos, the Greek vases, the colors of Rome, the awareness of the past.

Yellow ranges from very acid tones to warm almost orange hues. It is
called the color of jealousy. It is the color of the sun in basic iconography.
Its energy is solar, positive, and its connotations are radiant. In conjunc-
tion with black it becomes very assertive, compulsive; in conjunction
with red it is playful, popular. When it becomes gold, yellow transcends
its own dimension, and we all know the range of the connotations of
gold, from sublime to infamous.

Responses to green change immensely from country to country. For a
variety of reasons, rooted in each country's traditions, green is loved in
places like Italy and Ireland. . . . Sometimes there seems to be a mass
acceptance and predilection for the colors of each country's flags, not for
patriotic reasons, but perhaps because of exposure.

Blue stands for everything that is proper. . . . Navy blue is mascu-
line, businesslike, timeless. It is the color of Western elegance, the most
understated. As dark as black, but without the connotations of black,
blue (navy blue, midnight blue) represents the ambiguous boundary
between color and no color. Indigo blue represented the desire for color
without the presence of it. It was the color of the Shakers, it is the color
of blue jeans—the color of ubiquitousness.

Purple ranges from red-purple to blue-purple, from cyclamen to vio-
lets. It is an intensive range of hues and shades, with morbid intensities
and connotations of penitence, sorrow, and old age. The cardinal's robe is
purple; the crucifix is wrapped in violet during Holy Week. The lighter
range of lilac and lavender, however, reverses the connotations into its
opposite—young, educated, sensitive, probing and unconventional.

Black in our culture has two basic connotations: opaque black is
death; glossy black is formal. It is the only color which changes connota-
tions completely by changing finishes. It is quite dramatic how the notion
of dullness applied to black makes it appropriate for mourning. And it is
even more surprising how glossiness transforms black into a very elegant
celebration of richness.

White is the color of the absolute. Committed and uncommitted,
ambivalent in its richness and simplicity, it represents honesty, cleanliness,
and purity. The paper on which we write and read is usually white,
implying truth. Hospitals, ambulances, and appliances are white to con-
vey cleanliness and hygiene. For all purposes they could be any light color,
but they wouldn't look real. Brides wear white gowns to imply purity.
White is the color of objectivity, beyond subjectivity.[30]

*. . . Orange gives us
the sensation of
febrile gaiety and
quickness or of soft,
solid, dignity. . . .*

S. Macdonald-
Wright

*Blue is the preferred
color among adults in
the U.S. and
Canada.*

*It is a splash of
"black" in a sunny
landscape, but it is
one of the most inter-
esting black notes. . . .*

Vincent Van Gogh

Color versus Color

The word *color* is used in two quite different ways, which can cause mis-understanding and even confusion. Color, first and foremost, is a perception dependent on our eyes as a receiver and our complex brain as an inter-preter. Seeing is a perception in the same way hearing, smelling, tasting, and touching are. Seeing color is a subjective experience as are all per-ceptual experiences. Producing or reproducing color, for instance, on a computer monitor or inkjet printer, is physical and dependent upon the particular R, G, B phosphors in a computer screen or the C, Y, M, inks in an inkjet or dye sublimation printer. They are colors in an objective sense but not in a subjective sense. Physical attributes of colors (colorants) are relatively easy to measure and to map. Perceptual response to colors, that is, color appearance, is much more difficult to measure, due in part to the variability of human perception and the fact that colors are chameleons. Colors change as their backgrounds change (simultaneous contrast assimilation) and as the lighting situation changes.

Color
Colour
Couleur
Colore
Cor
Farbe

It is important, therefore, to keep in mind the context in which the word is used. Computer advertisements boast about the millions of col-ors that can be displayed on a monitor, and their boast can be supported by controlled physical measurements. The number of the colors that can be distinguished as being different, however, is far less. A lot depends on how the colors are displayed; under the best laboratory conditions, there probably are a million or so colors. To accomplish this, a carefully con-trolled side-by-side comparison of colors is necessary. The eye is an excel-lent instrument for judging small differences (just noticeable differences, JNDs). This is not, however, the way we experience color on a monitor or in the real world. Color is context dependent.

Subjective measurements of color discrimination made in a labora-tory use instrumentation far removed from how we see color in our every-day lives. One such measurement is made by using an instrument such as a colorimeter, which displays two monochromatic wavelengths of light next to each other in a very small and restricted area. The two samples of color are viewed through a peephole aperture (similar to looking through a pair of binoculars). The samples compromise the entire visual field so that they are seen in complete isolation.

Trying to identify colors as being different without a side-by-side com-parison or equivalent is, of course, possible but quite limited in the num-ber of different colors that can be so identified. The closer two colors are alike in hue, chroma, and brightness/lightness, the more difficult the judg-ment and the greater the error. Unless the colors being compared are in proximity to one another, memory comes into play. For example, you are shown a color that is then removed from view. You are then shown another color and asked if it is the same. Unless the colors are quite different, this is indeed a difficult task. Color memory for some individuals is a given talent and some people are much better at it than others. They are able

to retain colors in memory exceptionally well, just as there are people who have good taste memories and are able to judge the quality of wines from batch to batch and year to year. There are those who have good memories for smell and judge fragrances, and those with a perfect ear for music. People who are responsible for color editing film and videotape in post-production houses are blessed with unusual color memories.

Physical colors can be displayed in any of many ways: computer monitor, computer prints, photographic prints and transparencies, photomechanical images in newspapers and magazines, oil paint on canvas, water colors, and so on. Here is a question to ponder: Of all the colors we can see in the so-called "real world," how many can a computer monitor, for example, actually reproduce? According to the Munsell Color Science Laboratory in Rochester, New York, only a fraction of them. This might come as a surprise but should not since the color gamut of the monitor depends on various additions of only three pixel phosphors, red, green, and blue, an additive system of producing colors. Inkjet printers and sublimation printers, which use a subtractive system of reproducing colors (cyan, magenta, and yellow colorants—inks and dyes), do not do any better although it is necessary to include black to obtain satisfactory reproductions of darker colors with some systems (C, M, Y, K). It is in a way amazing, however, that both systems of reproducing color can create so many different colors with only three different colorants. For a painter to have only three colors on his palette with which to work would be an extreme handicap.

Different monitors may use different R, G, B phosphors to display color.

A practical question to be raised here is this: How many colors on a monitor are necessary to produce a quality color image? Again, according to the Munsell Lab cited earlier, "Many of us can select a setting for our computer monitors that displays millions of colors and we see an improvement in image quality with this setting. However, if you select the colors correctly, you can reduce the number of colors to a couple of hundred or even fewer (depending on the image) without noticing degradation in quality. This would indicate that we can't see millions of color variations simultaneously."[31] We can add here that the eye also has resolution limitations. Visual resolution is best at the small area of the retina called the *fovea,* and it is least at the periphery of the retina. A gradual loss in resolution occurs from the fovea to the periphery.

Neutral Colors

The photograph in Figure 4.12 was taken in a Chicago department store. It caught my attention because the T-shirt broadcasts an incorrect statement that black is the absence of color. It is not uncommon for people to confuse the terms "color" and "hue." Recall that colors have three visual attributes: hue, chroma (saturation), and value (lightness). One system for identifying hues is with descriptive names such as red, green, blue, cyan, magenta, and yellow. Saturation is the degree to which the color

deviates from a neutral color, white, gray, and black. Lightness refers to the position of the closest match to the color with a scale of grays from black to white. Black, then, is a neutral color (no hue or saturation) with low lightness, and white is a neutral color with high lightness. As paradoxical as it may sound, a black-and-white photograph is a color photograph. It has only one attribute of color, however, and that is lightness. (In a television or video image, neutral colors such as a black, white, and grays have no chrominance, only luminance.)

Our visual system encodes luminance at a higher resolution than chrominance.

Figure 4.12 Black is color, a neutral color.

Look at Color Plate II and note how the neutral colors from black to white have no hue or chroma, only increasing lightness (value). Refer also to Table 4.5 and see how the Munsell notations for neutral colors list black as N 2/ and white as N 9.5/. The N identifies the colors as neutral. The numbers 2/ and 9.5/ identify the value. The blank space after the slant sign indicates no chroma. (The notations could have read N 2/0 and N 9.5/0.) On a CIE diagram the neutrals all plot on the same x,y axis as 31, 32, a neutral area.

Black is a color having no hue chroma.

How important is the lightness attribute of color to an image? The short answer is that without lightness variations in the image it will look

Color Plate I
The Munsell color tree.

Color Plate II
Munsell color space.

Color Plate III
Pantone® color formula guides.

Color Plate IV
Munsell color solid.

Color Plate V
GretagMacbeth ColorChecker.

Color Plate VI
GretagMacbeth ColorChecker DC.

Color Plate VII
Additive and subtractive color systems.

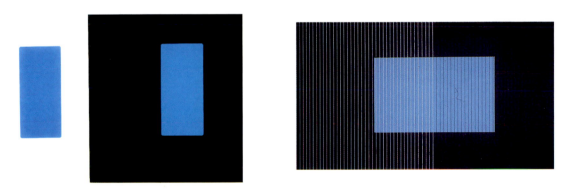

Color Plate VIII
Simultaneous contrast (left) and assimilation (right).

Color Plate IX
A practical example of assimilation.

Color Plate X
Illumination color.

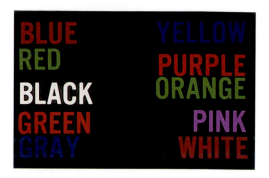

Color Plate XI
The Stroop effect.

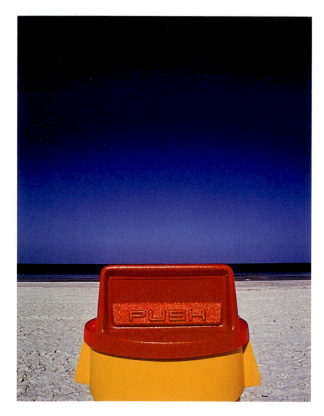

Color Plate XII
"Push" by Pete Turner.

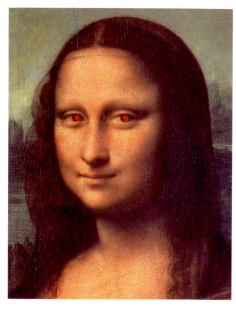

Color Plate XIII
Mona Lisa's mysterious smile and red-eye.

flat (low contrast). It will not be perceived as a reasonable representation of the subject even though it contains realistic variations of the hue and saturation attributes of the subject colors.

It is interesting that the viewing public has long accepted so-called black-and-white photographs, which contain no hue or chroma but only lightness variations. Some people even prefer black-and-white photographs to color photographs.

The painter of the future will be a colorist such as had yet never existed.

Vincent Van Gogh

Figure 4.13 *The Munsell color tree has a vertical trunk that represents a scale of values, branches that represent different hues, and leaves extending along the branches that represent chromas. The hues change as you walk around the tree, the values increase as you climb up the tree, and chromas increase as you move out along the branches. (From A. Munsell,* A Grammar of Color, *edited by Faber Birren, © 1969 by Litton Educational Publishing Inc. Reprinted by permission of Van Nostrand Reinhold.)*

KEY WORDS

additive mixtures (R, G, B)
afterimage
anisotropic
aperture color
assimilation
blackbody
chroma
CIE
color appearance
color connotations
color constancy
color dependency
color management
color modality
color temperature
colorant
ColorChecker
complementary colors
convexity/concavity
correlated color temperature
flare
hue
illuminant color
illumination color
isotropic
lightness
luminance
metamerism
mired
modes of color appearance
motion parallax
motion perspective
Munsell system
neutral color
neutral density (ND) filter
object color
Ostwald system
Pantone®
Pointillism
saturation
simultaneous contrast

subtractive mixtures (C, M, Y, K)
surface color
synesthesia
volume color

Space, Time, and Color Exercises

1. Space Vehicle

Make several photographs of the same scene using your camera as a space vehicle. Observe the scene as you move your camera up and down, left to right, forward and backward, and as you pitch, yaw, and roll it.

2. Cubistic Space

Take a series of photographs of the same subject from different positions —front, side, back, top, and at different distances from the subject. Make prints and mount the prints in such a way as to create an interesting and visually challenging mosaic. Look at some of the cubistic images of artists such as David Hockney, Robert Heinecken, and Joyce Neimanas for ideas.

3. Anisotropicism

Rudolf Arnheim writes: "The dominant pull of gravity makes the space we live in asymmetrical. Geometrically, there is no difference between up and down; dynamically, the difference is fundamental."[32]

Arrange a setup so that the objects are balanced top to bottom, left to right, and then take a photograph. Now add another object or two to the setup without disturbing the balance. Make a photograph and compare it to the first photograph.

4. Convexity/Concavity

Look around for architectural structures, building interiors, and outdoor and indoor sculptures that have convex and concave shapes. Study them and then photograph them to emphasize their shapes.

5. Transparency/Translucency

Photograph someone moving their hands up and down or head to the left and right using an exposure time of about 1/2 second. Repeat this using longer or shorter exposure times. (Look at some of the photographs by Man Ray and by Richard Avedon that display this type of transparency.)

6. Ghosts

Using an exposure time of about 1/2 second, photograph a person moving left or right out of the picture area as the shutter is tripped. (Review some of Duane Michals' photographs.)

All works of art are created on a certain scale. Altering the size alters everything.

Edward Hall

Does a pictorial work come into being at one stroke? No, it is constructed bit by bit just like a house.

Paul Klee

7. Implied Motion

Take a series of photographs to capture the gesture of a person that suggests movement. Study them and select the one that best captures the implied movement.

8. Levitating

Using a fast shutter speed, photograph a person jumping up and down. Try to capture them in midair so as to make it appear they are levitating.

9. Panning

Create the appearance of movement in a still photograph by "locking" your camera on a moving object, and then moving the camera smoothly with the object as it passes your field of view.

10. Disappearance

Photograph an outdoor sculpture (or other stationary subject) on a busy street and record only the sculpture, not the people or vehicle traffic in the area.

11. Disappearing/Reappearing

People and objects can be made to appear from nowhere and disappear simply by stopping the film or video camera during a shoot and having an object or person inserted into a scene or taken out, and then continuing the shoot. Try this with a friend or pet animal. It is a lot of fun, and very believable.

12. Creeping Shadows

Photograph a stationary object on a bright day, at different times of the day, to capture its "moving" shadow.

13. Flip Photo Animation

Set up a tabletop scene and place your camera on a tripod to photograph it. Make a series of photographs moving one or more of the objects slightly between each exposure. Make small prints, about 4 × 5 inches, and place them in a stack so that you can flip through them and create a "moving" image.

14. Color, Colour, Couleur

Using the same outdoor lighting, take color photographs of a person dressed in colorful clothes against a red brick wall, green foliage, and a neutral or near-neutral background. Make color prints and compare the person's skin tones and other colors.

Habit diminishes the conscious attention with which our acts are performed.

William James

The shadows are full of play. What resourcefulness in their relationship with each other.

Edgar Degas

It was when everything was covered with snow that I perceived that the doors and the windows were blue.

Albert Camus

15. Lightness Matching

Obtain samples of papers having different solid colors (paint-sample chips, construction paper, and the like) and a photographic gray scale. Place a small square of each color on the gray-scale tone that appears to match the lightness of the color. If the color appears to be between two tones in lightness, place it on the dividing line.

16. Color Temperature

Using color film in light having the wrong color temperature can sometimes result in some interesting slides. Daylight film shot at early morning or early evening will have a warming effect. Try this technique using moonlight, street lights, car headlights, gallery lights, and mixed lights. Experiment, play around with different films and light sources.

17. Reciprocity

Extended exposure times will cause reciprocity failure, which can result in a color imbalance. Try a normal exposure time of about 1/125th or 1/60th of a second and then exposure times of 1/2 second, 1 second, 2 seconds, and so on. Adjust the camera f-stop as needed to maintain equal exposures each time. You may need to add neutral density filters for long times. Remember, adding a 0.30 neutral density filter is the equivalent of one stop; a 0.60, two stops; a 0.90 (0.30 + 0.60), three stops; and so on. Compare the results. Look for both a loss in exposure effectiveness (a darker looking slide) and a shift in color balance.

Solid materials such as tungsten emit a continuous spectrum of light. Gases and vapors such as mercury found in fluorescent lights emit a discontinuous spectrum.

18. Complementary Afterimage

Stare at the snowflake pattern in the following figure for about 30 seconds and then shift your gaze to the dot in the white area. You should experience a reverse image. If the snowflake were the color blue, you would see a yellow afterimage; if red, a cyan image; if green, a magenta image. You may want to color the snowflake and test this out.

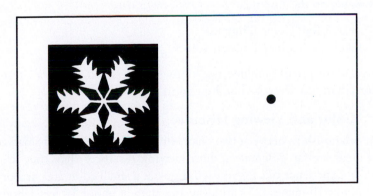

Complementary afterimages. Afterimages can be either positive or negative with respect to lightness and hue.

19. GretagMacbeth-Munsell and Pantone®

Request a catalog from either or both companies and learn about all the various color resources available. You will also find interesting and current information on their Web sites: www.munsell.com and www.pantone.com.

20. Munsell Color Science Laboratory

Housed at the Rochester Institute of Technology, this facility conducts color research and publishes current information on color measurement and appearance. Go to their Web site and find some basic color information (www.cis@rit.edu/mcsl/).

21. Flare (Ambient Light)

Minimize the flare from your computer monitor by shielding it from overhead and side lighting. In addition, use glass cleaner to clean the glass plate in front of the monitor screen. Notice the difference in color saturation, particularly in the dark shadow areas. Look at an image on the screen at night with the room lights on and then off. Notice how contrasty the image appears when there is no flare light reflected from the screen.

Scuba divers' yellow tinted goggles improve the perception of shadows or depressions.

Tom Lopez

22. Flare (Monitor Light)

Look at an image that occupies about 50 percent of your monitor screen. Using Adobe Photoshop, create a gray area surrounding the image and notice the change. Do the same thing using a black surround.

23. Test Chart

Make your own color test chart by gathering paint chips from a local paint store that are similar to the ones on the ColorChecker. Include some chips that have a glossy surface and some that have a matte surface.

24. Color Blindness

How is your color vision? Check it out using the color blindness test that is available on the Internet.

1. Search for "Color Blindness"
2. Click on "Color Blindness Check"

(There is also a color blindness test for preschoolers, which uses a Creamer Color Chart at www.colorblindtest.com)

25. Color and Viewing Distance

"The relationships between two colors or among any group of small colored areas are far different at short-viewing distances than they are at long."[33] Experience this for yourself. Look at a small color area in a print from about 10 inches (25 cm) away and then at about 10 feet (about 3 meters) away.

26. Saturation and Viewing Distance

"A painting may appear flat and of low saturation at short distances only to arrange itself into a contrasty pattern of moderately saturated colors as the distance increases."[34] What is true for paintings is also true for photographs and inkjet prints. Give this some thought when deciding on how to adjust the contrast for a large or extra large print. Think about this also when deciding where to stand when viewing a large painting or photograph in a museum.

27. Color Memory

How well can you remember colors? Pick up about 10 paint chips of similar colors, and two that are identical. Select one of the two identical chips and remember its color (hue, chroma, value). (Place the remaining paint chips out of sight as you do this.) Turn the remembered paint chip over, look at the other chips, and select the one you think matches. How well did you do? Try this under different lighting conditions: daylight, tungsten, fluorescent, mixed lighting. Studies in color memory have found that light colors are remembered as lighter; dark colors as being darker; hues as being more saturated; yellowish-reds as nearly red; and bluish-greens nearly green.

28. Synesthesia I

When you feel connected to a particular piece of music or visual image, how would you describe your experience? This is how Frank Dienst, a Florida medical doctor and fine art photographer, described his experience to me when I asked the question: "The effects of the images (or sounds) seem to produce the same type of internal effect. Either can produce profound visceral effects. I've gotten goose bumps when sitting in the middle of an orchestra playing a piece of Bach, as I have when viewing a platinum print by Weston. Different effects but equally exciting."[35]

I become a tree when I photograph a tree.

Ruth Bernhard

29. Synesthesia II

The February 2001 issue of *Smithsonian* magazine has an article on synesthesia by Susan Hornick with photographs by Kay Chernush. It is titled "For Some, Pain is Orange." It is worth a look. On page 51, the article mentions that when David Hockney was ". . . designing sets for the Metropolitan Opera, he would listen to music and, inspired by the colors (he saw), paint the sets accordingly."

30. Synesthesia III

American artists Stanton Macdonald-Wright and Morgan Russell, who worked together before World War I, became interested in what they called *synchromism.* They believed and practiced that color had sound equivalents. When the opportunity presents itself, you may want to search out some of their paintings. Alfred Stieglitz gave Macdonald-Wright a one-man show in 1917. In 2001 the North Carolina Museum of Art exhibited

a collection of his work borrowed from 34 major museums and private collections. Aside from his painting he was a writer, linguist, inventor, and gourmet cook.

Feel the color.

31. Color Connotations

Ad for an exhibition

Play a color association game with friends. Say a color and ask them to write down the feeling that first comes to mind. Insist on the association being that of feeling and not of an object. For example, given the color "green," do not accept "grass." Compare the associations with different colors that different people make, and compare it with your own associations.

Useful Color Web Pages

GretagMunsell	www.munsell.com
Munsell Color Science Lab	www.cis,rit.edu/mcsl/online/research/shtml
Pantone Color Institute	www.pantone.com
The Color Marketing Group	www.colormarketing.org
The Color Association	www.colorassociation.com
International Color Consortium	www.color.org
Eastman Kodak	www.kodak.com/US/en/digital/dlc/

Notes

1. R. W. Burnham, R. M. Hanes, and C. James Bartleson, *Color: A Guide to Basic Facts,* New York: John Wiley & Sons, 1963, p. 12.
2. Naomi Rosenblum, *A World History of Photography,* New York: Abbeville Press, 1984, p. 249.
3. Ibid, p. 255.
4. Gary Field, *Color and Its Reproduction,* Pittsburgh, PA: Graphic Arts Technical Foundation, 1988, p. 66.
5. Mark Fairchild, *Color Appearance Models,* Reading, MA: Addison-Wesley, 1988, p. 130.
6. Ralph Evans, *An Introduction to Color,* New York: John Wiley & Sons, 1948, p. 233.
7. Leslie Stroebel et al., *Basic Photographic Materials and Processes,* Boston: Focal Press, 2000, p. 379.
8. Josef Albers, *Interaction of Color,* New Haven, CT: Yale University Press, 1972, p. x.
9. Semir Zeki, *Inner Vision,* New York: Oxford University Press, 1999, p. 11.
10. Ibid, p. 22.

11. Arnold Gassan, "The Waterless Darkroom," *Rangefinder,* December 2000, p. 28.

12. www.piezography (Feb. 2004)

13. Rudolf Arnheim, *New Essays on the Psychology of Art,* Berkeley: University of California Press, 1986, p. 208.

14. Robert Hughes, *The Shock of the New,* New York: Alfred A. Knopf, 1980, p. 114.

15. Ibid, p. 116.

16. Burnham et al., *Color: A Guide to Basic Facts,* p. 11.

17. Richard E. Cytowic, "Synesthesia: Phenomenology and Neuropyschology," *Internet,* November 2000, p. 2; e-mail: neuroman@glib.org.

18. Ibid, p. 3.

19. Eric Johnson, "A Composer's Vision," *Aperture,* Vol. 16, No.3, 1972.

20. Ibid.

21. Carol Steen and Karen Chenausky, "Synesthesia and the Synesthetic Experience," MIT Web site: web.mit.edu/synesthesia, October, 17, 2000.

22. Greta Berman, "Synesthesia and the Arts," *Leonardo,* Vol. 32, No. 1, 1999, p. 15.

23. Ibid, p. 20.

24. Walter Murch, "Stretching Sound to Help the Mind See," *The New York Times,* Sec. 2, October 1, 2000, p. 25.

25. Cytowic, "Synesthesia," p. 5.

26. Nancy Newhall (ed.), *Edward Weston,* New York: Aperture, 1971, p. 46.

27. Paul Caponigro, private communication, October 26, 2000.

28. Ibid.

29. Arnheim, *New Essays,* p. 207.

30. Massimo Vignelli, "Chromotype and Connotations," paper presented at The Rhode Island School of Design Summer Semiotic Workshop, June 6, 1983.

31. Munsell Color Science Laboratory Web site, www.cis.rit.edu/mcsl/online/research.shtml, March 3, 2001.

32. Rudolf Arnheim, *The Power of the Center,* Berkeley: University of California Press, 1982, p. 11.

33. Evans, *An Introduction to Color,* p. 181.

34. Ibid, p. 182.

35. Frank Dienst, private communication, March 12, 2001.

5

Contours

The borderline between two adjacent shapes having double functions, the act of tracing such a line is a complicated business. On either side of it, simultaneously, a recognizability takes shape.

Maurits Escher

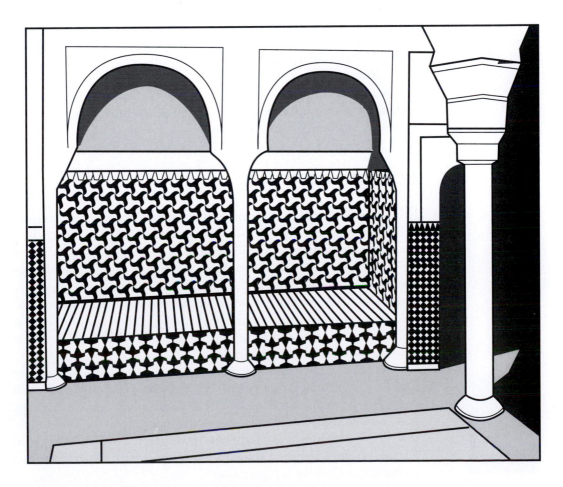

Mosaic patterns, Alhambra.

The Alhambra, located in southern Spain, was visited by Escher in 1936. "For whole days at a time he and his wife made copies of the Moorish tessellations [mosaic patterns], and on his return home he set to work to study them closely."[1] The repeated cloning of the shape that makes up the mosaic varies in orientation and tonality but all share a common contour. "These patterns represent a high point of the Arab exploration of the subtleties and symmetry of space. . . ."[2] Seen from the outside, the Alhambra takes the form of a fortress. From the inside it is a palace of honeycomb courts and chambers. "The Alhambra is the last and most exquisite monument of Arab culture."[3]

Contrast (density differences) between adjacent areas in an image allows us to see *contours* or *edges*. The sharper the edge, the higher the contrast appears; the higher the contrast, the sharper the edge appears. Sharp or "hard" edges appear to advance while soft edges appear to recede. Controlling the sharpness of an edge by selective focus controls, to some extent, contrast and depth. The more abrupt the tonal change at an edge the sharper it appears. The judgment of sharpness is strictly visual. A physical measure of sharpness is called *acutance*. Some films are rated in acutance as well as speed, resolution, and graininess. Some slow-working developers enhance the acutance of an edge in a photograph by increasing the density difference at the very edge. This result is called an *adjacency effect*.

Whereas sharpness is a visual effect, adjacency effects are physical effects within the photographic image; there is an actual increase and decrease in density at the edges (contours, boundaries) of an image.

COMMON CONTOUR

In his book, *Art and Visual Perception,* Dr. Rudolf Arnheim asks this question: "What happens when two similarly qualified competing surfaces both claim the same contour?"[4] The illustration in the margin shows that there is a competition between the two shapes sharing the same or *common contour.* Arnheim refers to this as contour rivalry. "Perceived as a whole, the figures look stable enough, but when we concentrate on the common central vertical we notice a tug-of-war. The sharing of borders is uncomfortable, and the two hexagons exhibit an urge to pull apart since each figure has a simple independent shape of its own."[5]

Examples of common or shared contours abound in the work of the Dutch artist Maurits Escher (1898–1972). Escher was keenly aware that shapes have a "double function," and he used this brilliantly in his drawings.

The Danish psychologist, Edgar Rubin, in the early 1900s called attention to the ambiguity and playfulness of common contours in his writing and exemplified in his figure–ground vase/face illustration seen previously in Chapter 1, Figure 1.6.

Most tribal art is hard-edge. It is art of sharp contrasts, sudden juxtapositions, and superimpositions. So is children's art.

Edmund Carpenter

But even much earlier than this, artists used common contours to embed shapes in a visual hide-and-seek game to make a variety of statements, some dangerously political. The 1794 print by Pierre Crussaire titled, "The Mysterious Urn," shown at the beginning of Chapter 1, is loaded with symbols and a number of embedded profile faces, the most prominent being the two that share contours with the urn.

In the photograph "Dunes, Colorado," seen in Figure 5.1, a common contour is shared by the very edge (contour) of the white and black areas.

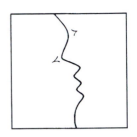

Edgar Rubin's double profiles, 1921. The two profiles share a common contour but are unable to share a kiss.

Figure 5.1 "Dunes, Colorado." ©Dr. Thomas L. McCartney. At the very edge where the black and white areas meet, a common contour is shared. Rivalry for possession of the edge serves to shift the figure–ground relationship.

Where the edges are sharp (hard edge), a competition takes place between the black and white shapes. Where the edges are not as sharp (soft edge), the competition is less noticeable. This photograph by Dr. McCartney is also a wonderful example of Notan; dark/light, opposites in harmony, opposites as complementary, figure and ground as one.

An example of the use of common contour in typography can be seen in the design of letter combinations such as Æ or æ. This tying together

or binding of letters is called a *ligature*—something that unites as seen in the text in Figure 5.2. Gutenberg's movable type consisted of a large assortment of ligatures so that he could create a printed page that was similar to that of a manuscript page.

> A ligature is a character that contains two or more letters. Ligatures were employed by the medieval scribes since they could be easily constructed with a pen and enabled them to write at a more rapid rate. Gutenberg's movable type included an extensive assortment of ligatures because he wanted to create a printed page that was undistinguishable from the hand drawn manuscript. The number of ligatures decreased as time went on for economic rather than esthetic reasons.

Figure 5.2 Common contours are the basis for ligatures in typography.

To perceive an image is to participate in a forming process; it is a creative act.

Gyorgy Kepes

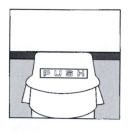

Line drawing of Pete Turner's color photograph, "Push."

Photographers can have fun with common contours by photographing objects located at different distances in space from a point of view that results in *shared contours* (Figure 5.3). This results in an ambiguous situation in which the perception of depth in the photograph is lost only in the contour area where the two disparate objects share a common contour. This illusionistic ambiguity can add interest and intrigue to a photograph.

A rather interesting color photograph made some years ago by Pete Turner shows a trash can on a sandy beach photographed from a set perspective that positions the edge of the red top of a yellow trash can so that it coincides with the blue horizon line (see Color Plate XII).

What is it about Turner's photograph that catches the eye and demands attention? Is it the beautiful symmetry and simplicity, the clever use of the perceptual primary colors red, yellow, and blue, the historical symbolism of earth, sky, and water? It is all of these and something more, something more subtle and puzzling to the eye. Turner's image plays tricks with the eye that viewers are probably not aware of at a conscious level. You probably noticed that part of the distant horizon line and the red top of the near trash can coincide. This was no accident. It was rather something carefully thought out, planned, and executed. By having the edge (contour) of the red top share the contour of the distant horizon line, the perception of depth, in that area, is destroyed. The distant horizon line and the trash can become connected in the same visual plane.

Figure 5.3 "A Playful Common Contour," Scott Johnson. When near and far objects share the same contour, there is no overlap. The perception of depth is lost. Overlap is an important depth cue.

So what? So a very important depth cue, that of "overlap," is lost while at the same instant the overlap of the trash can against the sandy beach and the water is preserved. The trash can, if you wish, may be seen in two places at the same time, near the viewer and far off at the horizon. Physically impossible? Yes! Visually impossible? No! We see it this way and are puzzled by it momentarily until our intellect overrides our visual experience. We chalk it up as just another illusion. Fine, but illusions are visual realities that should not be denied. Turner's photograph is just that: a visual reality that contradicts the physical reality of the original scene. He created something that wasn't there, something for us to puzzle over, think about, and enjoy.

The shared contour of the top of the trash can and the horizon line not only collapses depth in the photograph but according to the British psychiatrist Anton Ehrenzweig, and others, such a juxtaposition causes an enhancement in the colors at the very edge of the shared contours. Ehrenzweig calls attention to the experimental work of Josef Albers' nesting of squares and points out ". . . how much color interaction depends on a comparative weakness of form. . . ."[6] The simplicity of form in Turner's photograph makes it subservient to the colors that are set free to interact. At the very edge, the blue horizon line becomes bluer and the red top of the trash can, redder. (This may not be apparent in the reproduction.)

Ultimately, simplicity is the goal in every art, and achieving simplicity is one of the hardest things to do.

Pete Turner

A Frog and a Squirrel

In Figure 5.4A, a large plastic storage box is seen setting in front of a wooden railing. A squirrel sits atop the box and a frog sits on the rail. They are seen as separated in space. The box overlaps the wooden railing, an important depth cue. In the distance is a white house with a black roof. By lowering the camera slightly, the perspective is changed, as seen in the second photograph (Figure 5.4B). The top of the box and the top of the railing now share the same contour; there is no overlap. The perception of depth in that area is lost.

(A)

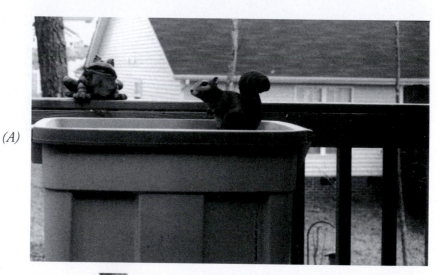

A photographer can bring coincidence of line simply by moving his head a fraction of a millimeter.

Bresson

(B)

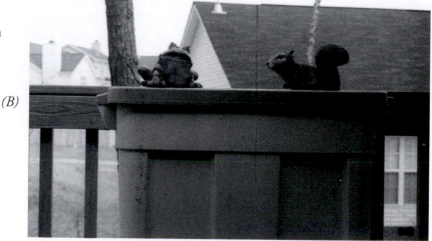

Figure 5.4 "Squirrel and Frog." (A) With overlap as a depth cue, the frog sits on the rail and the squirrel on the box. (B) When the box and the rail share the same contour the depth cue is lost and both appear to be located in the same plane in space.

The question before us is whether the frog is still sitting on the railing and the squirrel on the box. Because they both share the same contour, it is difficult to determine just where they are located in space. There is no way to determine this with certainty. They could even have exchanged positions. Visually they both appear to be sitting on both the box and the wooden rail. This is indeed strange since we know from looking at other areas in the photograph that the box overlaps the wooden railing and therefore must be located in front of it. What we have here is a variation of an early period of art called *trompe l'oeil,* a French term meaning "fooling the eye." Painters delighted in falsifying perspective to fool the eye. Viewers delighted in being puzzled and fooled by the visual magic.

Incidentally, did you notice that the black roof line of the house also shares the same contour as the box and wooden railing—a further collapse of depth in that section of the photograph. Part of the photograph has depth and part does not, and somehow we seem to accept this contradiction.

Common contour can be seen operating in the photograph shown in Figure 5.5. With a little imagination, one can experience a brilliant burst of sunlight from a dark sun. The eye can settle on the dark sun with ease and comfort but not on the radiating black, white, and gray lines. In that space, there is a competition for the shared black, white, and gray contours. This rivalry tends to visually activate the image, increasing its brilliance. The photographer was aware of this vibrating effect when he took the photograph but had not realized that the effect had a name.

With common contour in mind, take another look as some familiar photographs such as the landscape photographs by Brett Weston, the humorous photographs by Elliott Erwitt, and the altered landscapes by John Pfahl, as well as others. You might even review some of your own photographs or create some that show the effect of common contour on depth and on activating the image.

Common contour provides us with an opportunity to inject uncertainty into our photographs. A bit of ambiguity in an image is a useful thing; it makes the act of seeing more challenging and invites the viewer to participate more deeply in the visual experience. In the words of Victor Shklovsky, "The purpose of art is to impart in us the sensation of an object as it is *perceived* and not merely recognized. To accomplish this purpose art uses two techniques: the defamiliarization of things, and the distortion of form so as to make the act of perception more difficult and to prolong its duration."[7]

It is by great economy of means that one arrives at simplicity of expression.

Bresson

*Figure 5.5 "St. Johns River, Florida," by Dr. Frank Dienst. The radiat-
 ing lines are activated by the common contours they all share,
 causing vision to momentarily alternate within the black,
 white, and gray areas.*

SUBJECTIVE CONTOUR

The two triangles shown to the side provide a powerful example of how
our visual system, given incomplete information, fills in to form a clo-
sure on a familiar shape. The incomplete triangle with the disrupted lines
is readily seen as a complete triangle due to the Gestalt laws of *continu-
ation* and *closure*. The other, far less complete triangle, having no lines but
only short edges where the three black disks are located, is also seen as a
complete triangle. It is difficult not to experience it as a triangle, even with
the minimum amount of information provided. Notice also that the white
area enclosed by this triangle is whiter than the white of the surround.
This is strictly a subjective visual experience, a *subjective contour*.

The contour lines are *virtual lines* and the triangle is a virtual triangle—
existing as a visual effect, a *virtual contour*, and not as an actual physical
form. A famous photograph by Dr. Harold Edgerton of a golfer swing-
ing his club shows a similar effect (Figure 5.6). Between the repeated ends
of the golfer's club and his body, there appears to be a curved contour

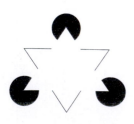

Subjective contour.

and the enclosed area appears to be blacker than the black surround. Density measurements would reveal no physical difference. (This photograph also serves as an example of the Gestalt laws in action. A shell-like pattern emerges as the visual elements—white golf clubs—are visually connected, as in a moving image. The similarity of the repetitive golf clubs and their proximity to each other provides for easy continuity, implied movement, and closure.)

Perception is a process of construction, of participation, of creativity; and the need to form closure is a basic perceptual need.

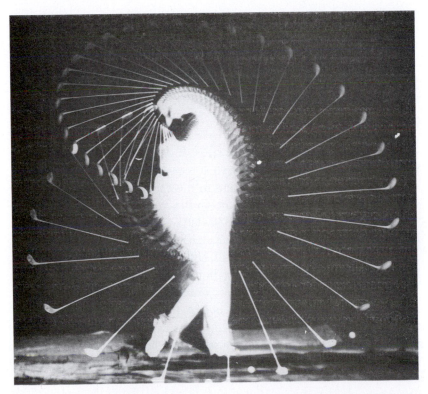

Figure 5.6 *"Densmore Shute Bends the Shaft," Harold Edgerton. ©The Harold E. Edgerton 1992 Trust. (Courtesy of Palm Press, Inc.) Notice how the enclosed "crescent" between the repeated ends of the golfer's club handle and his body appears darker than the surround; an example of subjective contour in a photograph.*

MACH BANDS

In a completely homogeneous visual field—a Ganzfeld—there is no vision, as mentioned in Chapter 1. Vision is dependent on change as is all perception—hearing, touching, smelling, tasting. Perception is a dynamic, interactive process.

In the fields of observations, chance favors only the mind that is prepared.

Louis Pasteur

The familiar gray scale in Figure 5.7 shows that at the very edge of the areas where there is a change in lightness, there appears to be an edge or contour.

Figure 5.7 The Mach effect. At the very edge of each gray area in the gray scale, there appears to be a very narrow dark and light band. This is strictly a visual effect. Without it there would be a loss in contrast. It is the way our eyes process edge information and shows why edges are so critical to perception.

The observer is part of the observed.

Thomas Merton

The edge is a virtual edge and exists as a result of the tonal change —the contrast—between adjacent areas. If you look closely at the edge, you will notice an increase in contrast at the very edge. This increase, consisting of a very narrow darker band in the dark area and a lighter band in the light area, is a visual effect known as a *Mach band,* named after the Austrian scientist, Ernst Mach (1838–1916) who first described it. It is important to realize that Mach bands have their existence in the way we see and not in the actual image. And, since it is a visual phenomenon, it is independent of the particular medium used.

The photograph of the Colorado dunes and St. John River shown in Figures 5.1 and 5.5 provide an excellent example of how the Mach effect enhances the contrast of the very edge of two adjacent areas. An attentive look at the edge separating the white and black areas will reveal the Mach phenomenon operating to enhance contrast and therefore sharpness. Contrast and sharpness go hand in hand. With a camera, the sharpness of an edge can be controlled by selective focus, depth of field, and special filters. This in turn will have an effect on the contrast of the image. In short, the contrast of an image can be manipulated by controlling the sharpness of the edges in the image. Software such as Adobe Photoshop increases sharpness and contrast of an image by electronically enhancing its edges.

Artists have known and used this contrast enhancement effect for centuries. "Artists of the 19th-century Neo-Impressionist school were unusually meticulous in their observations. . . . A good example is Paul Signac's 'Le petit dejeuner.' In this painting there are numerous contrast effects in and around the shadows and half-shadows."[8] Similar effects can be seen in Edward Weston's photograph "Nude, 1936" (Chapter 2, Figure 2.22B). Observe how some shadows have a soft edge and some a hard edge, and how this affects the local contrast.

VISUAL VIBRATIONS

Contours, boundaries, and edges are very important to the process of visual perception. The eyes continuously search them out for information. Under certain conditions, a shimmering movement can occur at the *boundary* of an area. With color images, boundaries of color areas having similar lightness and complementary hues, such as red and cyan, tend to appear to vibrate or shimmer.

The more saturated the colors, the stronger the effect. An early movement called OpArt was based on this phenomenon, most notably perhaps in the paintings by Victor Vasarely. Vincent Van Gogh was aware of the effect and used it in subtle ways. In a letter to his brother Theo in 1888, he wrote of trying ". . . to express the feeling of two lovers by a marriage of two complementary colors, their mixtures and their oppositions, the mysterious vibrations of tones in each other's proximity."[9] Josef Albers, who did extensive experimentation with color interactions in his "Homage to a Square" series, wrote in his chapter on "Vibrating Boundaries," "The conditions for these [vibrating boundary] effects occur between colors which are contrasting in their hues but also close or similar in light intensity."[10]

The reason that edges seem to vibrate under certain conditions is complex but appears to be related to physiological factors such as the inhibitory process in the retina and the tremors of the eye called *nystagmus,* and to perceptual phenomena such as simultaneous contrast (Figure 5.8).

Without contraries there is no progression.

William Blake

Optical art (OpArt) was based on repetitive patterns that vibrate.

Figure 5.8 Lateral inhibition. Note the on/off gray spots where the white areas cross.

Vibrations can also be seen with certain repetitive patterns of black-and-white lines, as in Figure 5.9. Although *visual vibrations* are not as evident in conventional photographs, they are easily created photographically

by making high-contrast photographs of moiré patterns or by playing off images using various darkroom techniques such as relief images and masking, or simply digitizing a photographic image and manipulating it on a computer.

The important task of all art is to destroy the static equilibrium by establishing a dynamic one.

Piet Mondrian

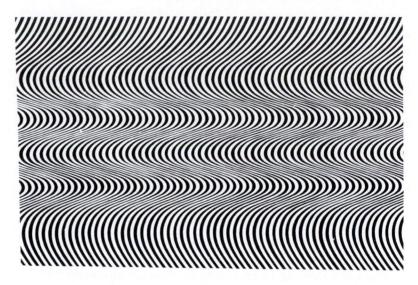

Figure 5.9 Visual vibrations. Various patterns of edges restrict the ability of the eye to fixate, thereby frustrating the eye and causing a shimmering sensation. Notice that if you rotate the pattern to a vertical position, the vibrations are not as pronounced. Orientation is an important factor in perception.

PHOTOGRAPHIC EDGE EFFECTS

A physical phenomenon similar to the visual Mach effect of an increase in contrast at the edges in an image occurs in photography, Xerography; and in video and computer monitor displays. In photography these effects exhibit a physical increase and decrease in density at the very edges of the image. Figure 5.10 is a graphical representation showing this density enhancement. It occurs over a very small distance on the order of a fraction of a millimeter—about 50 microns.

1 mm = 1000 microns

This increase in contrast as a result of an increase in edge density, in addition to being called an edge effect, is also referred to as an adjacency effect, neighborhood effect, border effect, fringe effect, and, depending on the size and shape of the image, the Eberhard effect and the Kostinsky effect.

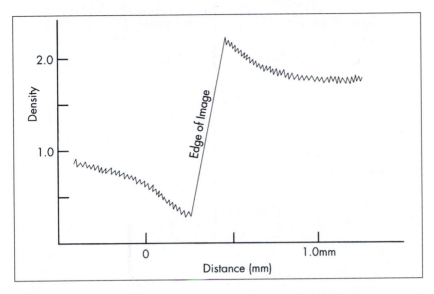

Figure 5.10 Photographic edge effect. The decrease and increase in density at the very edge of an image increase the density difference (amplitude) and therefore the sharpness of the image.

Acutance

Photographic edge effects serve to increase the sharpness of an image. How much that sharpness is increased is a subjective judgment. If a quantitative measure of sharpness is required, microdensity measurements of the edges are made with a scanning microdensitometer. The density numbers are then put into a mathematical formula, fed into a computer, and a measure of sharpness in terms of acutance values is arrived at. There is a positive correlation between acutance values and the subjective judgment of sharpness. Some technical and scientific films are rated in terms of acutance values.

Acutance is a physical measure of sharpness.

Development

Acutance and sharpness are dependent on not just the film characteristics but also the type of development the film receives. "Development factors that alter edge effects, and therefore image sharpness, include developer strength, developing time, and agitation. Diluting the developer and developing for a longer time with no agitation enhances edge contrast and sharpness. Unfortunately, this procedure can also cause uneven development with some film–developer combinations. . . . One developer specifically formulated to enhance image sharpness with normal-contrast film is the Beutler High Acutance Developer,"[11] named after the man who pioneered developers of this type. The formula is:

Some film developers can increase sharpness.

Sodium sulfite (Na_2CO_3)	5.0 grams
Metol	0.5 grams
Sodium carbonate (Na_2CO_3)	5.0 grams
Water	1 liter

As you can see, it is a rather simple formula, having only a few ingredients that are readily available. You may want to give this formula a try with the film you are using. As a starting point, increase your development time to 50 percent more than your usual development time. If your normal development time is 8 minutes, try 12 minutes.

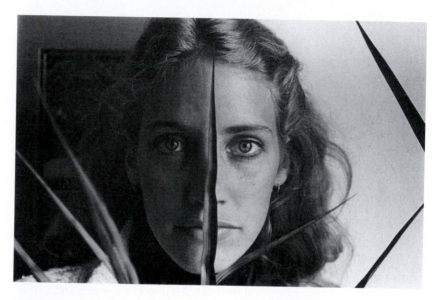

"Elizabeth." ©John Fergus-Jean. This photograph was taken by a former student of mine, John Fergus-Jean. The photograph is of his then-girlfriend, now wife/mother/artist. I know the narrow long leaf is in the front of Elizabeth's face, but why does it appear to embed itself in her nose and forehead?

KEY WORDS

acutance
adjacency effects
boundary
closure
common contour
continuation
contour
edge
ligature
Mach band

You can observe a lot by just looking around.

Yogi Berra

nystagmus
shared contour
subjective contour
virtual contour
virtual lines
visual vibrations

Josef Alber's color studies in his "Homage to a Square" series were precursors to the OpArt movement in the 1960s.

Contour Exercises

1. Common Contour

Photograph two objects located at different distance so that their contours or edges

 a) coincide (are shared).
 b) do not coincide.

2. Homage to Alber's Square

Create a photographic "Homage to a Square" by making four overlapping multiple exposures of a uniform square target and enlarging the square each time. This can be done on a computer or with a camera or enlarger. Remember that every photographic exposure increases the previous exposure and builds up density after processing. The opposite is true for reversal films.

3. Typography

Design a word so that the letters share a common contour, and with an alternating figure–ground as in this Eaton logo created by the firm of Lippincott and Margulies Inc. (Courtesy of the Eaton Corporation.)

4. Subjective Contour

Arrange some toothpicks or similar objects on a plain background so that they form a pattern that creates a virtual or subjective contour, and then photograph that pattern. Alternatively, create the patterns on a computer screen and observe the effects. Photograph them if you wish, and remember to use an exposure time longer than 1/30th of a second, or simply print them on a laser printer.

5. Sunlight, Shadow, and Mach Bands

Photograph an object in full sunlight and include the shadow. Observe closely the borderline area between sunlight and shadow. Notice a narrow half-shadow (penumbra) that exhibits a thin dark band at the shadow edge and a thin light band at the bright sunlit edge. Edward Weston's "Nude, 1936" (Figure 2.22B), photographed in bright sunlight, exhibits this Mach band phenomenon.

6. Contours and Vibrations

Visit museums, galleries, and libraries and study the paintings of Josef Albers, Victor Vasarely, Paul Signac, Georgia O'Keeffe, and others to discover how they represented edges and contours. Do the same with photographs by photographers such as Ralph Gibson, Eikoh Hosoe, and Barbara Kasten.

7. Contours and Computers

Select an image to scan that emphasizes contours. Make certain the image is cleaned well before scanning. After scanning the image, move it to a computer program such as Adobe Photoshop. Use either brightness/contrast control, levels control, or curves control and you will be able to significantly enhance the contours within your scanned image. Apply changes slowly, however, so that the visual effects of the contour enhancement can be studied.

8. Computer-Generated Contours

The color of a spot changes if its size is enlarged or reduced.

Anton Ehrenzweig

Create your own Mach band contours without a photograph by using Adobe Photoshop, Aldus Freehand, or Adobe Illustrator. Use one of the programs to draw shapes that vary in brightness and color, and fit them so that they share a common contour. In retouching programs such as Photoshop you will have to fill in selected areas with your paint bucket or paint brush. If you use a draw program such as Illustrator or Freehand you can actually draw the shapes and fill them with color afterward. Regardless of which route you follow, you will be able to explore the vivid effects of contouring.

Notes

1. Bruno Ernst, *The Magic Mirror of M. C. Escher,* New York: Ballantine Books, 1976, p. 36.
2. J. Bronowski, *The Ascent of Man,* New York: Little, Brown, 1973, p. 172.
3. Ibid., p.169.
4. Rudolf Arnheim, *Art and Visual Perception,* Berkeley: University of California Press, 1974, p. 223.
5. Ibid., p. 223.
6. Anton Ehrenzweig, *The Hidden Order of Art,* Berkeley: University of California Press, 1967, p. 155.
7. Richard Zakia, *Perceptual Quotes for Photographers,* Rochester, NY: Light Impressions, 1980, p. 92.
8. Floyd Ratliff, "Contour and Contrast," *Scientific American,* June 1972, p. 90.
9. *The Complete Letters of Vincent Van Gogh,* Greenwich, CT: New York Graphic Society, 1958, p. 277.

10. Josef Albers, *Interaction of Color,* New Haven, CT: Yale University Press, 1972, p. 62.

11. Les Stroebel, John Compton, Ira Current, and Richard Zakia, *Basic Materials and Processes,* Boston: Focal Press, 1990, pp. 265, 266.

6

Illusion and Ambiguity

Those things which are most real are the illusions I create in my paintings.

Eugene Delacroix

"Paris." ©Aaron Usher III

Even the clearest water appears opaque at great depths.

Anonymous

What we see is not identical with what is imprinted upon the eye.

Rudolf Arnheim

Illusion—contradiction between perceptual experience and its physical reality.

Illusions have been studied extensively by perceptual psychologists in an effort to understand the process of vision and to create robotic vision or machine vision. Knowledge of illusions can be useful to photographers, graphic designers, and animators in creating images that defy physical constraints.

People in the theatre and movies have created special effects for years with sight and sound. Illusions can also be used to create visual tension. Knowledge of perceptual illusions provides explanations as to why contradictions between our physical reality and our perceptual reality are part of our experience.

Illusions are real. They are real in the sense that they are perceived as being real. We deny this reality when we insist that the visual reality agree with the physical reality. There can be a difference between what we know to be and what we see.

Illusions are defined as experiences that are not in accord with physical reality. Usually when we think of illusions we think of visual illusions because vision is our dominant sense. The artist René Magritte, in his painting of a large eye titled "False Mirror," calls attention to the fact that the eye mirrors our world just as photography, the "mirror with a memory" does. The eye with its lens and iris diaphragm is but a camera. The image on the retina is not what we see. What we see is the result of millions of neurons exchanging information in the cerebral cortex of the brain. The retinal image is just the first step in the process.

All of our senses—sound, taste, touch, and smell—are subject to illusions and our language confirms this: "Your whistle sounds like that of a bird"; "This mock apple pie tastes like the real thing"; "I know it's not a silk scarf but it feels like silk"; "This new fragrance smells like roses."

TROMPE L'OEIL

Creating illusionistic images has a long recorded history that began in ancient Greece and extends to the sophisticated computer imaging we witness today. An incident was recorded by the Roman scholar Pliny regarding two Greek painters, Zeuxis and Parrhasius: "Writing about Zeuxis, who flourished about 400 BC, Pliny tells a story of his rivalry with a contemporary painter, Parrhasius. Challenged by the latter, Zeuxis drew aside the curtain covering his work to reveal a painting of grapes so realistic in effect that some birds attempted to peck them, but he had to admit defeat when, demanding that the drapery covering his rival's picture be drawn aside, he was chagrined to find the curtain itself was painted."[1]

What came to be known as *trompe l'oeil* ("fooling the eye") has taken many forms over the years including some of the graffiti we see on walls and buildings. Trompe l'oeil dealt with a type of hyper-reality where two-dimensional (2-D) images took on a realistic three-dimensional (3-D) appearance that was so convincing that one had to reach out and touch

the painting to confirm it was indeed a painting. (Some contemporary resin sculptures are so realistic that it is not unusual to see a person reach out and touch them to confirm they are not real.) "Trompe l'oeil painters . . . relied on the mutual reinforcement of illusion and expectation . . . the most successful trompe l'oeil I have ever seen was . . . a painting simulating a broken glass pane in front of a picture."[2]

A recent billboard in Times Square in New York City attests to the power artists and photographers have in fooling the eye (Figure 6.1). On a busy Broadway street corner atop a storefront is a huge photograph of a woman dressed in a fashion suit sitting on what appears to be a window ledge. Although this is a photograph, the illusion that the woman and window are three dimensional is quite convincing and it is nearly impossible to see it otherwise. The illusion is enhanced by both the size of the picture and its high location.

What we know to be physical reality is not always in accord with what we see. Illusions, like puns, can be playful, interesting, and engaging.

Allusion—a reference to something else.

A picture is something which requires as much knavery, trickery, and deceit as the preparation of a crime.

Degas

Figure 6.1 Billboard in Times Square, New York City, 1995, Richard Zakia.

SPACE, TIME, AND COLOR ILLUSIONS

There are many different types of visual illusions, but most can be placed into three broad categories; geometric, chronometric, and colorimetric. The *geometric illusions* are a result of misperception of length, size, shape, and direction. The *chronometric illusions* involve time and movement, and

colorimetric illusions testify to the fact that color is a chameleon whose perceived hue, saturation, and brightness can change with changes in the surround, color temperature of the light source, light level, and other factors (see Chapter 4).

GEOMETRIC ILLUSIONS

The whole is different from the sum of its parts.

An important aspect of human vision is that it does not see things in isolation but rather in relationships. As noted in Chapter 2, "Gestalt Grouping," the whole is different from the sum of its parts. Instruments, like 1-degree light meters "see" in isolation; humans do not. Perceptually we cannot separate figure from ground. We see them in relation to each other and that relationship determines what we see. This is the key to understanding most illusions. By controlling the background, the length, size, shape, and direction of a line can be changed.

MULLER-LYER (1889)
A and B are the same physical length,
but are seen as different.

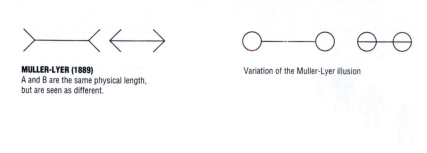

Variation of the Muller-Lyer illusion

PONZO
The two horizontal lines are the same length

OPPEL
The vertical and horizontal lines are the same length

*Draw a straight line
askew as long as it
gives the impression
of being straight.*

Degas

SANDER PARALLELOGRAM
The two dashed lines are the same length.

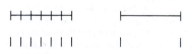

OPPEL-KUNDT
Interrupted or divided lines or spaces generally appear
to be longer than undivided ones.

Figure 6.2A Geometric illusion: length.

Figure 6.2A shows examples of illusions in which the lengths of lines appear to be different from their physical lengths. Perceptually they are different, physically they are not. If the surround were removed, we would see them as having the same length. You may want to prove this by putting a piece of tracing paper over the illustrations and tracing the lines that appear to be different lengths. You might also scan them into your computer and play around with them.

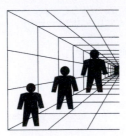

Converging lines create an illusion of depth.
All three persons are the same height. The one
furthest, however, appears the tallest. Size is
traded for distance.

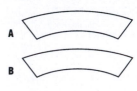

JASTROW
A and B are identical in size and shape.
A looks smaller because its bottom
curvature is in close proximity to the
larger outer curvature B.

EBBINGHAUS
The two center circles are the same size, but one
appears smaller compared to the larger circles
that surround it; the other appears larger because
of the small circles that surround it. Size is relative
to the surround.

DELBOEUF
The two inner circles are the same size.
One looks larger than the other because
of the size of the surround circle.

Figure 6.2B Geometric illusion: size.

The family of illustrations in Figure 6.2B shows how the surround
can change the appearance of the size of a visual element. Notice that some
illusions of size are just variations of others. Again, it is the relationship
between figure and ground that creates the illusion.

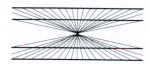

HERING
The horizontal lines bend away from
the vertex of the converging lines in
the background and appear somewhat
convex.

WUNDT
The horizontal lines bend away from the vertex
of the converging lines but now appear concave.
Both illusions have the same basis. The difference
is in the position of the verticies.

EHRENSTEIN
The angles at which the circular lines
intersect the square distort it.

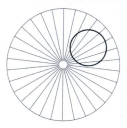

ORBISON
The angles at which the spoked lines
intersect the circle distort it.

*Why assume that to
look is to see.*

Picasso

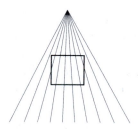

PONZO
The angles at which the converging
lines intersect the square distort it.

Figure 6.2C Geometric illusion: shape.

Figure 6.2C shows how angular and circular background lines can
change the perceived shape of a horizontal line, square, or circle. In the
Hering and Wundt illusions, horizontal lines bend and become convex
or concave depending on how the background lines intersect the hori-
zontal lines that are seen as figure. The same is true for the Ehrenstein,
Orbison, and Ponzo illusions. They are all variations of the Hering–Wundt
illusion.

This is not an optical illusion, it just looks like one.

Anonymous

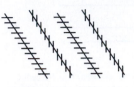

ZOLLNER
The angles at which the small lines intersect the longer parallel lines cause them to appear non-parallel. *(To prove this simply cover the even or odd lines with a pencil)*

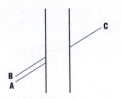

POGGENDORFF
Which line, A or B, connects with line C

Figure 6.2D Geometric illusion: direction.

How the surround can change the direction of a line is seen in Figure 6.2D. In the Zollner illusion the angle at which the short lines intersect the longer lines causes the longer lines to be seen as tilting in opposite directions. Figure cannot be separated from ground.

A number of geometric illusions are related in that the lines crossing or intersecting one another appear to bend and change shape. With the Zollner illusion the lines appear bent away from one another rather than parallel. The Hering and Wundt illusions exhibit similar characteristics. "Many other illusions are constructed on the basis . . . of an apparent tilting of certain lines away from other lines that cross them. The distortion of the square (Ehrenstein illusion) and the circle (Orbison illusion) are cases in point."[3]

In looking at something we tend to see it in such a way that it will cause the least amount of visual tension. Rudolf Arnheim gives an explanation of the bending of lines in the Hering illusion based on the principle of tension reduction (Figure 6.3):

An objectively straight line crossing a sunburst of radii bends toward the center. In this case the centric, expanding pattern creates an inhomogeneous field, in which objective straightness is no longer as devoid of tension as it would be in a homogeneous field (B). Its equivalent in the centric field would be a circular line (C) because all sections of such a line would be in the same relation to the field and to its center. The straight line in A, on the other hand, changes angle, size, and distance from the center in each of its sections. To the extent that the line gives in to the tendency toward tension-reduction we see it curving.[4]

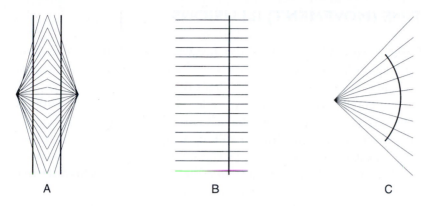

A B C

Figure 6.3 Hering illusion. Figure and ground are interdependent.

Reversibles

There is a class of illusions that could be called reversible images or "flip-flops." An article titled "Multistability in Perception" by Fred Attneave describes a number of these including the familiar *Necker cube* and works by artists Salvador Dali and Maurits Escher.[5] In Figure 6.4 all four reversible figures are related in that their geometry is similar and they are based on the initial configurations of Ernst Mach and Louis Necker.

Postage stamp, Sweden

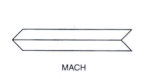

MACH

SCHRODER STAIRS

NECKER CUBE

VARIATION ON A NECKER CUBE

Figure 6.4 Reversibles. Variations on a theme; acute angles are critical to perception.

TIME (MOVEMENT) ILLUSIONS

Imagine two small lights a short distance apart in a darkened room. Number 1 light is flashed briefly, then goes off, and for a fraction of a second nothing is visible. Now number 2 light is flashed briefly, then goes off, and for a brief interval nothing is visible. The process continues with the lights going on and off. If the interval (dark time) between the light going on and off is right, the observer will see an apparent movement from 1 to 2. This illusion of movement by two stationary lights is so convincing that it cannot be distinguished from real movement. It has been referred to as the *phi phenomenon* or *stroboscopic movement*.

Without such a phenomenon, motion pictures, which are still pictures projected at a rate of 24 frames per second, would not be possible. A movie frame is projected at 1/48th of a second, followed by a dark period of 1/48th of a second (total time of 1/24th of a second per frame), and then the next frame is projected, and so on. The result is the perception of a moving image.

Movement on a video screen, which is made up of thousands of red, green, and blue phosphors (little colored lights) that go on and off, depends on the same phenomenon. A series of alternating horizontal lines of phosphors is scanned and lit up every 1/60th of a second for a total time of 1/30th of a second per still image on the screen. (To capture a still image on a video screen, the camera shutter must be set at 1/30th of a second or longer, otherwise the result will be only part of the image on the screen.)

Motion is the strongest visual appeal to attention.

Rudolf Arnheim

Computer Graphics and Animation

Computer graphics, computer animations, and multimedia lend themselves nicely to creating an illusion of 3-D on a video screen. The illusion of depth on a 2-D surface is something artists and others have worked with since Renaissance times. The depth cues being used involve perspective, overlap, texture gradient, size differences, aerial haze, motion parallax, motion perspective, and color. What adds greatly to the illusion of depth with moving images is the visual experience of movement. As objects increase and decrease in size, they appear to move forward and backward. They can move to the right and to the left, up and down, yaw, pitch, and roll—movement in every possible direction.

Colors add to the illusion—warm colors seem to move forward and cold colors recede. Movement is a powerful depth cue. Added to the other depth cues mentioned and to sound, the illusion becomes even more convincing. Sound can enhance the illusion of 3-D by increasing and decreasing in volume, in the type of sound, and also the direction it seems to come from relative to the moving image on the screen.

The greatest grace and life that a picture can have is that it expresses motion, which the painters call the spirit of the picture.

Lomazzo

The Pulfrich Effect

If one were to look at a simple pendulum movement ("A" in the marginal figure) with a dark filter or sunglass covering one eye, what would be seen is an elliptical movement (B), rather than a linear movement (A). The filter causes a delay in the signals reaching the brain from the retina. "Since the target is moving, a temporal delay corresponds to a spatial displacement: the covered eye is seeing the target with a delay in time, and thus at a spatially lagging point in its trajectory. The lag produces a stereoscopic disparity, and therefore a shift in depth."[6] This is called the *Pulfrich effect.*

The Pulfrich illusion applies not only to a linear pendulum movement but to any object in a horizontal movement relative to the eyes. "In an ordinary television picture, for example, objects moving from left to right will appear displaced in front of the screen if the right eye is covered by a filter."[7] Some years back an experimental video advertisement, based on the Pulfrich effect, successfully presented a 3-D appearance on a video screen for those who watched the television commercial with filtered viewers that had been made available.

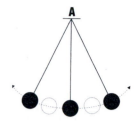

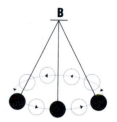

The Pulfrich effect

The Waterfall Effect

If one were to stare at a waterfall for a period of a minute or so and then look away from it, the aftereffect would be a movement of the waterfall image in an opposite direction; up instead of down. A similar illusion occurs when looking at a rotating spiral; the aftereffect is an image of the spiral rotating in the opposite direction. It seems that our perceptual system, like our biological system, tries to restore a balance and maintain equilibrium by responding in an opposite way. This happens with color as well. For example, looking at a red circle for a period of time and then away from it results in a cyan afterimage.

COLOR ILLUSIONS

The color of an object is highly dependent on its surround (see Chapter 4) and this can be used to advantage to overcome some of the physical limitations of color reproduction. Regardless of the medium used (photography, printing, Xerography, video) none will faithfully reproduce all colors. For example, a video screen is not capable of reproducing an aquamarine color correctly. The problem is not in the recording of the color but rather in the display on a video screen.

To be able to reproduce the largest gamut of color, compromises had to be made in the choice of the red, green, and blue phosphors that make up the video screen. A better reproduction with projection video is possible, however, since such a system uses red, green, and blue dichroic filters instead of phosphors.

One way to overcome the problem of reproducing an aquamarine color on a video screen is to change the surround. A red surround can strengthen the hue, saturation, and brightness of the aquamarine color (simultaneous contrast) and make it appear more correctly. A similar problem exists with other precise colors to be faithfully reproduced on a video screen such as IBM blue, Coca Cola red, and Kodak yellow. The choice of an appropriate surround color can improve the appearance of the color reproduction.

SIZE–DISTANCE TRADE-OFFS

Size and distance are interrelated. You cannot judge one without the other. Perception is relative: We see relationships. The size or distance of something is dependent on some familiar reference. Assumptions made about distance affect the perception of size and vice versa. This is the basis for a variety of interesting illusions, one of them being the Ames room illusion seen in Figure 6.5.

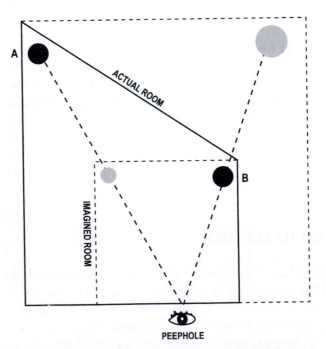

1. Black circles A and B are the same size in a distorted room.

2. The room (solid lines) as seen with one eye through a peephole is assumed to be a normal room having square corners.

3. The gray circles show the perceived size; A is seen smaller and B larger.

Figure 6.5 Ames room, top view.

The room is located in an enclosure and can only be seen from a peep-hole (one-point perspective). The viewer assumes that the walls, ceiling, and floor meet at right angles, which is what one would expect and indeed they appear that way viewed from a fixed peephole position. The fact, however, is that the room is distorted; ceiling and floor are trapezoids that slope toward each other—the right wall being smaller than the left. The floorboards are not rectangular and the far left corner of the room is twice the distance from the peephole as the right. The result is that a person B standing on the right is assumed to be the same distance as the person A on the left; and projecting person B to that distance would make the person appear much larger than he or she actually is.

The phenomenon is somewhat similar to the illusion that the moon or the sun at sunrise or sunset looks much larger at the horizon than in the sky above. Assumed distance determines size. Size–distance dependency provides opportunities for creative arrangements in imaging.

Dutch Cabinets

The Ames room illusion is an interesting variation of the early rooms created by Dutch artists in the 1600s. They would construct a normal-size room with a peephole. Inside the room were chairs, tables, walls, hangings, and so on that looked normal from only the peephole position. The rooms were called *Dutch cabinets,* and inside the room everything looked distorted when seen from another position. Samuel van Hoogstraten's "View Down a Corridor" and "Interior of a Peep Show" are wonderful examples.[8]

Nothing is more sad than the death of an illusion.

Arthur Koestler

SIZE–SIZE DEPENDENCY

Because perception is relative, the size of an object is judged on the basis of context, its relationship to other objects, and to some extent familiarity. A classic example of this is the painting, "The Listening Room" by René Magritte. An apple squeezed into a room appears to be the size of an elephant (Figure 6.6).

Illusions are perceptual realities.

Rashid Elisha

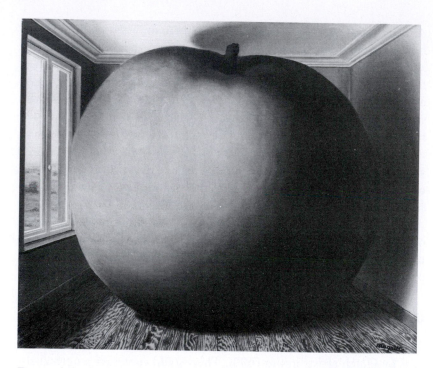

Figure 6.6 *"La Chambre d'Dcoute" ("The Listening Room"), René*
Magritte. ©C. Herscovici, Brussels/Artists Rights Association
(ARS), New York, and the Menil Collections, Houston, Texas.
The apple is seen as gigantic and filling the room. Why do we
not see it the other way; the apple as normal size and the
room being miniature?

Sketch of an early
photographic paste-
up. (Girl sitting atop
of three gigantic
peaches.)

By assuming the room is normal size there is no alternative but to
see the apple as huge, the "big apple." A question to be raised here, how-
ever, is why the room isn't seen as miniature and the apple as normal. Per-
ception of size is, of course, relative, but why does it favor one perception
and not the other? The same illusion occurs when normal-size people are
photographed or filmed in miniature settings: We see the people as giants
and not the furniture as miniature.

Magritte's "big apple" painting was done in 1952, but long before
that photographers were creating paste-ups to create a similar size–size illu-
sion. A number of them appeared on photographic postcards and can be
seen in the book *Larger Than Life*: a man standing next to a 6-foot ear of
corn; men pitching horseshoes that are about 5 feet wide; a farmer har-
vesting sweet potatoes the size of hippopotami; a little girl dressed in white
sitting atop three peaches the size of hot air balloons.[9]

Shrinking Size, Increasing Distance

A dramatic demonstration of the relationship between size and distance
requires only a white balloon and a darkened vacant stage or area. With

a spotlight on the inflated balloon, it is slowly deflated. As it becomes smaller and smaller it appears to be moving farther and farther away, distancing itself from the viewer. In fact, the balloon has not moved at all; it has merely gotten progressively smaller in size. Size determines distance and distance determines size. The two are inseparable. A video monitor and computer can be used to create the same illusion. As a white circular area with a dark surround on the screen is made to gradually become smaller, it will appear to be distancing itself.

Emmert's Law

If a person sits next to a slide projector as a slide is first projected onto a screen at a distance of about 10 feet and then onto another screen at a further distance, the person will see the second image as being larger, even though the angles of the projected image (at the projector) and the received image (at the eye), and the size of the images formed on the retina are identical for the two images. One can experience the same effect when an afterimage is projected onto surfaces at different distances from the viewer: The apparent size of the afterimage increases with the distance of the surface. The relationship between the apparent size of a projected afterimage and the distance to the projection surface is known as *Emmert's law.* The Ames room illusion exhibits a similar phenomenon.

Size–Distance Reversal

The relationship between size and distance is reversed in the playful and surreal B.C. cartoon by Johnny Hart shown in Figure 6.7. A person sitting on a rock seems absorbed in a book titled *The Law of Perspective.* A small figure in the distance approaches, but contrary to the laws of perspective and size–distance, he does not increase in size but challenges our perception by remaining the same size. In disbelief the person reading throws away the book on perspective and as he walks away into the distance increases in size instead of decreasing, as perspective and size–distance would dictate.

AMBIGUITY

Words that can take on double meanings are said to be ambiguous. They are *double entendres,* plays on words, puns. Some words called homonyms sound alike and can be used as puns: made/maid, rain/reign, board/bored, wood/would. The visual equivalent would be words that look alike: angle/angel, conservation/conversation, natural/neutral, public/pubic. During Edward Weston's career, a museum refused to display a couple of his photographs of nudes showing pubic hair. The letter from the museum

Shrinking white balloon

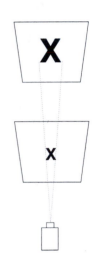

Emmert's law

The theory of perspective developed in the 15th century as a scientific convention; it is merely one way of describing space and has no absolute validity.

Herbert Read

stated that they would not display photographs showing public hair. From then on Weston referred to pubic hair as public hair.

Figure 6.7 B.C. cartoon. The world in which the law of perspective breaks down is depicted in this comic strip. (B.C. by permission of Johnny Hart and Field Enterprises, Inc.)

Because words are context dependent, they lend themselves nicely to ambiguity: "My professor's wife wakes up with a jerk"; "Our school cafeteria serves soup to nuts." Advertising thrives on such wordplay. A company wanting to increase their market share of product XXX in some of the larger cities ran a series of visually interesting ads showing the city in all its glory with headlines like *Boston Pops Over* XXX, *Chicago Goes for a Loop Over* XXX, *Don't Seattle for Less, Buy* XXX.

A wonderful cartoon that appeared some time ago in the *New Yorker* magazine shows a parking garage with a large opening for cars entering and exiting. A large sign above the garage opening reads PARK. At the opening of the garage is a beautiful park-like setting of trees, shrubs, grass, and flowers.

Pictures, like words, can take on more than one meaning and this can add to their interest or to their confusion. A simple and striking example of ambiguity in depth perception is the Necker cube, described by the Swiss geologist Louis Albert Necker in 1832. The "Impossible Triangle" devised by Lionel S. Penrose provides another example of visual ambiguity and confusion (Figure 6.8). Seen as a 2-D representation, it is confusing and impossible. It just doesn't make sense. Isolating the three connecting angles from the triangular shape will reveal the source of the confusion (Figure 6.9).

Some surrealist artists play hide-and-seek with the beholder, producing ambiguous pictures susceptible to different mutually exclusive views.

Rudolf Arnheim

Figure 6.8 *"Penrose Illusion." ©Thomas J. Shillea. Photographing this model of the Penrose triangular form from a carefully selected position reduces the three-dimensional model to a two-dimensional illusion. From another perspective it would look quite different, not as a closed form but an open one.*

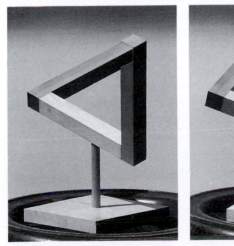

Figure 6.9 *The Penrose illusion in 3-D. A three-dimensional model of the Penrose illusion photographed from two different camera positions. (Three-dimensional model courtesy of Richard N. Norman.)*

Necker cube

Sketch of "Bull's Head" by Picasso[11]

The works of Maurits Escher rely on some of the same techniques to create ambiguity in depth and impossible construction as do the works of Salvador Dali, and others. They used their talent to exploit the dual interpretation that can be given an image. "The game had been played before in the 17th century by Archimboldo, who enjoyed creating two totally different interpretations of the same composition—a man's head could equally well be a pile of fruit."[10]

Picasso is noted for his visual double entendres. In one of them he used a bicycle seat and handle bars to create a sculpture of a bull's head, if you care to see it that way. The correspondence of what is and what appears to be can also be thought of as a structural equivalent or simply as a visual simile—it looks like a bull's head. In any case discovering such connections is a creative process independent of the medium used.

Photographers have used ambiguity to add interest and sometimes puzzlement in their photographs. Edward Weston's "Eroded Rock No. 51, 1930" (see Chapter 3, Figure 3.1) again comes to mind. It is a picture of a rock formation lying on a pebbled surface. The surface is a dark gray and the rock formation is just above a middle gray tone (a zone VI flesh tone). Is the picture that of an eroded rock as the caption states or of a reclining nude figure? In his diaries edited by Nancy Newhall, Weston wrote: "Clouds, torsos, shells, peppers, trees, rocks, smokestacks are but interdependent, interrelated parts of a whole, which is life. Life rhythms felt in no matter what, become symbols of the whole."[12]

Objects having one form can be seen as taking on another form, a similar form. This similarity of form is called *isomorphism* and it creates interest and involves the viewer. It is an invitation to creatively participate in the viewing of the image. In Chapter 7, "The Morphics," this will be expanded further.

Recording unfelt facts by acquired rule results in a sterile inventory.

Edward Weston

Visual illusions are visual realities. We see what we see.

"Untitled," Barry Myers. Breaking up or interrupting space can make an object appear longer. Here, an Italian policeman sitting at his desk seems to have a rather long left leg. Not only does the leg look longer than it actually is, the man appears to be standing as well as sitting.

KEY WORDS

Ames room
chronometric illusions
colorimetric illusions
double entendre
Emmert's law
geometric illusions
illusion
isomorphism
Necker cube

phi phenomenon
Pulfrich effect
stroboscopic movement
trompe l'oeil

Illusion and Ambiguity Exercises

1. Adjusting the Illusion

Refer to the Muller-Lyer illusion shown in the margin. Try extending the horizontal line in B so that it appears to be the same length as that in A. How much increase was required?

2. Visual Geometry

Play with some of the illusions in Figures 6.2A–D to discover discrepancies between the physical geometry and the visual geometry.

3. Visual Puns

Think up some verbal puns and contradictions (oxymorons) and translate them into visual form. Examples: "The object fell to the ceiling"; "My friend is stone sober"; "The fleecy cloud in the sky weighs a ton"; "The 10-ton boulder floats like a feather in the sky."

4. Visual Double Entendres

Photograph one thing so that it looks like something else as Weston did with his rock formation, peppers, and other vegetables.

5. The Big Apple

The Belgian artist René Magritte was a master of visual pun and paradox. Try creating a variation of his 1952 painting titled "The Listening Room" (Figure 6.6) that had what appeared to be a gigantic apple in a normal-size room. Trade size for size as he did. Use a camera, a PC, or simply create it by hand as Magritte did. (Graphic designer Milton Glaser created a Magritte-inspired variation in 1978 by putting what appears to be a huge tomato in a chair surrounded by a fancy, flowery carpet and wall.)

6. Emmert's Law

Stare steadily at a lighted opalized household light bulb from a distance of a few feet until the bulb appears to decrease noticeably in brightness, which usually occurs within 30 seconds. Then look at a sheet of white paper held at arm's length. You should see a dark afterimage that is the same shape as the light bulb. After a few seconds shift your gaze to a white or light-colored surface on the opposite side of the room and note any change in the apparent size of the afterimage. If the afterimage quickly disappears, it may be revived by blinking your eyes. (Never stare at the

sun or a laser or arc light source, as such intense sources can damage your retina.)

7. One-Point Camera Perspective

Arrange some string or rope in such a way that from a camera position it takes on a shape that is of interest relative to its surround. The photographer John Pfahl in his early book, *Altered Landscapes,*[13] made a number of such photographs.

8. Found Illusions

An entire art form occurred some years ago based on "found objects." Marcel Duchamp, Dada artists, and others led the way. With your camera in hand, keep an eye out for potential photographic illusions. Here is one I found as I walked down a motel corridor to my room. At first I thought the framed window at the end of the corridor was a large mural of a palm tree.

9. Paste-Up or Scan-In

Long before computers and scanners arrived on the imaging scene, photographers altered reality by doing "paste-ups." Photographic hair implants were put on the pictures of bald-headed men, students pasted portraits of themselves on the covers of national magazines such as *Time* and *Vogue,* and then photographed the combination. It is much easier to create such combination pictures with electronic imaging, but it is still a lot of fun doing it by hand. In any case, regardless of how it is done, the most important thing is the idea. "Creativity drives the technology." Try your hand and use your imagination to create such images.

Creativity is a radical necessity, not a luxury.

Jean Houston

Notes

1. Martin Battersby, *Trompe l'Oeil,* New York: St Martin's Press, 1974, p. 9.
2. E. H. Gombrich, *Art and Illusion,* Princeton, NJ: Princeton University Press, 1969, p. 207.
3. Irving Rock, *An Introduction to Perception,* New York: Macmillan, 1975, p. 401.
4. Rudolf Arnheim, *Art and Visual Perception,* Berkeley: University of California Press, 1974, p. 420
5. Fred Attneave, "Multistability in Perception," *Scientific American,* December 1971.
6. Richard L. Gregory (ed.), *The Oxford Companion to the Mind,* New York: Oxford University Press, 1991, p. 663.
7. Ibid., p. 663.
8. M. L. d'Otrange Masti, *Illusions in Art,* New York: Abaris Books, 1975, p. 191.

9. Cynthia Rubin and Morgan Williams, *Larger Than Life,* New York: Abbeville Press, 1990.

10. R. L. Gregory and E. H. Gombrich (eds.), *Illusions,* New York: Charles Scribner's Sons, 1973, p. 276.

11. Ibid, p. 244.

12. Nancy Newhall (ed.), *Edward Weston,* New York: Aperture, 1971, p. 41.

13. John Pfahl, *Altered Landscapes,* Carmel, CA: Friends of Photography, 1981.

7

The Morphics

Isomorphic, Anthropomorphic, Zoomorphic, Theriomorphic, Mechanomorphic, Anamorphic, Polymorphic, Amorphic

"Saguaro Cacti Couple, Arizona." ©Jennifer Steensma.

*Early primitive
anthropomorph*

1. Projection
2. Introjection
3. Confluence

The word *morphic* is from the Greek word *morphos,* which means "form" or "shape." I recall giving a lecture on what I called "The Morphics" and having a Korean student inquire in private, "What's the word morphic mean?" I said that it simply meant form. She then politely advised, well, why didn't I use that word instead of morph? (*Morph* was not in her Korean/English dictionary.) I thanked her and used her suggestion in subsequent lectures.

This chapter on morphics is about form, and the different forms objects can take and be photographed as. Or put differently, we seek out and try to discover and then photograph the various forms that objects can express. A particular object such as a rock or cloud, for example, might be photographed so that it resembles something else such as a person, an animal, or a deity. Words that describe such resemblances include these:

- *Isomorphic* — having similar form,
- *Anthropomorphic* — having human form,
- *Zoomorphic* — having animal form,
- *Theriomorphic* — having beastly, scary form,
- *Mechanomorphic* — having mechanical form, and
- *Anamorphic* — having a distorted form.

A form that can take on and represent a number of other forms is called *polymorphic.* Something that has no form, such as the wind, is called *amorphic.*

Seeing and photographing objects as if they possessed human attributes is a form of *animism,* the belief that things animate and inanimate possess a soul. It is an old idea. Pythagoras and Plato hypothesized that there was an immaterial force present everywhere that animated the universe.

The Oxford Companion to the Mind defines animism in this way: "The belief, common among primitive peoples, that all things in the world (including stones, plants, the wind, etc.) are imbued with some kind of spiritual or psychological presence; this may imply that things are 'ensouled' or 'animated' by a universal 'world soul' or by individual spirits of various kinds."[1] How strongly one believes or disbelieves in animism is a personal matter.

What is important, I believe, is the relationship that photographers develop with whatever they are photographing, be it a person, a tree, a stone, a landscape, a flower, or whatever. The relationship established between the photographer and what is being photographed is a critical one. At least three different approaches are possible. The first is called *projection;* the photographer projects onto the object what he or she feels at the time. If the object is a tree and the photographer sees the tree as standing tall and proud, then the photographer attempts to capture that feeling. The next level is one of *introjection.* Here the photographer spends time looking at the tree and studying it in a quiet way, attempting to "listen" to what the tree has to reveal. The photographer then tries to photograph that quality of the tree. The third approach, *confluence,* is a highly

meditative one in which the tree and the photographer become as one and the photograph reveals that intimate relationship. (In Chapter 8, I explore these three approaches in terms of personality in photography.)

Native American Indians would put on the skins of animals such as deer or buffalo and become one with them, taking on their characteristics as they prepared for the hunt. The practice, in a way, exists today in sports with teams such as the Atlanta Falcons, Buffalo Bills, Chicago Bears, Cincinnati Bengals, Detroit Lions, Los Angeles Rams, Miami Dolphins, Philadelphia Eagles, and so on. The same can be said of the names given to perfumes that women put on: Tabu, Opium, Passion, Beautiful, Temptation. If a person becomes one with what they "put on," they can assume the characteristics of what is put on—glamour, sensuality, beauty, risk, danger, strength, power, or whatever. Music is also a "put on," and our body and mind respond to its tempo and rhythm. In some way, when we put something on, depending on what our needs are, we can try to connect with someone or something else.

The photographer Aaron Siskind, when asked about the meaning of some of his photographs, pondered the question and after some thought responded, "Pressed for the meaning of these pictures, I should answer; obliquely, that they are informed with animism. . . . Aesthetically, they pretend to the resolution of . . . sometimes fierce, sometimes gentle, but always conflicting forces. . . ."[2] What we photograph becomes representative of our experiences at the time.

As a child, I noticed my mom and some of the women in the neighborhood talking to their flowers when they watered them. As a kid I thought it strange, but as I grew older I began to understand.

ISOMORPHIC

The word *isomorphism,* as used by the Gestalt psychologists in the early 1900s, suggested that there was a correspondence between what was looked at and how the brain functioned; between the stimulus pattern and the excitatory fields in the cerebral cortex. Used here, it refers to objects and things having the same or similar form or function. Turbulent water; for example, can be photographed in such a way that it looks like, takes on the appearance of, the turbulence of a flaming fire as seen in Figure 7.1.

When I looked at things for what they are I was fool enough to persist in my folly and found that each photograph was a mirror of my Self.

Minor White

Courtesy of the Buffalo Bills.

A man walks into an antique shop and asks "What's new?"

Marshall McLuhan

I attempt through much of my work to animate all things— even the so-called inanimate objects.

Clarence Laughlin

Figure 7.1 "Maine." ©Robert Walch. Isomorphism: Oncoming waves of water splashing against dark rocks take on the qualities of a flaming fire. Opposites can be seen as similar in shape and form.

Edward Weston's "Eroded Rock No. 51, 1930" (shown in Chapter 3, Figure 3.1), which resembles a reclining torso, is another example of isomorphism.[3] As photographed, it has a structure similar to that of a reclining nude. We relate and transfer meaning to those things that are similar; similar in form, shape, color, position, and so on. In short, we associate those things that have something in common. Other words that have been used to express similarity of form or function are as follows:

Correspondence by the Swedish scientist Swedenborg,
Predicate thinking by the Austrian psychiatrist Sigmund Freud,
Structural equivalent by the French poet Baudelaire, and
Equivalent by the American photographer Alfred Stieglitz.

The term *predicate thinking* was used by Freud to describe associations that are made at a subconscious or unconscious level. "The tendency of the id to treat objects as though they were the same in spite of differences between them, produces a distorted form of thinking which is called predicate thinking. When two objects, for instance a tree and a male sex organ, are equated in a person's mind because they both share the same physical characteristic of protruding, that person is doing predicate thinking."[5] Edward Weston's photograph, "Palma Cuernavaca II, 1925" is a possible example.[6] The original photograph was a vertical platinum print,

My God, Edward, your last photographs surely took my breath away, they contain both the innocence of natural things and the morbidity of a sophisticated distorted mind. They are mystical and erotic.

Tina Modotti[4] (in reference to Weston's shell photographs).

which shows only the middle section of the palm tree trunk against a bare black background. The top and bottom of the tree are not shown, only the trunk of the palm, somewhat like the middle section of a smoke stack.

Examples of objects and pictures suggesting a male sex organ have a long history, and how they are to be interpreted must be looked at in terms of both the culture and historical time. Barbara Walker writes that "Phallic symbols are objects of either overt or covert worship in all patriarchal societies. . . ."[7] As examples, she cites the pillars in India as representations of the lingam of Shiva, the Egyptian obelisk as representing the penis of Geb, and in Greece, the phallic pillar of the classic Herm.

Humans are very aware of and concerned about their own bodies. Advertising companies are well aware of and attentive to this fact. Cosmetic products and jewelry capitalize on this concern. A careful look at the ads in any magazine, on billboards, or on television will readily confirm this. In looking at ads attend not to just what is being shown but, more importantly, what is being suggested.

Shiva: the god of destruction and reproduction, a member of the Hindu triad along with Brahma and Vishnu.

Packaging design has not been blind to the power of the phallus to sell products. A number of packaged products in recent years resemble the pillars in India and Greece. These packaged pillars are contemporary, commercialized, sculptured equivalents. In his book *Visual Communication,* Paul Martin Lester writes: "Liquor, lipstick and cigarette advertisers also commonly use phallic imagery in the form of products' shape in the hope that potential customers will link the use of their products with possible sexual conquest."[8]

Herm: A statue of the head of the Greek god Hemmimes mounted on a stone post.

Graffiti can be looked on as a form of advertising—of making a public statement. It has its own interesting history. It is an old art form that can be traced as far back as the scrawls on the walls of Neolithic caves. Some of the graffiti that litters the walls of buildings, bridges, and subways, particularly in large cities, mimic these scrawls. The intents of modern man and Neolithic man may differ; but the symbolism used is similar. (The title of one of Nathan Lyons books came from graffiti someone had sprayed on a wall, "Riding First Class on the Titanic.")

Predicate thinking, mentioned earlier, is not limited to the visual mode and can occur in any modality, including the verbal. Freudian slips are examples of predicate thinking. At a gala reception one evening an announcer introduced the singer for the evening (a prominent entertainer with quite a loose reputation) in this way: "Ladies and gentlemen let's all give a warm welcome to our wonderful sinner from California. . . ." That was a verbal slip. Freudian slips can also be visual and many are, as some photographs and paintings will testify. Secondary images in paintings and photographs or other visual media can be considered visual Freudian slips, unless, of course, they are intentional. (In Chapter 9 on subliminals, I will explore this idea further.)

ANTHROPOMORPHIC

The prefix *anthro,* from the Greek *anthropos,* means "man." Anthropology is the study of man. *Anthropomorphic* refers to objects that can take on human form. The practice of attributing human characteristics to inanimate objects has a long history. Ancient drawings have been found in which facial features have been added to pictures of the sun, and no doubt early man as well as modern man was able to visualize a face on a full moon. Humans have a propensity to see faces in things. Facial patterns are one of the most distinguishing features among humans. "It can be argued and has been argued, that we respond with particular readiness to certain configurations of biological significance for our survival. The recognition of the human face, in this argument, is not wholly learned. It is based on some kind of inborn disposition. Whenever anything remotely face-like enters our field of vision, we are alerted and respond."[9]

Today, electronic photography provides all kinds of opportunities to anthropomorphize digitized images. Although this can provide challenges and be fun, there is still a wonderful sense of discovery in locating actual objects in the environment that exhibit human qualities. This not only provides the photographer with an exciting feeling of discovery, but when the photograph is executed with finesse, it provides the viewer with a similar feeling.

In the July 2001 issue of *Shutterbug,* George Schaub in his "Editor's Notes" writes, "In many cases the computer constructs of images rarely matches those scenes and moments available to the photographer's searching eye. Awareness is what separates us from machines, and awareness is gained through an artistic perception tuned into the harmony and discord of the world."

ZOOMORPHIC

It can be fun to discover inanimate objects in the environment that appear to take on animal forms. *Zoomorphic* (pronounced "zoh-mor-fic") is the term used to describe such a characteristic.

Many of the early gods and goddesses were represented as animals. "There is abundant evidence throughout the world that primitive human beings regarded animals as highly spiritual creatures, even deities. The human-bodied, animal-headed gods and goddesses of Egypt were obviously priests and priestesses costumed as animal spirits, wearing elaborate headdresses and masks. . . ."[10] (see Figure 7.2).

Figure 7.2 *"Sphinx and Pyramid," 1944, Captain Les Stroebel. The monumental Sphinx with the head of a man and the body of a lion represents an Egyptian deity.*

Zoomorphic expressions are often used in fashion design and in advertising. One of the prime examples is that of jewelry and leather products such as shoes and handbags taking on the qualities of a serpent. The snake/serpent was one of the oldest symbols of female power. Together, snake and serpent were considered holy in early civilization, since both seemed to possess the power of life.[11] One reason some ads are so effective is that they are able to continually transform myths and fairy tales into contemporary images using both old and new iconography.

Whilst part of what we perceive comes to us through our senses from the object before us, another part (and it may be the larger part) always comes out of our minds.

William James

THERIOMORPHIC

Forms that take on the characteristics of an imaginary beast are said to be *theriomorphic.* The term also pertains to a deity worshipped in the form of a beast. Theriomorphic representations have frightening appearances, such as the beastly gargoyles invented in the Middle Ages during the great age of cathedral building. Gargoyles can be found on many Gothic cathedrals. They took on theriomorphic forms and were used to scare away evil spirits. Some were used as decorative water spouts.[12]

Creation of beastly, theriomorphic objects and images preceded the Middle Ages by many years and continues to this day in horror tales and horror movies, and will undoubtedly continue in the future. Early on, shamans and witch doctors made use of theriomorphic masks, many of which now adorn museums throughout the world. Halloween gives children an early encounter with theriomorphic masks. History has much to tell us about our culture and rituals; one has only to look at how some products are advertised (Figure 7.3) and at what passes as entertainment.

Figure 7.3 *Theriomorphic. Contemporary gargoyles in a surreal setting. "Pure Mischief." (Courtesy Smirnoff.)*

Man can frame to himself ideas of things that are not actual as though they were actual.

Hegel

MECHANOMORPHIC

The converse of anthropomorphic is *mechanomorpic,* in which a human subject, or a picture of a person, is perceived as having mechanical characteristics (Figure 7.4).

*Figure 7.4 "Consumer Service," Vincent Comparetto. A mechanomorphic
image using mixed media.*

Thus, an elbow can be seen as a hinge, and as many young children
have observed, when the hands are clasped together, "Here's a church, here's
the steeple, open the doors and see all the people."

Photomontage provided early photographers a means of manipulat-
ing photographs to make social and political statements visually. A Ger-
man artist, Helmut Herzfelde, who assumed the English name John
Heartfield as a protest of Adolf Hitler's Nazi regime, was prominent in
using photomontage to show the mechanical nature of the regime. The
Dada artist Picabia created many mechanomorphic pictures, most with
strong sexual statements. He was fascinated by machines and the use of
machine parts to represent human features and human functions. On a
visit to New York City in 1915, he declared, ". . . upon coming to Amer-
ica it flashed to me the genius of the modern world is in machinery and
that through machinery art ought to find a most vivid expression. . . . I
mean to work on and on until I attain the pinnacle of mechanical sym-
bolism."[13] (One could substitute computers for machines in this quote
to reflect some of today's images.)

*I want to reveal in
my work the idea
that hides itself
behind the so-called
reality.*

Max Beckman

ANAMORPHIC

The word *anamorphic* refers to a distorted image that can be re-formed
visually, optically, or electronically using computers. It is forming anew,
transforming, from the Greek *ana* (again) and *morphos* (form).

Anyone who has looked at their reflection in a nonflat mirror, such as one found in an amusement park, has seen a distorted image that is very difficult to reform into a normal image. Reflections from any non-flat, reflecting surface will distort an image. The mirror-like surface of Mylar, a thin and flexible sheeting, can be twisted into a variety of curved surfaces and has been widely used to create anamorphic images.

Perhaps the most famous anamorphic image in art, "The Ambassadors," was painted in 1533 by Hans Holbein. Two gentlemen are standing side by side alongside expensive nautical instruments. In the bottom middle of the painting is a large, skewed, distorted image. When squinted at from the right-hand side of the frame, the distorted image is transformed into a skull—a reminder of the vanity of earthly possessions and power, and life's end.

One of the interesting aspects of Hans Holbein's painting is that only part of the image is distorted; the larger part is seen in normal perspective. When a camera or enlarger is used to create an anamorphic image, the entire image is distorted. This is unavoidable since conventional photography is an analog system of image creation. With electronic photography, however, photographs can be scanned and digitized, lending themselves to partial or complete distortion as well as to every conceivable form of image manipulation.

Albrecht Dürer in 1506 had made reference to anamorphic images as having a "secret perspective"—a point of view that allows the distorted image to be reformed and seen in its proper perspective. Anamorphic images can be found in early Chinese art where the technique was used to hide erotic images—images that could only be seen from a "secret perspective."

One of the earliest anamorphic photographic images was a self-portrait made in 1888 by a French photographer and experimenter, Ducos du Hauron (Figure 7.5). He distorted the camera image by using crossed slits instead of a lens. ". . . [H]is technique was published in amateur magazines as 'trick photography'—along with anamorphic images, exaggerated perspective, 'worm's-eye' and 'bird's-eye' views, double exposures, composite prints, photomontages. A whole book of them [these special effects] was published in 1896 under the title, *Photographic Amusements*."[14] The creative and effective use of anamorphic technique in an advertisement is shown in Figure 7.6.

Figure 7.5 *Anamorphic. An early photographic anamorphic image; a self-portrait created by Ducos du Hauron in 1888. (George Eastman House.)*

This overhead photograph of a runner, legs extended and exaggerated, and the dynamic composition, give a feeling of the enormous strides runners must take to win an event—to be a winner. And by analogy, this winning spirit reflects the product advertised.

(Courtesy Eastman Kodak.)

Figure 7.6 *Anamorphic ad.*

A few years ago while at a conference in Stockholm, Sweden, I came upon a metal gate made up of anamorphic letters. After taking a photograph of the gate, I tried to make out what the letters spelled. Later I made a line drawing from the photograph to make the letters stand out more clearly (Figure 7.7).

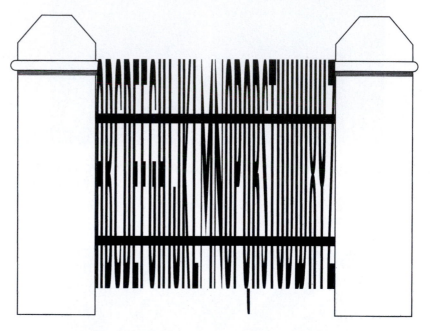

Figure 7.7 Anamorphic Gate, Stockholm, Sweden. Re-form the anamorphic letters on the gate and discover what is being stated. (See Appendix B, "Answers to Selected Exercises," if necessary.)

I began looking at the letters from different perspectives hoping to re-form them. I was successful in re-forming many of the letters but could not make out any words. Not knowing whether the words were in English or Swedish added to the problem. After some time, however, I did succeed.

"Reclining Figure." ©*Deborah Ditchoff.*

KEY WORDS

amorphic

anamorphic

animism

anthropomorphic

confluence

correspondence

equivalent

introjection

isomorphic

mechanomorphic

morphos

numen

polymorphic

predicate thinking

projection

structural equivalent

theriomorphic

zoomorphic

The mysterious way in which shapes and marks can be made to signify and suggest other things beyond themselves had intrigued me since my student days.

E. H. Gombrich

Morphics Exercises

1. Morphics

Look at some of the photographs of early photographers such as Wynn Bullock, Clarence Laughlin, Minor White, Frederick Sommer, André Kertész, and Bill Brandt to discover examples of the various morphics.

2. More Morphics

Create a series of photographs that suggest:

> Isomorphics (similar forms),
> Anthropomorphics (human forms),
> Zoomorphics (animal forms),
> Mechanomorphics (machine forms), and
> Theriomorphics (beastly forms).

3. Predicate Thinking

Search out photographs, paintings, and advertisements that may suggest predicate thinking. Review some of the photographs of Guy Bourdin, Helmut Newton, Paul Outerbridge, and paintings by Georgia O'Keeffe.

4. Anamorphics

Make several photographs having distorted images that can be visually reformed. This can be done in a number of ways: by the use of a special anamorphic lens on a camera or enlarger, by tilting the film plane in a view camera or the easel on an enlarger, by bending or buckling the printing paper, or by photographing images reflected from nonflat surfaces, shadows that fall on curved surfaces, and shadows that are compressed or stretched due to the angle of the sun or other light source.

5. More Anna Morphics

If you have access to a computer imaging system, scan in some of your photographs and try distorting them in interesting ways. Distort part of the image or the entire image. You might even try scanning in photographs that are distorted and using the computer to try to correct the distortion. (In wide-screen cinematography, anamorphic lenses are used on the camera and projector to "squeeze" a wide-angle scene onto standard-width film and then "unsqueeze" the anamorphic film image when it is projected onto a wide screen.)

6. Animistic Photographs

Think about this statement by the anthropologist Ladislas Segy, and try to create photographs that support his statement:

> *The unrecognized part of man's psyche below the threshold of consciousness, defies understanding in terms of causality . . . this is the domain of Being, the transrational, transpersonal, nondimensional region of the mind in which man's intuitive faculties are rooted. By reanimating his*

Being, man is able to sense and experience that essential part of reality which is numinous, which being beyond phenomenon gives a sacred dimension to his existence. All men have the potential to "take Being out of concealment" as Heidegger put it.[15]

"Domain of Being," George DeWolfe. "With my camera, I bring my hands together in prayer as I patiently wait for the all-consuming mystery of nature to reveal itself—a mystery of oneness—of primordial energy—one in which I and nature share a unique private moment."[16]

To create an image is to pay ultimate respect to the divine in life. To open other's eyes to the world through that image is to touch a part of that divinity.

George Schaub

7. Photography as Prayer

When asked why he photographed, Don Doll, a Jesuit priest, noted photographer, and friend, remarked, "For me photography is a form of prayer." Minor White, on a similar note while at MIT in the 1960s, put together a photographic exhibition called "Octave of Prayer." Prayer takes on many forms. Think of this as you photograph and try to capture the spirit in nature, in people, in animals, and in all forms of the animate and inanimate.

numinous: spiritually elevated;
numen: the spirit believed by animists to inhabit certain natural objects.

My photography is the best way I know of bringing me closer to some of the mysteries of existence.

Wynn Bullock

Notes

1. Richard L. Gregory (ed.), *The Oxford Companion to the Mind,* New York: Oxford University Press, 1991, p. 27.
2. Carl Chiarenza, *Aaron Siskind and His Critics, 1946–1966,* Tucson: Center for Creative Photography, University of Arizona, 1978, p. 7.

O' Great Spirit, whose voice I hear in the winds . . . hear me . . .

American Indian Prayer

3. Nancy Newhall (ed.), *Edward Weston,* New York: Aperture, 1971, p. 40.

4. Ibid., p. 23.

5. Calvin S. Hall, *A Primer of Freudian Psychology,* New York: New American Library, 1954, p. 40.

6. Beaumont Newhall, *The History of Photography,* New York: Museum of Modern Art, 1964, p. 124.

7. Barbara Walker, *The Woman's Dictionary of Symbols and Sacred Objects,* San Francisco: Harper & Row, 1988, p. 321.

8. Paul Martin Lester, *Visual Communication,* Belmont, CA: Wadsworth Publishing, 1995, p. 66.

9. E. H. Gombrich, *Art and Illusion,* Princeton, NJ: Princeton University Press, 1969, p. 103.

10. Walker, *The Women's Dictionary,* p. 360.

11. James Hall, *Dictionary of Subject and Symbols in Art,* New York: Harper & Row, 1979, p. 20.

12. Harold Osborn (ed.), *The Oxford Companion to Art,* London: Oxford University Press, 1975.

13. Robert Hughes, *The Shock of the New,* New York: Alfred Knopf, 1981, p. 51.

14. Newhall, *The History of Photography,* p. 162.

15. Ladislas Segy, *Masks of Black Africa,* New York: Dover, 1976, p. 18.

16. George DeWolfe, private communication, August 15, 1998.

8
Personality

I photograph to heighten and strengthen my awareness of the sublime beauty and grandeur of nature—to become one with nature.

Thomas L. McCartney

"Mount McKinley, Alaska." ©Thomas L. McCartney.

*Tain't what you do,
it's the way you do it.*

Fats Waller

Personalities are unique and so are photographs. Photographs can and do exhibit personalities, the personality of the photographer. Some understanding of personality differences can be helpful in relating to different kinds of photographs and to other people. It requires us to see things from different points of view; even though we may not relate or agree with them.

PROJECTION, INTROJECTION, AND CONFLUENCE

In Chapter 7, "The Morphics," we stated that photographers can relate to the things they photograph in three different ways: projection, introjection, and confluence. In *projection,* the photographer projects onto the object what he or she feels. With *introjection,* the photographer tries to understand the essential quality or essence of whatever he or she is photographing and then to capture it on film, tape, or disk. In *confluence,* the photographer and the subject become one.

Projection

*Sometimes trees strike
me as laughing or
crying and occasion-
ally as nurturing or
even threatening.*

John Sexton

As originally defined by Freud, projection is one of several defense mechanisms used for protection against certain anxieties. Thus, if people feel anxious because they dislike someone without cause, projection enables them to convert "I hate him" into "He hates me" and allows them to express their impulses under the guise of defending themselves against an enemy.

A broad view of projection suggests that people can find expression for many of their feelings and thoughts by projection onto the environment, including people, animals, pictures, motion pictures, television, music, and a variety of objects.

One of the oldest projective techniques is the word-association or free-association test. A word is presented and the subject responds quickly with the first word that comes to mind. The type of word used and the length of time required for a response are clues for identifying certain personality characteristics. The more ambiguous a projective test, the more the subjects depend on their own memories, feelings, and thoughts to make the word stimulus meaningful.

The *Rorschach test* consists of a series of ambiguous ink blots that were designed to arouse emotional responses. The test was devised by the Swiss psychiatrist Hermann Rorschach after discovering, during some experimental studies in form perception, that certain forms produced quite different responses among his patients. Rorschach's diagnostic method was reported in 1921.

The *Thematic Apperception Test (TAT),* worked out by Henry Murray and his colleagues in 1938, requires the subject to interpret a somewhat ambiguous picture by telling a story. The person attempts to reconstruct the events that led up to the situation presented in the pic-

tures and to predict the outcome. The responses can reveal significant information about the subject's experiences, memories, anxieties, feelings, needs, and aspirations. Essentially, subjects project themselves into the picture and identify with one of the characters represented.

Projective techniques can be useful in triggering ideas for creating photographs. During the Renaissance period Botticelli remarked to Leonardo da Vinci that ". . . by merely throwing a sponge full of paint at the wall it leaves a blot where one sees a fine landscape."[1] Leonardo agreed and added that in such a blot of paint you may see whatever you wish to see in it.

In his "Treatise on Painting," Leonardo speaks of this method of "quickening the spirit of invention":

> *You should look at certain walls stained with damp, or at stones of uneven colour. If you have to invent some backgrounds you will be able to see in these the likeness of divine landscapes, adorned with mountains, ruins, rocks, woods, great plains, hills and valleys in great variety; and then again you will see there battles and strange figures in violent action, expressions of faces and clothes and an infinity of things which you will be able to reduce to their complete and proper forms. In such walls the same thing happens as in the sound of bells, in whose stroke you may find every named word which you can imagine.[2]*

Chinese artists used projective techniques to "quicken the spirit" long before the Renaissance painters did. An 11th-century artist, Sung Ti, is reported to have criticized the landscape paintings of a fellow artist in this way:

> *The technique in this is very good but there is a want of natural effect. You should choose an old tumbledown wall and throw over it a piece of white silk. Then, morning and evening you should gaze at it until, at length, you can see the ruins through the silk, its prominences, its levels, its zig-zags, and its cleavages, storing them up in your mind and fixing them in your eyes. Make the prominences your mountains, the lower part your water; the hollows your ravines, the cracks your streams, the lighter parts your nearest points, the darker parts your more distant points. Get all these thoroughly into you, and soon you will see men, birds, plants, and trees, flying and moving among them. You may then apply your brush according to your fancy, and the result will be of heaven, not men.[3]*

Projective techniques used in a superficial way will lead to superficial images. Used with great concentration and imagination, in which the heart, mind, and memory unite, the projective technique can quicken the spirit and serve as a launching pad to creativity. Projection can be used as a mirror reflecting only the personal concerns of the photographer or as a window to the mystery of the world and universe. Minor White in *Mirrors, Messages and Manifestations,*[4] was perhaps alluding, in some way, to this.

I am unable to make any distinction between the feeling I get from life and the way I translate that feeling into painting.

Henri Matisse

The mind of the painter must resemble a mirror which permanently transforms itself into the color of its objects and fills itself with as many images as there are things placed in front of it.

Leonardo da Vinci

For me form is never abstract. It is always a sign for something. It is always a man, a bird, or something else.

Joan Miro

Photographer and art historian Dr. Carl Chiarenza, a student of Minor White when White taught at the Rochester Institute of Technology, uses projection in a very unique and creative way to arrive at his *Landscapes of the Mind.*[5] In his home studio, Carl arranges still-life landscapes using torn and crumpled pieces of various kinds of paper; cellophane, aluminum foil, and other material. He then spends hours arranging the crumpled material and the lighting, studying it quietly and reverently, rearranging it as the spirit moves him and then photographing it with Polaroid negative/print film. The print is studied and the negative is then projected with an enlarger. The image on the easel is again studied in the quiet darkness where it is further played with and manipulated using burning and dodging techniques. The result is a never-seen-before imaginative landscape that is somewhat understated, allowing the viewer, in the words of the anthropologist Ladislas Segy, ". . . to place himself in the action and complete it in his own imagination—and thereby enable him to share the creative process with the artist.[6]

New Orleans photographer Clarence John Laughlin (1905–1985) used projection to give life to what he photographed. "I attempt, through much of my work, to animate all things—even so-called 'inanimate objects'— with the spirit of man. I have come, by degrees, to realize that this extremely animistic projection rises, ultimately, from my profound fear and disquiet over the accelerating mechanization of man's life; and all the resultant attempts to stamp out individuality in all spheres of man's activities. . . ."[7]

The art critic Michael Brenson calls attention to the primal energy he finds in Van Gogh's paintings: "The foliage in Van Gogh's paintings is so alive, so much a cauldron of primal energy, darkness and light, that it shoots us back to the ages of animism and tree worship. . . . It is in the trees that we see most clearly the degree to which Van Gogh personified and projected himself into the natural world."[8]

Introjection

The title that John Sexton used for one of his books, *Listen to the Trees,* can be thought of as a way for the photographer to approach any subject he or she may wish to photograph—introjection, not projection. Look and listen, let the object look at and speak to you to reveal its presence and essence.

In the introduction to Sexton's book, Steward L. Udall wrote, "The truth is, trees are shy; they reveal their essence rarely. To capture these moments on film takes endless perseverance and prodigious labor."[9] One might add: To capture similar moments when looking at John Sexton's photographs or any artist's images requires quiet, patience, and perseverance. Listen, be quiet and let the photographs of the trees speak to you. Henry Thoreau would say, "Go not to the object; let the object come to you."

In his unpublished manuscript ("Visualization Manual," 1975), Minor White had a number of exercises to assist the photographer in capturing the essence of what is to be photographed. One exercise directed the photographer to sit quietly in front of the object, close his eyes, listen, and let the object speak. When you heard what the object is allowed to reveal, then, and only then, were you to open your eyes and create the photograph.

Confluence

Confluence suggests a deep commitment to what is being photographed. The photographer, for a fleeting moment or two, actually feels a kinship with the object being photographed—object and photographer become one and the photograph mirrors that union. Some statements made by persons in various disciplines attest to this precious moment in which union is experienced. The painter Paul Klee has written: "Color possesses me. I don't have to pursue it. It will possess me always, I know it. That is the meaning of this happy hour; color and I are one."[10]

Minor White used a circle as a metaphor for confluence: "Close the circle from the features of my inner landscape, I relate, take part, participate when I close the circle of joy. Image and I united, joyous."[11]

Fritjof Capra, author of *The Tao of Physics,* says it this way: "The experience of oneness with the surrounding environment is the main characteristic of the meditative state. It is a state of consciousness where every form of fragmentation has ceased, fading away into undifferentiated unity."[12] D. H. Lawrence writes, "If we think about it, we find that our life consists in . . . achieving of a pure relationship between ourselves and the living universe about us. This is how I 'save my soul' by accomplishing a pure relationship between me and another person, me and other people, me and a nation, me and a race of men, me and the animals, me and the trees or flowers, me and the earth, me and the skies and sun and stars, me and the moon: an infinity of pure relations, big and little. . . ."[13]

One of the short prayers of Pope John XXII was "Oh Truth! My God, make me one with thee in eternal love."[14]

I believe that confluence elevates a photograph beyond its content so that it expresses a dimension deep within the human psyche—a universal dimension inherent in all of us. I believe this is what constitutes art, regardless of the medium, for essential to any medium are the individuals' personalities and their ability to commune with their surroundings.

PERSONALITY TYPES

Carl Gustav Jung (1875–1961) was a Swiss psychiatrist and contemporary of Sigmund Freud (1856–1939). Some of the highlights of Jung's brilliant career were his elaboration of the theories of the collective unconscious

A man has not seen a thing who has not felt it.

Henry Thoreau

Too often we attempt to force a photograph out of a situation rather than allow the situation to speak to us.

John Sexton

I am no longer trying to "express myself " to impose my own personality on nature, but with-out falsification, to become identified with nature.

Edward Weston

and archetypes (which will be discussed in Chapter 9, "Subliminals"), and *personality types,* which we now discuss.

Jung believed that every judgment an individual makes is related to his personality type. Based on a large number of therapy sessions with a variety of patients and on observations of how people in general relate to one another; Jung published *Psychological Types* in 1921, in which he proposed a topology for classifying different types of personalities. The four types of personality can be thought of as points on a compass (Figure 8.1). Each point represents an opposite personality type. Thinking and feeling are considered rational functions while sensing and intuiting are considered nonrational. A personality can locate anywhere within the circle. A personality could, for example, locate somewhere within the upper left, sensing–thinking quadrant. A personality located near the center would be one that has integrated all four functions—a "self-actualized" personality.

As a generalization, Edward Weston could have been considered a sensing type; Minor White, intuiting; Harold Edgerton, thinking; and Ansel Adams, feeling. In addition, each personality can be extroverted or introverted, making a total of eight personality types. Again, as a generalization, Ansel Adams and Harold Edgerton tended to be extroverts; Edward Weston and Minor White, introverts.

It is impossible for the same person to see things from the poet's point of view and that of a man of science.

Henry Thoreau

The meeting of two personalities is like the contact between two chemical substances, if there is any reaction both are transformed.

Carl Jung

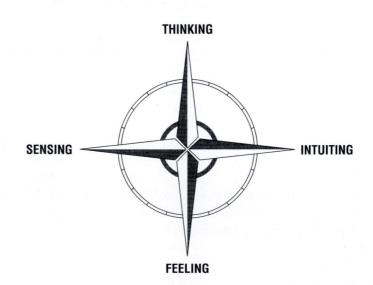

Figure 8.1 Jung's personality types.

Jung's topology, then, consisted of two general attitudes people have, introversion and extroversion, and four functions, thinking, feeling, sensing and intuiting. Attitudes and functions in combination make up eight basic personality types. Surprisingly enough, most people, despite their differences, fall into one of the eight types of personalities. Such classifi-

cation is of importance to a photographer because personality strongly influences how and what we see, how we relate to others, and how they relate to us.

Thinking and feeling are called rational functions. Thinking is logical and is concerned with ideas. It tells us what it is that we are experiencing at any one time. People use thought in attempting to understand the world and themselves. Feeling is a value function. It tells us whether something is desirable or not, and is responsible for such experiences as pleasure, pain, fear, and love.

Sensing and intuiting are nonrational functions. Sensing is part of the perceptual process that tells one that something exists. It provides concrete information about the world through the senses of seeing, hearing, smelling, tasting, and touching. Intuiting is an unconscious function; it is a way of attempting to gain knowledge through such means as hunches, guesses, and mystical experiences.

In establishing these functions, Jung cautioned that there is nothing dogmatic about them and that they should be considered as just four useful viewpoints or classifications. Further, they are not necessarily mutually exclusive. Some persons tend to be more feeling and less thinking, some more intuitive and less sensing. One can think of the illustration in Figure 8.1 as a personality "compass" that points in the direction of one's most prominent personality characteristic. Another way to look at it is as a personality map in which one's personality locates somewhere within the mapped area.

Personality also affects the way one perceives time. In a study of time perception, Mann, Siegler, and Osmond found that people experience time differently.[15] Generally, thinking types experience events in terms of a linear time dimension, continually relating past to present to future. The other types seem to concentrate on one dimension of time: feeling types on the past, sensory types on the present, and intuitive types on the future. Different perspectives on time result in different experiences of reality. One only has to travel from one culture to another to discover this firsthand.

Jung's personality types can be helpful in relationships with others on both a professional and personal level. First, one must decide on his or her own personality type. Is your tendency to be more thinking, feeling, sensing, or intuiting? Most people have personalities and ways of perceiving that favor one of the functions. Thinking photographers are highly analytical and logical (left-brained) in their approach, sensing photographers experience things as they are without much thought, feeling photographers are concerned about the potential values of a photograph, and intuitive photographers are concerned primarily with trying to capture something that transcends what is being photographed.

Included within each personality type are the two attitudes of *introversion* and *extroversion.* Photographers who tend to be introverted probably take pleasure in being by themselves when they are photographing and probably avoid photographing strangers. Photographers who are extro-

The mark of a first-rate intelligence is the capacity to entertain two contradictory propositions in one's mind simultaneously without going crazy.

F. Scott Fitzgerald

Movie stars project a variety of personality types with which we can identify

verted would probably prefer to photograph strangers and to attend all kinds of events that provide such opportunities.

These eight different personality types that Jung has formulated are not intended to be rigid, as Jung has suggested. Rather they are tendencies people have in the way they perceive things and react to things. Personal experience reminds us that it is possible to be a thinking type and introverted in one situation, such as a work situation, and to assume another personality type in a different situation such as a sporting event.

RIGHT BRAIN AND LEFT BRAIN

The idea of a right and left hemisphere in the brain relates to Jung's personality types. Thinking–feeling types are rational and tend to be left-brain oriented, whereas sensing–intuiting types are nonrational and tend to be right-brain oriented.

The two hemispheres of the brain are of special interest since each seems to serve a quite different function in our everyday activities. Although both work together; the left hemisphere tends to be highly analytical, logical, sequential, verbal, and mathematical, whereas the right hemisphere tends toward the opposite, being qualitative and intuitive (Figure 8.2).

The artist tends to be a right-hemisphere person, the engineer a left-hemisphere person. A visual artist depends heavily on pictorial language, the engineer on verbal and mathematical language. One tends to operate more on sensing–intuiting and the other on thinking–feeling. There is no value judgment attached to this. These are just different ways of responding to our world.

A photographer who has an underdeveloped right hemisphere may be unsuccessful in making highly aesthetic photographs, but may excel instead in the technical aspects of photography. Some photographers have been able to combine both, such as Edward Weston, who wrote, "There seemed to be two forces warring for supremacy, for even as I made the soft, artistic, work with poetic titles, I would secretly admire sharp, clean technically perfect photographs. . . ."[16] Highly creative effort requires the use of both hemispheres of the brain. If the interest and desire are present, a left-brain-dominant person can strengthen the less dominant artistic side of the brain and vice versa.

I am the first to recognize that daring is the motive force of the finest and greatest artists.

Igor Stravinsky

For me, the intellect is always the guide but not the goal of performance. Three things have to be coordinated and not one must stick out. Not too much intellect because it can become too scholastic. Not too much heart because it can become schmaltz. Not too much technique because you become a mechanic.

Vladimir Horowitz

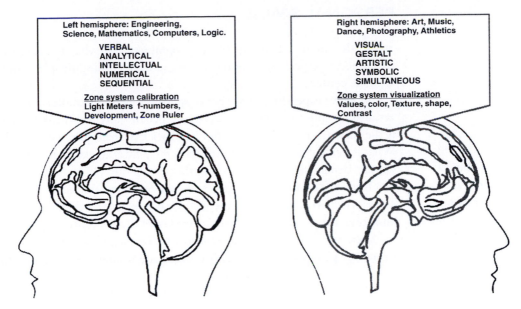

*Figure 8.2 Right and left brain. As a generalization, one can think of the
left brain as serving a thinking–feeling personality type and
the right brain as a sensing–intuiting type.*

Our right and left hands connect to the two hemispheres of the brain
in reverse order; that is, the right hand to the left brain and the left hand
to the right brain. The word *left* in Latin is *sinister,* implying evil, and in
French it is *gauche,* anyone who is awkward. On the other hand, *right* in
Latin is *dexter* (dexterous), and in French it is *adroit,* meaning nimble or
quick-witted. The literature is full of examples on how the right and left
hand have been used as a metaphor for good and evil, and the metaphor
is found in many cultures. An early Iroquois Native American myth reads,
"Twin brothers grew up representing two ways of the world which are in
all people. The twins were identified as right-handed and left-handed,
straight mind and crooked mind, upright and devious."[17] Fritjof Capra
writes that, in China, "The contrast of yin and yang is not only the basic
ordering principle throughout Chinese culture, but is also reflected in the
two dominant trends of Chinese thought. Confucianism was rational, mas-
culine, active and dominating. Taoism, on the other hand, emphasized
all that was intuitive, feminine, mystical, and yielding."[18]

Right-handedness, left-handedness, left-brain, or right-brain should
not be looked on or judged as foolish or wise, trusting or not trusting,
good or evil, but simply as preferences people have, both of which are
valid and essential to a healthy society.

*Since childhood I
have been enchanted
by the fact of the sym-
bolism of the right
hand and the left
hand—one the doer,
and the other the
dreamer.*

Jerome Bruner

PERSONAL SPACE

Space, the distance between the photographer and what is being photographed, is especially important when photographing people, with or without consent.

How we experience and react to space is a personal matter. In a conversation or photographic situation one person may feel uncomfortable if the distance is only 2 feet while another may feel quite comfortable. What is perceived as "appropriate" *personal space* is an elastic balloon that changes depending on such factors as the person, the culture, and the senses involved. For example, two people in love feel comfortable at very close range, Mediterranean people accept closer personal space than the English, and some people may require a greater visual than acoustical space.

A person who is a criminal or suspected by the police would not want his or her picture taken at any distance. An example of such a situation is a photograph taken by Lisette Model titled "Gambler Type, French Riviera, 1938." The photograph shows a man in a dark suit sitting in a cane chair with his legs crossed. His elbows rest on the arms of the chair; his head is tilted back slightly and he projects a piercing, threatening stare at the photographer. John Szarkowski wrote of it: "Model has made her photograph from very close, and from a low vantage point, which foreshortens the gambler's figure. It is an unfamiliar and menacing perspective. If she moves one step closer; he may kick the camera neatly from her hands."[19]

The photograph is worth studying as an example of the importance of personal space. "Some photographers, particularly press photographers, have taken that extra step closer and have indeed had their cameras kicked and have been roughed up in the process. . . . Model, I believe, reached the brink of disaster just before she clicked the shutter and, if she had not, the photograph would have lost its intensity and terror."[20]

Edward T. Hall, an anthropologist, has studied the reaction of people to the space around them and how they relate to it. In an attempt to structure some of the observations, he suggested four distinct zones in which most people function (Figure 8.3). These should be attended to by photographers to avoid unintentional intrusion into the personal space of their subjects.

Without . . . being aware of it human beings are constantly engaged in adjustments to the presence and activities of other human beings.

Ray Birdwhistell

Between photographer and subject there has to be distance. The camera may intrude, trespass, distort, exploit.

Susan Sontag

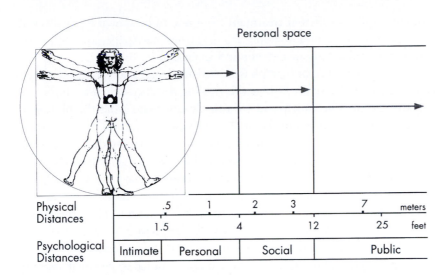

Personal space

| Physical Distances | .5 | 1 | 2 | 3 | 7 | meters |
| | 1.5 | 4 | 12 | 25 | feet |

| Psychological Distances | Intimate | Personal | Social | Public |

Figure 8.3 Personal space. Humans and animals require a certain distance between themselves and others in which to feel comfortable and not threatened. Photographers must keep this in mind when photographing people, particularly at close range (intimate and personal space).

Photographers can get around some of these intrusions by using long focal length lenses, which allow them to keep a reasonable distance from their subjects and still produce images of satisfactory size. Photographers should be alert and sensitive to nonverbal clues when they are posing persons for group shots and when they are trying to take intimate pictures. If the subject signals nervousness, it is best to back off. The cliché "never touch the model" is a statement about personal space. It is, however; too general a statement. Whether or not you touch the model is an understanding to be reached by you and the model. Some areas of the body are less personal than others. The important thing to remember is that in order to touch the model you must come close—you must enter the model's *intimate space.* This includes not only tactile space but also visual space, auditory space, and olfactory space. "Do not touch the model" really means "Do not violate the model's intimate space."

In motion pictures and television, actors and camera people are well aware of the need to use exaggerated gestures for long shots, whereas in close-ups emotion is conveyed by small changes in facial expression, such as a raised eyebrow or a quiver of the lips. The extent of gesture used is dictated by viewers' perception of the distance or the personal space between them and the person on the screen.

Similar consideration should be given to making still photographs. For example, with pictures of people the viewer may have vicarious feelings of personal space that vary with image size and cropping, eyes directed at or away from the lens, and so on. A picture to be used in a magazine

As between the soul and the body there is a bond so are the body and its environment linked together.

Kahlil Gibran

My joy as an actor is to live different lives without risking the real-life consequences.

Robert DeNiro

might require a different treatment from one to be shown in a gallery. A person looking at a photograph in a magazine, newspaper, or book looks at it from a fixed distance of about 8 inches.

In a gallery the photograph is viewed at a larger and variable distance, as it is on a video screen, where the viewing distance depends on the size of the screen. The anticipated viewing distance and what the photographer intends to express in the photograph dictate the size of the print. If the intent is to create an intimate space, and the viewing distance is fixed as in a magazine, then the print size should be as large as possible. Take note of the size of the face of models on fashion magazine covers (or in magazines). The ultimate intimate space of a photograph in a magazine is one that is based on a "scratch-and-sniff" invitation. Here the viewer actually makes nose-to-page contact with the picture or ad.

Photographers sometimes exhibit small prints in galleries to invite the viewer to move closer to the print, from a distance of personal space to intimate space. A small print, like a whisper, becomes intimate as one comes closer to it.

CHILDREN

When photographing children, photographers should be particularly sensitive to personal space. Children have their own personal space and at times parents and others are not sensitive to this when photographing them. I was not when taking a photograph of Reneé, my daughter, then 5 years old. She was sitting on her tricycle, having fun and not wanting to be bothered posing for a photograph. My insensitivity to her wishes and my determination on getting the photograph violated her privacy. To protect herself against my intrusion, she partially covered her face and spoke to me in the visual language of gesture and eye, telling me she did not want her picture taken (Figure 8.4).

The artist is a man himself nature and a part of nature within a natural space.

Paul Klee

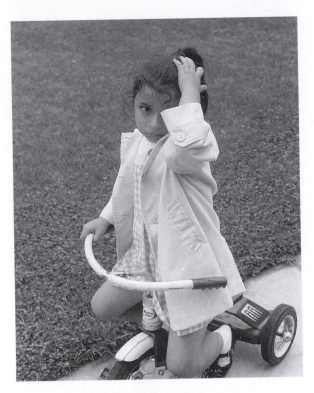

Figure 8.4 *"Reneé," Richard D. Zakia. Her mournful expression and hand-on-head gesture is a strong body language response to the photographer (her dad) who inadvertently violated her personal space.*

So intent was I on taking the picture that I failed to see her plea. Every time I look at this photograph of Reneé on her little bicycle, I am reminded of the incident and feel a bit of pain for having violated her personal space and having been visually deaf to her plea for privacy. It taught me first-hand the meaning of personal space and the protective bubble we all occupy to shield ourselves, whether we are adults or children.

FIELD DEPENDENCY

For a few minutes, pay careful attention to your visual field and notice that much of it is either vertical or horizontal—tables, chairs, desks, windows, walls, pictures, tree trunks, the horizon, and so on. The orientation of your visual environment tends to relate your body positions to the vertical and horizontal lines. Without hesitation you know whether your body is upright or tilted.

Such an ability to relate the position of your body to the vertical/horizontal axes of space has two bases. The first has to do with the gravitational field and the second with the visual field. The force of gravity acts

Tilted objects can cause visual tension.

on the kinesthetic sense in the muscles, tendons, and joints and the static sense in the inner ear so that you experience yourself as being upright or not. This is independent of the visual field and is easily experienced by tilting your body with the eyes closed. Immediately you know you are not upright and can usually sense the direction and degree of tilt. Spatial orientation is also influenced by tilting the visual field with the body in an upright position.

Everyday experiences are such that you find yourself upright relative to both the gravitational field and the visual field much of the time. It is difficult, therefore, to determine whether people perceive their body position on the basis of gravitational forces, visual forces, or both. One of the first perceptual researchers to investigate the extent to which the gravitational field and the visual field influence perception of the upright was Herman Witkin.[21] To separate and control both fields he built a "tilting-room/tilting-chair" apparatus (Figure 8.5).

(A)

(B)

Figure 8.5 *Field-dependency room. In an experimental room the chair in the room or the room itself can be independently rotated (tilted) without the subject's awareness. How the subject reacts to the tilted situation determines whether he or she is responding to the visual field or to the gravitational field for balance. (A) The room and the chair are shown in normal upright position. (B) The room (the visual field) has been tilted.*

If the subject in Figure 8.5 tilts the chair to coincide with the tilted room or the room to coincide with the position of the chair, the subject is considered to be *field dependent,* that is, dependent on the visual field for the sensation of balance. If, on the other hand, the subject does not tilt the room or chair; he or she is considered *field independent,* not dependent on the orientation of his visual field for balance but rather on the gravitational field.

Both chair and room can be rotated independently and the extent of rotation or tilt is measurable in terms of angle. A person sitting in the chair is tested under various tilted-room/tilted-chair combinations. For each situation the person is put into a nonupright position and is instructed to tell the experimenter to adjust either the room or the chair, and by how much, until an upright position is perceived. The results of Witkin's experiments, and others that followed, showed that people differed considerably in how they attempted to adjust to an upright position—some changed the visual field (tilted the room) and others the gravitational field (tilted the chair). The term *field dependent* was coined to describe those who adjusted the tilted room (the visual field) and *field independent* for those who adjusted the tilted chair in which they were seated. Similar results were found with embedded-figure tests in which a geometric shape is hidden in a larger geometric pattern.

My wife lost her inner ear balance a few years ago due to the extended use of a prescribed drug (gentamicin). She is now completely dependent on visual sighting to maintain her balance, which severely restricts her mobility. She can no longer drive, is thrown off balance when something in her visual field is tilted, or when she is trying to walk on a sloped sidewalk or driveway. At low light levels and poor visibility, the situation is exacerbated.

In the September 7, 2001 issue of *USA Today* (page 1D), an article titled, "Jewish Museum Berlin" by Steven Komarou describes how disoriented a person can become in an environment designed for that purpose. Seen from the sky the museum building is constructed in a long wandering zigzag pattern.

"The floors slant. The walls take strange angles. The windows have irregular shapes. And one room—designed to stimulate the sense of loss created by the Holocaust—has even caused visitors to feel nauseated."

A field dependent person, like myself, would have an extremely difficult time in such a museum, which of course is its purpose. My wife, completely dependent upon her visual field for balance, would find it impossible to walk.

People who can easily separate the hidden geometric shape from the larger pattern and see it as figure tend to be visually field independent. Field-dependent persons will feel uncomfortable when something within their visual field is tilted. The tilt creates a visual tension, a feeling of imbalance. I am such a person. If I am sitting in a room with a tilted picture on a wall, I either get up and straighten it or look away to avoid my feeling

What lies behind us and what lies before us are tiny matters compared with what lies within us.

Ralph Waldo Emerson

Does this picture make you feel a bit uncomfortable?

FOLIO

A tilted letter attracts attention and can be unsettling.

of imbalance. Aboard ship in the navy, the ship for me was like Witkin's tilted-room experiment. Every time the ship tilted it would cause me to feel an imbalance, which would at times, depending on the degree of tilt and how long it lasted, result in sea sickness, a common problem for field-dependent sailors. I have similar problems with tilted images on a movie screen or video screen, and severe problems with nausea during high-tech movies that have 180-degree screens or seating that moves in rhythm with the movement on the screen, such as those in Epcot Center in Florida.

Field dependency is a factor when taking pictures. Often photographers find themselves in situations in which their body posture is not upright relative to the gravitational field or visual field, and they must somehow make adjustments. Examples include photographing while leaning out a car window; airplane, or other vehicle; intentionally tilting the visual field in a motion picture camera for effect; operating swings and tilts on a view camera to adjust the vertical and horizontal perspective; and mounting prints in which the subject matter is not vertical relative to the mount board. In these situations, field-dependent photographers will experience a certain level of disequilibrium and visual tension that could affect their work.

How a picture is composed and printed will affect the viewer. If the intent is to create a bit of disequilibrium and visual tension, tilt the horizon line when photographing a landscape or seascape, or tilt objects within a vertical horizontal frame (Figure 8.6).

Figure 8.6 *"Texas Pickle, San Antonio, 1995," Richard D. Zakia. A field-dependent person, compared to one who is field independent, will experience more imbalance and visual tension when a photograph is tilted within a vertical and horizontal frame.*

LEVELING AND SHARPENING

The concepts of *leveling* and *sharpening* were put forth by the early Gestalt psychologists. People who sharpen tend to remember the detail and sequence of things they see and hear; whereas those who level tend to simplify their experience. Sharpeners attend more to detail and differences than do levelers.

I recall a situation in which a young couple was describing how they first met. The gentleman, a thinking type, recalled the sequence of events in minute detail (a sharpener). His girlfriend, however, a sensing type, related not the details of their first meeting but rather how she experienced the entire event (a leveler). Her description of their first meeting was somewhat poetic and romantic while his was analytical and detailed.

Rudolf Arnheim describes the difference between leveling and sharpening:

> *Leveling is characterized by such devices as unification, enhancement of symmetry, reduction of structural features, repetition, dropping of nonfitting detail, elimination of obliqueness. Sharpening enhances differences, stresses obliqueness. Leveling and sharpening frequently occur in the same drawing, just as in a person's memory large things may be recalled as being larger and small ones as being smaller than they actually were, but at the same time the total situation may survive in a simpler, more orderly form.*[22]

In Figure 8.7, Arnheim gives an example of early Gestalt research regarding leveling and sharpening. Illustrations A and B are not quite symmetrical. The two wings in A are a bit off-center as is the small rectangle in B. In making drawings of A and B, some subjects created symmetry to increase the simplicity (leveling), while others exaggerated the asymmetry (sharpening). The different shapes that result affect the dynamics. Leveling reduces the tension inherent in a visual pattern, whereas sharpening increases it. Photographers who are sharpeners are the ones who often create the more interesting photographs (Figure 8.8). They take their time and study the subject in great detail: the geometry, the color, texture, lighting, relationships, and so on.

A

leveling **B** **sharpening**

Figure 8.7 Leveling and sharpening. If illustrations A and B are adjusted to look more symmetrical, the person is leveling. If they are adjusted to exaggerate the asymmetry, the person is sharpening.

Figure 8.8 "East Hill Farm," Steve Kurtz. In this dramatic photograph of a worker in a dark hole, is the hole seen as a diamond shape, square, or somewhere in between? What shape is the brilliant white reflection in the upper center? Would the photograph have been as dramatic if the camera were positioned to record a perfect square or rectangular reflection?

The unconscious act of leveling or sharpening a picture invites participation. In Figure 8.8, note the metaphorical play of the man submerged in the dark hole and the brilliant patch of white light directly above him.

Some of the most difficult things to photograph are those that are familiar and have been given a name or label. We continually search for new things to photograph, things we haven't seen before. It is difficult to get inspired when photographing in an environment that is familiar. Perhaps this is the reason photographers do most of their work away from their daily surroundings. Photographing close to home is a real challenge. I recall some years ago when a colleague, Bea Nettles, had a sabbatical leave but could not travel because she had two young children to care for. To solve the problem she decided to do her photography "close to home." It forced her to see the familiar in an unfamiliar way and provided a number of interesting photographs and an exhibit called "Close to Home." Familiar things do not have to be photographed in a familiar way. Take time to "sharpen" what is familiar and see it in a new way.

In looking at photographs and pictures in general, a lot is missed because insufficient time is spent in studying the images. When looking at an image, look at what stands out as figure in the picture; look at the ground surrounding the figures; look at the tonalities, the colors; keep looking, look for relationships. Let your mind wander. Think of associations, metaphors. Take time and study the pictures. Look for the unexpected, study the unfamiliar.

I recall a cartoon some years ago in which some bird watchers are standing on a ledge, binoculars over their eyes and their heads tilted upward as they look up to study the birds across the way. I kept looking at the cartoon hoping to see something humorous. All I could see were the bird watchers with their binoculars and that was not funny. Suddenly, as I was studying each individual bird watcher, I noticed that one had his binoculars in the "wrong" place, covering his mouth instead of his eyes. Aha!! One of the bird watchers, head tilted like all the rest of the watchers, was having a little nip (drink). The binoculars looked like all the rest but served a different function; the form was the same but the function wasn't. Had I leveled the cartoon, as I almost did, rather than sharpened it, I would have missed the subtle humor it contained and not seen the one pair of unique binoculars as a flask.

More visual information on the retina is filtered out than filtered in.

Richard Norman

Little of what we look at do we see.

Richard Fahey

"Beaumont, Ansel and Willard," Barbara Morgan, 1942. Left to right: Beaumont Newhall, Ansel Adams, and Willard Morgan frolicking in front of the camera as Barbara Morgan tests a 1942 Harold Edgerton strobe unit attached to her 4 × 5 Graflex camera. (Courtesy Willard and Barbara Morgan Archives.)

KEY WORDS

confluence
extroversion
field dependent
field independent
intimate space
introjection
introversion
Jung's personality types
leveling
personal space
personality types
projection
right and left brain
Rorschach test
sharpening
Thematic Apperception Test (TAT)

The flow and shift of distance between people as they interact with each other is part and parcel of the communication process.

Edward Hall

Personality Exercises

1. Your Personality Type

A number of personality tests are available at counseling centers that can be taken to suggest your personality characteristics. The Meyers-Briggs test is a popular one and is available in hard copy as well as on a floppy disk. With the disk the results are immediate. Knowing your personality type will help you in understanding yourself and those you work for and with.

On the Meyers-Briggs test I found that I am more intuitive than sensing, more feeling than thinking, more perceptive than judging, and midway between being an introvert and an extrovert. The Meyers-Briggs test can be taken online and immediately scored. If you have never taken the test you will find it interesting and helpful. If you have taken the test, you may find some of the other personality tests available of interest. Here is what to do:

1. Have your server look for "Meyers-Briggs" + test.
2. Click on "Personality Tests Free on Line."
3. Click on "Meyers-Briggs Jung Type Test."
4. Take the test consisting of 72 yes/no questions.
5. Score your results.

There are a number of other tests available on this site that may be of interest. For example: "Self-Esteem Test," "All About You," "Coping Skill Inventory," "Your Charisma Quotient," and "Jung-Meyers-Briggs Marriage Test."

2. Projection

Find a subject to photograph that interests you. Study it for awhile and see it as being beautiful. Photograph it. Now see the same subject as ugly and photograph it. You may make whatever changes you feel necessary: lighting, focus, exposure, position, printing, and so on. You may want to take several photographs for each situation and choose the best. Compare the two photographs. Ask others to compare them and to describe any differences they see regarding the portrayed mood.

3. Chinese Photography

Carry out the advice that the 11th-century Chinese artist, Sung Ti, gave his artist friend. Find an old wall that is visually interesting, cover it with a piece of gauze or equivalent to diffuse the surface of the wall. Study the covered area and make some close-up photographs of areas that might suggest something else, such as surreal landscapes, patterns, abstractions, and so on.

4. Contemporary Animism

Look over some of Van Gogh's paintings of trees to discover the "primal energy" art historian Michael Brenson mentions. Study the trees John Sexton has photographed and writes about in his book *Listen to the Trees.*[23]

Journey into a wooded area, "listen to the trees," and try to capture their primal energy as Sexton has. Ponder some of these statements by the naturalist, Henry Thoreau:

"A man has not seen a thing who has not felt it."
"The question is not what you look at but what you see."
"Go not to the object; let it come to you."

Meaningful images . . . should in some way be a photographer's self portrait.

John Sexton

5. Thinking/Sensing

Take a series of photographs that are very carefully and thoughtfully composed. Take another series in which they are not—without looking through the viewfinder, aim your camera at what looks interesting and take a picture. Compare the two series of photographs.

6. Right and Left Brain

In her book, *Drawing on the Right Side of the Brain,*[24] Betty Edwards has a number of exercises that can be helpful to a photographer. Locate the book in a local or school library and look it over. Try some of the exercises. They will sharpen your visual awareness. Here is one to try:

Find a picture you like, turn it upside down, and draw it. Put what you have drawn to one side and draw the picture again, but this time right-side up. Compare the two copies. Looking at things upside down has a tendency to engage the right side of the brain. Some photographers believe that looking at an upside-down image on the ground glass of a view camera has this desired effect.

7. Personal Space

(a) In a conversation with someone, see how close you can get to that person, face to face, before one of you begins to feel uncomfortable. Try it with friends and acquaintances, male and female. Now try the same procedure with your eyes closed. Is there a difference?

(b) Take a portrait of a friend as you normally would and then make a series of prints of various sizes: from 4 × 5 to 16 × 20 or larger. Place them all on a wall and ask friends to look at them and to tell you which one they like or feel a closeness to and which they feel distant from. While they are studying the prints make a note of their distance from the print, whether they moved closer or further away.

Creativity with portrait involves the invocation of a state of rapport when only a camera stands between two people, mutual vulnerability and mutual trust.

Minor White

8. Field Dependency

(a) Make a series of photographs in which everything in the scene is vertical or horizontal. Now photograph the same situation with something tilted in the scene. Make prints and have friends look at the

prints in pairs and comment as to which print they feel more comfortable with.

(b) Look through magazines and collect pictures that exhibit tilted objects within the picture and see with which ones you feel the most visual tension, if any. You may want to try the same experiment by taping some events on television and studying them for tilted objects.

Notes

1. E. H. Gombrich, *Art and Illusion,* Princeton, NJ: Princeton University Press, 1969, p. 189.
2. Ibid., p.188.
3. Ibid., p.188.
4. Minor White, *Mirrors, Messages and Manifestation,* New York: Aperture, 1969.
5. Carl Chiarenza, *Landscapes of the Mind,* Boston: David R. Godine, 1988.
6. Ladislas Segy, *African Sculpture,* New York: Dover 1958, p. 17.
7. Charles Laughlin, "Beyond Documentation and Purism" (unpublished manuscript), New Orleans, LA, 1977.
8. Michael Benson, "The Faces that Haunt Van Gogh's Landscapes," *The New York Times,* January 4, 1987.
9. John Sexton, *Listen to the Trees,* Boston: Little, Brown, 1994, p. 11.
10. Richard D. Zakia, *Perceptual Quotes for Photographers,* Rochester, NY: Light Impressions, 1980, p. 74.
11. Ibid., p 93.
12. Ibid., p 94.
13. Ibid., p 93.
14. Ibid., p 93.
15. Harriet Mann, Miriam Siegler, and Humphry Osmond, "Four Types of Personalities and Time," *Psychology Today,* December 1972, pp. 76–84.
16. Nancy Newhall (ed.), *The Daybooks of Edward Weston,* Millerton, NY: Aperture, 1973, p. 57.
17. Zakia, *Perceptual Quotes,* p. 112.
18. Fritjof Capra, *The Tao of Physics,* New York: Bantam Books, 1977, p. 111.
19. John Szarkowski, *Looking at Photographs,* New York: Museum of Modern Art, 1973, p. 128.
20. Richard D. Zakia, "Spaced-Out," *Exposure, Journal of the Society for Photographic Education,* Vol. 15, No. 1, February 1977, p. 318.
21. Herman Witkin, "The Perception of the Upright," *Scientific American,* February 1959, pp. 50–56.
22. Rudolf Arnheim, *Art and Visual Perception,* Berkeley: University of California Press, 1974, p. 67.
23. Sexton, *Listen to the Trees.*

24. Betty Edwards, *Drawing on the Right Side of the Brain,* Los Angeles: J. P. Tarcher (New York: St. Martin's Press, distributor), 1979.

In every artist there is poetry. In every human being there is the poetic element. We know, we feel, we believe . . . The artist must express the summation of feeling, knowing and believing through the unity of his life and work. One cannot photograph art. One can only live it in the unity of his vision, as well as the breadth of his humanity, vitality and understanding.

Ernst Haas
(www.ernst-haas.
com/main.html)

9
Subliminals

The most important feature of subliminal perception is not that people can respond to stimulation below the awareness threshold, but that they can respond to stimuli of which, for one reason or another, they are unaware.

N. F. Dixon

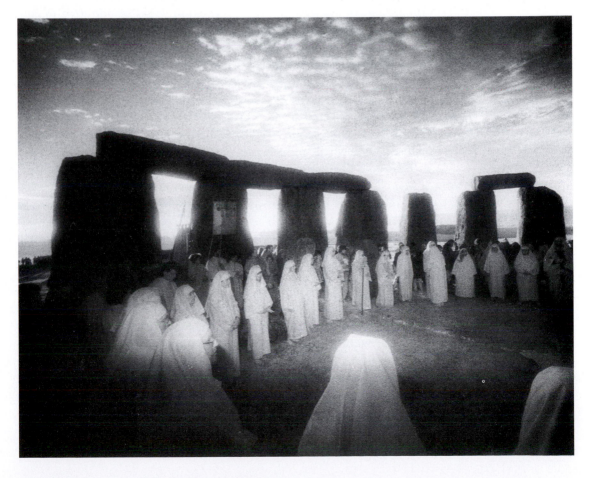

"Stonehenge, Summer Solstice." © 1987 Wes Kemp.

The word *subliminal* refers to something that is below conscious percep-
tion—stimuli received by the eye, ear, nose, tongue, or skin that is not
strong enough to be consciously seen, heard, smelled, tasted, or felt.

Subliminal perception suggests that there is unconscious awareness,
that we can be affected by stimuli that we do not consciously experience.
This notion may be a bit unsettling, knowing that we may not have com-
plete conscious control of our experiences and behavior. The fact of the
matter is that we do not, anymore than we have control of our dreams
or with whom we fall in love. Our experiences are a result of both our
conscious and unconscious perceptions. "Few hypotheses in the behav-
ioral sciences have occasioned so much controversy as the suggestion that
people may be affected by external stimuli of which they remain wholly
unaware."[1]

A number of research studies support the phenomenon of sublimi-
nal perception and the fact that much of the information on the retina
is not attended to at a conscious level. If it were, we would be overwhelmed;
there is simply too much information. "Since the span of consciousness
is severely restricted, selective processes evolved whereby only a limited
proportion of available sensory information could be admitted to con-
sciousness. Subliminal stimuli constitute some part of the remainder-stim-
uli which, though insufficiently strong or important to warrant entry into
consciousness, may nevertheless be received, monitored, and reacted to."[2]

The idea of subliminal perception is not new and has a rather long
history. Perception without awareness was taken for granted by such
philosophers as Democritus, Socrates, Aristotle, and Leibniz. Despite this
historical acceptance and research supporting it, subliminal perception
remains somewhat controversial.

I would like to suggest a second meaning to the term *subliminal per-
ception* that can be more relevant to photographers and other image mak-
ers, and perhaps less controversial. Subliminal perception need not be
restricted to physical stimuli below the perceptual threshold. It could well
include physical stimuli above the threshold of perception—stimuli that
are visible or audible but not seen or heard—not attended to—*unseen* and
unheard stimuli. We only see a small fraction of what we look at, and more
often than not we "level" what we look at rather than "sharpen" it. (Lev-
eling and sharpening were discussed in Chapter 8.)

A painting of the human eye by René Magritte called "The False Mir-
ror" is a reminder that the eye mirrors all that is in front of it on the light-
sensitive retina. The optical system of the eye forms inverted images on
the retina in much the same way a camera lens forms inverted images on
film. What we see, however, is what we choose to see, and it is only a
fraction of what is optically imaged on the retina.

THE RETINA

The retina is not flat, like film, but roughly spherical like the inside of a ping-pong ball and slightly smaller. This provides a visual field of a little over 180 degrees. (To experience a 180-degree field, look straight ahead and with your arms extended sideways, draw an imaginary arc. This represents a 180-degree field.)

Figure 9.1A shows a cross section of the human eye and the location of the curved retina. The retina contains millions of tightly packed light-sensitive *rods* and *cones* (Figure 9.1B). About 5 million cones are located in a small central area of the retina called the fovea. This assembly of cones is responsible for perception of the colors (hue, saturation, and brightness) we see and for visual acuity—the ability to see fine detail. The fovea occupies a very small area of the retina, and the millions of closely packed cones are about 3 microns wide—about the size of the point of a pin. The remaining area, which surrounds the fovea and makes up most of the retina, consists mostly of larger rod receptors. The rods are responsible primarily for movement and sensitivity to low light levels.

The average digital camera has 2 to 3 million pixels, the best have 6 to 16 million.

The eye jumps around in what are called *saccadic* movements to fixate on areas of interest so that it can use *foveal vision* to pick up color and detail. Surrounding the small foveal area is a much larger area that makes up about 95 percent of the retinal surface and it consists mostly of rods.

The rods are much more sensitive to light than are the cones, but they do not respond to the hue content of color, only to brightness or lightness. Although rod vision is very sensitive to movement within the visual field, it has low acuity. Since the rods are located around the fovea and extend to the periphery of the retina, rod vision is referred to as *peripheral vision.*

Our retina, consisting of rods and cones, has over 100 million sensors (receptors).

Some writers have described peripheral vision as a scout that is continually searching and telling the eye where next to focus and pick up information. An important aspect of peripheral vision regarding subliminal perception is that we may not be aware of the image information there even though we are affected by it in some way.

Although identification requires foveal vision, more information reaches us at an unconscious level than at a conscious, foveal level.

We would be overwhelmed if we were consciously tuned in to all the information on the retina. In other words, peripheral vision is attended to at a subconscious level. Everyday experiences in driving a car, and many other visual activities, will confirm this.

Mihai Nadin

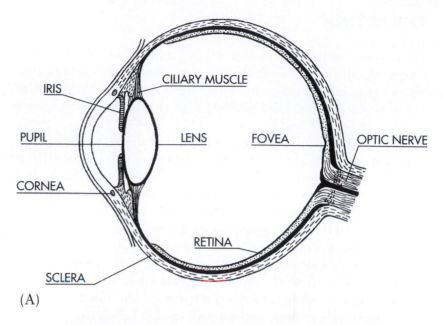

(A)

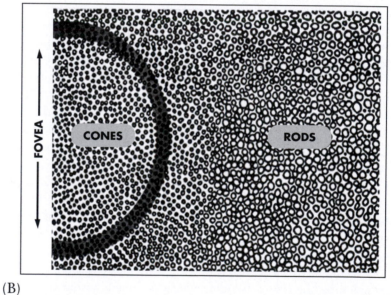

(B)

*Figure 9.1 The human eye and retina. Studies have shown that portions
of an image that fall in the peripheral area of the retina (rod receptors) can
subconsciously influence perception. The retina is made up of two kinds of
photoreceptors called rods and cones. Within the fovea area (described here
by a partial circle) are most of the millions of small cones responsible for
color vision, resolution, and sharpness.*

What we see and how we see is a very complex process involving billions of nerve cells and memory, as well as expectations.

EMBEDS

A critical look at some photographs, paintings, and advertisements reveals embedded information that viewers are often not aware of until it is pointed out to them (Figure 9.2).

Figure 9.2 Embeds. An advertisement with a playful embed—a secondary image. In this Guerlain fairytale, a handsome young man gazes into the billowing clouds just to the left of the castle, and bears witness to the magic and charm the product promises. (Courtesy of Guerlain.)

Whether the embedded information is intentional or not (a possible visual Freudian slip) is not important; what is important is whether such unnoticed stimuli—part of our peripheral vision—affect our foveal vision, that is, what we consciously attend to. Peripheral vision is, to a large extent, unconscious vision.

In her book on the Mexican artist Remidios Varo, Janet Kaplan writes of how, as a young girl growing up in Spain, Remidios found herself in a strict convent school sitting with a group of other young girls embroidering images into a continuous fabric. Kaplan quotes Varo telling how she embedded a picture of herself and her lover in an embroidery and much later in a painting, "Embroidering Earth's Mantle." Varo referred to her embed as a "trick."[3]

The writer D. H. Lawrence used embedding to express a concern of his. "In his paintings, as in his writings, he tried to break the Victorian moralistic traditions which bound his generation. He would embed *phalluses* in his paintings, as a letter to a Buddhist friend reveals, 'I try to put a phallus, a *lingam* you call it, in each of my paintings somewhere.'"[4]

In the summer of 1977, a disgruntled employee embedded a phallus in an ad for Caterpillar tractors. The ad appeared in *The Wall Street Journal,* to their embarrassment. The embed evidently had not been noticed during the preparation and production stage, but it did get noticed shortly after it appeared on the newsstands. One does not expect to see such an obvious phallus in an advertisement.

Secondary Images

Some art historians have referred to embedded images as secondary images and as physiognomic intimations. As photographers we might think of them as "latent" images—images not seen that are developed by the chemistry of our unconscious.

Michael Brenson, art critic for the *New York Times,* in his column "Art View," calls attention to secondary images in some of the paintings by Van Gogh and Cézanne. In a 1987 review of an exhibition of paintings by Vincent Van Gogh at the Metropolitan Museum of Art he wrote:

> *Of the issues that suggest the problem in distinguishing between the rational and irrational in Van Gogh's work, none has more urgency than the one of "secondary imagery." The phrase refers to images that are rarely noticed at first glance, that refuse to get lost once they are found, and whose meaning, importance, or role is hard to define. Van Gogh's landscapes are inhabited. What faces and heads are doing in his trees and clouds, whether they are intended—and indeed whether they are even there—are questions that can mobilize impressive rational and irrational resources. What cannot be denied after this show is that these faces and heads exist.[5]*

In an earlier article on an exhibition of some of the paintings by Paul Cézanne he wrote:

> *There seem to be expressive heads in Cézanne's work . . . some of them almost visionary in their force. The problem is that they are not part of the primary imagery but rather of what has been called his "secondary imagery." These heads do not seem to have composed themselves; it is as if they had used whatever imagery was available to will themselves into being. The heads are never obvious and sometimes they remain inaccessible even after the person who notices them points them out. What gives the issue a scope that goes well behind Cézanne is that the history of art is filled with these kind of subliminal images.[6]*

Statements by Anton Ehrenzweig and by Arthur Koestler are relevant in this context. Ehrenzweig writes, "While the artist's conscious attention may be occupied with shaping the large-scale composition, his (unconscious) spontaneity will add the countless hardly articulate inflections that make up his personal handwriting. . . .We cannot define their hidden organization and order any more than we can decipher their unconscious symbolism."[7] Arthur Koestler writes, "Perception is loaded with unconscious inferences, from visual constancies, through spatial projections, empathy, and synesthesia, to projection of meaning into Rorschach blot, and the assigning of purpose and function to the human shape. The artist exploits these unconscious processes by the added twist of perspective, rhythm, and balance, contrast, 'tactile value,' etc."[8]

An interesting story about faces in photographs is told by Joan Murray in an article that appeared in *Popular Photography*. Edward Weston was showing Moholy Nage some of his photographs while Beaumont Newhall looked on. Beaumont tells how Moholy upset Weston by calling attention to what he saw as secondary images in the photographs. "Moholy kept finding in the photographs hidden and fantastic forms, which were often revealed when—to Weston's obvious but politely hidden annoyance—he would turn the prints upside down. These after-products of Weston's vision fascinated Moholy; he considered photographs not interpretations of nature, but objects in themselves fascinating."[9] (If one assumes that Weston was using a view camera, then the images composed on the ground glass would have been upside down, as Moholy Nage viewed them.)

Arnold Newman tells about what he called a "happy accident" while photographing the surrealist artist Max Ernst. As Ernst was sitting for his portrait and smoking, Newman asked him to let the smoke out slowly. As he did, Newman took the photograph. Upon viewing the print, Max Ernst noticed, in the cloud of smoke, at the left of the photograph, an image of a bird. This fascinated Ernst since he was drawing birds during that period of time.

Perceive those things which cannot be seen.

Miyamoto Musashi,
Samurai,
16th century

If supraliminal stimuli are not attended to, they become like subliminal stimuli. . . .

N. F. Dixon

A work of art must narrate something that does not appear within its outline.

Giorgio DeChirico

Of significance to the photographer is the fact that the elements of a photograph not consciously perceived may have a profound influence on the viewer. Nondistinct imagery and peripheral placement of information can be perceived subliminally. What is consciously seen as figure is influenced by the subliminally perceived ground.

Faces

Art historian E. H. Gombrich calls attention to the importance of faces, sometimes hidden, to human vision, reminding us of its importance to our survival and that it is inborn and not learned.[10] Faces fascinate us from birth with a "language" that is simple and direct. The face is made up of many muscles, and is capable of hundreds of different expressions.

The research pediatrician René Spitz has written extensively on the importance of the face, particularly the mother's face, to an infant. "In the course of the first six weeks of life a mnemonic trace of the human face is laid down in the infantile memory as the first signal of the presence of need gratifier; the infant will follow all the movements of this signal with his eyes."[11]

We learn to read the information expressed in a human face long before we learn verbal language. The language of the face is a visual language that we learn in infancy. In psychoanalysis few patients can verbally remember much prior to about age 2. Between infancy and 2 years a large, latent reservoir of visual experience and visual information is stored.

"The image of the face seems to take precedence over all others when the visual scene is at all unclear. The face seems to be, for all of us, a preferred shape. We can see faces in fire, faces in rocks, faces in clouds. . . . It is strange to discover, too, how artists . . . seem to be impelled, in their creative work by the same hidden image of the face."[12]

It is as if we are "imprinted" at birth to respond to a human face as a way of survival. When a mother walks away from her infant and she is no longer in sight, the child experiences the mother as having disappeared. This is perhaps why the game "peek-a-boo" is so fascinating to an infant. A mother covers her face with her hands and, to the infant she actually disappears; she removes her hands from her face and suddenly she reappears. In the infant's world it is magic: She actually disappears and reappears. I remember a student telling me that as a child she did not want to have her mother watch her when she went "potty." Her mother, being cautious and perhaps recalling earlier experiences, told her to cover her eyes and she would disappear, which the child did.

Embedded figures can be playful and one cannot help but remember the fun, as children, of discovering hidden animals, faces, and such in pictures (Figure 9.3). Today's children experience the same thrill. Hidden figures provide a sense of discovery that begins early in the infant stage with "peek-a-boo," and progresses to that of the child playing the game "hide-and-seek" and finding things hidden in "hidden pictures."

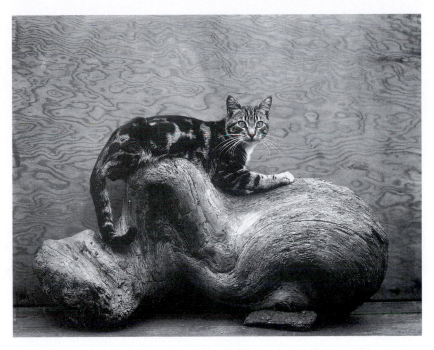

Figure 9.3 "Johnny, 1944," Edward Weston. © Center for Creative Photography, Arizona Board of Regents. Edward Weston was a great lover of cats, many of which roamed the hills surrounding his modest home in Carmel, California. In this wonderful and compelling photograph, his cat, Johnny, drapes himself comfortably over a piece of bulbous driftwood with focused attention. He proudly sports long white whiskers as he peers directly and perhaps quizzically, at the photographer and his camera. The patterned plywood board that completely fills the background is also of interest. Not only are the patterns similar to the markings of Johnny's fur, but they also present the potential for secondary images.

Perhaps photography is a variation of this need to discover things, searching for something to photograph that is hidden in the sense that we have yet to discover it and reveal it in a photograph. Other activities could also be "hide-and-seek" discovery variations; visits to a flea market, searching for knowledge in books and libraries, all forms of research, and so on. Searching for something "hidden" is a lifelong pursuit that can be thought of as archetypal.

What is most important is invisible.

Antoine de Saint
Exupery

PUPILLOMETRICS

The study of how the size of the pupil changes when a person becomes emotional is called *pupillometrics.* We mentioned earlier that considerable

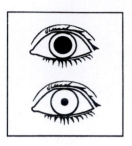

Pupil size automatically changes with strong emotional responses.

Dance is continuous in time and space.

Barbara Morgan

I feel myself one vibrating center in a galaxy of vibrations.

Barbara Morgan

research confirms subliminal experiences. Research on the effect of pupil size on perception of images is of particular interest. It demonstrates how important unseen stimuli are to perception, and such research does not need any sophisticated lab equipment.

It is common knowledge that the size of the pupil in the eye increases (dilates) as the light level decreases and decreases (constricts) when the light level increases. By analogy, the same thing happens to the automatic diaphragm control in a camera. In a dim room it increases (f/5.6) and in sunlight it decreases (f/16).

An interesting aspect of the eye is the automatic change in pupil size that can result from changes other than in light intensity. There is a high correlation between a person's pupil size and his emotional response. When something is seen that excites a person, pupil size tends to increase.

Automatic changes in pupil size are not limited to the visual sense. Changes can also be observed when a person is smelling, tasting, touching, or hearing something pleasant or unpleasant. Mental activities such as intense concentration can also cause changes in the pupil size. The eye is an extension of the brain.

This pupil size phenomenon has been known for a long time and has, for example, been effectively used by magicians, card sharks, and early Chinese jade merchants. Dilation and constriction of pupils are a direct and reliable means of nonverbal communication. They tell your friend or adversary that something has triggered you and changed your mental or emotional state.

The uniqueness of the early photographs by Barbara Morgan that captured the essence of dance was due in part to her ability to read the dancer's eyes, to "dance" with the dancer. Her son Lloyd remembers watching his mother photograph dancers in her New York studio:

> *From a low position on the floor, her favorite position, and with a 4×5 Speed Graphic in hand, she would fixate on the eyes of the dancer and the dancer's movements. Her vision, concentration, and incredible reflexes were as sharp as a hawk's. Patiently she would study and track the dancers' movements and concentrate on the pupils of their eyes. Dancer and photographer would actually carry on a dialogue. They developed a rhythm with each other and would resonate together. At times it almost seemed as if Mom helped choreograph the dance. Mom would say "ready–go." Dancer and the photographer's eye, hand and shutter were in sync for the planned gesture. At the very instant the pupils of the dancer's eyes dilated—CLICK—"the decisive moment," the unique moment.[13]*

With portrait photography in a studio, the use of electronic flash with low-wattage modeling lights has an advantage over the bright tungsten lights that cause pupils to constrict. The dim modeling lights allow the pupils to enlarge and remain enlarged while the lighting is being adjusted.

The bright electronic flash exposure captures the image before the pupils can constrict. Most portrait photographers are aware that large pupils in portraits are more interesting than small pupils and that they tend to provide a more romantic appearance. Women as far back as the Middle Ages knew of this and some used the drug belladonna ("beautiful woman") as a cosmetic to dilate their pupils. Perhaps one of the reasons dinner by candlelight is considered romantic is that the low light level induces larger pupils.

The pupil can expand as much as 45 percent when looking at something exciting and pleasant.

In a 1965 research study by Dr. E. Hess of the University of Chicago, a large number of students were asked to look at two photographs that appeared to be identical and to choose one of them.[14] The task was difficult and students would often remark that they were both the same. When forced to make a choice most picked the photograph having the larger pupils. Asked later whether they were aware of the difference in pupil size nearly everyone said no.

I conducted a similar study in 1988 using a total of 80 male and female college students. Shown the "identical" portraits in Figure 9.4 and forced to make a choice, 87 percent of them preferred the portrait with the larger pupil size. There was no difference between male and female preferences. Only two of the subjects were aware of the difference in pupil size when they made their choice.

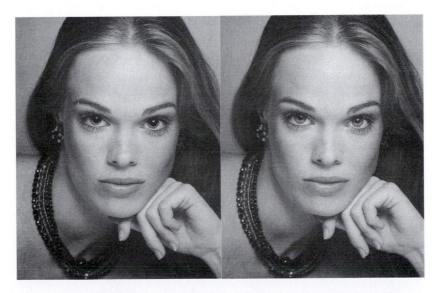

Figure 9.4 Pupillometrics. Both of the original photographs were identical except for the size of the pupils. Most subjects preferred the photograph to the left without being aware of the larger pupil size. © Richard Gicewicz.

The myths of ancient peoples are still meaningful to us because they express preoccupations and moods which are universal and eternal.

René Dubos

The mother archetype is associated with things and places standing for fertility and fruitfulness: the cornucopia, a plowed field, a garden.

Carl Gustav Jung

As we become familiar with more objects of art, we discover certain similarities between images which are thousands of years and miles apart.

Graham Collier

One might conclude from such studies that we can be influenced by things of which we are not consciously aware, things that are subliminal, in the sense that the difference in pupil size did not register as such but somehow affected choice.

ARCHETYPES

Pictures with embedded images such as latent faces, skulls, sexual parts, and the like are universal and may be more effective unseen in an image than seen—subconscious rather than conscious.

One of the early theories of Carl Gustav Jung was that of the archetype. The word *archetype* means an original model after which other things that have a similar quality are patterned. Jung distinguished between our unique *personal unconscious* and our *collective unconscious,* which all humans, past and present, possess. The collective unconscious is a universal memory that contains the archetypes, variations on the original models. Some of the more important models that all humans possess in memory are the hero, mother, trickster, wise old man and woman, God, giant, demon, birth, death, rebirth, and many natural objects such as trees, sun, moon, river, and fire. "Endless repetition has engraved these experiences into our psychic constitution, not in the form of images filled with content, but at first only as forms without content, representing merely the possibility of a certain type of perception and action."[15]

Consider any one of the many archetypes and the number of different ways that the original model, the prototype, can be represented. The mother archetype takes many forms: mother, grandmother, mother of God, mother earth, nurse, church, synagogue, mosque, university, in music Ave Maria, Mother McCree. Photographs of modern-day madonnas, plowed fertile fields, gardens, and landscapes are archetypal. "The primordial image or archetype, is a figure . . . be it a demon, a human being, or a process . . . that constantly recurs in the course of history and appears wherever creative phantasy is freely experienced."[16]

The hero archetype remains with us throughout our lifetime but takes on different forms. As children our heroes might have been our parents or playmates; consider Superman, Batman, the Lone Ranger, G.I. Joe, Wonder Woman, Cat Woman, Barbie, Ninja Turtles, Power Rangers. All of the more than 20,000 Westerns produced by Hollywood had a cowboy hero and, of course, a villain (another archetype). As we matured we got interested in other heroes, heroes in sports, music, literature, history, politics, religion, science, military, space exploration, space odysseys (*Star Trek*), and so on. The success of the movie *Star Wars,* according to its creator George Lucas, was the inspiration he derived from reading Joseph Campbell's book, *The Hero with a Thousand Faces.*

The scenes of a chase we often see in movies are archetypes in which someone is being pursued and is having difficulty in getting away. The

chase is seen in many different ways and places: on land or water, in the air, in space, underwater, across rooftops, in the streets, deserts, or woods. The chase can occur on horseback over rugged terrain, in cars racing through busy streets and intersections, in airplanes in a dogfight, on boats, underwater in scuba gear, on trains as in some old movies, or simply on foot, running as the pursuer closes in with each step. The chase also occurs in our dreams where someone or something pursues us and we feel completely helpless—the dream becomes a nightmare.

Adolf Bastian (1826–1905), who preceded Sigmund Freud (1856–1939) and Carl Jung (1875–1961), termed recurring themes and features such as hero, mother, birth, and so on *elementargedanken* (elementary ideas), and the various ways they represent themselves in the arts, *volkergedaken* (folk ideas). The motifs that Bastian listed as "elementary ideas," Jung called archetypes of the collective unconscious.

Two cognitive scientists in a 1992 article, "The Problem of Consciousness," wrote: ". . . the information available to our eyes is not sufficient to provide the brain with its unique interpretation of the visual world. The brain must use past experiences (either its own or that of our distant ancestors, which is embedded in our genes) to help interpret the information coming into our eyes."[17]

KILROY

During and shortly after World War II, *Kilroy* graffiti began appearing everywhere, a child-like caricature of a face with a long phallic nose and the words "Kilroy was here." Similar features persist in comic strips, cartoons, drawings, illustrations, advertisements, paintings, and photographs. The salient features are two eyes and an elongated nose. (As a secondary image in detailed pictures, the eyes are usually two dark shadows.) The Kilroy figure contained a horizontal line representing the edge of a wall, an extended nose hanging over it and hands holding on to the edge of the wall. The English had their own Kilroy, a chap they named *Chad.* In Australia Kilroy took on the same features using the symbols of positive (+) and negative (−) for the eyes, and a distorted sine wave for the eyes and nose; which was probably the first way Kilroy was portrayed.

The pervasiveness of this Kilroy symbol suggests a subtext, a hidden meaning. As it is displayed, it is direct, confrontational, and a bit humorous. It is not a secondary image, although in some pictures it appears as such (Figure 9.5).

One British author writing on "Depth Psychology of Thing Perception" explains Chad in this way, "May I suggest that its [Chad] astounding expressiveness is due to the thinly veiled phallic exhibitionism expressed by the nose. . . . In primitive dancing or infantile play the heroic display of the phallus represents provocation; little wonder, therefore, that the

Freud used the term "archaic remnants" to refer to archetypes.

This unexpected image was the record of an inner state that I did not remember seeing.

Minor White

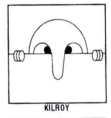

KILROY

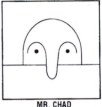

MR. CHAD

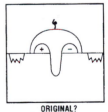

ORIGINAL?

The milestones of the old French posts in India have occasionally been turned into altars because of their resemblance to the lingam, the phallic symbol and emblem of the god, Shiva.

Henri Cartier Bresson

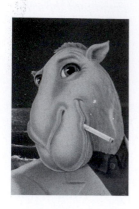

Joe Camel, R.I.P.

strongly symbolic 'Mr. Chad' should have appeal to the military (heroic) sense of humour."[18]

In this context one cannot help but recall an advertisement featuring Joe Camel, that pervasive anthropomorphized camel (really a dromedary) that had become an icon for Camel cigarettes but has since been laid to rest. Joe had features equivalent to Kilroy and Chad, but perhaps a bit more subtle. Not everyone would agree with this. In an article in *Artforum,* Stuart Ewen refers to Joe Camel as an example of "desublimated advertising." Ewen writes, "The 'smooth character' is truly the Henry Ford of phallus worship . . . this desublimated ad is seen as relatively benign, an amusing form of blue entertainment. . . ."[19] Regardless of how adults read Joe Camel's features, he had been an attraction to children, which led to his demise. He was the second most recognizable character for children, Mickey Mouse being first.

Deep rooted symbols are used subliminally and cynically in advertisements, and even in the images and rhetoric of political campaigns.[20]

David Fontana

Figure 9.5 *"Kilroy and the Rhinemaidens." (Courtesy Dover Publications.) An illustration by Arthur Rackham from the book* Arthur Rackham's Color Illustrations for Wagner's Ring, *New York: Dover, 1979. Notice the Kilroy equivalent in the form of a tree root just to the left of the Rhinemaiden hand.*

Some other Kilroy equivalents that have appeared over time are worth noting since the Kilroy image is a variation of a prototype that can be found worldwide—that is, the phallus. Some time back a *Popeye* comic strip series featured a character called "Alice the Goon" whose features were very similar to Kilroy's. On March 10, 1978, the comic strip, "Dr. Smock" featured Kilroy grafittied on a hospital wall as "Dr. Kildare." A December 1990 ad for Jim Beam Kentucky whisky, with the headline "You always come back to basics," had a vintage Kilroy illustration representing the war year 1944.

Kilroy and Chad continue to be with us for they serve to represent an archetype. Their image appears in many places, at different times, in different ways, with an inexplicable similarity of meaning. The Kilroy archetype is not only seen on walls but can be found in early sculpture, rituals, folklore, fairy tales (Figure 9.6), mythologies, dreams, and perhaps even on the Internet.

"Alice" (Reprinted with special permission of King Features Syndicate.)

The very edge of the human retina . . . gives primitive unconscious vision.

Richard Gregory

Figure 9.6 *Kilroy lives on. Kilroy appears again as a tree root with dark eyes peering at the Hobbit just to his right. Compare this Kilroy structural equivalent (likeness) to the Pinch bottle with the two dark eyes and phallic nose on the Key Words page of this chapter. (Courtesy Xerox Corporation.)*

Archetypes are important to the photographer and other image makers because they feed the collective unconscious, our universal memory that transcends time and culture. A powerful image, regardless of the medium, is one that can trigger an archetype. Memorable images do this and some are called works of art.

Kilroy in a bottle? From how many different perspectives can a bottle be photographed? What makes this representation of a bottle of Pinch Scotch so interesting and engaging? (Courtesy Pinch Scotch.)

The unconscious depth-messages of ads are never attacked by the literate, because of their incapacity to notice or discuss non-verbal forms of arrangement and meaning. They have not the art to argue with pictures.[21]

Marshall McLuhan

KEY WORDS
archetype
Chad
collective unconscious
cones
foveal vision
Kilroy
lingam
peripheral vision
personal unconscious
phallus
pupillometrics
rods

saccadic
secondary images
subliminal
unheard stimuli
unseen stimuli

Subliminals Exercises

1. Secondary Images

As mentioned in the chapter text, in the two articles by Michael Brenson in the *New York Times,* he cites paintings by Van Gogh and Cézanne that have, in his opinion, secondary images. Look up some of these in art books and form your own opinion. Remember that what you will be looking at are reproductions. There is no substitute for actually viewing the original whenever you can. Here are some of the paintings Brenson mentions:

Ninety-nine percent of what our brain does is not available to us in terms of consciousness.

Michael Gazzaniga

- *By Cézanne:* "The Large Bathers," "Montagne Saint-Victoire," "Rocks at Fountainbleau," "Trees Near a Road," "Great Pine."
- *By Van Gogh:* "Pine Trees with Setting Sun," "Olive Trees with the Alpilles in the Background," "Cypresses," "Olive Orchard," "Road with Cypress and Star.'

The work of other painters mentioned in Brenson's articles are Gauguin (to whom he refers as the third member of the Post-Impressionist triumvirate), Odilin Redon, and Jackson Pollock. Works by Surrealist artists such as Salvador Dali and Max Ernst are also a potential source of secondary images as are the works of Paul Klee and illustrations by Arthur Rackham in early children's books. It is also enlightening to look for examples in non-Western art.

2. Photographs

Look for secondary images in some of the photographs in photographic books, or when possible on exhibit, by photographers such as Edward Weston, Brett Weston, Ann Brigman, Ruth Bernhard, Minor White, Charles Laughlin, David Hamilton, Wynn Bullock, Lucien Clergue, Jerry Uelsmann, Judy Dater, and others. If you are holding the photograph in your hand, look at it in different orientations, as Moholy Nage did when he turned Edward Weston's photographs upside down. Attend to the background in the photographs, and in particular to fuzzy backgrounds.

. . . [A]dvertising is a subliminal pill designed to massage the unconscious.

Marshall McLuhan

3. Advertisements

Advertisements are a rich source of secondary images, particularly those for nonessential items such as cosmetics, jewelry, alcohol, and cigarettes, as seen in the following photograph. When you find ads with such images, show them to friends, and without revealing your discovery, see if their vision is the same as yours.

*Take another look at
the Pinch scotch bot-
tle and notice the two
dark, peering eyes.*

*A little magic. In this cleverly designed ad, notice the two small white cir-
cles to the right of the Baileys bottle. According to Picasso, two holes—
that's the symbol for a face, enough to evoke it without representing it. A
number of research studies with infants over the years support this. (Cour-
tesy Baileys.)*

4. Subliminal Time?

Look for advertisements for watches and clocks and notice the time. More
often than not the hands on the face are arranged so that the time is ten
minutes to two or ten minutes after ten. Had you noticed this before?
What do the hands in an upward position signify or suggest? How would
you experience the same watch if the hands read twenty minutes after eight
or a quarter past nine?

5. Photographing

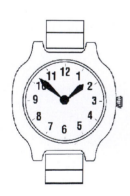

Create some photographs that have potential secondary images. Attend-
ing to things in the background and at the periphery of the camera frame
is important. Look through the viewfinder in a single-lens-reflex or view
camera and study what happens to the background when you move it pro-

gressively out of focus. Try large diaphragm openings such as f/5.6 and f/3.5 to decrease depth of field and cause fuzzy backgrounds.

6. Photo Rorschach

Sharpen your vision by searching out interesting facial patterns in natural things such as cut wood, old tree bark and roots, and flowers. (Edward Steichen saw hundreds of faces in a large cluster of pansies and photographed them.) Look for potential images in the variety of patterns in marble and graffiti.

You may want to create your own chance images by splattering ink or paint on a paper surface. Try the Jackson Pollock technique of "drip-painting," only use "drip-developer" on photographic paper and then develop it.

7. Pupillometrics

Carry out the pupillometric experiment cited in the text by photographing a friend, making matched prints, and then increasing the pupil size of one of the prints. This is easily done on a computer with software such as Photoshop. You may want to make three or four matched prints with increasing pupil size. Ask a number of men and women, boys and girls their print preference. Shift the prints' positions each time, for position can be a factor; some people will prefer the print on the right and some on the left.

8. More Pupillometrics

Study the eyes in some of the close-up photographs of models in magazines. Look for pupil size and position of the iris of the eye relative to the white area that surrounds it. Also look to see where the catch-light falls and the shape of it as it reflects off the eyeball.

9. Pupillometrics and Animals

Do the pupils in the eyes of an animal enlarge when they become excited? Much to my surprise, I found this to be so with our cat. When he is stalking and preparing to strike, his pupils dilate. After the strike, they return to normal. Observe your cat or that of a friend. Do you think the same to be true for other animals?

10. Archetypes

Look at paintings, photographs, sculptures, advertisements, and movies to discover the importance of archetypes and the different forms they take now and have taken in earlier days. Some good references to look at are:

- Joseph Campbell, *Hero with a Thousand Faces,* Princeton, NJ: Princeton University Press, 1968.
- Carl Gustav Jung (ed.), *Man and His Symbols,* New York: Doubleday, 1964.

Environments by reason of their total character are mostly subliminal to ordinary experience.

Marshall McLuhan

The primordial image or archetype is a figure, be it a daemon, a human being, or a process, that constantly recurs in the course of history and appears wherever creative phantasy is expressed.

Patricia L. Musick

- Jolande Jacobi, *Complex Archetype Symbol,* Princeton, NJ: Princeton University Press, 1959.
- Carol S. Pearson, *Awakening the Heros Within,* New York: Harper-Collins, 1991.

11. Kilroy Lives

Keep an eye open for Kilroy-type graffiti and pictures. You will be amazed to discover the proliferation of such archetypal imagery. Search though some books on mythology such as *Myths* by Alexander Eliot (New York: McGraw-Hill, 1976), with contributions by Joseph Campbell and Mircea Eliade. Books on symbols such as Barbara Walker's book titled *The Woman's Dictionary of Symbols and Sacred Objects* (San Francisco: Harper & Row, 1988) are good sources.

12. The Human Eye

I claim not how man thinks in myth but how myth operated without his being aware of the fact.

Lévi-Strauss

(a) *The Dominant Eye.* The dominant eye is the one that tends to determine perception when images formed by both eyes fail to fuse. It is the eye we tend to use when looking through a camera viewfinder or gun. To determine which eye is dominant, look at an object at a distance of about 10 feet with both eyes open. Now with your arm extended and both eyes open, align your upright thumb (as an artist does when studying perspective), with the object. Close one eye and then the other as you continue looking at the object. The eye that causes the most displacement when you close it is your dominant eye.

What you have to do, you do with play.

Joseph Campbell

(b) *Blind Spot.* Holding this book at a comfortable reading distance, close your left eye and fixate on the X with your right eye. Slowly move the book back and forth between about 4 to 12 inches (about 10 to 30 cm) until a position is reached where the black dot disappears. When this happens, the image of the black spot has fallen on the region of the retina where there are no photoreceptors, just nerve fibers that group together and leave the eye. This area is called the *blind spot* or optic disk.

(c) *Astigmatism.* Look at the center of the following radial pattern without glasses or contact lenses. If some of the spokes look less sharp than others it is an indication of astigmatism. Try the same thing with corrective lenses if you wear them.

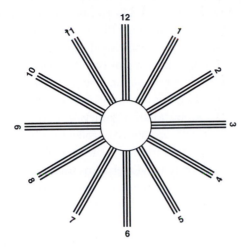

Work begins when you don't like what you are doing.

Joseph Campbell

(d) *Foveal and Peripheral Vision.* While looking straight ahead and not moving your eyes to the right or left, have a friend hold a colored object a foot or so behind your head and then slowly move it in a circular arc past your ear toward a position directly in front of your eyes. Notice when you can first (1) detect movement of the object, (2) identify the approximate shape of the object, and (3) identify the color of the object.

(e) *Convergence: Boy Meets Girl.* Introduce this couple to each other and have them hold hands by slowly moving this page toward your nose.

13. Mona Lisa's Peripheral Smile

Leonardo da Vinci's portrait of Mona Lisa has puzzled onlookers for nearly 500 years with her on-again, off-again smile—now you see it, now you

don't. Dr. Margaret Livingston, a Harvard neuroscientist, has made a study of this phenomenon. In viewing the painting and staring at it for a time, it seemed to flicker. She noticed the smile would appear and then disappear, depending on where her eyes fixated. When she focused on Mona Lisa's eyes, as most people do, the smile was apparent but when she focused on her lips, the smile disappeared. Do you find this so when you look at the picture of the Mona Lisa in Color Plate XIII? (The reason for her red eyes, a rhetorical substitution, is explained in Chapter 11, Exercise 2.)

The retina in the eye is made up of two distinct areas for seeing. The small central area called the fovea, which is responsible for color and detail, and the larger surrounding area, which is less responsive to color but is highly responsive to motion and low light levels. Foveal vision is conscious vision while we are normally less aware of the image in the surround area.

Some years back, John Szarkowski, the former curator of photography at the New York Museum of Modern Art, used a metaphor to describe how we use foveal vision to see things and to see them clearly. He remarked that we "point with our eyes" at whatever we look at, that we go about pointing with our eyes at what we want to see. He did not mention, however, that as we do, our peripheral vision is also picking up information, but not at such a high level of consciousness. This, I think, is the key to Dr. Livingston's finding.

When people look at a face, whether it is face to face, on a magazine cover or in portrait photograph or painting, they usually look at the face eye to eye, and with foveal vision. Dr. Livingston pointed out that with the Mona Lisa, as a person focuses on the eye, fuzzy peripheral vision is picking up the shadows from Mona Lisa's prominent cheekbones, which tend to extend the slight curvature of a smile. We are not aware of this, but somewhere in our perceptual process, and at a subconscious level, it is affecting what we see. When a person's eyes shift, and with foveal vision points to Mona Lisa's lips, the extended smile disappears until the person again gazes at the eyes.

Of her discovery, Dr. Livingston remarked, "I do not mean to take away the mystery of Leonardo. He was a genius who captured something from real life that rarely gets noticed in real life" (*New York Times,* November 21, 2000). We might add here that much in real life does not get noticed. This is the reason magic and advertising works so well.

Seeing is a creative operation, one that demands effort.

Henri Matisse

14. Pupillometrics and Animals

Do the pupils in the eyes of an animal enlarge when they beome excited? Much to my surprise, I found this to be so with our cat. When he is stalking and preparing to strike, his pupils dilate. After the strike, they return to normal. Observe your cat or that of a friend. Do you think the same to be true for other animals?

Notes

1. Richard L. Gregory (ed.), *Oxford Companion to the Mind,* New York: Oxford University Press, 1991, p. 752.

2. Ibid., p. 754

3. Janet A. Kaplan, *Unexpected Journeys,* New York: Abbeville Press, 1988, p. 21.

4. Stephen Foehr, "D. H. Lawrence, the Forbidden Paintings," *Horizon,* July 1980, p. 66.

5. Michael Brenson, "The Faces that Haunt Van Gogh's Landscapes," *New York Times,* January 4, 1987.

6. Michael Brenson, "Head-Hunting in the Landscapes of Cézanne," *New York Times,* October 14, 1984.

7. Anton Ehrenzweig, *The Hidden Order of Art,* Berkeley: University of California Press, 1971, p. 29

8. Arthur Koestler, *The Act of Creation,* New York: Dell, 1975, p. 392.

9. Joan Murray, *Popular Photography,* December 1975.

10. E. H. Gombrich, *Art and Illusion,* Princeton, NJ: Princeton University Press, 1969, p. 103.

11. René Spitz, *The First Year of Life,* New York: International University Press, 1965, p. 52.

12. John Liggett, *The Human Face,* New York: Stein and Day, 1974, p. 174.

13. Lloyd Morgan, private communication, November 12, 1994.

14. E. Hess, "Attitude and Pupil Size," *Scientific American,* April 1965, p. 212.

15. Calvin S. Hall and Vernon J. Nordby, *A Primer of Jungian Psychology,* New York: New American Library, 1973, p. 42.

16. Hull, R. (ed.), *The Portable Jung,* New York: The Viking Press, 1971, p. 72.

17. Francis Crick and Christof Koch, "The Problem of Consciousness," *Scientific American,* September 1992, p. 153.

18. Anton Ehrenzweig, *The Psycho-Analysis of Artistic Vision and Hearing,* New York: George Braziller, 1965, p. 214.

19. Stuart Ewen, "The Public Eye," *Art Forum,* January 1991, p. 28.

20. David Fontana, *The Secret Language of Symbols,* San Francisco: Chronicle Books, 1994, p. 8.

21. Marshall McLuhan, *Understanding Media,* New York: Signet, 1964, p. 205.

10
Critiquing Photographs

Criticism of my work . . . now means something to me whereas previously my self-deception admitted nothing.

Paul Klee

"Katharine, Upper Taughannock Falls, NY, 1992." © John D. Carroll.

Pictures are made to be looked at as original images or as reproductions in printed media such as magazines, newspapers, books, brochures, catalogs, billboards, and electronic media such as video, computer monitors, photo CDs, and CD-ROMs. The medium used to display the image and its context will have an effect on how the picture is experienced. A matted and framed photograph displayed in a well-lit gallery will be seen differently than an unmounted photograph pinned to a wall. A photograph reproduced in a quality magazine will look much better than one in a newspaper. A color print viewed as an original (object color) and also viewed on a video screen (illuminant color) represents different color modalities and will be seen differently.

The total context in which a photograph appears will influence how it is perceived. Placement of a photograph in a magazine with text, with other photographs, or with advertisements surrounding it can have different meanings. Any title or caption given the photograph can affect the meaning as well. Some photographers have titled their photographs "Untitled" to allow the image to speak for itself. Jerry Uelsmann's surreal images are an example. Others have used a title to identify a location, as did Dr. Thomas McCartney in his mountain landscape titled "Mount McKinley, Alaska" (the opening photograph in Chapter 8). Mary Ellen Mark identified person and place in her photograph "Tiny, in Seattle." Sheila Metzner uses a title to echo the sensuality of one of her photographs, "Jako Passion." Duane Michals not only provides philosophical titles for his photographs such as "All Things Mellow in the Mind," but also adds handwritten narrative; a contemporary "Illuminated manuscript."

In addition, time is part of the context—our perceptions can change throughout the day and evening. Historical time is also a factor. Photographs that were considered unworthy of museum exhibits when they were made are now admired and collected, such as Weegee's photographs of accidents taken in New York City in the early 1900s. The high-speed stroboscopic photographs pioneered by Dr. Harold Edgerton while at MIT are another example. Edgerton's work can be seen as a continuation of the earlier motion studies of animals and humans by Muybridge and Marey.

CRITIQUE AS EVALUATION

The word *critique* refers to a critical review or commentary, written or spoken, regarding someone's work, usually artistic work but certainly not limited to that. The act of critiquing or passing judgment on a photograph involves evaluation, and for the evaluation to be fair and reasonable there must be some type of criteria or purpose. Photographs take on many different expressions, from, for example, the artistic (fine art) to the informative (photojournalism), to the highly technical (high-speed photography). One cannot critique a photograph without some overt or covert criteria, either one's own or those of the photographer. (There are excep-

The photographs are not illustrative. They and the text are coequal, mutually independent, and fully collaborative.

James Agee,
Walker Evans

I'm willing to be judged by posterity, it's not important what people think now.

Frederick
Remington

If I could tell the story in words, I wouldn't need to lug around a camera.

Lewis Hines

tions, as will be noted later.) Remarks such as "I like it" or "It's not interesting" may be based on the critic's unspoken criteria but are of little help to the photographer. I am reminded of the remark the writer James Thurber made when someone asked him, "How's your wife?" His sharp reply was, "With respect to what?"

VALIDITY

Evaluation of any kind, artistic or otherwise, must assume some kind of a purpose to be valid. The criteria can be based on the intention of the photographer or on the stated purpose of the client or instructor. An assignment to go out and photograph a tree is quite loose and would be difficult to judge with any *validity* unless the photographer is asked what his or her intentions were and then judged on that basis. Students sometimes complain about a test question not being fair and their complaint is often justified. It is not valid to teach one thing (for example, how to use a 35-mm film camera), and then test for something else (how to use a 35-mm digital camera).

VARIABILITY

Valid: Well grounded, sound, supportable, convincing.

Critiquing a photograph is a subjective task and more often than not different critics will have different opinions. This is easily demonstrated by showing the same photograph to several critics, independently telling each of them what the criteria are, then having them rate the photograph on a scale from 1 to 10 and write a short statement supporting their rating. Regardless of how expert the critics are, they will rarely be in agreement in their evaluations. Photographers must accept this variability of response to their pictures, listen to what others have to say, but also believe in themselves and their work.

No individual symbolic image can be said to have a dogmatically fixed generalized meaning.

Carl Jung

The Impressionist painters believed strongly in their style of painting regardless of the criticism they received from the classical painters and the French Academy at that time and their inability to initially find one gallery or museum willing to display their work.

"The first Impressionist exhibition was held in 1874, and for much of the ensuing century Impressionism—at first so disconcerting that cartoonists predicted it would cause pregnant women to miscarry—has been the most popular of all art movements."[1] The importance of their work took time to be realized as did the importance of the modern art paintings that Dr. Albert C. Barnes was collecting in the early 1900s. He was severely criticized by the art establishment of Philadelphia for wasting money collecting questionable work by painters such as Cézanne, Matisse, Picasso, Degas, and Renoir. The photographer/painter Barbara Morgan,

Beauty, like truth, is relative to the time when one lives and to the individual who can grasp it.

Gustave Courbet

as a young art teacher at the University of California, realized the importance of his modern art collecting and studied with him.

She and her husband Willard were the first photographers to photograph Barnes's entire collection. It was put on lantern slides and made available to schools. His collection now is recognized as one of the largest and most important private collections of modern art and is on display at his home in Marion, Pennsylvania.

PHOTOGRAPHERS' COMMENTS

Listen to what some photographers have to say about their most popular photographs. About his photograph "Rock Wall," Paul Caponigro writes, "In an unexpected moment the print spoke to me as if with a voice. The words were registered in my head or my heart, of course, but I was aware that my rational mind had not shaped that sequence of words which I now heard."[2]

Sally Mann writes, "My work appears to have turned irrevocably from the decorative to a commitment best described as humanistic. 'Jessie at 6,' however, is evidence that the documentary impulse I am yielding to need not be without occasional lyricism and grace."[3] Duane Michals' photograph "All Things Mellow in the Mind" is in his words, ". . . a traditional momento mori, which illustrated my awareness of being and not being. It is about youth, our illusion of permanence, and our unawareness of the moment of now, which is all there is or ever will be."[4] Tom McCartney recalls his experience when photographing Mount McKinley (Chapter 8) in 1982: "The Indians of Alaska gave the name Denali ('The High One') to the mountain. . . . I decided to try to show this mountain in all its majesty. Darkening the shadowed glacier bed and contrasting it with numerous glacier rivers and streams would produce the richness and luster the print deserved. Brilliance would be supplied by maintaining the values of the sunlit snows while increasing the separation of the mountain peaks from the sky."[5]

Regarding her most popular photograph, "In the Box," Ruth Bernhard, who studied with Edward Weston, writes, "I was photographing a friend and, briefly glancing out the window; saw a United Postal Service driver carrying a very large box over his shoulder. I immediately envisioned her in it. . . . I obediently followed my intuition and posed the model in the box, precisely as I imagined. It was not until ten years later that it suddenly occurred to me that this image might have come to me from reading D. H. Lawrence's book, *The Man Who Died*."[6] Bernhard's photograph reminds me of a section of a painting by René Magritte titled "Le Dormeur Téméraire" ("The Daring Sleeper"). One writer describes it thus: ". . . suspended in the night, lies the sleeper in an upturned wooden box—a coffin."[7] There are probably other references to this painting and

to Bernhard's photograph suggesting that they might be archetypal images, prototypes taking on different literary and visual forms.

Birth, death, and rebirth are archetypes.

CRITIQUING

Different styles of critiquing are used by different critics and by a given critic in different situations. A critique can be one on one or can be done with a group, somewhat like a counseling session. Either way, it should be fair and constructive, not confrontational, although some critics are able to use confrontation in a positive way. The critic should serve as a counselor helping photographers gain insight into their work, which in some ways is an extension of the photographer, a *projection* of feelings on the object photographed.

One repents having written succinct and lapidary phrases upon art.

Pierre Bonnard

One of the most difficult tasks in critiquing is having to use words to discuss the content of the photograph, which itself is wordless. The same problem exists in critiquing music and other forms of nonverbal expression. Words are inadequate but they are the basis for our spoken and written language, and we are limited by them. Some photographers are uncomfortable with words and are "at a loss for words" to express themselves when talking about a photograph.

Group critiques in which photographs are arranged on a wall and the group is asked to start talking about them usually begin with an extended dead silence. Everyone is a bit guarded and waiting for someone else to begin. The first person to speak can set the direction for the entire group. The direction can be useful or detrimental. Many research studies in the social sciences have shown how easy it is for the first speaker in a group to influence the response of the others. What might be called *open-ended critiques,* which are unstructured, have their place, but they also present problems in that the most talkative members control the direction of critique.

When judging a photograph or a series of photographs:

- Try to maintain a neutral position and not be influenced by the remarks of others.
- Take sufficient time to seriously study the photographs before making any remarks.
- Consider not just the content of the photograph but also the photographer's viewpoint in making the photograph.
- Identify issues that are being expressed and determine whether the issues deal with specifics or universals.
- Consider whether the approach is historical, political, sociological, psychological, and so on, and whether it is unique or represents a cliché.

It is not just what you photograph but how you photograph. How are you seeing what you are seeing?

Nathan Lyons

CLUSTERING

And what is word knowledge but a shadow of wordless knowledge?

Kahil Gibran

The idea of *clustering* is based on the open-ended use of words as pio-neered by the *free-association* techniques of Freud and Jung. To bypass a conscious response, clients were asked to respond quickly to each word in a list of words spoken. Their responses and quickness of response gave insight into the person's feelings and problems.

With Freud and Jung, a spoken word was used to respond to a spo-ken word (*word–word association*). With clustering, words are used to first respond to a picture and then words are used to respond to those words (*picture–word–word association*). When a large enough cluster of words is gathered, they are studied, edited, and grouped in an attempt to find rela-tionships that will provide insight into the photograph. One advantage of such a technique is that it allows spontaneity, and the words spoken are associated less with thinking and more with sensing and intuiting. In a way, clustering is similar to brainstorming techniques.

How clustering can be used to unveil the layered and latent mean-ings in the photograph of boats shown in Figure 10.1 will serve as an exam-ple. The procedure took place in a classroom setting. We began by using a word to literally identify the photograph. In this case the word "Boats" was used. The word was written on the chalkboard and a circle drawn around it. "Boats" now served as a centering word on which other word associations could be made. Students were then invited to look at the pho-tograph in Figure 10.1 and quickly say or write whatever words came to mind. In this way the right brain is engaged and words that describe how one feels about the photograph are given without much thought. The words most frequently given were "serenity," "tranquility," "quietness," "peace-fulness," "idyllic."

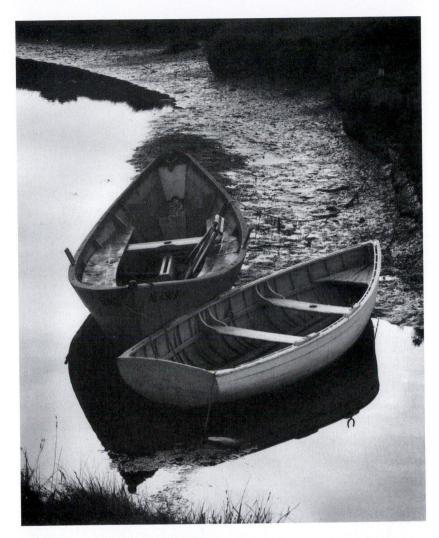

Figure 10.1 *"Eventide." © Tom McCartney. At a literal level this is a photograph of two boats tied to the shore by a rope, but at a connotative, poetic level it is much more. (As Minor White would remind his students. "Yes, it is a photograph of two boats but what else is it?)*

The title of the photograph, "Eventide," conveys the same feeling. A number of other words were given, the most significant being "relationships," "direction," "serenity," and "nostalgia." As shown in Figure 10.2, these became key words that set off other word associations.

Figure 10.2 Word clustering. Word associations around a centering word ("Boats") serve to trigger a number of word relationships that provide insight into the meaning of a photograph.

Relationships

In Figure 10.2, the words associated with "Relationships" suggested two opposing interpretations. One, that the two boats serve as a metaphor for an older couple who have journeyed through life in a loving relationship and have now reached shore and departed gracefully. The title of the photograph supports this idea of the later years in life. (It is important to note here that a title given to a photograph becomes part of the photograph, and directly influences how it is experienced.)

An opposite interpretation, one of separation and divorce, was suggested by another student who probably had experienced such an event as a child of separated or divorced parents. The shape of the boat on the left suggested the woman and the boat on the right, the man. (When I later asked the basis for this interpretation, the response was that the boat on the left was more almond shaped.)

Notice also that the dark shadows of the two boats could suggest a feeling of sadness, remorse, and the uncertainty of what the future holds.

Trope: A figure of speech; a word or picture used in a nonliteral way. A metaphor or simile is an example.

Direction

The two boats that are moored point in different directions. This reminded one student of a poem by Robert Frost, "The Road Not Taken." Recall these lines:

Two roads diverged in a wood, and I—
I took the one less traveled by,
And that made all the difference. . . .[8]

Boats suggest a journey and they have been used in various art forms as metaphors for our journey through life, and in some cases the journey into the afterlife.

Nostalgia

For other students the photograph was reminiscent of earlier days—of childhood. They recalled summer days rowing with friends and docking along the shore, taking their oars with them for security, and then walking into the darkness in search of new adventures. One student, in recalling his childhood, revealed a rather sad experience. His single mother would put him on a train each summer to go to camp so she could be free to work. He did not want to leave his mother and felt isolated and afraid, and was never sure where the train was to take him. He also mentioned that whenever he hears a train whistle he remembers that same experience.

"Eventide" is rich with meaning, and other interpretations are certainly possible depending on the personal experiences and memory of the reader/viewer. The associations made are all valid because they are based on personal experiences. We all see things a bit differently and should not deny this to please someone else's vision.

Paramount to the photograph "Eventide," of course, is the feeling of serenity and tranquillity—peacefulness, which is probably archetypal, a collective experience based on a universal memory we all harbor.

Composition

Some students who were deeply into design were attracted to the compositional features of the photograph and free-associated with words such as "nice lines," "symmetrical," "hour-glass look," "almond shapes," "curvatures," "tonalities," and the like.

As a side note, the photographer, who was in the class when our clustering critique was going on, was asked what he saw in his photograph. He remarked that he certainly was not aware of all of these associations and that something had drawn him to the boats and compelled him to take the photograph. When he first looked at the print he made he remarked, "WOW!!" The photograph, for him, represented what he had experienced in taking it and it is one of his favorite photographs.

Education is man's going forward from cock-sure ignorance to thoughtful uncertainty.

Kenneth G. Johnson

Everything I see and experience in Kentucky is to some extent colored and shaped by the thoughts and emotions I had when I first came to the monastery. It cannot be otherwise.

Thomas Merton

To design is much more than simply to assemble, to order, or even to edit. To design is to transform prose into poetry.

Paul Rand

On Location

This technique of clustering to derive meaning from photographs can be used in reverse. It can be used in planning where to take photographs and what kind of photographs to take. For example, in arranging for a photographic trip to Florida, personal or on assignment, a clustering procedure can provide a useful start. Beginning with the nucleus or centering word "Florida," free-associate the first words that come to mind as shown in Figure 10.3.

Figure 10.3 Location planning. Word clustering can be used to develop a theme for things to photograph when preparing to photograph in a particular location.

Some of the key words to build on to portray a favorable side would be "sun," "seashore," "sports," and "Everglades." If a negative image is to be portrayed, then perhaps words such as "heat," "humidity," "crime," "poverty," "traffic," or "insects" are recalled. Once this is done, and depending on how you want to portray Florida, pick out one or two of the key words and expand on them in some detail. On the positive side, sunshine and seashore might be considered; on the negative side, perhaps heat and crime. Once this is done, a focus is provided for the photographic journey. The result would be a series of photographs having a common theme and such a series could serve as a portfolio of work.

More information on the clustering technique can be found in a book by Gabriele Lusser Rico called *Writing the Natural Way.*[9] The author has

found the technique very successful in helping college students write papers for class assignments and even to compose poetry.

SEMANTIC DIFFERENTIAL

Another method for trying to gain insight into the meaning of a photograph is by using a *semantic differential* scale, which consists of a series of *bipolar adjectives.*[10] The scale was developed to investigate the meaning a person gives to a word as compared to the dictionary definition of the word.

Given a phrase such as high definition television (HDTV), for example, a person is asked to rate the phrase on a seven-point scale between each pair of oppositional (bipolar) adjectives. The instructions specify that the closeness of the mark to each of two adjectives indicates the closeness of the relationship, with the middle position being neutral. In the example given below, the rater felt neutral about whether the phrase HDTV was bad or good, but felt that it was slightly complex, moderately pleasant and intimate, strongly active, and very useful.

Each word means something slightly different to each person, even among those who share the same culture.

Henry James

HDTV

Bad	__ __ __ X __ __ __	Good
Simple	__ __ __ __ X __ __	Complex
Pleasant	__ __ X __ __ __ __	Unpleasant
Intimate	__ __ X __ __ __ __	Remote
Active	__ X __ __ __ __ __	Passive
Useful	X __ __ __ __ __ __	Useless

There are a number of different ways to interpret the responses. One is to look for relationships. A thinking person might rate HDTV as complex and very good while a sensing person might rate it complex and remote.

In a group session it would be of interest to summarize the data and determine what the average response of the group is and how consistent or inconsistent (variable) the responses are for each bipolar adjective. Group responses that are quite inconsistent should be studied to determine the reason.

Connecting the Xs with a line for each bipolar adjective will show a pattern of responses—a graph—that can be compared with other individual responses for agreement and disagreement.

Bipolar adjectives can be classified according to three major dimensions for additional study:

It is not often that we use language correctly; usually we use it incorrectly, though we understand each other's meaning.

St. Augustine

1. *Evaluation* (good or bad),
2. *Potency* (strong or weak), and
3. *Activity* (active or passive).

These three dimensions, evaluation, potency, and activity, represent important aspects of connotation in a wide variety of languages. By studying the responses to the different bipolar adjectives, one can separate the three related qualities of responses.

Although the semantic differential has been used mostly to determine connotative meanings of words, it has also been used to determine the meanings associated with paintings and photographs. In a study to find out if there was a difference between the meanings that a group of artists and a group of nonartists gave paintings, it was found that meanings for representational paintings were similar for both groups but quite dissimilar for abstract paintings. This suggests that artists have worked out and agreed on a system of evaluation for abstract paintings.

A study of the effect of captions on photographs revealed that the captions could shift the meaning associated with a picture. For example, on a scale of happy to sad, a scene of a couple at an airline terminal captioned "Reunion" would be marked happy while the one captioned "Parting" would be marked sad. Captions that were quite the opposite of the pictorial content, however, did not alter the judgment of the photograph.

Figure 10.4 is a semantic differential scale with a number of bipolar adjectives. The scale can be added to or edited to suit a particular photograph (portrait, landscape, scientific, architectural, fashion, nude, medical, forensic, and so on).

SEMANTIC DIFFERENTIAL

pleasant	――	――	――	――	――	――	――	unpleasant		
vibrant	――	――	――	――	――	――	――	still		
repetitive	――	――	――	――	――	――	――	varied		
happy	――	――	――	――	――	――	――	sad		
chaotic	――	――	――	――	――	――	――	ordered		
smooth	――	――	――	――	――	――	――	rough		
superficial	――	――	――	――	――	――	――	profound		
passive	――	――	――	――	――	――	――	active		
simple	――	――	――	――	――	――	――	complex		
relaxed	――	――	――	――	――	――	――	tense		
obvious	――	――	――	――	――	――	――	subtle		
serious	――	――	――	――	――	――	――	humorous		
violent	――	――	――	――	――	――	――	gentle		
static	――	――	――	――	――	――	――	dynamic		
emotional	――	――	――	――	――	――	――	rational		
bad	――	――	――	――	――	――	――	good		

Figure 10.4 Semantic differential scale. This rating scale of bipolar adjectives can be used to measure the word meanings a person associates with a photograph or other type of image. An X in the middle of the scale designates a neutral position. This scale was originally constructed to derive the meaning people gave to different words as compared to a dictionary definition.

CRITIQUE USING GROUP DYNAMICS

Bruce Cline of Lakeland Community College in Kirtland, Ohio, has developed a critique procedure that involves group interaction. It is based on group dynamics, the interactions within a group that can influence attitudes and behavior. Research work in this area was done in the early 1900s by the Gestalt social psychologist Kurt Lewin, who pioneered work in the field theory of behavior, a field being the total environment in which an event takes place.

In the interactive group critique, a large class of students is first segmented into several small groups to discuss student photographs that are not their own. They are then reconvened to share their results with the entire class and carry on further critiquing. Dr. Cline's original article, "Using a Small Group Approach to Critiquing Student Photographs" (© 1966 Bruce Cline) was published in the *Ilford Photo Instructor,* 1996, No. 17.

Quite a few photographers give their prints "body English." They talk up their prints and add value and meaning with words.

Ralph Steiner

Most of my photographs are compassionate, gentle, and personal. They let the viewer see himself.

Bruce Davidson

The most common group work in a photography course is the class critique, which can be can be very challenging, even for experienced instructors. Undergraduate students are often reluctant to share their responses to images in a group setting. In many cases young people are insecure and believe that what they have to say is not important. Some believe that there is a correct answer for most questions and that the teacher knows that answer and expects them to guess what it is. Thinking critically and making independent judgments may be a relatively new experience for many of our students.

Students are also concerned with negotiating the social conventions in the class critique. They may find it difficult to express negative judgments about someone else's work or they may be worried that others will find fault with their photographs. In some cases, an insecure student might react to this stress by being hypercritical of the work of others. Young students generally don't have the experience in making aesthetic judgments that would allow them to express themselves confidently. Consequently, encouraging class participation is often the teacher's foremost concern during the critique.

By applying some of the theories developed by psychologists about small group dynamics, student participation in class critiques can be significantly increased. Begin by breaking the class down into groups of three to five students each and having them cluster their desks together in separate parts of the room. Each group exchanges prints with another so that no group is holding a print of one of its members. This allows for some freedom in the discussion of the print since the photographer is not in the small group. A spokesperson and a secretary are designated in each group. The student's task is to participate in the discussion of the images held by their group and for the secretary to take brief notes on what is said. The discussion is allowed to continue until each of the prints has been considered. At this point the whole class is reconvened as one large group.

The spokesperson for each small group recounts to the entire class what was said about each image as the secretary holds it up. The author of the photograph is identified and asked not to participate in the discussion until after the group has finished. This relieves the photographer of feeling as if he or she has to defend or explain the image. Equally important, it avoids the introduction of information not contained in the photograph itself. If this kind of information is introduced before people have a chance to interpret the image, it might influence the group's reading of it. All class members are encouraged to participate in this phase by building on the small group's discoveries or by adding new observations. The job of the instructor at this point is to:

1. *encourage the precise use of language so that everyone understands clearly what the group's comments mean;*
2. *clarify which elements in the image evoked which responses from the group, i.e., how the image affects the audience;*
3. *point out anything that the students might have missed.*

There are several advantages of the small group method over the teacher-dominated critique. First of all, the instructor is free during the discussion period to observe the group process. It is important to find out who is participating, how often, and the pace or tenor of the small group discussion. Students are usually less apprehensive about small group discussion than they are about speaking in front of the entire class. Small group discussions are often lively, humorous, and in the student's own language. When talking in small groups, students are forced to rely on their own experiences and their internal value systems in order to critique the prints. This is creative in and of itself, and the students are active rather than passive. In addition, several students are given the chance to play leadership roles within the groups. Using this method shifts the primary responsibility for analysis of the image from the teacher to the students and promotes teamwork rather than individual achievement. Furthermore, each photographer receives feedback from his or her peers as well as from the teacher, so that everyone benefits from hearing multiple points of view. The small group critique allows the classroom experience to be laterally structured rather than hierarchically structured, without the teacher giving up responsibility for what happens overall.

The only drawback of using this method is that it takes a teacher relatively skilled in group dynamics. It requires that the teacher exert both obvious and more subtle control over the classroom process, though these are skills that anyone can learn with practice. Group process is something we deal with every time we enter our classroom. Applying the small group method of critiquing photographs is one way you can try out a new method of classroom management at minimal risk.

> *A photographer's work is given shape and style by his personal vision.*
>
> Pete Turner

> *I have nothing to say, and I have said it.*
>
> John Cage

CRITIQUING WITHOUT WORDS

Photographs that are not being made for some kind of an assignment such as a classroom assignment or a commercial assignment are often not specified in terms of intent or criteria. These are personal photographs that are created out of some need for individuals to express themselves. Photography, like other arts, including performing arts, is a wonderful means for personal expression. *Personal photography* involves approaching a subject from a sensing or intuiting position, in Jung's terms, from a nonrational position. Here we look for clues in the photograph that will reveal what is being expressed at a level below consciousness. This will require more than a single photograph—a series of about 30 or more photographs would be required.

Once the series is completed, the prints are viewed and studied by both the photographer and the critic. Considerable time is spent in studying each photograph individually and in relationship to the other photographs in the series. As insight into the series is gained, the critic may edit out some of the photographs that do not seem to be relevant and reposition others. In effect, what the critic is attempting to do, without

> *Work with the images, don't talk about them. Let the photographs speak for themselves.*
>
> Nathan Lyons

using words, is to have the photographs speak for themselves—to reveal the latent information in the pictures that is waiting to be discovered. Words are not necessary, but attention to the photographs and what they are saying is. It is as if one were given a scrambled text and had to edit out some words and rearrange others in order to find the statement being made.

Similar procedures have been used in a movement called *Photo Therapy,* the use of photographs in a counseling situation. A client may be having difficulty resolving some nagging problem, and sessions with a counselor, based on words, may not provide an avenue for insights into the problem. The counselor may then ask the client to bring in a family album of photographs or a series of photographs that the client has taken recently or over the years. The counselor then goes through the same procedure a critic does, carefully studying the photographs, editing out some and sequencing the remainder.

I recall a situation told to me by a psychiatrist friend from Toronto. One of his clients had a severe problem that seemed to revolve around her childhood relationship with her father. Each time the psychiatrist would inquire about her childhood she would become defensive and tell about their closely knit family and her closeness to her father. After weeks of no progress, she was asked to bring in a family album, which she did. She and the psychiatrist then went through the album looking at the series of photographs taken over time. As the psychiatrist was looking over the photographs he was also editing out some and rearranging others. He noticed that in most of the group photographs, his client was at one end of the photograph near her mother and her sister was at the other end close to her father. Her sister was often smiling and very often the father had his arm around her. When the psychiatrist pointed this visual evidence to her, she broke down in tears and was then able to admit to herself and to her psychiatrist the roots of her problem. This led to more productive therapy sessions and a resolution of her problem.

Photographs are statements that can be read and that provide useful information, but like all statements they must be read in context—in context with other photographs or verbal information, and in historical context, for all photographs to some extent are historical. Traditional disciplines such as sociology and anthropology, realizing the importance of photographs as a source of information, now have offshoot groups specializing in visual sociology and visual anthropology. Their research involves not only utilizing photographs others have taken but also photographs they have taken to document events.

SEMIOTICS

Yet another way to find meaning(s) in photographs is through the use of semiotics. *Semiotics* can be described as the study and application of *signs,* signs being anything and everything that conveys meaning. Think for a

A photograph is always seen in some context; physical, remembered, imagined.

Rashid Elisha

A sequence of photographs is like a cinema of stills. The time and space between time photographs is filled by the beholder.

Minor White

Semiotic is the Greek word for "sign."

moment of the number of ways that meaning is conveyed: through words, numbers, symbols, color, music, dance, body language, aroma, texture, movement, movies, and on and on. Photographs are signs, signs that can convey both information and emotion.

In Europe semiotics is called semiology. Their meaning is the same.

Saussure and Peirce

Two of the early pioneers in the field of semiotics were Ferdinand de Saussure, a Swiss linguist, and Charles Peirce, an American philosopher. Saussure referred to signs as *signifiers* and the information or emotion conveyed as that which is *signified*. The flag of the United Nations, for example, is a signifier. What is signified is a gathering of nations in search of peaceful ways to solve conflicts. The familiar and famous photograph of the first man setting foot on the moon is a signifier, and one of the things it signifies is adventure, the spirit of man to conquer the unknown. The flight of the first man in space, a Russian, is another example of man's spirit. The clustering technique, used earlier with the photograph "Eventide," can also be used to arrive at the various significations or meanings of an image.

Sporting events display a variety of signals and signs (codes), many of which are not understood by the opposing team or the spectators.

Charles Peirce described a sign as a relationship between an object or idea, how it is represented, and how the object or idea is communicated. This relationship can be visualized as a triad shown in Figure 10.5.

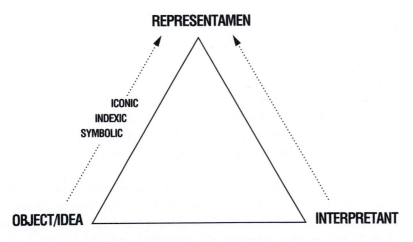

Figure 10.5 Charles Peirce's triad. The three ways to represent something are iconically, indexically, and symbolically.

Semiotics is an old concept that can be traced back to the writings of St. Augustine in about the year 397.

In Peirce's triad, the object or idea is what is signified and the signifier is the *representamen* (represent + amen), a word Peirce coined. A photograph is a representamen or sign. The *interpretant* (interpret + ant), another word he coined, is the process of interpreting the representamen —that which represents or signifies the object or idea. In concrete terms, the object might be a product such as an automobile, the idea being to

represent it as something luxurious. The representamen would be a photograph taken in such a way as to suggest luxury. The process of interpretation includes the person looking at the photo/ad along with how and where the photo/ad was exhibited—in an expensive magazine, in *USA Today,* the *New York Times,* in a slick brochure, on television, on a billboard, or whatever.

Representation

Representation is the process of having one thing stand for another.

James M. O'Neil

Fossil remains are indexical, as are train whistles, police sirens, and the like.

According to Charles Peirce, there are three ways to represent something: iconically, indexically, and symbolically. In an *iconic representation* the representation looks like the object. A photograph of a car looks like a car. An *indexical representation* is an indirect reference, such as the shadow of a car or the wet tread marks of the tires left on a dry road. A *symbolic representation* would include the car's logo.

Other examples of indexical representations are a person's fingerprints, the smell of smoke, a fragrance in an empty room, an empty chair on the porch of an old home, footprints on a sandy beach, an arrow or finger pointing to something. In short, an indexical representation is an index to something else. Indexical representations are often more interesting than iconic ones, for they are more involving.

Symbolic representations are culturally agreed on things, our language being a prime example. Words are symbolic, as are flags of different countries, crests, logos, religious symbols, trees, animals, and colors, among other things.

The three methods of representation are not mutually exclusive. For example, a picture of a serpent or snake is iconic but it can also, depending on context, be symbolic of sin or temptation. A tree is a tree but it can also symbolically represent life (as in the tree of life), or strength (an oak tree); the rock of Gibraltar is a rock but it is also a symbol of security and safe haven. The color red of a traffic light means one thing but the color red on a flag or in a photograph of a sunset means something else.

Indexic

Another point to be made is that an iconic representation can have various levels of iconicity. On a scale of 1 to 10, a color photograph would be a 10, a black-and-white photograph about a 5 and a line drawing about a 1 or 2. As a general statement, the more you show the less interesting it becomes. Always try to leave something for the imagination.

Symbolic

Analyzing an Ad

A semiotic triad can be used to interpret the photograph of the model in the Fidji perfume ad shown in Figure 10.6. Looking at the photograph (the original is in color) and free-associating as in the clustering technique, a number of descriptive words are found.[11] By editing them down to about four they suggest that the ad is sensual, sophisticated, exotic, and androg-

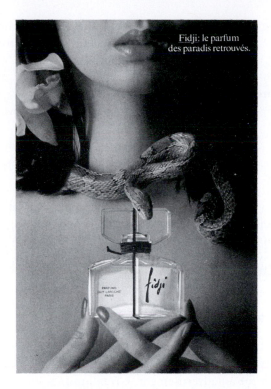

Figure 10.6. Fidji ad. Exotic, sensual, sophisticated, androgynous. The original ad was in an array of rich, warm colors. (Courtesy Guy Laroche, Paris.)

ynous. How is this so? What is it about the photo/ad (a representamen) that conveys this? We can find an answer to this by identifying the iconic, indexic, and symbolic elements in the photo/ad that suggest sensual, sophisticated, exotic, and androgynous.

Sensual
Iconic:	Partially opened lips, long flowing neckline, long loose hair
Indexic:	Feminine finger pointing to the product
Symbolic:	Interlocking fingers, warm red, amber, yellow colors

Sophisticated
Iconic:	Elevated face, fancy bottle laced and sealed
Indexic:	Paris address, placement of the ad in *Vogue* magazine
Symbolic:	Serpent as danger and risk (take a chance)

Exotic
Iconic:	Foreign-looking flower in upper left
Indexic:	Paris, France, Fidji (Fiji) islands

People's behavior makes sense if you think about it in terms of their goals, needs, and motives.

Thomas Mann

| Symbolic: | Native woman, serpent (Garden of Eden), text is in French—"Fidji: le parfum des paradis retrouves"—(paradise regained with Fidji perfume) |

Androgynous

Iconic:	Female: face, neck, fingers, fingernails; Male: flat chest, broad shoulders
Indexic:	Ad is half light (female) and half dark (male)
Symbolic:	Yellow flowers and finger interlocking; male and female forms, long phallic neck

Not everyone will agree with this interpretation and that is to be understood, for perception is a personal matter. A good photograph or advertisement is one that is layered, one that lends itself to several meanings. Semiotics provides yet another way to get a handle on what photographs and advertisements convey.

Designing a Photograph for an Ad

This semiotic procedure of interpreting a photo/ad can be used in reverse as was done with the clustering technique earlier. It can be used to plan a photograph for an advertisement. Given information on what is to be signified to sell a product (romance, nostalgia, power, guilt, sexiness, Americana, and so on), give some thought to the kind of iconic, indexic, and symbolic elements (props, signifiers) that would work well together, including the model or models (casting), the lighting, styling, and so on.

The use of semiotics, as well as clustering and free-association, is not limited to photographs and advertisements but can be applied to any medium being used to convey meaning.

Semiotic Operations

The terms *syntax, semantics,* and *pragmatics,* borrowed from linguistics, can be used in a visual mode. Syntax refers to the visual grammar, the design or composition of a photograph—how the various elements are arranged to convey a particular message. Semantics refers to the meaning that the reader/viewer gives the photograph—what is signified. Pragmatics refers to the context in which the photograph is viewed, which includes not only the space or environment in which it is displayed but also the time in history. Some photographs that were not considered of importance years ago are now valued as art.

If one changes the syntax of a photograph or the pragmatics, the meaning (semantics) will change. In this way photographs can be altered or displayed differently to clarify, amplify, or alter their statement. There are four distinct and practical ways to change the syntax of a photograph or other form of communication and expression:

1. Add something to the message.
2. Subtract or remove something.
3. Substitute one thing for another.
4. Exchange one element for another.

As an example, consider the Fidji ad in Figure 10.6, and how the meaning of the advertisement can be altered by using any of these four operations or combination thereof. Here are some possibilities:

1. Add a bust line to emphasize the sensuality of the model and therefore the product.
2. Remove the serpent or the flower, two important signifiers that suggest temptation and the sexual act.
3. Substitute a red, yellow, or white rose for the exotic flower shown. Flowers and colors are signifiers that can alter what is signified. (Barbara G. Walker writes, "There is an old maxim: the language of flowers is the language of love. It is true not only in a metaphorical sense, but also in the sense of botanical biology, since flowers are the genitalia of plants. Perhaps the beauty of flowers is not the only reason, then, that they so often symbolize human sexual relationships. The arum plant called a Jack-in-the-Pulpit in the United States had many European names that identify it as a lingam yoni symbol more than anything else."[12])
4. Exchange the position of the flower and the caption in the ad.

Flower as metaphor

BC (Before Computers), changing the syntax of a photograph required great manual skill on the part of a retoucher. Now, with the aid of computers and appropriate software, photographs can be scanned and digitized, lending themselves to all kinds of manipulation. Capturing a photographic image is only the beginning of the creation of an image. Using semiotic operations of addition, subtraction, substitution, and exchange allows the photographer to "postvisualize" the image, change its syntax and therefore its meaning.

Other Applications

A lecturer and consultant to businesses on how to think creatively bases his technique on the notion that every new idea is simply a variation of something that already exists. His advice for creating new ideas is the same as that for semiotic operations: Combine something with something else, eliminate something, substitute one thing for another, rearrange something.

DOG
DODGE
DO
LOG
GOD

Some examples of how these techniques can be used on word statements will reveal their usefulness:

- The Sesame Street program "Monsterpiece Theater with Alistair Cookie" is a playful example of substitution and addition, a play

Add

Subtract

Substitute

Exchange

In 1919, Duchamp, in a satire on art, added a mustache to the Mona Lisa and titled it L.H.O.O.Q., which reads "look" in English, and something else in French.[13]

on the early successful TV program, "Masterpiece Theater with Alistair Cook."

- New book titles are sometimes a play on familiar clichés. With a simple substitution, *Fountain of Youth* becomes the title for an optimistic book on aging titled, *Fountain of Age.*
- A decorative and humorous book on women's bras uses addition to connect it to the familiar German design school, The Bauhaus. The title of the book is *Brahaus.*
- A book called *A World Without Women* features a back cover with the familiar 1504 painting of "Adam and Eve" by Albrecht Dürer. The front cover has the same painting, except that the picture of Eve has been air-brushed out.
- Clichés can be put to good use in coming up with new ideas. "Pay now or pay later" can be given a religious tone using addition of one letter, "Pray now or pay later."
- "One if by land, two if by sea, three if by World Wide Web (WWW)" gives a well-remembered historic and patriotic call a contemporary twist.
- The first day of an international golf game held in Rochester, New York, in 1995 began on a rainy day. On the sports page, a photograph of a golfer swinging his club in a drizzling rain was cleverly captioned "Swinging in the Rain."

What is also significant in all of these manipulations is the use of the semiotic code of recognition. In creating any new message there must be some level of recognition—something that will connect with information and emotions held in memory. Perception is a process that is memory dependent. The new message should pull something out of memory and add something new and novel.

For example, I recall a political cartoon depicting the growing influence of the religious right that shows a representative pushing and turning the letter "*p*" upside down, in the letters *gop*. As the "*p*" is inverted, it is exchanged for the letter "*d*" and the billboard now reads *god*. Many cartoons, political and humorous, use these simple types of semiotic operations.

The power of these operations comes from their universal application to all forms of message creation and communications. One can even make a game out of these operations that can be a fun way to spend an evening with a friend or friends. For example, football is a game that attracts quite a following. The culmination of the football season is the Super Bowl. If you're sitting down for dinner during the game it becomes the Supper Bowl. If you're cheering a team that has just made a touchdown, it becomes the Super Howl, and so on.

Ernst Haas (right) with professor John Head and students at a 1985 exhibit of his work in the RIT Photo Gallery. One of the freshman students, puzzled as to why his recent work was exclusively of flowers, asked "Mr. Hass, why are you photographing flowers?" After a quiet moment of reflection, silence, and student anticipation, he replied quite honestly and simply, "I like flowers." "Ernst Haas," photo by Richard D. Zakia.

To learn more about Ernst Haas (1921–1986) have your server call up ["Ernst Haas"]. There are more than 1000 Web sites dealing with his life and his photography. Most are in English but some are in German and other languages.

KEY WORDS

activity
bipolar adjectives
clustering
critiquing
evaluation
free-association
iconic representation
indexical representation
interpretant
open-ended critique
personal photography
Photo Therapy
picture–word–word association
potency
pragmatics

Language can become a screen which stands between the thinker and reality. This is the reason why true creativity often starts where language ends.

Arthur Koestler

projection
representamen
semantic differential
semiotics
signified
signifier
signs
symbolic representation
syntax
validity
variability
word–word association

Critiquing Photographs Exercises

1. Word Critique

Every discipline has its own specialized vocabulary for describing things and it is no different with critiquing. Compile a list of the words and phrases most frequently used to critique artistic work in the fields of photography, painting, sculpture, music, film, video, dance, theater.

A good place to start is by looking through the Sunday Art and Leisure section of a major newspaper such as the *New York Times, Washington Post, Philadelphia Inquirer, Los Angeles Times,* or in magazines such as *Time* or *Newsweek.*

Try relating the words and phrases in writing a critique about your own photographs or those of others. Being able to verbally articulate your photographs can be helpful in promoting your work, but never let the words interfere or take precedence over the photographic statement.

2. Clustering

All the arts apper-taining to man have a common bond.

Cicero

Use the clustering technique on one of your photographs or on someone else's that interests you. Begin by using a centering word to literally identify the photo and then, looking at the photograph, do a word association. Now edit the words to about four descriptors and use these descriptors to talk or write about the photograph. You may want to do the same exercise in a group setting to take advantage of the group dynamics and the rich exchange of ideas.

3. Location Preparation

Use clustering to prepare for a location shoot. Decide on the location, have it become your centering word, and then free-associate around it. Collapse the words to about four word descriptors, and then photograph

on select locations based on those words. After the work is printed and edited, compare the photographs with the themes you intended to record.

4. Semantic Differential

Put together your own semantic differential scale or use the one in this book to have friends rate one or two of your photographs. Before you do, however, rate the photograph yourself. Compare your assessment with those of your friends. Where you agree will be of interest but of greater interest will be where there is disagreement. Search out the reason for the disagreement. Sometimes the problem is simply a different interpretation of the bipolar adjectives. At other times it is the fact that we see the photograph differently, we see it from our own personal point of view. Once the photograph is exhibited or published, the photographer has no control over how his photograph will be interpreted by others.

The mind is insatiable for meaning drawn from or projected onto the world of appearances.

Arthur Koestler

5. Famous Photographs

Use the semantic differential with friends to rate some famous photographs that are of interest, depending on the type of photography you practice: fine art, documentary, photojournalism, landscape, nude, advertising, technical, scientific, biomedical, architectural, forensic, and so on.

6. Applied Semiotics

Find an ad that has a strong photographic presence. Using free-association, list several words that you feel signify the intent of the ad, and then identify the relevant iconic, indexic, and symbolic elements to support the words you have chosen.

Once the work is displayed the author has no control over how it is interpreted. He or she is out of the picture.

7. Props as Signifiers

Look over photographs and advertisements that interest you. Study them and make a list of the iconic, indexic, and symbolic signifiers that you think can be useful to you in your future work. Then record what each signifier signifies. You may want to organize your list under different categories such as trees, animals, flowers, birds, fruit, body language, and the like.

8. Individual Critique

Seek out an instructor or knowledgeable friend with whom you find it easy to relate and are comfortable with, and ask him or her to look over your work. A one-on-one critique and dialogue can be a very rewarding experience (Figure 10.8).

Semiotics goes beyond clustering to identify the iconic indexic and symbolic signifiers.

Be ever so soft and pliable like a reed, not hard and unbending like a cedar.

The Talmud

Figure 10.8 An individual critique can provide a more intimate understanding of your work than a group critique.

Notes

1. Robert Hughes, *The Shock of the New,* New York: Alfred Knopf, 1981, p. 113.
2. Stephen Carothers and Gail Roberts, *Photographer's Dialogue,* Boca Raton, FL: Boca Raton Museum of Art, 1989, p. 106.
3. Ibid., p.114.
4. Ibid., p.119.
5. Ibid., p.116.
6. Ibid., p.105.
7. Sarah Whitefield, *Magritte,* London: The South Bank Centre, 1992, p. 35.
8. Robert Frost, *The Complete Poems of Robert Frost,* New York: Holt, Rinehart and Winston, 1968, p. 131.
9. Gabriele Lusser Rico, *Writing the Natural Way,* Los Angeles: Jeremy P. Tarcher, 1983.
10. C. Osgood, G. Suci, and P. Tannenbaum, *The Measurement of Meaning,* Urbana, IL: University of Illinois Press, 1971.
11. Mihai Nadin and Richard Zakia, *Creating Effective Advertising Using Semiotics,* New York: The Consultant Press, 1994, p. 101.
12. Barbara Walker, *The Woman's Dictionary of Symbols and Sacred Objects,* San Francisco: Harper & Row, 1988, p. 422.
13. Hughes, *The Shock of the New,* p. 66.

11

Rhetoric

Trying to find a verbal equivalent to a visual experience seems to make one more sensitive to both seeing and to language.

Ralph Steiner

"Paris," Richard D. Zakia.

Rhetoric has been defined as the art and study of using language in an effective and persuasive manner to influence the thoughts and actions of listeners. It relies heavily on rhetorical devices such as metaphor, simile, and allusion.

This traditional definition seems to restrict oratory to the written and spoken word. In a larger sense, rhetoric deals with any and all means of communication—persuasive communication. In this day and age persuasive communication is highly visual—pictures, pictures combined with musical background, and depending on the message, voiceovers. Films, animations, multimedia, and advertisements in particular, all use rhetoric. If we extend the concept of rhetoric to visual imaging, it can be, and has been, most useful.

In 1970, a French researcher, Jacques Durand, reported on an extensive and systematic study of the use of visual rhetoric in advertising, which is applicable to any visual message. His analysis of thousands of ads provides a very useful rhetorical matrix for analyzing the syntax of an ad, photograph, or any visual statement, and also for showing how easily one can alter pictures and words to modify or change meaning.

For each semiotic operation of addition, subtraction, substitution, and exchange, there are five things that you can do to alter the message in a particular direction. For example, in the case of addition, you can add:

1. Identical elements (A A),
2. Similar elements (A a),
3. Different elements (A Z),
4. Opposing elements (R Я), or
5. Ambiguous elements. (See Figure 2.6.)

Which one of the five elements is added will determine how the meaning of the message is altered. Durand developed a rhetorical matrix (Figure 11.1A) to show these relationships. You will note that he uses the word *suppression* rather than *subtraction*. Suppression can be partial or complete, which would be total subtraction. Also note that similarity and opposition have two subcategories: form and content.

Figure 11.1B looks a bit more complex, because it adds the various rhetorical terms used to identify each rhetorical operation. These operations can be applied to any form or combination of forms of communication. Some of the terms, such as hyperbole and metaphor, are familiar, while others are not, and some are tongue twisters.

What is important here is not the peculiar terms used to describe each operation, but the operation itself. Note that these operations are used routinely in computer manipulations of images. Durand's rhetorical matrix provides a map that can be helpful in deciding which operation to use to emphasize or alter the meaning of a visual message.

Relation between elements	Rhetorical operation			
	Addition	Suppression	Substitution	Exchange
1.Identity				
2.Similarity				
Form				
Content				
3.Difference				
4.Opposition				
Form				
Content				
5.False homologies				
Ambiguity				
Paradox				

Figure 11.1A Jacques Durand's rhetorical matrix (1970).

Palindrome: A word (or sentence) that is spelled the same backward and forward, such as radar, level, civic, noon, tenet, eye, abba.

Relation between elements	Rhetorical operation			
	Addition	Suppression	Substitution	Exchange
1.Identity	Repetition	Ellipsis	Hyperbole	Inversion
2.Similarity				
Form	Rhyme		Allusion	Hendiadys
Content	Simile	Circumlocution	Metaphor	Homology
3.Difference	Accumulation	Suspension	Metonymy	Asyndeton
4.Opposition				
Form	Zeugma	Dubitation	Periphrasis	Anacoluthon
Content	Antithesis	Reticence	Euphemism	Chiasmus
5.False homologies				
Ambiguity	Antanaclasis	Tautology	Pun	Antimetabole
Paradox	Paradox	Preterition	Antiphrasis	Antilogy

Figure 11.1B Rhetorical matrix with identifiers.

Metonymy: A figure of speech in which the name of one thing is substituted for the name of something that can be associated with it. Example: The "mustache" looks suspicious (in a detective movie, the villain often has a mustache).

USING THE RHETORICAL MATRIX

Most of what has been written about rhetoric pertains to verbal rhetoric. Visual rhetoric, to paraphrase, might be defined as the art and study of selecting and arranging visual elements to influence the thoughts and actions of the viewer—to persuade.

One must not think of pictures and words as being separate but rather as complementing one another in much the same manner as moving pictures and music complement each other. The power of a visual statement

*Whatever is well said
by another is mine.*

 Seneca

depends not only on the rhetoric used but also the aesthetics—how the elements are arranged. A quote by the German philosopher Nietzche is relevant here: "The most intelligible part of language is not the words, but the tone, force, modulation, tempo in which a group of words are spoken—that is the music behind the words, the emotion behind the music; everything that cannot be written down."[1] With a little substitution, this could read: "The most intelligible part of a visual language is not the elements, but the tone force modulation, tempo in which a group of visual elements are arranged and displayed—that is the music behind the elements, the emotion behind the music, everything that cannot be 'written' down."

Being able to identify the various rhetorical devices used in a successful visual statement is a necessary exercise in understanding how one might put them to use in their own line of work, whether it is photography, graphic design, Web design, filmmaking, animation, video, self-promotion, or advertising. This, like anything else worth achieving, will take practice.

So as not to be overwhelmed by some of the unfamiliar and, sometimes, arcane rhetorical terms, start by ignoring the terms and concentrating on the rhetorical operations and the relationship between elements. This should be your first step in your rhetorical journey.

Where to Begin

*The crescent moon
was looked upon as a
boat carrying
departed souls to
heaven.*

 Barbara Walker

Begin by locating a photograph or advertisement that is of interest, and then search out the elements that are *added, suppressed, substituted,* or *exchanged.* Take a look at "Eventide" in Figure 10.1 as an example. The richness of the photograph lies in the many meanings and vicarious experiences that it can provide. Using a clustering technique, it was seen as suggesting relationships, direction, serenity, and nostalgia. Using a rhetorical matrix to assess the rhetorical structure of the image, two boats represent the addition of elements that are identical, which is a rhetorical form of *repetition.* If one of the boats were positioned in an opposite direction, it could be considered an opposition of form, *zeugma,* suggesting disagreement, breaking up a relationship, taking a different direction in life. To guide a student toward further meaning, a teacher might say "Yes, it is a photograph of two boats, but what else is it?" The "what else is it" query gives the photograph added richness and meaning—the music. The something else could be the representation of a journey and, therefore, serve as a *metaphor,* showing or saying one thing in terms of another, which is an example of *substitution.* Symbolically, boats throughout the ages have been used to suggest a journey. "Norseman used the same word for boat, cradle, and coffin, sending their dead into the sea-womb by boat to be reborn."[2]

You will find as you begin to study images in terms of their rhetorical composition that some, as might be expected, do not fall neatly into

one category. Yet it is helpful to begin by assuming they do and then branching out from there. A rather complex image such as Maurits Escher's "Sky and Water," a 1938 woodcut, consists of the addition of elements that are similar and different. In the lower part of the woodcut a school of similar fish emerges from the deep black depths of the water. The spaces between the fish begin to take on the shape of birds rising upward with the fish. About halfway up the image, the white fish are transformed into black duck-like birds flying off to the right of the picture frame. In the complex arrangement we have *addition,* of the fishes and birds, *suppression* of the birds in the space between the fish, *substitution* of birds for fish, and *exchange.* Beyond the imaginative use of visual rhetoric are the potential statements that can be read, one being that of metamorphoses and the possibility that all life emerged from the sea.

Years ago when I was in the navy on a destroyer, we would hold exercises off the coast of San Diego in which we would play hide-and-seek with an American submarine. The submarine would hide somewhere in the vast depths of the Pacific Ocean and we would use our sonar detection equipment to try to locate it. The exercises, called "Search and Destroy," were essential to our future mission. A useful rhetorical exercise for your future mission would be to "Search and Discover" the rhetorical composition of photographs, paintings, advertisements, and so forth. The time you spend will reward you in your career as an image-maker.

One day in 1975 while working with Minor White on *The New Zone System Manual*, he appeared a bit preoccupied and a little tense. When asked why, he replied that he was reprinting many of his old negatives for an exhibition in New York City. Naively, I asked, "Don't you already have prints from your old negatives?" He replied, "Yes, I do but I see them differently now." I can now make a similar statement about photographs and other images I have written about here. I see them differently now and with a greater appreciation thanks to the rhetoric they integrate.

Horse and Truck

A few years ago while photographing in the picturesque mountain area around Santa Fe, New Mexico, I came across an interesting sight that caught my attention. A horse was grazing in a meadow in the sun-filled quiet of the afternoon. Further back was a stalled pick-up truck with its hood raised and a farmer looking at the engine attempting to figure out why the truck stalled. In the background was the magnificent, majestic mountain range. I was taken not only by the beauty before me but also the grazing horse juxtaposed in front of the stalled truck. For some reason, unbeknown to me at the time, I felt that I should photograph the event, and did. It wasn't until some time later, when printing the color negative, that I realized what had prompted me to take the photograph. The stalled truck represented the technology of its time, efficient, powerful and dependable but now

Search and discover.

The path my feet took was lined with images. . . .

Minor White

If all the animals ceased to exist, human beings would die of a great loneliness of spirit.

Chief Seattle

inoperative. The horse, representing a tried-and-true older means of transportation was still operative. He had been put out to pasture, so to speak, but at the moment was the only means of transportation the farmer with the stalled truck had available. The stalled truck was going nowhere but the horse was free to go anywhere. The image can serve as a metaphor for our present digital imaging technology. Cameras, for example, have become so complex and battery dependent that they are on occasion less reliable than the earlier, less complicated cameras. Computers and computer software change so often that one is left with a "stalled truck" and looking for a reliable "horse" to work with. (In preparing this second edition and reviewing many of the photographs by Elliott Erwitt, I now realize that I might have been influenced by his 1961 photograph *Brasilia,* although at the time I took the picture I was not aware of it. Erwitt's black-and-white photograph shows a horse standing in a pasture with a stalled pick-up truck in the background. The hood of the truck is up and three men are seen working on the motor.)

Rhetorical figures have the potential to be discovered in any language: verbal, visual, musical, motion pictures, video, dance, theatre. This is just one of the reasons for seriously studying how rhetoric is used in images. Another is that it provides a wonderful and meaningful opportunity to review some of the images in the history of photography and the history of art. You will soon discover that many of the images that have survived the test of time contain rhetoric and that some of the images are creative variations of earlier photographs.

The importance of rhetoric to picture making can be traced back to the 15th century when the Florentine ecclesiastic and artist Leone B. Alberti advised painters ". . . to familiarize themselves with the poets and rhetoricians who could stimulate them to discover (inventio!) and give form to pictorial themes. . . ."[3]

Intuition First

Professor Hanno of the Nova Scotia College of Art and Design in Canada is a proponent of the importance of rhetoric for graphic designers, illustrators, photographers, typographers, and other visual communicators. He writes that to account for the many successful images they create ". . . it must be inferred that there exists a body of principles, an underlying ruling system that has been mastered in the process, even if the masters are unaware of it. It follows that the creative process, the process of finding an *appropriate* design solution would become more accessible and could be enriched, if designers could become conscious of a system which they seem to use intuitively."[4]

Photographs and other images are not created by thinking about rhetoric first and then making the picture. That is putting the cart before the horse, to use a familiar metaphor.

You should not imitate what you choose to create.

Georges Braque

Everything worked out perfectly because I said yes to my intuition.

Ruth Bernhard

Rather, photographers work intuitively, from the heart, from what they feel and then from the mind. The best advice one could give for the importance of learning rhetoric is similar to the one the psychiatrist Carl Gustav Jung gave to his students after they completed their studies: Forget all you have learned about symbols and go out and practice. Likewise, after you have learned all you can learn or all that you want to learn about rhetoric, forget about it and go out and take pictures. Later, in looking and studying your pictures, what you have learned about rhetoric will help you understand them better; understand why some are more effective than others, and suggest ways you might alter some to increase their impact.

Examples of how rhetoric has been used in making visual statements follow. To simplify matters, no distinction will be made between "form and content" for the categories of *similarity* and *opposition*. You will notice that some of the examples given fit very nicely into the categories listed in the rhetoric matrix and some could be listed in more than one category. Examples given and not shown can be found in the references at the end of this chapter and in the bibliography. Make an effort to find them and study them. There are suggested exercises at the end of the chapter that you may want to consider. Definitions of the rhetorical terms used by Durand can also be found there. You may find it helpful to refer to them from time to time, especially with the less familiar terms.

ADDITION

Identity

Identity refers to the repetition of the same visual elements in a picture or other visual statement, such as an advertisement. The elements can be words, color, texture, shape, form, line, parts of an image, the interval between elements, and movement. Duchamp's "Nude Descending a Staircase" comes to mind as well as some of the paintings of the Italian Futurist movement, especially those of Giacomo Balla. The multiple exposure strobe photograph "College Basketball," by Andrew Davidhazy, the opening photograph in Chapter 4, is another example of identity.

Never, never, never, never give up.

Winston Churchill

A photograph by Joyce Tenneson in her book, *Light Warriors,* shows a young woman with long hair draped over the front of her body as she quietly gazes at the viewer. On each shoulder is perched a graceful, white turtledove.

Similarity

Similarity refers to visual elements that are similar, yet not identical, as in repetition. The photograph "Maine" by Robert Walch (Chapter 7, Figure 7.1) is an example of *rhyme*—similar form, the form of waves crashing

against the rocks is similar to the form of fire emanating from logs in a fireplace or a bonfire.

Milton Glaser's poster titled "5 Bach Variations" was a collage of 12 portraits of Bach in various colors and tonalities. The portraits were arranged in an interesting 3 × 4 matrix of images. The poster demanded attention and the portraits of Bach were such that he was looking directly at the viewer in each portrait. The verbal equivalent of this poster would be the word "Bach" repeated twelve times but in different type styles.

In a vertical 20-cent postage stamp created in 1984 by graphic designer James Bradbury Thompson, the identical word LOVE appears five times. A heart shape is substituted for the V in the word love and is a different color for each word; red, yellow, green, blue, and violet. (The substituted different color heart shapes are also an example of metonymy.) "Thompson has designed over ninety stamps for the U.S. Postal Service including a stamp featuring a painting by Josef Albers."[5]

Jasper Johns, "Three Flags" (1958) shows three American flags of different sizes, centered on each other. They are layered one on top of the other, a small one on the top of a larger one on top of the largest one.

Charles Demuth's painting, "I Saw the Figure 5 in Gold" (1958) makes reference to his experience of seeing a fire engine with its number 5 glittering as it passed, and diminishing in size. In his painting, a large number 5 is centered, followed by a smaller one and a smaller one yet.

Edward Weston's "Eroded Rock, No. 51, 1930" (Chapter 3, Figure 3.1) is indeed a photograph of an eroded rock but it can also be seen as something else—it looks like a reclining nude figure.

Man Ray's photograph "Violon d'Ingres" (1924) displays the bare back of his favorite model, Kiki. The shape of her back, as Man Ray has arranged and photographed it, looks like the shape of a violin. With the addition of two S-shaped violin sound-holes added to her back, there is no mistaking the simile. This photograph is not only an example of simile, but also of the addition of two identical elements. Further, Man Ray intended it as an allusion to the odalisques nude figures by the French painter Ingres. Kiki is ". . . crowned with a Turban, seated in a position similar to one of the beauties in the *Bain turc* of Ingres,"[6] a reference to his paintings of baths in Turkey. Of additional interest is the fact that Ingres was a violinist before becoming a painter.

Man Ray's photograph referencing Ingres's painting was used for an ad by Christian Dumas as a reference to Man Ray's photograph of Kiki. It appeared in a 1980 issue of *Italian Vogue* and is playfully titled *Violon de Dumas*. A further reference to Man Ray is that the image is partially "solarized" and that a small print of Man Ray's photograph of Kiki appears in the lower right (Figure 11.2).

*Figure 11.2 An advertisement for Christian Dumas chemises looks like,
and mimics, Man Ray's photograph "Violon d'Ingres."*

Difference

The addition of visual elements need not be identical or similar; they can
be different and different with a purpose. *Accumulation* is often used in
advertising to call attention to the abundance of, for example, cosmetic
products produced by one company—lipstick, hair coloring, nail polish,
face powder, eye makeup and the like, or jewelry such as bracelets, ear
rings, finger rings, and watches. Another example would be the variety
of tattoos a tattoo artist can offer.

In a recent 15-second television commercial, a quick sequence of dif-
ferent men's apparel flashed across the screen: T-shirts, shorts, shirts, ties,
sweaters, shoes, socks, designer jeans, belts, hats, and even some jewelry.

In the 1813 drawing of Napoleon (Chapter 2, Figure 2.2), the artist,
Johann M. Voltz, uses a variety of referential visual elements in a collage
that profiles Napoleon. The picture serves as a narrative of the rise and
fall of Napoleon and the death and devastation he left behind.

New York photographer David Spindel used accumulation to portray the heroic career of Joe DiMaggio by arranging a collage of baseball memorabilia to reference his accomplishments. These include his New York Yankee baseball cap, pennants, baseball jersey, framed photographs, headlines from a newspaper, shoes, baseball cards, buttons, baseball tickets, and his photograph on the cover of *Time* magazine—all part of Spindel's private collection. In the upper right of the photograph Joe DiMaggio, in what appears to be a nostalgic and thoughtful look, reviews his accomplishments as one of the great baseball players of our time (Figures 11.3A and B).

Figure 11.3A An accumulation of visual elements portraying the many accomplishments of Joe DiMaggio during his highly successful baseball career. (Photograph by David Spindel.)

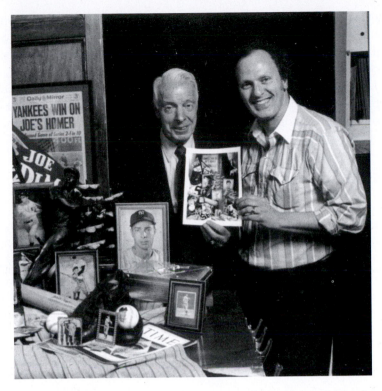

Figure 11.3B A snapshot of Joe DiMaggio and David Spindel in the studio where the photograph was made.

In the 1960s, to lament the loss of edifying heroes, songwriter and singer Paul Simon composed the song *Mrs. Robinson,* in which part of the lyrics uses Joe DiMaggio as a metaphor for the loss of heroes in the 60s: "Where have you gone Joe DiMaggio?" DiMaggio was a brilliant baseball player, and at the young age of 21 became a replacement for the great New York Yankee hitter, Babe Ruth.

Is seeing believing or is believing seeing?

Sandy Skoglund's installations are constructs of familiar settings, such as a bedroom or restaurant, in which she included the unexpected, such as sculptured fish peppered all over the setting. In her photograph "Fox Games" (1989), the setting is a restaurant with covered circular tables, baskets of bread on the tables, chairs, and a couple at the far table being served by a waiter. The colors of everything in the restaurant are all suppressed, having a grayish-blue appearance, which provides a muted background and contrast for about 25 red foxes that are seen jumping on tables, over tables, hiding under tables, rolling on their backs, drinking from a saucer on the floor. The foxes have taken over the place. All the foxes are red except for one, which is the same grayish-blue as the surround and is hardly noticed. The whole scene is bizarre and unreal. In explaining the theme of her work

Skoglund says, "My work is based on this Frankensteinian model where the intervention of the human being has created something out of control. The theme of invasion is the theme of other animals or components —the world that we have made—turning on us."[7]

A television example of accumulation would be a setting in which a performer on MTV is singing and gyrating while an image of him or her is simultaneously displayed on several television screens in the immediate background.

Opposition

Opposites attract as the saying goes. A juxtaposition of opposing visual elements is a sure way to attract attention. Imagine a photograph or an advertisement of the Eiffel tower in its true Paris location and another with the same tower in quite a different setting, for example, alongside Mount Fuji in Japan or in downtown Toronto, Canada. Such an image is sure to grab attention, and indeed was used in an ad in which the famous Paris landmark was displaced and put into a French countryside (Figure 11.4).

Figure 11.4 French government tourist advertisement, 1973.

Robert Heinecken, in the early 1970s, seemed to be following a recommendation by an earlier artist, Hans Richter, who advised artists to "Give chance a chance." Heinecken would place a large photographic transparency of a nude figure over a television screen, turn on the TV, and photograph a fleeting television image superimposed on the transparency. The resulting combination images were full of unexpected juxtapositions—full of surprises, intrigue, ambiguity, irony, and satire.

A wonderful example of antithesis is a photograph by Elliott Erwitt who is well noted for his subtle visual humor. It is titled "East Hampton, New York, 1983" and shows an artist's studio in which five student artists, with their backs to the camera are standing in front of their easels painting a model. A typical scene one might find in any art school studio except for one variation; Erwitt changed the content, by reversing the roles. The model is posed and fully clothed while the five artists with their backs to the camera (three women and two men) are completely nude except for their socks.

A promotion for an early magazine called *Collier* in 1939 designed by Lester Beall shows a large bloody handprint suggesting the spoils of war. Superimposed over the hand is a small photograph of Winston Churchill in full formal dress, holding his hat in one hand and his cane in the other, and with a resigned look. The poster makes reference to Churchill's dire prediction that there will be war (World War II). The poster ". . . uses a reverse perspective in which the large . . . handprint is placed in the background with the smaller photograph of Winston Churchill in the foreground."[8]

In the 1920s Hannah Hoch combined fragmented pictures of body parts and other things from magazines to create photomontages.

False Homology

Ambiguity and paradox play off the opposition between what is seen (perception) and what is known ("reality"). Similarity of form can cause a difference in content and cause ambiguity.

A jewelry advertisement for pearls uses a vineyard as a background for a woman's hand that is gracefully cradling a cluster of shiny white pearls in the form of a cluster of grapes.

In an advertisement for a video CD, two CDs are shown side by side and look identical, having the same circular shape and size. The headline below the two CDs reads "Same CD, Different Quality Content."

A sporting goods store's window display showed two men, one dressed as a golfer and the other as a fisherman. Each holds the same identical golf bag by his side; one bag holds a set of golf clubs and the other an array of fishing poles.

Magritte, in an exposé of what he referred to as "the tyranny of language," added a caption to his painting of a pipe: *Ceci n'est pas une pipe* (This is not a pipe). When one first comes across this painting, puzzlement, disbelief, and questioning are observed. The image and caption seem

to contradict each other, yet the statement is true—a painting of a pipe is not the pipe, simply a representation, as is any image.

SUPPRESSION

Identity

It is not always necessary to include everything in a visual statement. Holding back or suppressing something can give the picture an enigmatic quality and serve as an invitation for the viewer to become more involved and participate in the framing of the statement. Ellipses are the opposite of repetition; elements are suppressed or left out instead of added. The meaning of the message becomes more of a challenge and a reward.

An ad announcing the introduction of a new automobile simply has an outline of the shape of the car on a full page that was blank, except for the identification of the car. By leaving out a detailed photograph of the car, the viewer is invited to imagine what the new car might look like and wait in anticipation of what it will look like.

A clever advertisement for wine shows what appears to be a bottle of wine cradled in a wicker basket. A bottle is seen as expected but there is no bottle there, just a floating wine label with the label carefully arranged so that the omission of the bottle is not readily seen (Figure 11.5). Suppressing the physical presence of the bottle calls attention to the B&G label. This is reinforced by the headline that suggests buying Beaujolias by the label, not by the bottle.

In the ad for Heublein in Chapter 1, two drinking glasses and two liquor bottles are readily seen. What is not readily seen is the completely suppressed third liquor bottle in the space between the two bottles. All that one sees is the blank shape of the bottle. The same is true for the third drinking glass in the space between the two glasses. The careful arrangement of the picture and word elements has suppressed, and for a time, hidden the third bottle and glass.

Similarity

An ad shows a fashion model looking into a mirror, her back to the viewer and part of her face and body reflected in the mirror. In such a situation, only part of the model is seen and assumed to be similar to the model in front of the mirror. It is a roundabout, indirect, and interesting way to show the model and the product (a dress and jewelry) being advertised.

A scene from a movie shows an airport at night in which a woman stands by a window looking out as her lover prepares to board a plane. In the darkness, the window acts as a mirror, reflecting the woman's tearful face, albeit with salient features suppressed.

COLES PHILLIPS

USA 34

I am a horse for a single harness, not cut out for tandem or teamwork. . . .

Albert Einstein

Alfred Hitchcock was a master at movie suspense.

Figure 11.5 A levitating B&G wine label? It is easier for us to fill in and see a wine bottle that isn't there than to see a floating wine label. It is also an example of the Gestalt principle of closure.

Difference

Advertisements are a good source of temporarily holding back something to create suspense, and then to reveal. For example, an enigmatic picture or question might be raised on one page of a magazine and then answered on the following page or elsewhere.

An attractive, sophisticated, and well-designed four-page ad for a woman's cigarette uses a colorful Egyptian motif in which two royally dressed woman, their faces in profile, face each other. The tantalizing headline reads "Some Women Have Always Known Their Place," leaving the reader to question the possible negative implication. As the page is turned, another Egyptian woman is shown. Her name is "Hatshepsut, The Woman Who Would Be King" the headline proclaims. Hatshepsut of the 18th-century dynasty ruled as the only female pharaoh of Egypt, "See Yourself as King," the ad proclaims. The following two pages reveal how easily this can be accomplished by simply purchasing a pack of Virginia Slims cigarettes. (The ad appeared in the January 2001 issue of *Vanity Fair.*)

In sequencing photographs for an exhibition or for a book of photographs, a puzzling situation might be presented in an earlier photograph that is then resolved later in the sequence of photographs. The same idea is used in motion pictures and video. Certain information is held back to create suspense and then revealed at an appropriate time.

In one of O'Henry's delightful short stories, *The Last Leaf,* which is shown on American Movie Classics each Christmas season, a very sick young lady lies in a bed looking out the window at the 21 leaves remaining on an ivy vine. She is 21 and becomes very much connected to the vine because she sees the falling leaves as a sign of her failing health. She truly believes that when the last leaf falls, she will die, and keeps looking out the window expecting death. The leaves fall one at a time over a few days until only one leaf remains mysteriously hanging on the vine. The suspense heightens a beautiful and very touching climax.

Opposition

An example of opposition of form would be a photograph taken of a person in which the shadow he casts is not his own, but takes on a different form. If the dark shadow has a sinister form, it could well describe the darker side of man. If, on the other hand, it took on an angelic look, it could suggest the spiritual side.

In the 1920s and 1930s, Edward Steichen was the chief photographer for *Vogue* and *Vanity Fair.* His fashion portrait of the movie star Gloria Swanson titled *The Cat*, shows her beautiful face and eyes partially hidden behind a lacy veil of delicately patterned flowers and leaves. The slightly suppressed photograph adds a sense of mystery and cunning to the portrait.

He is right wing but is he the right man? We'll be right back.

TV News Reporter

An early German silent film classic, *The Strange Cabinet of Dr. Caligari,* used false shadows on the movie sets to disorient the viewer and project a sense of fear and bewilderment.

A full-page color advertisement in *USA Today* (August 23, 2001) promotes the 2010 U.S. Open Tennis Championship by showing a young girl on a tennis court hitting a yellow tennis ball. Her body casts and elongated shadow across the court, and the tennis racket she holds in her hand becomes a trophy, which she holds above her head.

False Homology: Ambiguity

Tautology is a form of redundancy in which the same word can be repeated but take on a different meaning. For example, "A Rolex is a Rolex." The redundancy is at first ambiguous until the reader realizes that the first word identifies the product and the second word implicitly and proudly suggests the quality of the product. A visual example would be an elegant photograph of a Rolex watch seen by itself in an ad on a blank white page

of a magazine. Without a headline or explanatory copy, the image speaks for itself—a Rolex is a Rolex.

False Homology: Paradox

A photograph of a fashion model feigning a secret or false modesty is an example of *preterition*. Some years ago the Japanese photographer Eikoh Hosoe wanted to make a satirical political statement regarding his government's ban on pubic hair being shown in a photograph. While visiting in California, he photographed several nude women models all lined up in a row fully exposed with their hands covering not their pubic area, but rather their faces.

In the Atlanta, Georgia, High Museum of Art, there is a beautiful marble statue of a woman clothed in a flowing garment with her face veiled. When I first looked at her veiled face, I thought it was actually a veil of cloth draped over her face. It was not, it was marble skillfully crafted so that it gave the impression of a veil; an example of trompe l'oeil, fooling the eye. It is amazing that something as hard as marble can take on the look of a soft veil, which suppresses and softens the marble face behind it. The sculpture is by Giovanni Maria Benzoni and is called *The Veiled Rebekah,* 1864.

SUBSTITUTION

Identity

A *hyperbole* calls attention to a visual element within an image by exaggerating some characteristic. An ad for a perfume, for example, shows a model with a bottle of perfume in her hand, but twice its normal size.

Réne Magritte's painting "The Listening Room" (Chapter 6, Figure 6.6) displays what appears to be a gigantic apple in a room. The apple appears many times its normal size. If some of the New York skyline were to be seen through the window on the left, the painting might be titled *The Big Apple.*

Some photographic postcards in the early 1900s, based on hyperbole, exaggerated the size of familiar farm products being taken to market: potatoes, pumpkins, apples, corn, cabbage, and the like. The cards originated in the Midwest farm communities where farming was their pride and the primary source of income. The cards were motivated by the farmers' desire to even things up with "city slickers" who used farmers as the brunt of their jokes. ("Did you hear the one about the farmer. . . .") Realizing that city folks knew next to nothing about farming and might be a bit gullible, believing photographs do not lie, they created a number of these postcards and sent them on to friends in the East. They were an immediate success and led to a number of other items being exaggerated; oversized

Headline: A national celebration of cosmic proportions.

fish being caught, chickens the size of a pony transporting children, sheep the size of a horse grazing in pasture, 10- to 20-foot insects roaming around, and frogs the size of kangaroos. A book titled *Larger Than Life,* published by Abbeville Press, has many wonderful and humorous examples of early photographic hyperbole.

A *litote* calls attention to something by miniaturizing it and calling attention to its smallness. The classic example of this was the ad introducing the VW Beetle some years ago. It was a time when Americans were enamored with and proud of their big automobiles. To gain a foothold with its small car, which went against the popularity of the big American cars, VW created an ad praising smallness. It showed a VW car in miniature displayed in the center of a blank white page in a magazine. The bold headline read "Think Small." Many people did, and purchased the car designed for ordinary folks, the VW Volkswagen Beetle.

The recipe for a good speech includes some shortening.

Anonymous

Similarity

The January 7, 1991, cover of the *New Yorker,* a magazine famous for its covers, had 12 pictures in the style of 12 important and well-known artist/painters. The content of picture for each month related to the month. For example: March winds, April showers, May flowers, etc. Each picture was in the particular style of the artist and served as an allusion to his work. January pictured two people fighting over a January Sale item and it was done in the cubistic style of Picasso. March, noted for its windy days, showed a windstorm with fences and houses falling, debris flying and a young couple airborne in the style of Marc Chagall with reference to his famous painting, "Birthday" 1915. August, a sweltering month, has a hot summer sun shining on a street scene in which everything seems to be melting; street signs, lamp poles, "Don't Walk" signs, buildings, and a large circular clock melting over a horizontal tree limb. Instead of 12 numbers for the hours on the face of a clock, 12 months of the year are represented. It is a wonderful allusion to Dali's "The Persistence of Memory" 1931.

January	Picasso	July	Miro
February	Lichtenstein	August	Dali
March	Chagall	September	Magritte
April	Rousseau	October	Matisse
May	de Chirco	November	Munch
June	Warhol	December	Manet

As a photographic example of allusion, consider Judy Dater's most popular photograph, "Imogen and Twinka at Yosemite." The photographer Imogen Cunningham, in her 90s and wearing a long dark dress with

a camera hanging from her neck, stands beside a large tree trunk peering at Twinka, a nude model in a frontal pose, one knee slightly bent as she looks at Cunningham with a pixie-like expression. Dater and Cunningham had been conducting a photographic workshop and the painting, *Persephone*, by Hart Benton inspired the idea for the photograph, according to Dater. In the painting an old farmer is peering around a tree trunk gazing at an unaware nude woman lying on a red blanket. Dater's photograph alludes to Benton's painting and Benton's painting alludes to the Greek myth of Proserpine (Persephone).

The designer William Golden's CBS logo created in 1952 references René Magritte's painting of an eye titled "Le faux miroir" ("The False Mirror"), which in turn references the early Egyptian mythological Eye of Horus (see Appendix A). As a side note, one might speculate on why Magritte called his eye a "false mirror." Was he suggesting that the eye could mislead us?

Cindy Sherman is a master of impersonation, of performance, parody, and allusion. Photographs of herself, carefully staged, have portrayed the way women have been stereotyped in fashion, Hollywood B movies, sex pictures, and historical portrait paintings. In each situation she puts on the persona of the character she mimics. Sherman is uncanny in her ability to disguise herself, using elaborate costumes, cosmetics, makeup, various props, lighting, and, of course, her ability to mime. Her photographs echo and ridicule the way mass media have typically portrayed women.

"What is a meta phor?" someone once punned. Metaphors are used often in our daily speech and writing. It is a figure of speech by which a word used to designate one thing is used to implicitly designate another. Neil Armstrong remarked when he first landed on the moon, "The eagle has landed," making reference to both the name of the lunar module he landed with and America, whose symbol is the eagle.

Ansel Adams' photograph "Moonrise, Hernandez, New Mexico" (1941), taken on All Souls day—the day the dead are remembered, can be seen as a metaphor representing the archetypes life and death; the moon above symbolizing life shining on the gravestones. Professor Ralph Hattersley once suggested to me that it could appropriately have been titled "Moonrise Over Graveyard."

From "Moonrise" to "Sunrise." Figure 11.6 is an engaging advertisement in which the rising sun is replaced with an egg yolk. The egg yolk is a potential substitute for the sun; both have the same circular shape and similar color. In addition, just as the yolk provides sustenance to the developing chick inside the egg, so too does our sun provide sustenance to all life on earth.

Figure 11.6 *"Good Morning America"—one egg, sunny side up metaphor.*

The sun burst through with its atomic mane.

Gordon Parks

One of Judy Dater's favorite photographs is not her most popular one, "Imogen and Twinka at Yosemite," but rather one titled "My Hands, Death Valley, 1980." It was a very personal photograph that she wrote about in *Photographer's Dialogue*. She was nearing her 40th birthday, facing a midlife crisis, and looking for a new direction. As she was sitting in her parked car during a photographing sojourn, looking out the partially opened window, she noticed the landscape looked slightly different through the glass and without the glass. The idea came to do a photograph of her hands pulling aside a window so that it is half open so that one may see the landscape more clearly. "It was a metaphor for me in regard to my own life, my personal quest to see things more clearly."[9]

Duane Michals' "Illuminated Man" (1968) shows a man walking out of a traffic tunnel under Park Avenue in New York. Michals has positioned the man coming out of the tunnel so that a single bright shaft of light falls on his face, completely obliterating it with pure light. The photograph is somewhat reminiscent of a painting by Magritte for whom Michals had a great respect and a friendship. Michals writes of his photograph "The Illuminated Man illustrates my idea of enlightenment, in the Eastern sense

by which one becomes what we are and have always been, but have forgotten—a joyous energy and light transcendent."[10]

An early Russian film classic has a scene in which a politician stands boastfully on a balcony overlooking a large crowd of people. With typical political oratory and gestures, he bellows his message—he goes on, and on, and on, nonstop. Every so often during his verbal diarrhea the scene changes showing workers struggling desperately and in vain to turn off a broken water main flooding the street. The gushing water from the main mimics the cadence of the politician.

Chuck Jones, creator of the animated cartoon *The Roadrunner*, has his coyote character, under great peril, always chasing the roadrunner, hoping to catch him, but never succeeding. Jones, at a broadcasters' conference some years back, suggested that the coyote was a metaphor for those who are continually chasing after something, never finding it, and even if they did find it they probably would not know what to do with it.

Difference

Metonymy in classic rhetoric is the substitution of one word for another that it suggests; for instance, "The pen is mightier than the sword." In a visual statement, an associated detail is used to connect an object or idea. For example, the *New Yorker* magazine is noted for its many interesting covers. One that comes to mind is a picture of a large cornfield after the harvest with a row of three large smiling pumpkins dancing with three playful turkeys. The farmer in coveralls is off to one side playing his violin as they do their dance (November 26, 1984). Pumpkins and turkeys are associated with the happy and joyful day in which we give thanks.

An advertisement for zoom lenses shows three photographs of a young girl holding a bouquet of flowers. Each photograph is the same size but the picture of the girl in each photograph becomes larger and larger as one would expect when using a zoom lens at different focal lengths.

The North Carolina Museum of Art in March 2001 announced an exhibition of the paintings of the American artist Stanton Macdonald-Wright with a full-page color picture of one of his famous and familiar paintings. Under it is the title of the exhibition: "Color, Myth, Music." An earlier Ansel Adams exhibition at the same museum was announced with a full-page ad displaying "Moonrise, Hernandez, New Mexico" his signature photograph.

Andreas Feininger's self-portrait, "The Photojournalist, 1951," shows him holding his 35-mm camera vertically so that the camera lens covers one eye and the flash unit the other. Behind the camera lens, the iris shutter, partially open can be clearly seen and easily associated with the human eye, the iris and the pupil. Reading into the photograph one might take this as a statement of the fact that a photojournalist sees not with his eyes alone but also with the camera, both work together to create memorable images.

The scale of red-violet is the calm before the storm, whereas violet is the storm itself.

S. Macdonald-Wright

Synecdoche is a form of metonymy—understanding one thing in terms of another. It is based on the use of a part to represent a whole or vice versa. The ad for Parker pens (Chapter 2, Figure 2.16) shows three hands holding pens and writing. We project that two of the hands are men's and one is a woman's from seeing just the hands. Another example is the exotic Fidji ad (Chapter 10, Figure 10.6), which shows only part of the model's face and hands, inviting the viewer to fill in the rest.

Another example of synecdoche is Man Ray's "The Lovers or Observatory Time" (1931–1934). It shows an enormous pair of red lips hovering over part of a landscape, floating among white puffy clouds in the sky.

Opposition

An anamorphic image can be considered as a roundabout way of showing something to make a statement. A classic example is Holbein's painting "The Ambassadors," in which two seafaring explorers stand side by side in front of the various instruments used for their explorations. In the middle of the painting is an anamorphic skull that can only be seen from a single perspective. It serves as a reminder that no matter who we are or how successful we are, death will someday greet us all—momento mori.

The Hungarian photographer André Kertéz and the British photographer Bill Brandt went through a period of creating anamorphic nudes. Kertéz's interest in distorted figures began in the early 1900s when he was photographing the bodies of swimmers refracted in a swimming pool. The distorted bodies interested him, and with a special mirror he later created a series of distorted nudes. His anamorphic images of nudes were similar to the deformations of the human body that occupied Picasso at the time.

Wagner's music is better than it sounds.

Mark Twain

Used cars are no longer called "used" cars. They are now "pre-owned." An ad for used cars shows a large selection of polished cars, flags waving, and a young man and woman in the market for a car. An exceptionally courteous sales representative is treating them like royalty. The headline for the ad reads "The Best Selection of Pre-Owned Cars Anywhere." Other euphemistic ads include those for men's and women's hygiene products and for funeral services.

False Homology: Ambiguity

Puns play on words or visual elements suggesting different meanings, often humorous. A photograph by Elliott Erwitt, "Puerto Rico, 1969" shows the side of a house with artificial brick siding. In the center of the photograph is a white window frame without a window, just more artificial siding in the window space. In another photograph of a nudist colony, a man stands in the middle of the photograph, his back to the camera. In the near distance, a woman and child walk away from the camera. The

man standing in the middle appears to have a baseball glove in his right hand, and in his left hand he prominently hold two baseballs.

The designer Saul Bass told how he and his colleagues looking for ideas would get together for fun and play word games. For example, given the word "fish"—The cat is perched in the tree. For the word "dog"— The bark on the tree is loose. Given the word fish, a person can free-associate with anything that comes to mind without thinking. Cats like fish and Perch is a type of fish. Someone else might have associated cat with purring, and remarked—the car engine purred quietly. When working in a group, one response can trigger another producing spontaneous ideas. It is a playful form of brainstorming. Suppose, as an example, one was looking for a poster idea dealing with students. Given the word "student" in a group setting, someone might respond—Look at the school of fish in the pond. Someone else might remark—Pencil in your name on the form—and another—Book me on a later flight—and so on. Out of the cluster of association could come an idea for a poster.

Long before the artist Christo began covering up large objects, and keeping them covered for a period of time before unwrapping them, Man Ray, in 1930, created "L'Enigme d'Isidore Ducasse," an object in the shape of the dancer Isadora Duncan all covered up in a black cloth with rope around it. The shape and form of the covered piece resembled that of the proponent of modern dance before Martha Graham, Isadora Duncan. The work serves as a pun, fooling one into thinking Duncan might have modeled for the piece or is actually under the cloth.

The cover of the Winter 2000 Christmas issue of *Forbes fyi* has a beautiful and somewhat seductive three-quarter close-up portrait of a model. She looks at the viewer in a flirting way with her highly accented, dilated green eyes suggesting interest and excitement. Her prominent and protruding lips are candy-striped red and white like the familiar peppermint candy canes that make their debut during the Christmas season. Directly below the lips in large red type are the words "MERRY KISSMAS."

Echo answers echo; everything reverberates.

Georges Braque

False Homology: Paradox

A clever television ad that I remember well began with a group of people in an art gallery standing in front of, and admiring, a billboard-size painting of a new luxury car with an attractive model at the wheel. After 10 or 15 seconds to establish the setting, and much to the utter surprise of the group viewing the painting, the car starts up, the motor roars, and the car laterally drives across the gallery wall and out of the television-viewing screen.

In Figure 11.7 a man holds an identical image of part of the building that is behind him. It is a paradox, which reminds one of Magritte's statement that everything that is visible hides something else that is visible. This is how the photograph was made and it was made BC (before computers). A photograph of the man holding a blank mount board in

front of the building was first taken and printed. Then a second photograph was taken of only the building. The section of the building obstructed by the man was then cut out and pasted on the first photograph so that it coincided with the building behind the man. This combination photograph was then photographed to create what is seen in Figure 11.7.

Figure 11.7 A photograph of the author taken and manipulated by Dr. Leslie Stroebel. The picture was created photographically by combining two photographs. Years later, a somewhat dramatic sky was digitally substituted for a dull, cloudless sky.

I shut my eyes in order to see.

Paul Gauguin

A photographic illustration in the February 2001 issue of *American Photographer* shows a model, dressed in a bikini bathing suit, standing in front of what appears to be a large window through which one can see an overhanging roof and mountains in the distance. A reflection of the model with her head slightly tilted downward appears in the "window." It takes a few minutes before one realizes a clever play on what one expected to see—the window has all the features of a window but is not a window.

The inspiration for this photograph might have been Magritte's 1955 painting "Euclidean Walks," in which an easel with a canvas sets in front of a window overlooking a settlement of buildings. Part of the painting is an exact copy of what one might see through the window. In other words,

the painting in front of the window coincides exactly with the area in the landscape that is blocked by the painting. Part of what is seen is in front of the window in the room and part outside the window. Magritte is leading us to question what we see and how we see. Whatever we look at, part of what we see comes from the inside, from our memory and from what we expect to see.

EXCHANGE

Identity

In an exchange, the elements in a visual statement are identical but inverted. An advertisement for men's stylish dress consists of a handsome male model in full dress from head to toe in a very fashionable outfit. Alongside of him is the same image but upside down. This grabs one's attention. To show that a newly designed ball point pen can be used in any position, a man in a business suit is standing on his head, pen and pad in hand and writing upside down.

On September 11, 2001, tragedy struck New York City and America. Two hijacked commercial airplanes loaded with fuel crashed into the two World Trade Center Towers and completely destroyed them. Both crumbled and collapsed to the ground from the impact and intense heat of the fireball explosion. A third hijacked plane struck the Pentagon building in Washington. Many innocent lives were lost and the Nation was put on high alert.

An illustration depicting the event appeared on the Editorial page (14A) of the Raleigh, North Carolina *News and Observer*. It showed the side view of the Statue of Liberty looking at the New York City skyline without the Towers. An ominous, opaque, gargantuan dark cloud of smoke and debris hovers over the skyline.

Liberty, with her body slumped and with her head bowed, covered her face with her left hand. In her right hand the torch of liberty that has been held high, welcoming immigrants, was now lowered. The Statue of Liberty, symbol of freedom, was now inverted to a symbol of sorrow; a symbol of a nation in mourning.

"Noire et blanche" ("Black and White"), a 1926 photograph by Man Ray, shows a woman's face resting sideways on a tabletop. In her left hand she holds a black African mask. Paired with the photograph is its negative, reversed laterally. The African mask is now white and the woman's face black. The paired photographs can be seen as a metaphor that we are all the same under the skin or that color is only "skin deep." "Noire et blanche" is one of the photographs Man Ray valued most highly.

The painting "Male Nude (Self-Portrait)," by the German artist Georg Baselitz (Figure 11.8), is part of the permanent collection of the North Carolina Museum of Art in Raleigh. The text accompanying the painting

on exhibit reads, in part, "Georg Baselitz paintings—large, ambitious, and emotionally turbulent—explore the territory between abstraction and representation." By inverting the figure he shifted attention to the abstract quality of the composition as he explained: "An object painted upside down is suitable for painting because it is unsuitable as an object."

Figure 11.8 "Male Nude (Self-Portrait)" by Georg Baselitz. (Courtesy of the artist and the North Carolina Museum of Art.)

Similarity

In a visual *hendiadys,* a similarity is established between a concrete object and an abstract idea. An ad emphasizing the creative quality of Italian design pictures a side view of a stylish new blue convertible automobile in the upper part of the ad. Below it is the side view of a fashionable woman's blue shoe. Both the car and the shoe are shown in complete isolation except for some puffy white clouds in the background. The headline reads, in part, "Italian design on wheels, about $96,000, Italian design on heels, about $130." (The quality of the ad itself speaks well of Italian design.)

Two images having the same meaning but different forms can be seen in a recent ad for a cake mix. The first image shows the box partially open and to the left of the ad. Next to it is a deliciously looking, ready to eat, cake. The form is different but the content similar.

A segment from a television show on sea animals shows a seal performing in the water. In one sequence the trainer, with his hands cocked to mimic the flippers on the seal, is flapping his arms, and the seal is doing the same with his flippers.

Difference

In the difference element of exchange, *asyndeton,* one or more of the visual elements are unconnected or fragmented. In the early 1970s, Professor Heinecken of the University of California pieced together fragments of images and rephotographed them to make sociopolitical or sexual-erotic statements. His image titled "Cliché Vary//Fetishism, 1974" is one example. In a brochure for the book *Heinecken* he writes, "I am interested in what I term gestalts, picture circumstances which bring together disparate images or ideas so as to form new meanings and new configurations . . . it is the incongruous, the ironic and the satirical which interests me. . . ."[11]

In the 1960s, Rauschenberg began applying found images, not found objects, to his canvas using silkscreen. "With access to anything printed, Rauschenberg could draw on an unlimited bank of images for his new paintings . . . rocket, eagle, Kennedy, crowd, street signs, dancer, oranges, box, mosquito—creates an inventory of modern life, the lyrical outpourings of the mind. . . ."[12]

Change reality! If you don't find it, invent it.

Pete Turner

Opposition

A picture that presents an impossible situation (*anacoluthon*) is René Magritte's "Carte blanche, 1963." The setting is a forest of trees shown in perspective. A horse and rider are shown in the middle of the grouping of trees independent of the fact that some of the trees are near and some far. The horse straddles both the near and far trees simultaneously and appears segmented: Parts are seen in front of, as well as behind, the trees. "Visible things can be invisible. When someone rides a horse in the

forest, first you see them then you don't, but you know they are there. . . ."[13] The horse and rider hide the trees and the trees hide the horse and rider. We are thrust into a conflict between physical reality and image reality—between what is seen and what is hidden, a problem that fascinated Magritte.

Christmas 2000 found Bethlehem as a place, not of peace, but of warring factions. In a television news segment, children are seen decorating a Christmas tree, not with traditional ornaments, but rather with empty brass bullet shells. A color photograph of an elderly lady with a wrinkled face is shown sporting a very colorful youthful-looking blond wig. In another photograph, a little girl is all dressed up in her mother's clothes, a long flowing dress, a fancy hat, high heels, and carrying a large purse. An advertisement for candles during the Easter season has different colored egg-shaped candles in an egg carton.

False Homology: Ambiguity

A cartoon appearing in the *New Yorker* shows one side of a pyramid in its triangular shape and next to it an imaginary road in perspective having a triangular shape. The road can be seen as a road in perspective or as a pyramid lying flat.

An ad for a computer software company was based on the cliché "Don't put the cart before the horse." The photograph in the ad showed a horse and a cart but the cart was before the horse. The horse, shown as being somewhat perplexed, had his head turned to the viewer with a puzzled expression.

False Homology: Paradox

In Magritte's "Dangerous Relationships," a nude woman facing the viewer holds a large mirror in front of part of her body. In the mirror, the back of her body is reflected. One sees part of the front and part of the back simultaneously.

In one of Magritte's classic visual enigmas, "La reproduction interdite" ("Not to be reproduced") (1937), a well-dressed man stands in front of a mirror. His back is to the viewer as he looks into the mirror but the image in the mirror is not of his face, as one would expect, but of his back. Figure 11.9 is an advertisement based on this painting. In the ad, the man in the mirror is replaced by an attractive woman facing the man to add a romantic touch.

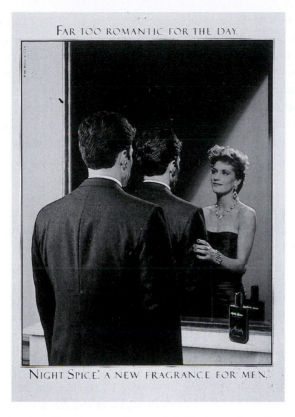

*Figure 11.9 An advertisement for a man's fragrance based on the paint-
ing "Not to be reproduced" by René Magritte.*

WORDS, SOUNDS, AND RHETORIC

Photographers have many opportunities to use and improve their verbal
skills by wisely using rhetoric. So much effort and emphasis are placed
on the visual statement that we sometimes overlook the importance of
the verbal statement. As important as the photograph is, the captioning
of it is also important, and that caption becomes part of the photograph.
Captioning is just one way the use of rhetoric can help. Skill with words
is also important in setting up a Web site. The style of the type used, color,
size, and placement chosen can, in Nietzche's words, provide "the music
behind the words."

*Language is required
to mediate pictorial
representation, at
least initially.*

T. G. R Bower

 In preparing an announcement for an exhibition or to promote your
own work, how you say what you say reflects on your photography. On
occasion a photographer may have an opportunity to prepare a magazine
article to show and discuss his or her work. In an oral presentation, the
choice of words and the way these words are spoken can enhance the
images, just as music enhances the quality of films. Rhetoric is the key to
creating interesting and memorable verbal statements, as well as visual
statements.

To the rhetorical terms used earlier, some additional terms bear consideration. Sound is an important component of a word or group of words. How the word sounds, when read aloud or silently, plays an important role and should do so without drawing attention to itself. Five rhetorical terms related to sound are: *alliteration, assonance, onomatopoeia, amplification,* and *cacophony.*

Mighty Mouse
Mickey Mouse

Alliteration is the occurrence of two or more words in sequence having the same initial sound. Some years back a vocalist became an overnight celebrity by singing a song titled *Tip Toe Through the Tulips.* His name was Tiny Tim, a tall man with long hair, a ukulele, and a falsetto voice. At about the same time, a woman scientist, Rachel Carson, concerned about the hazardous use of pesticides on the environment and health published a book called *Silent Spring* that alerted the nation to the danger. The NCAA finals each year come down to the two winners of the "Final Four" teams. Remember the tongue twister we struggled with when we were children? "She sells seashells on the seashore."

Red sky at night
sailors delight. Red
sky in the morning,
sailors take warning.

Assonance is similar to alliteration, but the identity occurs with the *vowels* (a, e, i, o, u) in the words in sequence. A good example is the familiar saying, "The rain in Spain is mainly in the plain." How pleasant and memorable are the sound and the rhythm.

Onomatopoeia is a name given to a word that sound like what it represents. Words such as meow, bow-wow, moo, zap, and buzz all serve as examples. Part of the lyrics of McNamara's band can also be cited, "Oh, the drums go bang and the cymbals clang. . . ."

Cacophony refers to words that have a harsh and discordant sound. It is the opposite of *euphony*, which describes words that have a pleasing and harmonious sound. Some languages tend to be more cacophonous than others, and some more euphonious. Romance languages, such as French, Spanish, and Italian, tend to be euphonious. Three lines from the poem *Comus* by John Milton serves as an example of both cacophonous and euphonious sounds:

How charming is divine philosophy!
Not harsh and crabbed as dull fools suppose,
But musical as Apollo's lute.

Garish colors can be
cacophonous.

The first and third lines are euphonious, while the middle line is cacophonous.

Amplification is a way to emphasize and expand a statement to call attention to its importance. For example, to emphasize that a person has very good taste in things, one might write that he or she shows elegant taste for good photography, good music, good food, and good friends.

DEFINITIONS OF RHETORIC TERMS

Addition

Repetition: The act or process of repeating something: "I have asked you over, and over, and over again, not to take my picture."

Rhyme: Words that sound alike and words that echo each other: "Why are you not saying what you are seeing?"

Simile: A figure of speech in which two unlike things are compared: "In the Olympics of 2000, Marion Jones ran like a deer and won three gold medals."

Accumulation: The act of collecting or amassing things, to pile up

Zeugma: From the Greek *zeugos*, meaning "yoke" or "means of binding." When a word is used to modify two or more other words although its use is only correct with one of the words: "The digital camera and books were on top of the computer."

Antithesis: The direct opposite. The juxtaposition of opposing or contrasting ideas: "We were promised freedom but kept in slavery."

Antanaclasis: To reflect, bend back, in the opposite direction. A figure of speech is repeated with contrary meaning: "The condemned against hope, believed in hope."

Paradox: A statement that seems at first contradictory is found to be true: "We will have peace if we have to fight for it."

*Weston's sliced arti-
choke looks like the
wings of an angel . . .*

Ralph Steiner

Suppression

Ellipsis: The omission of a word or words necessary to complete a statement: ". . . stop taking photographs" instead of "Will you please stop taking photographs."

Circumlocution: A roundabout way to say or show something.

Suspension: The process of holding back on something and revealing it later to create a sense of suspense.

Dubitation: A 15th-century archaic word meaning doubt, dubious.

Reticence: Restrained, reserved, and somewhat silent.

Tautology: Needless redundancy of an idea: "The film was either exposed or not exposed."

Preterition: The act of neglecting, disregarding, or omitting something.

*A photograph is a
secret about a secret.*

Diane Arbus

Substitution

Hyperbole: An exaggeration: "It was an event of cosmic proportions." A hyperbole need not be a statement of "cosmic proportions." Any exaggeration to make a point and make it in a dramatic fashion qualifies. In 1943, at the age of 16, Professor Nile Root was a high school student in Denver, Colorado, and more interested in photography than in his school work. His composite photograph in Figure 11.10

serves as a visual record of what a burden books were for him at the time.

I'm running on instinct. I'm running off my soul.

Musiq Soulchild

Figure 11.10 The exaggerated burden of books (school) when you are 16 years old and more interested in photography. (The books, representing school, can be seen as an example of metaphor.) Photograph by Nile Root.

Allusion: Making reference to an earlier familiar event: "The girl admiring herself in a mirror references the myth of Narcissus."
Metaphor: Saying or showing one thing in terms of another: "The Internet provides us with a whirlpool of information." (Some critics might use the word cesspool as the metaphor.)
Metonymy: The name of one thing is substituted for the name of something else that can be associated with it: "Washington plans to lower taxes."
Periphrasis: The use of a longer phrasing in place of a possible shorter one—a roundabout way of saying or showing something.

Euphemism: A nice way of saying or showing something that may be considered offensive or hurtful: "Your portfolio requires some additional work" rather than "Your portfolio has been rejected."

Pun: A play on words, sometimes on the different sound of the same word or the different meaning of the same word: "The panda bears in the National Zoo broke loose, causing pandamonium."

Antiphrasis: An ironic or humorous use of words.

Exchange

Inversion: To turn something upside down or inside out, to reverse color or tonalities.

Hendiadys: The use of two words connected by a conjunction to express one idea: "It sure was terribly cold and windy yesterday" rather than "uncomfortably cold."

Homology: Similar with respect to some quality. The same meaning is presented in successive images but in different forms.

Asyndeton: When one or more elements are not connected. The omission of conjunctions that are normally used to connect words or phrases: "I came, I saw, I conquered."

Anacoluthon: A sentence that lacks a grammatical sequence.

Chiasmus: A rhetorical inversion of the second of two parallel structures: "It is the dull man who is always sure, and the sure man who is always dull." (H.L. Mencken)

Antimetabole: Double meaning: "Some of the students in our school are exceptional."

Antilogy: Against speaking, a contradictions in terms of ideas: "The seeming antilogies of the Bible."

"FrogHorse"

(From an old advertising card)

I travel to take pictures and take pictures to travel.

Rick Sammon

Only morality in our actions can give beauty and dignity to life.

Albert Einstein

Jewish and Arab boy holding the globe.

KEY WORDS

accumulation

alliteration

allusion

amplification

anacoluthon

assonance

cacophony

chiasmus

ellipsis

euphony

hendiadys

hyperbole

inversion

metaphor

metonymy

onomatopoeia

preterition

pun

repetition

rhetoric

rhyme

simile

suspension

synecdoche

tautology

zeugma

Rhetoric Exercises

1. Look-Alike, Feel-Alike

In his book, *Point of View,* Ralph Steiner encouraged his students to express how they felt when looking at a photograph, and not what the thing in the photograph looked like. Instead of look-alikes, he suggested feel-alikes. "I saw as possibly helpful that students attach feel-alikes to each of my tree pictures as a learning process. These should be anything that came freely to mind on viewing each tree picture: titles, quotations, parallel, images, equivalents, metaphors."[14] Try Steiner's exercise with some of your images or with those of others.

Ruth Bernhard felt that Weston's vegetables were more sensuous that his nudes.

2. Variations on a Theme

One of Marshall McLuhan's famous one-liners was "A man walked into an antique store and asked, 'What's new?'" "What's new?" has relevance to some of the images we see today—they have their roots in earlier images. For example, the classic image of The Three Graces, in Appendix A, can be traced back to the early Greeks, and it is often used in fashion advertisements. There have been more variations on Leonardo da Vinci's Mona Lisa than one can count, including the one for Prince spaghetti sauce shown in Figure 11.11.

The movie, Life Is Beautiful, *was based on "The Rubaiyat" of Omar Khayyam.*

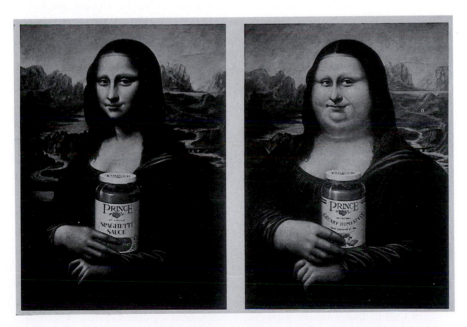

Figure 11.11 Mona Lisa for Prince spaghetti—regular or chunky.

In 1919, Marcel Duchamp added a mustache to the *Mona Lisa*. In 1967, Joe Stalin's daughter, Svetlana, defected from the then Soviet Union, which was quite a news event. Every magazine was given the same

photograph. To make the cover of *Esquire* stand out from the rest, George Lois added a mustache similar to her father's to her photograph. It appeared in the November 1967 issue of the magazine with the title "Her Father's Mustache." The magazine turned out to be the best selling issue for *Esquire*.

On my first visit to the Louvre, I wanted to first see the famous painting of the Mona Lisa and to my surprise it was much smaller than I expected. I was also surprised to see a crowd around it taking flash shots even as a security guard stood near by, and signs on either side of the painting requested, "Please, No Flash." I began to wonder whether the painting was the real Mona Lisa by Leonardo or a substitute. In any case, later in the day while having a cup of coffee, I imagined that with all the flash photographs being taken, Mona Lisa could end up with a red eye. I went back and took a photograph of her, and when I got home digitally substituted two red pupils (see Color Plate XIII).

Take a look at images, particularly in advertisements and see if they are variations of earlier images. An ad in a February 2001 issue of a magazine showed a man holding a Compaq Microportable Projector in front of his face in such a way that it mimics Andreas Fenniger's portrait, "The Photojournalist."

The movie, Sixth Sense, *was based on William Shakespeare's* "Hamlet."

Maurits Escher's "Drawing Hands," a 1948 lithograph, shows a hand that is drawing a hand that is drawing a hand, and on infinitum. The hands have no beginning and no end as does a circle and the ancient symbol of the ouroborus on page 84. Escher's drawing has been imitated in ads a number of times, most recently in an ad for a wireless pen that appeared in the February 2001 issue of *Time Digital*.

3. Paired Photographs

Three different photographic books are based on the rhetoric of addition: *Double Take* by Richard Whelan, *Second View, the Rephotographic Survey Project* (1984) by Mark Klett, Ellen Manchester, and Joanne Verburg, and *Deja View,* by Willie Osterman. Paired photographs displaced in time are shown side by side for easy comparison and new interest. Look over photographs that have interested you over the years and you may discover your own déjà vu.

In *Double Take,* a number of examples of similar photographs taken by different photographers years apart are shown. Dorothea Lange's 1938 photograph, "Woman in the High Plains, Texas Panhandle," shows a poorly dressed woman, one hand on her neck and the other on her forehead, isolated and with a look of despair. The gesture of the woman is similar to that in Ben Shahn's "Rehabilitation Clients, Boon County, Arkansas," taken in 1935. Lange's photograph, however, is much more powerful.

Man Ray's photograph "Torso," taken in 1923, shows the upper part of a nude woman with illuminating patters of light, as does Edward Weston's "Nude, 1920," taken three years earlier. The forms are similar, but the patterns of light are not.

John Vachon's 1938 photograph titled "Atlanta, Georgia" is very similar to that taken by Walker Evan's two years earlier in Atlanta. The two old houses in the background are the same but the large billboards in the foreground have different advertisements as one might expect. Vachon was familiar with Evan's photograph and had set out to record a similar one. Trying to duplicate someone else's photograph is a difficult but interesting exercise.

Willie Osterman's book was influenced by, *Second View, the Rephotographic Survey Project* (1984). "When I first heard of the Rephotographic Survey Project, I was impressed by the comparisons the photographers had made and even more by the rituals they performed to identify, go to, match the light in, and finally rephotograph the original scene."[15] Osterman performed a similar ritual in the paired photographs of people and places in Bologna, Italy.

The word "jeans" in "blue jeans" comes from Genoa, Italy, where jeans were first produced.

4. Recycled Myth

The advertisement in Figure 11.12 was very successful in introducing a new fragrance for woman. In terms of rhetoric, it is wonderful example of the substitution of similar form. Do you recognize the form, the allusion? It is based on an early myth, except that the gender roles are reversed.

Figure 11.12 "The Passion of Rome."

5. Poetry and Rhetoric

If you haven't met the Spanish poet and playwright Frederico Garcia Lorca, born in 1898, introduce him to yourself. In his poem, *Dance,* the identical phrase "Girls, shut the curtains" is repeated three times throughout his short poem.

6. Song Lyrics and Rhetoric

Spend more time studying the lyrics of current and earlier songs and discover how rhetoric has been used. The use of metaphor is often in the lyrics as well as in poetry.

> *Candle in the Wind* (Elton John)
> *Please, Please Me* (The Beatles)
> *Beautiful Noise* (Neil Diamond)
> *Ocean Without Shores* (Constance Damby)

7. Signs and Rhetoric

Look for signs in places of business that exhibit rhetoric. Here are some humorous false homologies:

> *Sign in front of a home:* "We are all vegetarians, except our dog."
> *Dry cleaner:* "Drop your pants here."
> *African safari park:* "Elephants Please Stay in Your Car."
> *London department store:* "Bargain Basement Upstairs."
> *Business office:* "Toilet out of order, please use floor below."
> *Electrical repair shop:* "Let us remove your shorts."

8. Cartoons and Rhetoric

Many cartoons employ rhetoric and it is fun to discover this. For example, in the Catholic magazine *America,* a cartoon showing a sink with faucets marked "Hot" and "Cold," with which we are all familiar, adds a third faucet—"Holy" (water).

9. The Bible and Rhetoric

The Bible is full of rhetorical phrases. For example:

> "By their fruits ye shall know them." *Matthew* 7:20
> "Be not overcome by evil but overcome evil with good." *Romans* 12:21
> "Let your speech be always with grace, seasoned with salt." *Colossians* 4:6
> "There is a time for everything . . .
> > a time to weep and a time to laugh.
> > a time to mourn and a time to dance . . .
> > a time to embrace and a time to refrain,
> > a time to search and a time to give up. . . ." *Ecclesiastes* 3.2

10. Oratory and Rhetoric

Review some of the speeches of Abraham Lincoln, Winston Churchill, Jack Kennedy, Martin Luther King, and others for the power, persuasion and influence of their rhetoric:

> "With malice towards none, and charity for all. . . ."
> "Never in the field of human conflict was so much owed by so many to so few."
> "Ask not what your country can do for you, but what you can do for your country."
> "I've been to the mountain."

11. Symbols and Rhetoric

The American flag is a powerful symbol of America, as is the Statue of Liberty. Both have been used rhetorically to make political and social statements. To promote ecology, the color green was substituted for the red stripes and the blue field of the flag. Smog problems in America found the Statute of Liberty wearing a gas mask. During the Vietnam War rifles were substituted for the red horizontal stripes of the flags and bullets for stars. Search out ways in which the flag and Statue of Liberty are being used or have been used to make rhetorical statements. Posters from Poland and Russia during the cold war are rich in rhetoric.

JAMES MONTGOMERY FLAGG

There are many different ways in which an advertisement for an international corporation can identify the corporation as being global. The more direct and simpler the ad, the more memorable. Identify the rhetoric used in the ad shown in Figure 11.13.

12. Art and Rhetoric

The work of artists such as René Magritte, Maurits Escher, Man Ray, Duane Michals, John Pfahl, and Elliot Erwitt have a lot to show in terms of visual rhetoric. Even if you are familiar with their work, take another look in terms of the richness of the rhetoric in their images. René Magritte, in particular, has much to offer. His images continually challenge what we see and how we use language. "One of the most frequently quoted artists—sometimes at the borderline of trivialization—is René Magritte (1898–1976). His paintings evoke a silent and disquieting universe where the recognizable and familiar coexist with the fantastic and the surreal."[16]

13. Photoshop and Rhetoric

Photoshop software provides an open door to rhetorical improvisation of existing images. One can easily and readily add, suppress, substitute, or exchange visual elements within an image and modify the meaning. Find a picture that interests you and completely change its meaning by using one of the rhetorical operations.

Figure 11.13 *"The Real Thing"—in any language.*

14. Postage Stamps and Rhetoric

If you are a stamp collector, look over your collection in terms of the rhetoric used. Look over some of the new stamps being minted. Even if you are not a collector, notice how rhetoric is used in the image and text of some stamps.

15. Create Your Own Chiasmus

Chiasmus is the reversal in the order of words in two otherwise parallel phrases. Chi stands for the letter X in the Greek alphabet. If you make up a chiasmus like "Is she walking her dog or is the dog walking her?" then line up the reverse phrases thus:

> Is she walking her dog or is
> her dog walking her.

You will notice that if you draw a line connecting walking and a line connecting dog, lines cross to form an X. Play around with creating your own chiasmuses.

16. Photographic Reality

The Fuji ad in Figure 11.14 serves as an interesting example of addition, false homology, and ambiguity. Can you identify the model that is a photograph within the photograph of the "Three Graces" who are sunbathing?

Figure 11.14 Can you identify which one of the models is a "paste-in" photograph?

17. Graphic Design and Rhetoric

As professor Hanno Ehses pointed out earlier in this chapter, rhetoric accounts for many highly successful graphic designs. Look over some of the work by graphic designers that you find interesting and identify the rhetoric used. Some of the designers that come to mind are those listed in *Nine American Graphic Designers,* by Roger Remington and Barbara Hodik:

I went around looking with eye like twin vacuum cleaners sucking up designs. . . .

Ralph Steiner

Mehemid Fehmy Agha	Lester Beall	Alexey Brodovitch
Will Burton	Charles Coiner	William Golden
Alvin Lustig	Ladislav Sutnar	Bradbury Thompson

Additional designers can be found in *A History of Graphic Design*, by Phillip B. Meggs:

Saul Bass	Herbert Bayer	Peter Behrens
A. M. Cassandre	Jules Chéret	F. H. K. Henrion
Ando Hiroshige	El Lissitzky	Herbert Matter
Joseph Muller-Brockman	Paul Rand	Anton Stankowski

18. Photographs and Rhetoric

A good source of important historical and contemporary photographs can be found in Naomi Rosenblum's *A World History of Photography*, first published in 1984 with a third edition in 1997. Another useful book is *The Photo Book*, published by Phaidon Press, London. There are many photographs in Rosenblum's third edition that you might look at for rhetorical references. Some suggestions to begin with include these:

Photography USA 15c

Recording images of serenity and beauty was a matter of devout observance.

Gordon Parks

"Hampton Institute: Students at Work on the Stairway" (1899–1900) by Francis Benjamin Johnston
"Second Hand Tires, San Marcos, Texas," (1940) by Russell Lee
"Adolph the Superman; He Eats Gold and Spews Idiocies" (1932)
"Violin d' Ingres" (1942) by Man Ray
"Hosokawa Chikako" (1932) by Kozo Nojima
"The Photojournalist" (1955) by Andreas Feininger
"The Critic (Opening Night at the Opera)" (1943) by Weegee (Arthur Fellig)
"Anna May Wong" (1930) by Edward Steichen
"Housewife, Washington, D.C." (1942) by Gordon Parks
"Pilgrimage from Lumbier Spain" (1988) by Christina Garcia Rodero
"Georgia O'Keeffe, Ghost Ranch" (1968) by Arnold Newman
"Chance Meeting" (1969) by Duane Michals
"Drottningholm, Sweden" (1967) by Kenneth Josephson
"Untitled" (1981) by Joyce Neimanas
"Untitled (Cloud Room)" (1975) by Jerry Uelsmann
"Ordeal by Roses #29" (1961–1961) by Eikoh Hosoe
"The Actor" (1973) by Author Tress
"Four Pears" (1979) by Olivia Parker
"Tomato Fantasy" (1976) by Bea Nettles
"Revolution in Time" (1994) by Martina Lopez
"Kiesler" (1966) by Robert Rauschenberg
"Red Elvis" (1962) by Andy Warhol
"Self-Portrait/Composite, Nine Parts" (1979) by Chuck Close

19. Poster Rhetoric

James Van Der Zee and Gordon Parks, two great American photographers, appeared together in 1981 at the Rochester Institute of Technology thanks to the support of the Eastman Kodak Company. Mr. Parks showed great respect for the older photographer who people in his New York Harlem neighborhood called "The picture-taking man." Identify the rhetoric used to create the poster of the two men shown in Figure 11.15.

Figure 11.15 Two great American photographers.

Notes

1. Richard D. Zakia, *Quotes by Artists for Artists,* Rochester, NY: Zimzum Press, 1994, p. 7.
2. Barbara G. Walker, *The Woman's Dictionary of Symbols and Sacred Objects,* San Francisco: Harper & Row, 1988, p. 121.
3. Hanno H. J. Ehses, *Design Papers 4,* Halifax, Nova Scotia, Canada: Nova Scotia College of Art and Design, 1989, p. 8.
4. Ibid, p. 5.
5. Roger Remington and Barbara Hodik, *Nine Pioneers in American Graphic Design,* Cambridge, MA: The MIT Press, 1989, p. 164.
6. Roland Penrose, *Man Ray,* Boston: New York Graphics, 1975, p. 92.

7. Dennis P. Weller and Janis Goodman, *Is Seeing Believing?*, Raleigh: North Carolina Museum of Art, 2000, p. 16.
8. Roger Remington, *Lester Beall*, New York: W. W. Norton, 1996, p. 61.
9. Steven Carothers and Gail Roberts, *Photographer's Dialogue*, Boca Raton, FL: Boca Raton Museum of Art, 1989, p. 119.
10. Ibid, p. 119.
11. Enyeart, Jim (ed.), *Heinecken,* Carmel, CA: Friends of Photography, 1980.
12. Robert Hughes, *Shock of the New,* New York: Alfred Knopf, p. 345.
13. Suzi Gablek, *Magritte,* Greenwich, CT: New York Graphic Society, 1972, p. 42.
14. Ralph Steiner, *A Point of View,* Middletown, CT: Wesleyan University Press, 1978, p. 76.
15. Willie Osterman, *Déjà View, Bologna, Italy,* Bologna: Pendragon, 2000, p. 4.
16. Mihai Nadin and Richard Zakia, *Creating Effective Advertising,* New York: Consultant Press, 1994, p. 122.

Appendix A
Additional Concepts

If metaphor is a verbal strategy to evoke images, then as a photographer I'm interested in combining images to alter associations by extending the image itself. . . . It is this act of transformation, interactivity between images, that I find the most challenging.

Nathan Lyons

"Tina Tan." Photograph by Cheng-Sung Chan.

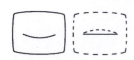

Aftereffect The change in perception that occurs after looking at a bright and contrasty image, such as a line graphic on a video screen, and then looking away from it. For example, looking at a curved line for some time and then looking at a straight line can make that line appear curved and bending in the opposite direction. (*See also* Waterfall Effect.)

Afterimage The visual image that is experienced after looking at a bright and contrasty image for some time, and then looking away from it. The image is seen as similar in shape but complementary in color, or in the case of black-and-white images, reversed in tonalities. The more intense the light source used for looking at the picture, the longer the duration of the afterimage.

Agnosia Introduced by Freud in his writings, the word means the absence of recognition. A person afflicted with agnosia can identify the characteristics of an object, but fail to recognize what the object is. In visual agnosia, for example, a person looking at a face can identify all the facial features but cannot recognize the face. In auditory agnosia, a person can hear but is not able to interpret sounds, including speech.

Allusion A pointed reference to something or someone, either directly or implied—an indexical sign.

Androgynous The combination of both male and female characteristics in one person. In mythology the Asian Androgyne, Hermes, and Aphrodite were a united deity called Hermaphroditus.

Anima and Animus "Jung called the persona the 'outward face' of the psyche because it is that face which the world sees. The 'inward' face he called the anima in males and the animus in females. The anima archetype is the feminine side of the male psyche; the animus archetype is the masculine side of the female psyche. . . . Every person has qualities of the opposite sex . . . in a psychological sense of attitudes and feelings."[1]

Many people are strong in anima—full of imagination, close to life, empathetic and connected to people around them.

Thomas Moore

Aspect Ratio The format proportions for motion pictures and television are normally expressed as aspect ratios, obtained by dividing the width by the height. (*See also* Golden Section.)

The ratio numbers given below represent the shorter dimension divided by the longer for comparison with the golden section. The aspect ratio for television and conventional motion pictures is 1.33 (0.75). Wide-screen motion picture aspect ratios range from 1.8 (0.56) to 3.0 (0.33).

Film Formats Arranged in Increasing Aspect Ratios

Format	*Ratio*
6 × 12 cm	0.50
24 × 36 mm (6 × 9 cm)	0.67 (Golden Section)
2 1/4 × 3 1/4 in.	0.69
3 1/2 × 5 in.	0.70
5 × 7 in.	0.71
6 × 4.5 cm	0.75 (film, video)
11 × 14 in.	0.79
4 × 5, 8 × 10, 16 × 20 in.	0.80
2 1/4 × 2 3/4 in.	0.82
6 × 7 cm	0.86
6 × 6 cm	1.00

Bit A contraction of the phrase *binary digit.* It is the primary unit for measuring information. The bit is an on–off, 1–0, yes–no decision. In imaging, it is the number of tones that can be displayed in a digitized image. A 7-bit image can display 128 tones including black-and-white ($2^7 = 128$).

Byte One byte contains a group of 8 bits.

Caduceus A universal emblem of the medical profession having its origin in Mesopotamia. Intertwined snakes represent a healing god.

Chiaroscuro The arrangement of dark and light, shadows and highlights, in a picture. (From two Italian words meaning "light" and "dark.")

Chimaera (chimera) A demonized monster from classical mythology.

Cognitive Dissonance Inconsistent thoughts that can cause a person, in an effort to favorably resolve differences, to distort or otherwise alter the facts. For example, a person buys a photograph as an investment for a large sum of money only to find out later that it is ordinary and not worth much. Embarrassed, the person then tries to justify the expenditure in terms other than money.

Color Preference Although color preference is a personal matter and somewhat culture dependent, in general, studies find this order of preference: blue, red, green, violet, orange, yellow.

Colorfulness A visual sensation in which the color that is seen appears to be more or less chromatic, that is, colorful.

Common Fate The Gestalt principle in which visual elements that function, move, or change in unison will tend to be grouped and seen as a pattern or movement (similarity of movement).

Color in its tremendous variety of hues and shades organizes our feelings according to precise connotations related to whatever society generated them and reads them in a codified manner.

Massimo Vignelli

Constancy The perception that the attributes of an object, such as color, shape, size, and lightness do not change much, even though the viewing conditions may change. For example, with color and lightness constancy, objects look the same indoors as they do outdoors, even though the lighting is quite different in color balance and intensity. This, of course, is not true for film, and it is the reason why we have outdoor and indoor film types.

Cryptomnesia An apparently new experience or idea that is thought to be original but is later discovered to have been experienced before but not remembered. For example, one captures or creates what he thought was an original image. Later he finds the same image in one of his earlier photographic books.

Cyclops Mythological giants with only on eye located in the middle of their face.

Déjà vu An experience in which a person looks at an unfamiliar scene and feels she has experienced it before. It is the opposite of *jamais vu.*

Direct Perception Perception requiring little cognitive processing. For example, the letters AA are identified as being the same faster than are the letters Aa.

Doppelganger "A visual hallucination in which the 'other person' is recognized as being oneself. The concept of the phantom 'double' seems to have perturbed mankind since ancient times. It figures in folklore and fairy tales throughout the world, and is still prevalent in the religious beliefs of many primitive societies."[2]

Eidetic Imagery A somewhat rare visual effect in which a person with a vivid and accurate visual memory image is able to recall an image in great detail and with accuracy. For example: a person is shown a picture and after it is removed, he is asked to recall various elements in it such as, Was there a dog in the picture? What kind of dog? How big was it? In which direction was it looking? Where in the picture is the dog located? etc. To answer each question the person actually scans the picture in memory as if it were in front of him. The person's eye movements confirm this, as he scans the picture that is not physically present.

Expectancy A condition in which a person is more receptive to seeing what he anticipates or wants to see rather than what is.

Eye of Horus This symbol appears on the back of every United States $1 bill and represents an Egyptian solar deity—an all-seeing deity.

Feature Detectors A specific cluster of receptor cells in the retina that are excited by stimulus configurations such as lines, angles, curves, color, and movement.

Fibonacci Numbers A series of numbers created by adding the number that follows to the number that precedes it: 1, 2, 3, 5, 8, 13, 21, 34, 55, and so on. The series represents a mathematical equivalent of many of the spiral shapes in nature such as seashells, sunflowers, and galaxies.

Golden section and expanding logarithmic spiral.

Flare Light Light reaching the eyes comes from both the image being viewed and the area surrounding the image. The light entering the eye from the surround area diminishes the quality of the image, and is called flare light or non-image-forming light. The effect of flare on an image is most noticeable in the dark shadow areas.

Gargoyle Invented in the Middle Ages, gargoyles adorned cathedrals and were thought to represent demons.

Gestalt Therapy A holistic problem-centered approach to psychotherapy that gives equal emphasis to mind and body and takes into consideration environmental factors. It is noninterpretative and nonjudgmental. It is sometimes referred to as family therapy.

Golden Section A ratio of proportions between two dimensions of a plane that is approximately 3 to 5, an aspect ratio of 0.60. Similar proportions are evident in photography, film, and video. (*See also* Aspect Ratio.)

Hallucination A false perception in which one experiences something that is not there—perception without the presence of an object. These false perceptions can occur in any sense modality: seeing, hearing, tasting, smelling, touching. (*See also* Negative Hallucination.)

Hallucination: From the Latin hallucinan, *meaning "to dream, to wander in mind."*

Hybridization A term used by René Magritte to describe two familiar objects combined to produce a third interesting, engaging, and bewildering one.

Hypnagogic and Hypnopomic (pre-sleep and post-sleep) "The drowsiness experienced as one falls asleep, and again as one wakes up, is often accompanied by pronounced imagery. . . . The intermediate state between wakefulness and sleep is referred to as hypnagogic; that which precedes full wakefulness after sleep is termed hypnopomic. . . ."[3]

A dream is the shadow of something real.

Aborigine aphorism

Both types of dream images are vivid and realistic, and their content sometimes bizarre. Hypnagogic images are most often visual or auditory but they can occur in any sense modality.

"The most common type of hypnagogic imagery is probably 'faces in the dark' which often terrify children as they are falling asleep, and which are also reported by some adults. The 'faces' are often distorted in size and shape, and may be in bright but unnatural colors."[4]

Image Dissection Photographs and other images are made up of tiny elements for recording, transmitting, or manipulating. Photographic elements consist of silver grains, press prints of halftone dots, inkjet prints of dots, CCDs of pixels, video screens of phosphors, and of the receptors in the rods and cones of the eye.

Jamais vu An experience in which a person looks at a familiar scene or photograph but does not experience it as being familiar. It is the opposite of déjà vu.

Janus A mythological Roman god that looks in two directions at the same time—forward (future) and backward (past).

Just-Noticeable Differences (JNDs) The threshold of sensory response, in which a very small increase in intensity is required to see or not see, hear or not hear something.

Lingam-Yoni The lingam-yoni is a symbolic carved altar stone of the male and female genitalia. Joined together, the symbol is a spiritual representation of the integration of both sexes representing the generating power of the universe. It is commonly found in Hindu temples. In Western countries it is often misinterpreted since many symbols are culturally defined. Edward Weston's photograph of the dancer Fay Fuqua[5] may suggest such a symbol. The isomorphic commercial equivalent of the lingam-yoni, the joining of the sexes, can be found in advertisements (Figure A.1).

Lingam-Yoni

Myths and dreams are heroic struggles to comprehend the truth in the world.

Ansel Adams

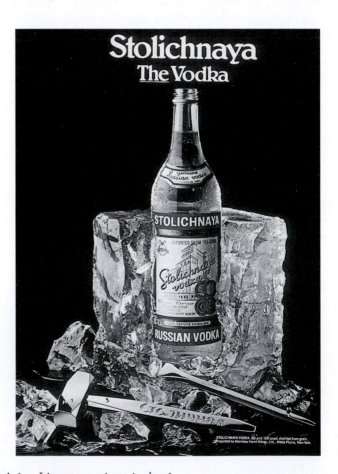

Figure A.1 Lingam-yoni equivalent?

Mandala The Sanskrit word *mandala* means "circle" in the literal sense, usually a concentric arrangement of geometric shapes. As a religious symbol it represents wholeness as symbolized by any circular image that is painted, drawn, modeled, or danced. The lotus flower and stained glass rose windows found in churches are examples.

Mandalas can appear in dreams during periods of stress and conflict. Frequently they contain a multiple of four, in the form of a cross, a star, a square, and so on.

Mandorla Two intersecting circles suggest a union of two worlds, the physical and the spiritual. Seen in a vertical position, the circles take on the shape of an almond, a symbol for the female genital, suggesting fertility and maternity.[6]

Maslow's Hierarchy Abraham Maslow's hierarchy of needs proceeds from our very basic need for physical survival to our spiritual and psychological needs. Our basic needs must first be provided for before we can advance to other needs. Maslow's hierarchy, in order from the physical to the spiritual, are:

1. Physiological needs (such as food and drink);
2. Security and stability (shelter);
3. Belongingness (love, affection, identification);
4. Esteem (recognition and self-respect); and
5. Self-fulfillment or self-actualization (being oneself).

Maypole A large erect pole decorated with ribbons around which May Day dances are performed. During the dance the ribbons become interwoven to represent the decking of the pole with colorful leaves, flowers, and fruit; all gifts from the moon goddess, giver of fertility.[7]

Metamerism A situation in which two color samples visually match each other under one type of light source (such as daylight), but when viewed under a different source (such as tungsten or fluorescent), they look different. The reason for this is that the two color samples have different spectral characteristics, that is, they absorb light selectively and differently.

Metaphor A figure of speech that provides an understanding of one thing in terms of another—having one thing represent another. For example, a feather can serve as a metaphor for lightness; a daisy for freshness. The term is from the Greek word *metapherein*, meaning "to transfer."

Misoneism An unreasoning fear and hatred of new ideas.

Myth "Any real or fictional story, recurring theme, or character type that appeals to the consciousness of people by embodying its cultural ideals or by giving expression to deep, commonly felt emotions."[8]

A Simple Mandala

The first function of a mythology . . . is to waken in the individual a sense of awe, wonder, and participation in the inscrutable mystery of being.[9]

Joseph Campbell

Fatboy Slim

Entertainer

I would like to paint a star-spangled sky but how can I manage unless I make up my mind to work from imagination?

Vincent Van Gogh

Negative Hallucination "In ordinary visual hallucinations the subject 'sees' something which is not there; in negative hallucinations he apparently does not 'see' something that is."[10]

Oxymorons A figure of speech that combines contradictory terms such as "holy war," "paying guests," "taped live," "perfect mistake," "plastic silverware." A visual oxymoron is one that includes contradictory elements in a picture such as a blatantly sexy model wearing a cross, a Star of David, or other religious symbol.

Pareidolia "Most people with strong visual imagery have seen pictures in the fire or in clouds. They would probably describe this activity as daydreaming or imagining. But strictly speaking it involves misperception of an external stimulus, and so is classed as an illusion, the technical term for which is pareidolia."[11] (*See also* Rorschach.)

Parks Effect The perception of a complete image when a picture or word is passed behind a narrow slit aperture. If the picture is stationary and the slit is moved rapidly, a complete undistorted image is seen. If, however, the slit aperture remains stationary and the picture is moved, the image is compressed. The reason for this is probably that the successive slit images are incident on the same part of the retina producing a masking effect. (See Figure A.2.)

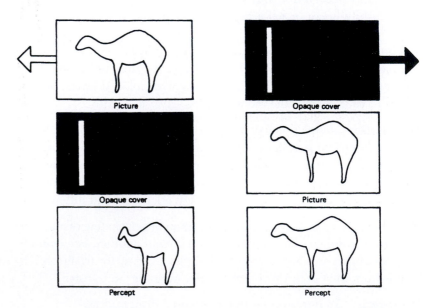

Figure A.2 Moving a picture rapidly behind a stationary slit-aperture (left) produces the perception of a complete but compressed image. This has been called the Parks effect. Moving the slit-aperture rapidly in front of a stationary picture (right) produces a complete and normal appearing image.

Perception A psychological process that includes sensation, memory, and thought and results in meaning such as recognition, identification, and understanding.

Perceptual Defense A psychological process by which we use our perceptual system to avoid threatening stimuli. Perceptual defense is a form of repression, an attempt to prevent unpleasant situations from reaching conscious awareness.

Perceptual Dissonance "Dissonance is created whenever a person is confronted with information that is inconsistent with his expectations. . . . [Imagers] by design introduce dissonance into their work to create visual tension. The viewer attracted by this, becomes involved, and finds pleasure in reducing tension."[12]

Persistent Image A visual image of high fidelity and short duration that is seen immediately after the stimulus has been removed. (*See also* Afterimage *and* Aftereffect.)

Phi Phenomenon The appearance of motion when two similar visual stimuli, somewhat displaced in position, are observed briefly with a short time interval between them.

Polysemantic An image can have several different interpretations. Photographs are polysemantic.

Psychogenic Amnesia In a highly emotionally stressful situation, a person can find it difficult or impossible to recall information, which, under normal conditions, would present no problem. A familiar example is a student's mind going blank during an examination.

Pulfrich Effect If an oscillating pendulum is viewed with one eye covered by a dark sun glass or filter, it will appear to trace an elliptical path, giving the sensation of depth. The information received by the brain through the filtered eye, being of less intensity, is delayed, causing a spatial displacement. (During a Super Bowl football game some years back, a TV commercial was specially designed to give a 3-D effect when viewed with one eye filtered.)

REMs Rapid eye movements during sleep that signify a person is in a dream state.

Rhetoric The study and application of the artful, effective, and persuasive use of verbal or visual language.

Rorschach "The 'inkblot' test devised by the Swiss psychiatrist Hermann Rorschach. The shape of the blot can serve as a stimulus for free-association; in fact almost any irregular free shape can spark off the associative process. Leonardo da Vinci wrote in his Notebooks, 'It should not be hard for you to stop sometimes and look into the stains of walls, or ashes of a

I wanted to show them that things they considered ugly and have forgotten to see are really sublime wonders.

Jean Dubuffet

Art is a lie that makes us realize the truth.

Pablo Picasso

fire, or clouds, or mud or like places, in which . . . you may find really marvelous ideas.'"[13] (*See also* Pareidolia.)

Sense of Presence The feeling that one is not alone, even though no one else is physically present. When one is captivated by a photograph, movie, or video, he or she sometimes experiences a "sense of presence." Some daguerreotype portraits have such a presence.

Sensory Deprivation A severe reduction in the variety and intensity of environmental information received through our sense receptors. In extreme prolonged cases, a person will become disoriented and begin to hallucinate. We are part of, connected to, and dependent on our environment.

Stroop Effect Perceptual interference caused when a person is given a series of color names such as red, green, blue, yellow, and brown that are printed in contradictory colors, and asked to name the color, not the word. For example, the word *red* is in green, the word *green* is in brown, and so on (see Color Plate XI). The person seeing the word must not name the word but rather the color of the word. This is a difficult task at first but with practice, a person learns how to filter out the word and respond to the color. The Stroop effect calls attention to the fact that it takes time to learn new things, particularly when they interfere with our established habits.

Applied to pictures, the Stroop effect suggests that it takes time to accept the representation of objects in colors that are not common to the object. For example, a green sky, purple grass, a red lemon, a blue apple. Look at some of the paintings of Paul Gauguin.

Subliminal Perception A response to a stimulus that is below the level required for conscious perception. The hypothesis that visual and auditory information can be processed without ever having conscious representation. Subjective experiences and neurophysiological and behavioral research support this hypothesis. Early philosophers such as Aristotle, Democritus, Socrates, and Leibniz were aware of this phenomenon and took it for granted.

Synchromism (*syn,* "with"; *chromism,* "color") A method of painting based on a proposed equivalent between the 12-tone scale of Western music and the scale of 12 related colors. Synchromism was developed and practiced by Stanton Macdonald-Wright and Morgan Russell in the early 1900s.

Synchronicity A term introduced by Carl Jung to describe meaningful coincidences in which an unconscious inner event such as a dream is

I cannot see or write or bear—I have nothing left but the will—and that I have in abundance.

Francisco de Goya

We see, hear, smell, and taste many things without noticing them at the time. . . .

Carl Jung

realized in a physical outer event concurrently or at a later time. Jung referred to synchronicity as an acausal connecting principle.

Here are two examples of synchronicity:

1. A person vacationing in Boston has a dream or envisions that someone has just broken into her apartment in San Francisco. Later it is confirmed that the event did occur, and at the time it was envisioned.
2. A person has a premonition that while traveling on a cruise ship two weeks hence, a fire will occur. Two weeks later, while on the ship, the event actually takes place as imagined.

These events, according to Jung, are not just mere coincidences but rather synchronistic events—dreams or premonitions that somehow connect to an outer event and are noncausal, that is, not cause and effect. The inner event (the dream or premonition) did not cause the outer physical event (the robbery or fire).

When I hear Bach in my photographs, I know I've succeeded.

Edward Weston

Synesthesia The ability of one sensory input to affect another. In a 1993 article in *Wired* magazine, Nicholas Negroponti wrote, "One of the most frequently cited studies conducted by the [MIT] Media Lab was authored by Professor Russ Neuman, who proved that people saw a better picture when sound quality was improved. This observation extends to all our senses as they work cooperatively."[14]

The Three Graces "The conventional image of the three naked Graces (Charites), the center one with her back to the observer, occurs again and again throughout Greek and Roman art, and similar figures are even found carved on Hindu temples. It was apparently one of the most popular pictures of the Triple Goddess, all three of her aspects seen as beautiful, joined together as one, like all divine trinities."[15]

Verbal Imagery The ability of words and phrases to arouse visual or other sensory images. A sampling of such words is listed here:

Seeing: colorful, bright, dim, dark, hazy, smoky, milky, clear, glaring, murky, blinding, dull.
Hearing: loud, soft, dulcet, piercing, melodious, raucous, cacophonous, dissonant, shrill, reverberating, throbbing, rhythmic, hollow, dull.
Feeling: sore, soft, warm, cold, moist, dry, hot, sticky, throbbing, texture, dull, excruciating.
Tasting: sweet, sour, bitter, salty, foxy, smoky, tart, spicy, hot, moist, dry, sharp, stringent, citric, musty.
Smelling: acrid, pungent, mephitic, putrid, sweet, spicy smoky, musty, fetid, rotten, fragrant, flowery.

And what is word knowledge but a shadow of wordless knowledge.

Kahlil Gibran

Visual Masking "When pictures or other images are presented in quick succession, the alteration or even elimination of the perception of one image by an immediately preceding or following image."[16] In a moving image

The waterfall illusion was first described by Aristotle

such as a film or video, a single frame, preceded or followed by quite a different image, can alter or eliminate the information on the other frame.

Visual Search The strategy one uses to select specific information from a photograph or other visual image.

Visual Thinking "Visual thinking is problem solving with visual imagery, and involves the receiving, storing, retrieval and processing of pictorial information. These operations can be carried out consciously or subconsciously, voluntarily or involuntarily."[17]

Waterfall Effect "In 1934 a Mr. R. Adams wrote in a British philosophy journal about an optical effect known as the waterfall illusion. The effect is evoked by staring steadily at a rapidly moving object—a waterfall is ideal—and then quickly glancing at a stationary object such as a tree. For a brief period of time the tree will appear to surge skyward, in a direction opposite to the flow of water."[18] If one looks at concentric rings spinning and expanding outward and then shifts his or her gaze, the rings will appear to reverse directions and move inward.

The human perceptual system strives to establish equilibrium by creating aftereffects that are the opposite of the physical stimuli. This perceptual phenomenon seems akin to the biological phenomenon called homeostasis, which monitors the body to maintain equilibrium.

Word Imagery, Concreteness, and Meaningfulness In an article by Allan Paivio and others an extended study was conducted to classify and quantify 925 nouns in terms of their imagery, concreteness, and meaningfulness.[19] Some examples follow:

IMAGERY

High: acrobat, boy, car, dawn, elephant, fire, girl, honeycomb, ink, jelly, kiss.
Low: adage, banality, chance, context, ego, fallacy, greed, hindrance, idea, jeopardy, knowledge.

CONCRETENESS

High: lawn, mountain, nun, ocean, painter, queen.
Low: love, malice, necessity, opinion, panic, quality.

MEANINGFULNESS

High: research, season, tempest, university, valley, warmth.
Low: rosin, savant, temerity, unreality, vanity, wench.

Words are symbolic and are associated with meaning, and trigger emotions, particularly high-imagery words. When the Eastman Kodak Company changed the name (not the product) of one of their films to "Royal Gold" there was a substantial increase in sales and customer satisfaction.

Naming is important to perception. The Shakespearean question "What's in a name?" can be answered "Quite a lot!" A rose named "Pretty Pink" would not be as popular as one named "Paradise Pink," nor would it "smell as sweet." Naming is part of the gestalt in everything we choose to produce or purchase.

Zoetrope ("Wheel of Life") The zoetrope was the forerunner to movies and animation. It consisted of a series of narrow apertures arranged as a wheel. When the wheel was spun slightly, different pictures could be seen through consecutive slits, which gave the perception of movement. It was

invented in the 1830s by William Horner, an English mathematician. Motion pictures were first shown in Paris, in 1895, by Louis and Auguste Lumiere. (*See also* Phi Phenomenon.)

Notes

1. Calvin S. Hall and Vernon J. Nordby, *A Primer of Jungian Psychology,* New York: New American Library, 1973, p. 46.
2. Graham Reed, *The Psychology of Anomalous Experience,* Boston: Houghton-Mifflin, 1974, p. 53.
3. Ibid., p. 37.
4. Ibid., p. 38.
5. Amy Conger, *Edward Weston Photographs,* Tucson: Center for Creative Photography, University of Arizona, 1992, Figure 555.
6. J. E. Cirlot, *A Dictionary of Symbols,* New York: Philosophical Library, 1983, p. 203.
7. M. Ester Harding, *Woman's Mysteries Ancient and Modern,* New York: Harper & Row, 1975, p. 45.
8. William Morris (ed.), *American Heritage Dictionary,* Boston: Houghton-Mifflin, 1980, p. 869.
9. Alexander Eliot (ed.), *Myths,* New York: McGraw-Hill, 1976, p. 10.
10. Reed, *Psychology of Anomalous Experience,* p. 52.

11. Ibid., p. 43.
12. Les Stroebel, Hollis Todd, and Richard Zakia, *Visual Concepts for Photographers,* London: Focal Press, 1980, p. 64.
13. Carl Jung, *Man and His Symbols,* Garden City, NY: Doubleday, 1983, p. 27.
14. Nicholas Negroponti, "Virtual Reality: Oxymoron or Pleonasm?" *Wired,* December 1993, p. 136.
15. Barbara Walker, *The Woman's Dictionary of Symbols and Sacred Objects,* San Francisco: Harper & Row, 1988, p. 256.
16. Stroebel et al., *Visual Concepts,* p. 156.
17. Ibid., p. 44.
18. "The Waterfall Illusion," *Scientific American,* July 1995, p. 18.
19. Allan Paivio, John C. Yuille, and Stephen A. Madigan, "Concreteness, Imagery, and Meaningfulness Values for 925 Nouns," *Journal of Experimental Psychology Monograph Supplement,* Vol. 76, No. 1, Part 2, January 1968.

Appendix B
Answers to Selected Exercises

What is material, tangible and permanent to most people is ephemeral to me. Change is what I believe in. It is the essence of learning, growth and creativity.

Wynn Bullock

"Phoenix" (mixed media). © Andrew Davidhazy.

CHAPTER 1: SELECTION

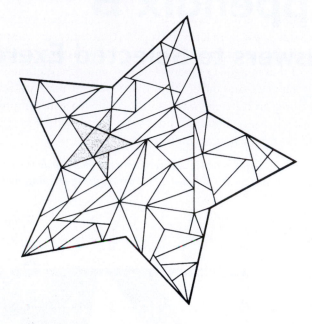

Figure B.1 Answer to the star visual search.

CHAPTER 2: GESTALT GROUPING

WHALE PORTRAIT

HORSEMAN BOAT

Figure B.2 Answer to tangrams.

Answers to "Don't Be a Square"

Most people see the dot array as forming a square. This is predictable based on the Gestalt laws of similarity, proximity, continuity, and closure. Unconsciously, then, one assumes that the problem must be solved within the confines of that imaginary square. The moment this position is taken, the person is trapped—and the problem is not solvable. Force yourself to think and see things in different ways, and by doing so you will produce new and exciting pictures. Look around at images you find interesting and creative and ask yourself why you find them so.

I have always been impressed with the plastic qualities of American Indian art. . . . Their vision has the basic universal of all real art.

Jackson Pollock

9-Dot Puzzle 16-Dot Puzzle

Figure B.3 An important perceptual lesson can be learned from these simple puzzles. Do not impose limitations or constraints on yourself. Be imaginative, organize things differently, avoid habit. Sharpen things instead of leveling them and you will see and experience more.

CHAPTER 7: MORPHICS

Answer to "Swedish Gate" Problem

If you tried to form a word out of the anamorphic letters on the gate in Stockholm, Sweden, you experienced the same problem I did at first. The letters do not spell out a word or words but rather they display the alphabet.

Bibliography

Art is a conventionally accepted reality in which, thanks to artistic illusion, symbols and substitutes are able to provoke real emotion.

Sigmund Freud

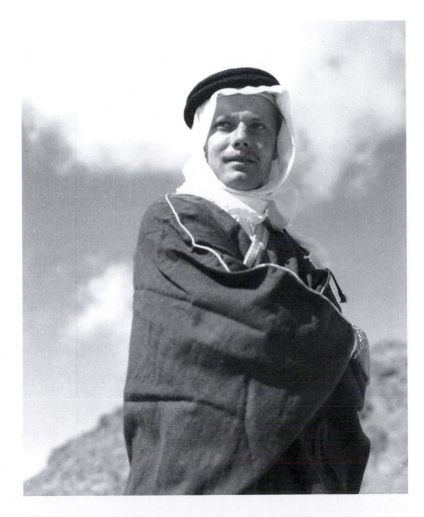

"Lawrence of RIT," Captain Leslie D. Stroebel, U.S. Air Force geodetic control unit in Taif, Saudi Arabia, 1945—out of uniform but in a royal uniform thanks to a gift from King Ibn Saud.

345

Akeret, Robert U. *Photolanguage.* New York: W. W. Norton, 2000.

Albers, Josef. *Interaction of Color.* New Haven, CT: Yale University Press, 1972.

Ang, Tom. *Tao of Photography.* London: Octopus Publishing, 2000.

Arnheim, Rudolf. *To the Rescue of Art: Twenty-Six Essays.* Berkeley: University of California Press, 1992.

Arnheim, Rudolf. *The Power of the Center.* Berkeley: University of California Press, 1982.

Arnheim, Rudolf. *Art and Visual Perception.* Berkeley: University of California Press, 1974.

Berger, Arthur. *Seeing Is Believing.* Mountain Valley, CA: Mayfield, 1989.

Berman, Greta. "Synesthesia and the Arts," *Leonardo,* Vol. 32, No. 1, 1999, pp. 12-22.

Bloomer, Carolyn. *Principles of Visual Perception.* New York: Design Press, 1990.

Burnett, Ron, *How Images Think*, Cambridge, MA: MIT Press, 2004.

Campbell, Joseph. *The Inner Reaches of Outer Space.* New York: Harper Perennial, 1988.

Caponigro, John Paul. *Adobe Photoshop Master Class.* Berkeley, CA: Peachtree Press, 2000.

Caponigro, John Paul. "Messages From the Interior: Interview with Paul Caponigro," *View Camera.* July/August, 2002, pp. 34–39.

Cartier-Bresson, Henri, *The Man, The Image, and The World*, New York: Thames and Hudson, 2003.

Chevreul, Michel Eugéne. *The Principles of Harmony and Contrast of Colors and Their Application to the Arts.* New York: Reinhold Publishing, 1967.

Cohen, David. *The Secret Language of the Mind.* San Francisco: Chronicle Books, 1996.

Conger, Amy. *Edward Weston Photographs.* Tucson: Center for Creative Photography, University of Arizona, 1992.

Cytowic, Richard, E. *The Man Who Tasted Shapes.* New York: Putnam, 1993. (A book on synesthesia.)

Danly, Susan, Jonathan Spaulding, and Jessica Todd Smith (eds.), *Edward Weston, a Legacy*, San Marino, CA: Huntington Library, 2003.

Dixon, N. F. *Subliminal Perception: The Nature of the Controversy.* New York: McGraw-Hill, 1971.

Eakin, Emily, "Penetrating the Mind by Metaphor," *New York Times*, 23 February 2002, Section B p. 9.

Ehrenzweig, Anton. *The Hidden Order of Art*. Berkeley: University of California Press, 1971.

Eliot, Alexander. *Myths*. New York: McGraw-Hill, 1976.

Engeldrum, Peter. *Psychometric Scaling: A Toolkit for Image Systems Development*. Winchester, MA: Imcotek Press, 2000.

Enyeart, Jim (ed.). *Heinecken,* Carmel, CA: Friends of Photography, 1980.

Erwitt, Elliott. *Elliott Erwitt*. Greenwich, CT: New York Graphic Society, 1972.

Escher, M. C. *Escher on Escher: Exploring the Infinite*. New York: Abrams, 1989.

Evans, Ralph. *An Introduction to Color*. New York: John Wiley, 1948.

Fontana, David. *The Secret Language of Dreams*. San Francisco: Chronicle Books, 1994.

Fontana, David. *The Secret Language of Symbols*. San Francisco: Chronicle Books, 1994.

Green, Jonathan. *The Garden of Earthly Delights: Weston and Mapplethorpe*. Riverside, CA: California Museum of Photography, 1995.

Gregory, Richard (ed.). *The Oxford Companion to the Mind*. New York: Oxford University Press, 1991.

Gross, Philippe, and S. I. Shapiro. *Tao of Photography*. Berkeley, CA: Ten Speed Press, 2001.

Heller, Steven. *Paul Rand*. London: Phaidon Press, 1999.

Hornik, Susan, and Kay Chernush. "For Some, Pain Is Orange." *Smithsonian,* February 2001. (This article deals with synesthesia. The article is available on the Smithsonian Web site. Have your server search for ["Smithsonian" + magazine]. You can also purchase a copy of the article or other *Smithsonian* articles on the site.)

Hughes, Robert. *Shock of the New*. New York: Alfred Knopf, 1980.

Hulten, Pontus, et al. *The Arcimboldo Effect: Transformations of the Face from the 16th Century to the 20th Century*. New York: Abbeville Press, 1987.

Image, Object and Illusion. San Francisco: W. H. Freeman, 1974. (Readings from *Scientific American*.)

Johnson, Brooks. *Photography Speaks*. New York: Aperture/Chrysler Museum, 1989.

Jung, Carl. *Man and His Symbols.* Garden City, NY: Doubleday, 1983.

Kohl, Herbert. *From Archetype to Zeitgeist.* Boston: Little, Brown, 1992.

Leppert, Richard. *Art and the Committed Eye: The Cultural Function of Imagery.* Boulder, CO: Westview Press, 1996.

Livingston, Margaret, *Vision and Art: The Biology of Seeing*, New York: Abrams, 2002.

Locher, J. L. *The World of M. C. Escher.* New York: Abrams, 1971.

Lyons, Nathan. *Riding 1st Class on the Titanic.* Cambridge, MA: MIT Press, 1999.

Man Ray Photographs. London: Thames and Hudson, 1982.

Marks, Lawrence, *The Unity of the Senses.* San Diego: Academic Press, 1978.

Marx, Kathryn. *Right and Left Brain Photography.* New York: Amphoto, 1994.

Mary Ellen Mark, American Odyssey, 1963-1999. New York: Aperture, 1999.

Matthaei, Rupprecht (ed.). *Goethe's Color Theory.* New York: Van Nostrand Reinhold, 1971.

McCloud, Scott. *Reinventing Comics.* New York: HarperCollins, 2000.

McCloud, Scott. *Understanding Comics.* New York: HarperCollins, 1994.

Meggs, Phillip B. *A History of Graphic Design.* New York: John Wiley, 1998.

Mora, Gilles, and John T. Hill. *W. Eugene Smith Photographs 1934-1975.* New York: Abrams, 1998.

Morris, Desmond. *Manwatching.* New York: Abrams, 1977.

Nadin, Mihai, and Richard Zakia. *Creating Effective Advertising Using Semiotics.* New York: Consultant Press, 1994.

Newhall, Nancy (ed.). *Edward Weston.* New York: Aperture, 1971.

Noth, Winfried. *Handbook of Semiotics.* Bloomingdale, IN: Indiana University Press, 1990.

Orland, Ted. *Scenes of Wonder and Curiosity.* Boston: David R. Godine, 1988. (Witty and wise commentary and photographs.)

Ostermann, Willie. *Déjà View, Bologna Italy.* Bologna: Pendragon, 2000.

Parks, Gordon. *Arias in Silence.* Boston: Little, Brown, 1994.

Perkis, Philip. *Teaching Photography.* Rochester, NY: OB Press, 2001.

The Photo Book, London: Phaidon Press Limited, 1999.

What you are is God's gift to you. What you become is your gift to God.

An African-American mother to her son, long before he became a star athlete.

Ramachandran, Vilayanur, and Edward M. Hubbard, "Hearing Colors, Tasting Shapes," *Scientific American*, May, 2003.

Rand, Paul. *Design Form and Chaos.* New Haven, CT: Yale University Press, 1993.

Robin, Harry. *The Scientific Image.* San Francisco: W. H. Freeman, 1993.

Rosenblum, Naomi. *A World History of Photography,* 3rd ed. New York: Abbeville Press, 1997.

Rubin, Cynthia Elyce, and Morgan Williams. *Larger Than Life.* New York: Abbeville Press, 1970.

Schiff, Bennett. "The Artist (Magritte) Who Was a Master of the Double Take." *Smithsonian,* September 1992.

Shepard, Roger. *Mind Sights.* New York: W. H. Freeman and Co., 1990.

Solso, Robert. *Cognition and the Visual Arts.* Cambridge, MA: The MIT Press, 1995.

Sontag, Susan. *On Photography.* New York: Farrar, Straus and Giroux, 1977.

South, Will, *Color Myth, and Music-Stanton Macdonald-Wright and Synchromism,* Raleigh: North Carolina Museum of Art, 2001.

Stafford, Barbara Maria. *Good Looking.* Cambridge, MA: The MIT Press, 1996.

Steichen, Joanna. *Steichen's Legacy, Photographs 1895-1973.* New York: Alfred Knopf, 2000.

Steiner, Ralph. *In Pursuit of Clouds, Images and Metaphors.* Albuquerque: University of New Mexico Press, 1985.

Steiner, Ralph. *A Point of View.* Middletown, CT: Wesleyan University Press, 1978. (Fascinating reading as Steiner relates personal experiences with such notables as Ansel Adams, Paul Caponigro, Aaron Copeland, Walker Evans, Georgia O'Keeffe, Alfred Stieglitz, Paul Strand, Clarence White, and Minor White.)

Stroebel, Leslie, John Compton, Ira Current, and Richard Zakia. *Basic Photographic Materials and Processes.* Boston: Focal Press, 2000.

Stroebel, Leslie, Hollis Todd, and Richard Zakia. *Visual Concepts for Photographers.* London: Focal Press, 1980.

Stroebel, Leslie, and Richard Zakia. *Focal Encyclopedia of Photography.* Boston: Focal Press, 1993.

Turner, Pete, *Pete Turner African Journey,* New York: Graphis Press, 2000.

Twitchell, James. *Adcult USA.* New York: Columbia University Press, 1996.

Van Campen, Crétien. "Artistic and Psychological Experiments with Synesthesia." *Leonardo,* Vol. 32, No. 1, 1999, pp. 9-14.

Walker, Barbara. *The Woman's Dictionary of Symbols and Sacred Objects.* San Francisco: Harper & Row, 1988.

Walker Evans. New York: Metropolitan Museum of Art in association with Princeton University, 2000.

Whelan, Richard. *Double Take.* New York: Clarkson Potter, 1981. (Distributed by Crown Publishing.)

Whitfield, Sarah. *Magritte.* London: The South Centre, 1992.

Williams, Robin. *Non-Designers Design Book.* Berkeley, CA: Peachpit Press, 1994.

Willis-Braithwaite, Deborah. *Van Der Zee, Photographer.* New York: Abrams in association with the National Portrait Gallery, Smithsonian, 1993.

Winogrand, Gary. *The Man in the Crowd.* San Francisco: Fraenkel Gallery, 1999.

Zaltman, Gerald, *How Customers Think: Essential Insights Into the Mind of the Market,* Boston: Harvard Business School Publishing, 2003.

Zeki, Semir. *Inner Vision.* Oxford: Oxford University Press, 1999.

Zettl, Herbert. *Sight, Sound, Motion: Applied Media Aesthetics.* Belmont, CA: Wadsworth Publishing, 1990.

Index

Index to Quotes